TEXTUAL EXPOSURES

Latin American and Caribbean Series

Hendrik Kraay, General Editor
ISSN 1498-2366 (PRINT), ISSN 1925-9638 (ONLINE)

This series sheds light on historical and cultural topics in Latin America and the Caribbean by publishing works that challenge the canon in history, literature, and postcolonial studies. It seeks to print cutting-edge studies and research that redefine our understanding of historical and current issues in Latin America and the Caribbean.

No. 1 · **Waking the Dictator: Veracruz, the Struggle for Federalism and the Mexican Revolution** Karl B. Koth

No. 2 · **The Spirit of Hidalgo: The Mexican Revolution in Coahuila** Suzanne B. Pasztor · Copublished with Michigan State University Press

No. 3 · **Clerical Ideology in a Revolutionary Age: The Guadalajara Church and the Idea of the Mexican Nation, 1788–1853** Brian F. Connaughton, translated by Mark Allan Healey · Copublished with University Press of Colorado

No. 4 · **Monuments of Progress: Modernization and Public Health in Mexico City, 1876–1910** Claudia Agostoni · Copublished with University Press of Colorado

No. 5 · **Madness in Buenos Aires: Patients, Psychiatrists and the Argentine State, 1880–1983** Jonathan Ablard · Copublished with Ohio University Press

No. 6 · **Patrons, Partisans, and Palace Intrigues: The Court Society of Colonial Mexico, 1702–1710** Christoph Rosenmüller

No. 7 · **From Many, One: Indians, Peasants, Borders, and Education in Callista Mexico, 1924–1935** Andrae Marak

No. 8 · **Violence in Argentine Literature and Film (1989–2005)** Edited by Carolina Rocha and Elizabeth Montes Garcés

No. 9 · **Latin American Cinemas: Local Views and Transnational Connections** Edited by Nayibe Bermúdez Barrios

No. 10 · **Creativity and Science in Contemporary Argentine Literature: Between Romanticism and Formalism** Joanna Page

No. 11 · **Textual Exposures: Photography in Twentieth Century Spanish American Narrative Fiction** Dan Russek

 UNIVERSITY OF CALGARY
Press

TEXTUAL EXPOSURES
Photography in Twentieth-Century Spanish American Narrative Fiction

DAN RUSSEK

 UNIVERSITY OF CALGARY
FACULTY OF ARTS
Latin American Research Centre

Latin American and Caribbean Series
ISSN 1498-2366 (Print) ISSN 1925-9638 (Online)

© 2015 Dan Russek

University of Calgary Press
2500 University Drive NW
Calgary, Alberta
Canada T2N 1N4
www.uofcpress.com

This book is available as an ebook which is licensed under a Creative Commons licence. The publisher should be contacted for any commercial use which falls outside the terms of that licence.

LIBRARY AND ARCHIVES CANADA CATALOGUING IN PUBLICATION

Russek, Dan, 1963-, author
 Textual exposures : photography in twentieth-century Spanish American narrative fiction / Dan Russek.

(Latin American and Caribbean series, ISSN 1498-2366 ; 11)
Includes bibliographical references and index.
Issued in print and electronic formats.
ISBN 978-1-55238-783-2 (pbk.).—ISBN 978-1-55238-786-3 (epub).—ISBN 978-1-55238-787-0 (mobi).—ISBN 978-1-55238-785-6 (pdf)

 1. Spanish American fiction—20th century—History and criticism. 2. Photography in literature. 3. Literature and photography—Latin America—History—20th century. I. Title. II. Series: Latin American and Caribbean series ; 11

PQ7082.N7R88 2015 863'.609357 C2015-901357-7
 C2015-901358-5

The University of Calgary Press acknowledges the support of the Government of Alberta through the Alberta Media Fund for our publications. We acknowledge the financial support of the Government of Canada through the Canada Book Fund for our publishing activities. We acknowledge the financial support of the Canada Council for the Arts for our publishing program.

This book has been published with the help of a grant from the Canadian Federation for the Humanities and Social Sciences, through the Awards to Scholarly Publications Program, using funds provided by the Social Sciences and Humanities Research Council of Canada.

Photos on pages 118, 119, 122, and 129 provided courtesy of Siglio XXI Editores.
Cover images: #2358460, #3679918, #5114747 (colourbox.com)
Cover design, page design, and typesetting by Melina Cusano

*I dedicate this book
to my late father Salomón, my mother Geula,
my brother Guil, and my sister Dalia.*

CONTENTS

Acknowledgments	*ix*
Introduction	*1*
1: Uncanny Visions: Rubén Darío, Julio Cortázar, and Salvador Elizondo	*17*
2: Family Portraits: Horacio Quiroga, Juan Rulfo, Silvina Ocampo, and Virgilio Pinera	*77*
3: Politics of the Image: Julio Cortázar and Tomás Eloy Martínez	*115*
Conclusion	*153*
Bibliography	*159*
Notes	*181*
Index	*221*

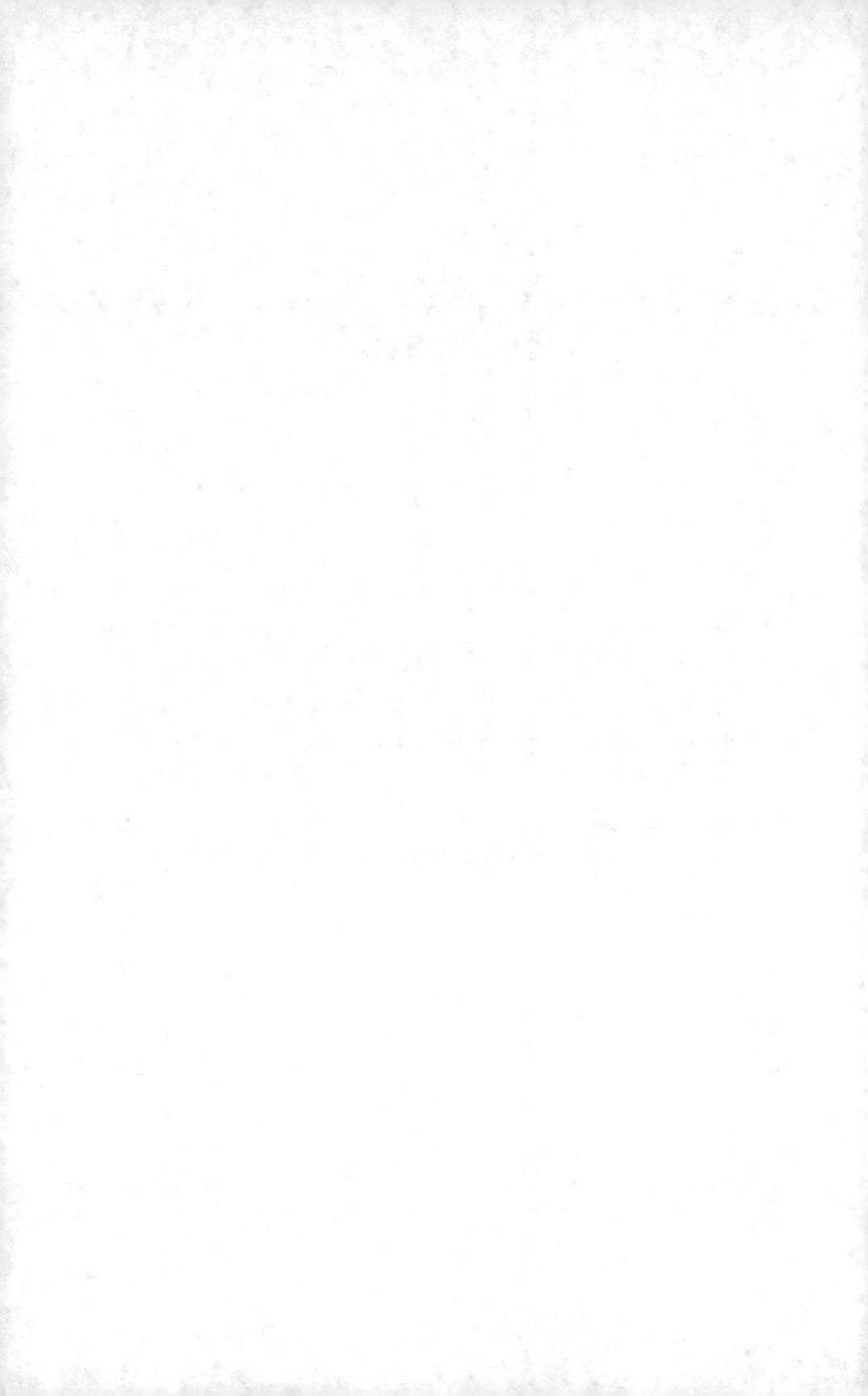

ACKNOWLEDGMENTS

This book was long in the making, and I owe a debt of gratitude to many people and many institutions. The research project was supported by grants from the Consejo Nacional de Ciencia y Tecnología (Mexico) and a Standard Research Grant from the Social Sciences and Humanities Research Council of Canada. Research trips were made possible through the generous support of the Tinker Travel Grant, the Center for Latin American Studies Travel Grant, the Doolittle Fellowship, and the Humanities Travel Grant, all from the University of Chicago, as well as Internal Research Grants from the University of Victoria. My thanks go to the directors and staff of the Benson Latin American Collection at the University of Texas at Austin, the Biblioteca Nacional at the Universidad Nacional Autónoma de México in Mexico City, and the Biblioteca Nacional and Hemeroteca, the Biblioteca del Congreso, and the Biblioteca Tornquist in Buenos Aires. To these agencies and institutions, my acknowledgement for the invaluable privilege of engaging in serious and enjoyable academic work.

Over the years, I have profited from the guidance, scholarship, and wisdom of professors, writers, and artists in courses and conferences. In Mexico, Rosa Beltrán, Flora Botton, Horacio Costa, Carlos Pereda, Luz Aurora Pimentel and Pablo Soler Frost; in the United States, Alicia Borinsky, Françoise Meltzer, W. J. T. Mitchell, Mario Santana, Joel Snyder, and Yuri Tsivian; in Argentina, Abel Alexander, Sara Facio, Ana María Shua, and Susana Zanetti; and in Canada, my colleagues at the University of Victoria, Lloyd Howard and Pablo Restrepo-Gautier.

I want to acknowledge the photographer Alicia Sanguineti for allowing me to use the portrait of Silvina Ocampo by the late Alicia D'Amico, and Ezequiel and Gonzalo Martínez, from the Fundación Tomás Eloy Martínez, for the use of the photograph of their father with Juan Domingo Perón.

I had the good fortune of meeting the late Tomás Eloy Martínez, as well as the late Salvador Elizondo, to whom I am grateful for their teachings in person and in writing.

To my friends, many of them now fellow colleagues, my thanks for the rich conversations we have been engaged in over the years: Irene Artigas, Yael Bitrán Goren, Flavia Cesarino Costa, Josefina Ghiglino, Susana González Aktories, Alejandra González Aktories, Eduardo Gutiérrez, Georg Leidenberger, Marcos Natali, Alberto Nulman, Rosa Sarabia, Alisú Schoua-Glusberg, Michael Schuessler, Ana María Serna, and Alvaro Vázquez Mantecón. My thanks to Susan Abrill, for the exchange of ideas and her proofreading over the years; to the editors of my scholarly contributions, Mary Beth Tierny-Tello, David William Foster, Dawne McCance, and Jesús Pérez-Magallón; and to the editors of the University of Calgary Press, Peter Enman, Karen Buttner, Melina Cusano, and the Latin American Series editor, Hendrik Kraay. Thanks also to Alison Jacques for copyediting the text, and to Reader D, for her thorough reading of the manuscript and her many useful suggestions.

I want to acknowledge in particular Lois Parkinson Zamora and Marcy Schwartz for their professional and personal support over the years. Last, a very special thanks to Patrick O'Connor, my former PhD advisor, a wise, knowledgeable, and kind person—a true mentor—without whom this scholarly project would not have come to fruition.

INTRODUCTION

This book explores the relationship between twentieth-century Latin American narrative fiction and the photographic medium. It probes the ways in which literature registers photography's powers and limitations, and how authors elaborate its conventions and assumptions in fictional form. While this is essentially a study of literary criticism, it aims to show how texts critically reflect the media environment in which they are created. The writings I analyze enter a dialogical relationship with visual technologies such as the X-ray, cinema, illustrated journalism, television, and video. This book examines how these technologies, historically and aesthetically linked to photography, inform the works of canonical writers in Spanish America.

Photography holds a special status in the array of modern technologies of representation. From a conventional rubric that defines it as a technique through which a sensitized material surface is exposed to light and developed through mechanical means to produce a picture of whatever is placed in front of the camera, the medium has evolved into a hybrid, protean, multipurpose application.[1] While on many occasions writers have taken photography's conventional definition for granted, on others they have challenged, transgressed, and transcended it.

It is perhaps fitting that this analysis comes at a time when "traditional" ideas about the photographic medium are being challenged and reassessed, if not superseded, in view of the powerful new tools of photographic production, manipulation, and dissemination brought about by

the digital revolution. The so-called "information age" brings with it a paradigm shift from photomechanical to digital technologies, from laboratory work to software, from glass and paper to handheld devices and computer screens, and from the exhibition of images in galleries and museums to their dissemination through the Internet. Inevitable as it may be to speak about a post-photographic age, as a number of artists, critics, and scholars have done, this stance risks missing the distinctive evolution of the photographic medium since its origins as well as its endurance and continuity.[2] Ever since the emblematic but quickly defunct daguerreotype, photography has undergone a steady flux of technical innovations and has seen an ever-widening sphere of influence on modern visual culture. This technical reshaping has created a great variety of uses and contexts where photography is applied and practiced. While issues regarding the truthfulness and objectivity of the photographic image have been at the forefront of modern and postmodern critical debates, the uses of the photographic medium, regardless of the profound changes digitalization implies, do not seem bound for extinction any time soon. Rather than the death of photography, we are experiencing yet another of its incarnations. As Henry Jenkins persuasively argues,

> once a medium establishes itself as satisfying some core human demand, it continues to function within the larger system of communication options. . . . Printed words did not kill spoken words. Cinema did not kill theater. Television did not kill radio. Each old medium was forced to coexist with the emerging media. That's why convergence seems more plausible as a way of understanding the past several decades of media change than the old digital revolution paradigm had. Old media are not being displaced. Rather, their functions and status are shifted by the introduction of new technologies.[3]

In an age of accelerated time, information overload, and constant technological change, it could be argued that the fixed image has acquired a privileged status, one that promises the illusion of permanence and the possibility of easy retrieval. In modern times, photography emblematizes the fixed image better than any other medium. One of the claims of this study is that literary texts often attest to this privileged condition by regularly

employing photographs as representations of last resort for conveying visual meaning.

The emergence of modern Latin American literature since the end of the nineteenth century coincided with the rise and ongoing transformation of photography as a means of communication and visual representation. The American critic and historian Alan Trachtenberg, referring to Lewis Carroll, Emile Zola, and Wright Morris, pointed out that "a history of photographic criticism must take into account the important and largely uninvestigated transactions between photography and formal literature."[4] Since then, a variety of anthologies have been devoted to these links, most notably two groundbreaking collections edited by Jane M. Rabb: *Literature and Photography: Interactions 1840–1990* (1995) and *The Short Story and Photography, 1880s–1980s* (1998). It is worth noting, however, the cultural and linguistic limitations of these volumes, which are mainly concerned with English and French literatures. Texts in Spanish are conspicuously absent.[5] The inclusion of Julio Cortázar's short story "Blow-Up" (originally "Las babas del diablo," 1959) in the second of Rabb's volumes is due in part to the international attention the text received when credited in Antonioni's film *Blow-Up* (1966).[6] However, other than the Argentine writer, whose texts have produced an abundant bibliography, not enough critical attention has been devoted to the systematic study of the wealth of narrative texts about photography in twentieth-century Latin American literature. While an increasing number of studies have been published about particular Latin American authors as diverse as Leopoldo Lugones, Guillermo Cabrera Infante, Elena Poniatowska, and Roberto Bolaño, no single book in English has attempted a comprehensive examination of the topic.[7]

In recent years, scholars in the field of Latin American literature have recognized the importance of the links between literature and photography. Daniel Balderston uses photography as a category by which to classify the short story in Spanish America, in an entry in the *Cambridge History of Latin American Literature*.[8] The collection of essays entitled *Double Exposure: Photography and Writing in Latin America* (2006), to which I am a contributor, advances the study of the links among photography, writing, and a host of social and political practices. Another collection of essays, *Phototextualities* (2003), edited by Alex Hughes and Andrea Noble, explores the intersection between photography and narrative. This

collection includes two essays about Latin America, but they do not pertain to literature. The first, by Catherine Grant, is about photographs of the disappeared in Argentine films about the "Dirty War," and the second, by Noble, is a study of a photograph of a *soldadera*. Antonio Ansón reviews the interactions between world literature and photography in his brief but informative *Novelas como álbumes* (2000). Roberto Tejada's *National Camera: Photography and Mexico's Image Environment* (2009) and Esther Gabara's *Errant Modernism: The Ethos of Photography in Mexico and Brazil* (2008) are concerned mostly with the interactions of photography with history and culture. John Mraz's illuminating *Looking for Mexico* (2009) provides a clear exposition of the evolution of the field of visual culture in modern Mexico.

Two recent books, both in Spanish, are noteworthy contributions to the field. The first is Valeria de los Ríos's *Espectros de luz: Tecnologías visuales en la literatura latinoamericana* (2011). It is a collection of essays that deals with the impact of photography and cinema upon modern and contemporary Latin American literature. It includes analyses on Leopoldo Lugones, Salvador Elizondo, Juan Luis Martínez, Roberto Bolaño, Horacio Quiroga, Julio Cortázar, Edmundo Paz-Soldán, Vicente Huidobro, Roberto Arlt, and Guillermo Cabrera Infante, among others. Photography and film are seen as triggers that unleash fantasies, desires, and anxieties thematized in the literary text. Though the group of essays could be more tightly knit, and there is some unevenness in the arguments they develop, the collection, relying on a host of cultural critics and poststructuralist theorists, has the virtue of throwing new light on the impact of modern visual technologies upon the work of important Latin American writers. The second book, entitled *Pliegues visuales: Narrativa y fotografía en la novela latinoamericana contemporánea* (2013), by Magdalena Perkowska, is a thoroughly researched and theoretically solid investigation of the *fotonovela*. This literary subgenre refers to a hybrid form: novels that include actual photographs along with the text. Perkowska argues that in the works she studies—*Mil y una muertes* by Sergio Ramírez, *Tinísima* by Elena Poniatowska, *La llegada (crónica con "ficción")* by José Luis González, *Fuegia* by Eduardo Belgrano Rawson, and *Shiki Nagaoka: una nariz de ficción* by Mario Bellatín—photographs should not be read merely as illustrations or supplements, because they are indispensable elements that invite, or even force, the reader to develop new strategies of reading

and interpretation, given the semiotic and aesthetic match between literary word and photographic representation.

Interactions and analogies between literature and photography occur on multiple levels. On the most elemental one, photography, like painting, cinema, and other visual arts, has been a constant source of creative inspiration. It has also been a discursive model: writers creatively exploit the snapshot and the postcard as forms of verbal/visual representation, and the photo album has been employed as a useful literary device for conjuring memories, weaving stories, and constructing identities. On another level, very much like the notebook that accompanies the novelist, the camera has functioned as a shorthand device, a portable machine that provides the means to immediately register a spatial setting and a moment in time.[9] Conversely, as Shloss notes, there is an analogous creative impulse in literature and photography, since, for the writer, "constituting the text, finding its material, is similar to using a camera."[10]

Authors frequently mention photographs in poems and stories, make the photographer a recurring character, and place the photographic act at the centre of the plot. Narrative texts often refer to the topical uses of photography, such as the preservation of life against the action of time and death, the latency of memory, the power of visual reconnaissance, the extension of vision, the aesthetic and erotic capacity to shock and to excite, the social and political aspects of visual testimony, and the many specific cultural uses of the medium, ranging from portraiture and the ethnographic survey to fashion, advertising, and travel. Ambivalent fetish or endearing token, a photograph embodies the constructed nature of personal and collective identities. Photography, as applied to a style or to memory, connotes a supposedly accurate, neutral, matter-of-fact depiction, which was articulated in its classical version by Emile Zola, referencing the scientific ideas of Claude Bernard, in his 1880 essay "The Experimental Novel": "The observer relates purely and simply the phenomena which he has under his eyes. . . . He should be the photographer of phenomena; his observation should be an exact representation of nature."[11] Endowed with these connotations, actual photographs have themselves been understood in metaphorical terms. For Bazin, they are akin to mummified remains; Barthes saw them as a theatrical act and McLuhan as a medium endowed with the qualities of gesture and mime.[12]

As for their affinities, the intellectual acts of decoding, interpreting, and inspecting in a sustained effort of reflection apply to reading verbal texts as well as photographic images. Some of the most frequently quoted pieces of photographic criticism, such as Barthes's essays "The Photographic Message" and "Rhetoric of the Image," address the issue of photography's readability. Both the printed word and the photographic image elicit an immediate scanning and require a sustained act of attention for their interpretation. Contrary to the moving images of cinema, television, video, and media streaming, photography can be compared to writing in that both media constitute a portable storage of fixed symbolic forms. They are nomadic media that are tasked with fixing, while inscribing in a material substratum, a stream of thoughts or an event in space and time.

A photograph is an invitation to narrate, as writers widely recognize.[13] But photographs are not purely visual signs that inspire stories; they are also defined by, and embedded in, the multiple stories a culture generates. As Victor Burgin argues, "photographs are texts inscribed in terms of what we may call 'photographic discourse,' but this discourse, like any other, engages discourses beyond itself, the 'photographic text,' like any other, is the site of a complex 'intertextuality,' an overlapping series of previous texts 'taken for granted' at a particular cultural and historical conjuncture."[14]

While the photograph has been frequently read as a text, literary writing and photographic image nonetheless remain heterogeneous regimes of representation, ruled by different codes and modes of reception and interpretation. The word may contextualize the image, and the image may provide information to illustrate the text, but the visual specificity and materiality of the photograph stand in opposition to the abstract power of the literary imagination to suggest and evoke. Even if the materiality of the sign is implied in any signifier, the ideality and intelligibility of the text stands in contrast to the material nature and impact of the photograph.[15]

European and American writers, such as Victor Hugo, Lewis Carroll, George Bernard Shaw, Arthur Conan Doyle, and Jack London among others, took up photography as a hobby.[16] A number of renowned Latin American authors also engaged in photography as a means of visual production at some stage in their careers, such as Horacio Quiroga, Juan Rulfo, and Adolfo Bioy Casares.[17] Julio Cortázar, a committed practitioner,

even published his pictures in his later years. They appear in *La vuelta al día en ochenta mundos* (1967), *Ultimo round* (1969), and *Prosa del observatorio* (1972), as well as in *Los autonautas de la cosmopista* (1983), written with his then partner, Carol Dunlop. Though for Cortázar photography remained largely a personal, non-professional enterprise, the impulse to visually capture his surroundings attests to a photographic sensibility that is reflected in a variety of ways in his work. Photography, both as actual practice and as artistic subject, is an endeavor particularly well-suited to a writer who railed against the boring habits of civilized life and embraced the insights of intuition and spontaneity, whose literary work chronicled the fragmented pace of modern life, and whose creative process, deeply indebted to Surrealism, depended not on the development of predetermined plans but on the encounter with the random and the unexpected. The three volumes of Cortázar's correspondence provide ample evidence of a photographic hobby that became a decades-long practice.[18] In an interview with Evelyn Picón Garfield in 1973, he mentions that he took three hundred pictures of the observatories of the Sultan Jai Singh in Jaipur and New Delhi. He also refers to his early photographic practice and dwells upon the art of photography, which he links to an underlying literary interest.[19]

Though I refer to some actual photographs in my analysis of the works of Cortázar and Elizondo, this book is only partly concerned with real pictures that appear in literary works. Scant attention is paid either to illustrated works or to the collaborative effort between writers and photographers, a relation that has yielded a significant number of works in Latin American letters.[20] Rather, the focus is on the thematic, structural, cultural, and political imprints the photographic motif leaves on narrative texts. Organized as eight case studies, it highlights the evolution of the uses of the medium in literature by drawing an arc that spans from the fantasies of the technological uncanny in Rubén Darío at the end of the nineteenth century to the social roles photographic images play in the late twentieth century in texts by Cortázar and Tomás Eloy Martínez.

Theorists of photography have understood the medium in two different, though not necessarily incompatible, ways.[21] The first emphasizes what Barthes called the photograph's "analogical plenitude," that is, its objective, direct, or transparent link to a referent and its attendant power to certify, authenticate, or bear witness.[22] Contemporary critics such as Bazin, Arnheim, and Sontag have advanced versions of this point of view,

which is attuned to the common understanding of photography as a sign that "proves" the reality of an event. The second way stresses less what the photograph shows or purports to show, focusing instead on the contexts that make it possible, such as the social, political, and historical conditions that are not apparent in the purely visual information the sign conveys. This position takes a critical stance with regard to the alleged transparency of the medium, arguing that photographs always depend on contexts of production and reception. Language, with its powers to shape and reshape meaning, is never absent from the way we consider photographs. Theorists such as Berger, Burgin, Krauss, Sekula, Tagg, and Sontag have advanced this position as well. When it comes to fictional literature, writers are less concerned about determining the "ontology" of the photographic image as such. However, they operate in the environment of a visual culture that makes them both sensitive to the power of photographs and aware of their potential use in their works. In this sense, they exploit the "blind spots" of the image. On the one hand, the photograph's realist assumption (its direct link to a referent) is upset or challenged by writers who explore its potential fantastic or demonic uses; on the other hand, they comment and interpret the social, historical, and political conditions that lay beyond the frame of the photographic sign.

The relationship between literary word and photographic image can be framed, at least initially, in reference to the traditional comparison between poetry and painting, which dates back to classical antiquity.[23] The concept of ekphrasis is employed in this study as an interpretive tool that helps to illuminate the links between verbal and visual representations. A rhetorical and literary device, ekphrasis was defined in its modern sense by Leo Spitzer as "the poetic description of a pictorial or sculptural work of art" and "the reproduction, through the medium of words, of sensuously perceptible *objets d'art*."[24] Following Spitzer, Murray Krieger considers ekphrasis a topos "that attempts to imitate in words an object of the plastic arts," but he expands this notion to refer to an impulse and an aspiration, an ekphrastic principle which, in the words of W. J. T. Mitchell, makes the visual arts "a metaphor, not just for verbal representation of visual experience, but for the shaping of language into formal patterns that 'still' the movement of linguistic temporality into a spatial, formal array."[25] Mitchell's own definition considers ekphrasis "the verbal representation of

a visual representation."²⁶ Wagner extends it to all verbal commentary on images, be it "poems, critical assessments, [or] art historical accounts."²⁷

In its modern incarnation, ekphrasis has been considered a paradoxical concept, a complex knot that simultaneously invites and resists semiotic fullfilment. In the words of Krieger, "to look into ekphrasis is to look into the illusionary representation of the unrepresentable, even while that representation is allowed to masquerade as a natural sign, as if it could be an adequate substitute for its object."²⁸ In this respect, photography itself has been understood on paradoxical grounds, mingling the referential power of the natural sign and the conventions of a coded message.²⁹ The analysis of photographic representations in literature may provide a useful window through which to elucidate the complex figures drawn by the interaction of verbal and visual media.

While ekphrasis is a useful interpretive tool for delving into the links between the realms of the verbal and the visual, it must be noted that the photographic medium introduces a new regime of representations with regard to traditional visual arts such as painting, graphic arts, and sculpture, as Benjamin's classic essay on the work of art in the age of mechanical reproduction pointedly asserts. Contrary to the uniqueness and static condition of the traditional work of visual art, photography's widespread dissemination and potentially endless reproduction, the discovery it allows of new visual realities through optical and mechanical devices, and its integration in everyday cultural practices and social contexts add a new dimension to the ekphrastic model in which a writer describes an object of visual art. In this context, photography allows for an extraordinarily rich and dynamic incorporation in literary texts.

My analysis relies mostly on "notional ekphrases," that is, verbal renderings of imagined photographs.³⁰ As it will become clear, fictional photographs often share the qualities of actual pictures. Of course, these have an important role to play in my study, but ekphrastic creations will play the most prominent role. Understood this way, photographs become textual knots or narrative folds: figures that complicate the representational *mise-en-scène* of a short story or novel. They become verbal renderings of visual representations that lend their concise powers of communication to a work of verbal art. While literary texts register some of the conventional features of the photographic medium, they also invent or recreate them, as noted above, for their own ends.

Contemporary scholars such as James Heffernan and Peter Wagner have advanced the notion of a struggle among media, a concept that can be traced to the Renaissance notion of the *paragone*, or contest among the arts. This competition has been framed by Heffernan as "a perpetually contentious kind of marriage whose very antagonisms provoke the ambivalent urge to resolve and to sustain them."[31] With regard to my analysis, Leonardo da Vinci's arguments about the superiority of painting over poetry,[32] or the visual over the verbal, could be employed, *cum grano salis*, to assert the (paradoxical) superiority of the photographic sign over its verbal representation. It would seem that, when it comes to literary texts, the last word, if the pun is acceptable, belongs to the verbal. However, my interpretation shows how often in the writings I examine the text seems to yield its powers of description and narration to the photographic image. Even if they remain textually rendered, photographic representations are endowed with an intensity to affect and haunt that seems to transcend the verbal. In this sense, they become privileged signs that, even if made out of words, enjoy a heightened authority in the establishment of meaning and truth.

No tailor-made, cross-disciplinary framework covers all possible links between literary writing and the photographic medium. My close textual and cultural readings rely on an immanent approach, in which I analyze the selected texts according to their own specificities and make relevant thematic and structural connections among them. Insights from contemporary theorists and historians of photography as well as media and film scholars allow me to develop a conceptually informed interpretation. I also employ the work of critics who have explored the role of visual arts and media, particularly photography, in the Latin American context. I draw from the works of Jean Franco, Carlos Monsiváis, Beatriz Sarlo, Marcy Schwartz, and Lois Parkinson Zamora, among others. These authors recognize photography's impact on contemporary culture and reflect upon its importance as the foremost modern visual medium, one that decisively shapes our ideas about memory, death, truth, and identity.

My study covers the years 1895, the date of the discovery of the X-ray, to 1985, the peak of television's reach and the cusp of the digital revolution. It is divided into three chapters and a conclusion.

Chapter 1, "Uncanny Visions," analyzes the demonic aspect of photography in texts by Rubén Darío ("Verónica," 1896), Julio Cortázar ("Las

babas del diablo," 1959, and "Apocalipsis de Solentiname," 1977), and Salvador Elizondo (*Farabeuf*, 1965). This chapter, the longest in the book, highlights how photography, as both technique and representation, is employed by these authors to advance a sense of the uncanny, experienced, as Laura Mulvey states, as "a collapse of rationality."[33] Associated primarily with all that arouses dread and horror, the uncanny is defined by Freud as "that class of the frightening which leads back to what is known of old and long familiar."[34] The concept of the uncanny has acquired, especially in the last two decades and often beyond its psychoanalytical context a renewed critical currency in fields such as cultural, media, and film studies, art history, aesthetics, architecture, and of course literary studies.[35] Freud recognized the potential of the uncanny to be used as a critical tool for literary criticism and even pointed out that "fiction presents more opportunities for creating uncanny feelings than are possible in real life."[36] I begin with Darío's "Verónica," a short story that I read as inaugurating a literary tradition in terms of its treatment of the photographic medium. Though photography was mentioned by late-nineteenth-century writers such as Eduardo Holmberg, José Martí, and Clorinda Matto de Turner,[37] Darío is the first major writer who seized photography's potential as a literary motif in a narrative text. I bring to the fore the background of Darío's text, especially the discovery of the X-ray, its introduction in Buenos Aires at the end of the nineteenth century, and the author's literary elaboration under the guise of a critique of modern science. Next, I analyze the photographic medium in Cortázar's widely known short stories "Las babas del diablo" and "Apocalipsis de Solentiname." I show how, on the one hand, Cortázar employs established practices of modern photography to articulate the plot of these texts, and on the other, the way the medium contributes to their fantastic *dénouement*. I conclude the chapter examining the central role of photography in the poetics of Salvador Elizondo. I analyze the ways in which the photographic medium becomes the focal point of an obsessive delirium in his major novel, *Farabeuf*. I explore how the intricate narrative structure of this novel, in its complex network of connections between memory, perception, and representation, is organized by the photographic image. Chapter 1 attests to the ways in which Darío, Cortázar, and Elizondo upset and transgress the conception of the photograph as a flat, fixed, and realist representation. While reflecting on notions of embodiment, the tactile, and the moving image in relation to

photography, these authors highlight the materiality of the photographic sign.

Chapter 2, "Family Portraits," focuses on texts by Horacio Quiroga ("La cámara oscura," 1920), Juan Rulfo (*Pedro Páramo*, 1955), Silvina Ocampo ("Las fotografías," 1959, and "La revelación," 1961), and Virgilio Piñera ("El álbum," 1944). The chapter examines the ambiguities of memory and the illusory power of the image to overcome death in family portraits. By exploring the material conditions in which photographs are taken, developed, and archived, this chapter throws light on aspects of these texts that have been overlooked by most critics. I show how the four authors work within the conventions of the medium while simultaneously upsetting them for literary effect. Some topics from chapter 1 are touched upon again in the analyses of chapter 2. The concept of the uncanny provides a useful transition to the interpretation of the short story by Quiroga. I reinterpret "La cámara oscura," despite its flaws, as one of Quiroga's most emblematic texts. Its importance lies in making prominent not only sudden death (a central concern, as is well known, of Quiroga's work) but also its representation. In the case of Juan Rulfo, I focus on a passage in *Pedro Páramo* that mentions a portrait of the protagonist's mother. Examination of this "textual photograph" reveals the desolation and anguish that underpins Rulfo's literary world. In the case of Silvina Ocampo, I study her stories "Las fotografías" and "La revelación" as exemplars of photography's power to disrupt, rather than preserve, social conventions. Finally, in the case of Virgilio Piñera's "El álbum," I read this absurdist story as a social critique that targets ceremonies of remembrance such as the collective viewing of a photographic album.

Chapter 3, "Politics of the Image," presents the aesthetic and political dimensions of photography in Julio Cortázar's *La vuelta al día en ochenta mundos* (1967), *Ultimo round* (1969), and "Apocalipsis de Solentiname" (1977), and Tomás Eloy Martínez's *La novela de Perón* (1985). The chapter examines how late-twentieth-century illustrated journalism serves as a discursive model in these texts, and how the fixed image competes with the rise of new technologies such as television and video. In the case of Cortázar, I analyze the pivotal role those texts play in his shift toward a politically committed intellectual stance, an attitude reflected in the use of photography in his writings. In the case of Martínez, I display the rich panoply of references to photography in a novel that has been read mainly

as a fictionalization of historical events. I claim that this is a paradigmatic novel with regard to the ways it develops the photographic motif in literature, on the cusp of the digital age.

The Conclusion assesses the general trends outlined in the preceding chapters, highlighting the creative links made by these authors between word and photographic image. It also addresses the interactions between literary texts and visual media within the current paradigm shift to a digital media environment. It suggests that, while "traditional" (i.e., photo-chemically produced, paper-based) photography might be outdated, the photographic archive of the last two centuries will still be a fertile ground for stories spun by writers.

As for the criteria used in selecting the texts, I have chosen a number of well-known writings as well as other, lesser-known works. My intention is to show how these texts, when read together, shed light on a number of issues that would not come to the surface as forcefully if considered separately. On occasion, the chosen text may seem marginal to the author's overall literary output or to his main contributions to literary history ("Verónica," by Darío, is a case in point). My hope is that my analysis will advance a new appreciation of the chosen works. The choice of authors also aims to offer a broad view of the interactions between Spanish American literature and photography. While the inclusion of writers such as Cortázar and Elizondo is obvious given the centrality of the photographic medium in their works, the reason for including other texts may not seem so evident. On the one hand, texts about photography by canonical authors have been somewhat forgotten or not deemed representative (such as "Verónica" and "La cámara oscura"). On the other, my analysis of a novel that deals mainly with the rise and fall of a political figure (*La novela de Perón* by Martínez) aims to reveal and interpret the pervasive presence of the photographic medium in a text that critics have read mainly as a historical and political novel. By assembling this array of writers from different periods who are linked by similar concerns, I showcase a literary tradition that has not been fully recognized by scholars in the field.

Cortázar's work stands at the centre of this study, like a hinge that connects a number of common themes and textual strategies. Though an extensive critical bibliography has emerged around his writings on the subject, few critics have attempted a systematic close reading of his texts in terms of the specificities of the photographic medium.[38] While

acknowledging his prominent role in the field, I leave aside two of his illustrated books.[39] The first is *Prosa del observatorio* (1972), where the photographic images not only enhance but structure the poetic effect of Cortázar's prose.[40] Since my primary concern is an analysis centred on ekphrasis and the impact of photography as a medium, *Prosa del observatorio* does not readily lend itself to this interpretive perspective. The second book, *Los autonautas de la cosmopista* (1983), includes photographs that document the playful journey made by Cortázar and his companion Carol Dunlop from Paris to Marseille. Here, the photographs are essentially dependent on their captions and the entries in the travelogue. In the same vein, only selective use will be made of the prologues and other items Cortázar wrote for a number of photography books. In most of his texts about actual photographs, Cortázar comments on the images on his own terms, letting his intuition and sense of lyrical association lead the way. The photographs become points of departure for fashioning a personal literary commentary.[41] It is worth mentioning here that he advanced a famous analogy between the genres of the short story and the novel understood, respectively, as photograph and film.[42] Even if he did not systematically develop this analogy, his idea contains an insight about the economy of visual and textual representations and points to an affinity between diverse media in terms of artistic effects.[43] It could be said that if the short story is understood as a photograph, Cortázar's own short stories, where photography prominently appears, bring a metafictional reflection and a narrative density that add a new layer of meaning to the texts. In this sense, "Las babas del diablo" and "Apocalipsisis de Solentiname" enjoy an emblematic place in Cortázar's poetics.

Needless to say, references to photographers and photographs abound in modern Latin American literature, and many other writers could have been included in this book. As in a photographic album or museum display, the act of selection already implies a creative and critical stance. My project is restricted to narrative fiction. Mexican writers such as Elena Poniatowska and Carlos Monsiváis, who have written mainly within the frameworks of the journalistic chronicle, the testimonial essay, and the history of photography, are excluded from this study, despite the extensive use of the photographic medium in their works.[44] A sample of authors who have made references to the topic would encompass, among others, canonical authors (Adolfo Bioy Casares, Jorge Luis Borges, García

Márquez, Carlos Fuentes, José Donoso, Juan Carlos Onetti, Guillermo Cabrera Infante, Isabel Allende), writers mostly known in their home countries (Enrique Amorím, Angelica Gorodischer, Ana María Shua, Rodolfo Walsh) and more recent writers from a variety of regions and cultural contexts (Mario Bellatín, Roberto Bolaño, Sergio Chejfec, Sergio Ramirez, Cristina Rivera Garza).[45]

My book intends to open up a new line of interpretation in a field where literary criticism, the theory of photography, and communication and media studies intersect. This revisiting and reinterpreting of Latin American authors and texts takes place in the context of the consolidation of visual culture and media studies as fields of academic study. Given our current cultural and academic environment, there is a need to redefine and reassess the disciplinary areas in which scholarly work about the image can and should take place. This environment has witnessed a ceaseless parade of new technologies of representation, a global market where signs and pictures pervade everyday life and circulate as never before, and the impact of mass culture as opposed to the traditional sites of privilege of the work of art such as the gallery and the museum. New lines of inquiry emerge from this cultural context, creating a space for critical reflection on the links between literature, arts, and media. In this sense, this project looks with renewed interest to a body of literary works from Latin America, highlighting otherwise neglected themes, strategies, and relationships. My intention is to offer a novel reading of texts that have not been analyzed in terms of their media import and to advance an interpretation that reads literature in terms of current issues at the centre of contemporary visual culture.

1

UNCANNY VISIONS: RUBÉN DARÍO, JULIO CORTÁZAR, AND SALVADOR ELIZONDO

Ruben Darío

The short story "Verónica," by Rubén Darío, has been read mainly in the context of his fantastic short fiction. The text, in which a friar sets out to produce a photograph of Jesus Christ, can be interpreted as a product of its age—or rather, against it, insofar as the Nicaraguan writer makes a statement against the narrow scientistic trends of his time. This section explores the literary strategies through which Darío makes use of the visual technologies of the late nineteenth century. Although critics recognize photography as a central motif in "Verónica," few have examined in detail the role that this medium plays in the text.[1] By contextualizing "Verónica" in its cultural period and literary lineage, I show how issues central to Darío coalesce around photography: first, the representation of the divine in modern times; second, the cultural clash between religious faith and scientific knowledge; and third, the reassessment of the body and the contest between the senses, in particular between the visual and the tactile or haptic. My reading shows that Darío's story draws a more complex figure than the common anti-positivistic and quasi-apologetic interpretation proposed by literary critics.[2]

Octavio Paz pointed out the indifference and even rejection that *modernismo* showed toward the machine.³ It is no wonder that *modernista* poets, who saw in the aristocracy of taste, the cult of beauty, and the flights of the imagination their native land, considered with some disdain the wave of technological changes sweeping the Western world as well as Latin America during the second industrial revolution. However, there were exceptions to this attitude. Leopoldo Lugones, whom Darío met in 1893 and befriended during his stay in Buenos Aires, developed his own brand of science fiction in his 1906 collection of stories "Las fuerzas extrañas," where imaginary machines and scientific speculations play a prominent role.⁴ In the same vein, "Verónica," a text that predates those of Lugones, is testament to the use of technology as a *modernista* literary motif.⁵

The protagonist of the story, Fray Tomás de la Pasión, is "un espíritu perturbado por el demonio de la ciencia" (416) [a spirit possessed by the demon of science].⁶ The friar is a man of faith, but he is under the powerful spell of curiosity, and his intense desire to know distracts him from the right path of prayer and monastic discipline. The story, told by a particularly biased narrator, raises the issue of the opposition not primarily between science and faith, but between the spirit of simplicity and the thirst for knowledge, or, according to the text, between "las almas de amor" [the souls of love], which, says the narrator, "son de modo mayor glorificadas que las almas de entendimiento" (416) [are glorified in higher degree than the souls of understanding]. Having learned about recent advances in visual technology, in particular the invention of the X-ray machine, Fray Tomás imagines the great service that this new device could provide to the cause of the faithful:

> Si se fotografiaba ya lo interior de nuestro cuerpo, bien podía pronto el hombre llegar a descubrir visiblemente la naturaleza y origen del alma; y, aplicando la ciencia a las cosas divinas ¿por qué no? Aprisionar en las visiones de los éxtasis, y en las manifestaciones de los espíritus celestiales, sus formas exactas y verdaderas. ¡Si en Lourdes hubiese habido una instantánea durante el tiempo de las visiones de Bernadette! . . . ¡Oh, cómo se convencerían entonces los impíos! ¡Cómo triunfaría la religión! (418)

[If the interior of the body was already being photographed, pretty soon man would be able to discover the nature and origin of the soul by visual means; and, by applying science to divine things, he would be able (why not?) to capture their exact and truthful forms in the ecstatic visions and in the manifestation of the heavenly spirits. If only there would have been a photographic camera in Lourdes! How ungodly people would then be convinced! Religion would triumph!]

The devil, disguised as a fellow friar, pays Fray Tomás a visit and then provides him with one of the machines he craves. After testing it, the friar secretly carries out his most ardent desire, namely, to photograph (or rather, radiograph) the host that he has stolen from the altar. The next day, the provincial priest and the archbishop find the dead body of Fray Tomás in his cell, beside a photographic plate in which the effigy of a crucified Jesus Christ appears.

There are a number of loose ends and contradictions that invite us to read the text less as a successful fantastic story and more as a symptomatic work to which one could apply the same heuristic tools employed by its protagonist. The aim here would thus be to produce a textual radiography that reveals the fissures of the text as well as to uncover the assumptions of its cultural context. One example of these structural problems is the almost self-parodic anachronism of the friar's situation. Even if it is premeditated, it forces the reader to accept the implicit incongruity of Fray Tomás's contemporaneity, that is, the situation of a man secluded in a seemingly medieval monastery who, nonetheless, receives a newspaper through which he reads about recent scientific and technological advances. He even has a functioning laboratory.[7]

The narrator represents the voice of orthodoxy and implicitly censors the heretical attitude of Fray Tomás. Darío himself did not entirely share the seemingly strict Catholic interpretation that emanates from his text. Enrique Anderson Imbert aptly sums up Darío's intense but ambiguous attachment to Catholicism:

> For a short time as an adolescent, he demonstrated anticlerical attitudes, but almost immediately came back to the Church. At least, that is, he declared himself respectful

toward her mysteries and sacraments. He did not, however, take part in the rituals or the moral teachings of Catholicism. From 1890 on he professed a kind of religious syncretism that combined and confused bits of Catholic theology with oriental cosmogonies, the cabala with masonry, the theories of Pythagoras with mesmerism, and esoteric doctrines with the occult sciences.[8]

For Cathy Login Jrade, Darío's syncretism was both a symptom and a solution to the spiritual crisis of the late nineteenth century, advancing a "faith in the fundamental unity of all religions [which] provided Darío with a framework in which he could reconcile catholic dogma" with other belief systems, even Paganism.[9] This is attested by many of his best known poems, such as the 1896 "Responso" in homage to Verlaine and "Yo soy aquel que ayer no más decía . . ." included in *Cantos de vida y esperanza* from 1905. If this drive toward a superior spiritual unity strives to encompass a variety of religious traditions and beliefs, nineteenth-century science, with its emphasis on a narrow understanding of matter and spiritual values, was an intellectual challenge to which "Verónica" can be read as an answer. The story draws a symbolic space where the ideological clash between religious beliefs and esoteric lore, on the one hand, and the emerging claims of modern science and technology, on the other, is performed. Jrade points out that Darío showed in his writings a fundamental ambivalence between science and faith.[10] From the point of view of Fray Tomás, his is an attempt to reconcile religious faith with the scientific advances in visual technology.

Darío was one of many artists of his time concerned with the representation of Christ in the context of the modern crisis of religion. As Ziolkowski notes, "toward the end of the nineteenth century the theme of *Jesus redivivus* showed up all over Europe in a variety of forms."[11] Photographers also took up the subject. Contemporaneous to Spanish American *modernismo*, the photographic movement known as Pictorialism sought to claim for photography the artistic status enjoyed by the traditional visual arts.[12] The movement shares a number of characteristics with *modernismo*: both assert the pre-eminence of aesthetic values, as well as oppose a bourgeois society that imposes its mediocre taste and marginalizes or negates the artist. Among the American Pictorialists, Frederick Holland

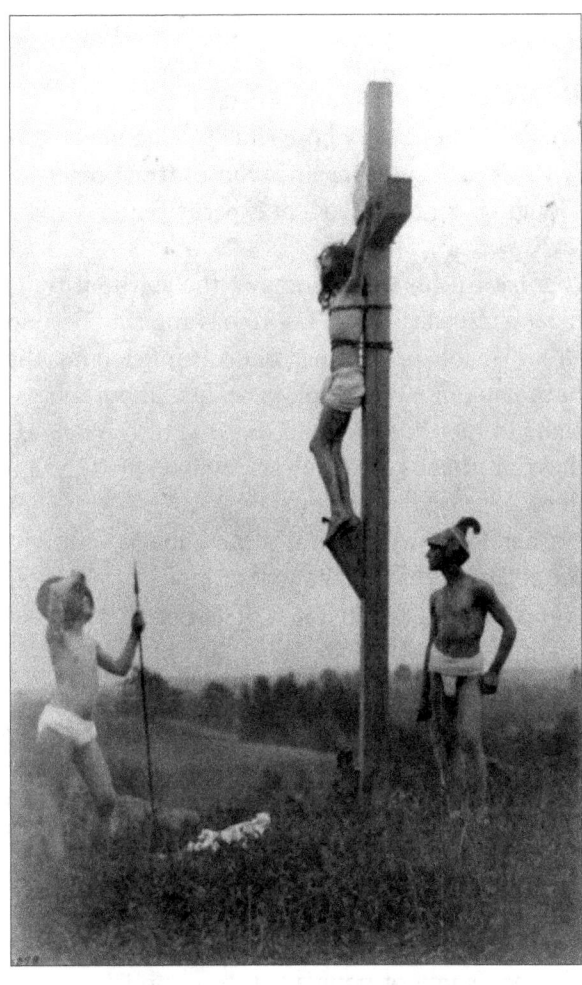

01 FIG 1: "Crucifixion with Roman Soldiers" (1898) by Frederic Holland Day. From *Slave to Beauty: The Eccentric Life and Controversial Career of F. Holland Day, Photographer, Publisher, Aesthete.* Reprinted by permission of David R. Godine, Publisher, Inc. Copyright © 1981 by Estelle Jussim.

Day acquired notoriety for the scandal his photographic work created in the Philadelphia Salon of 1898. Day made pictures of Christ on the cross, in which he himself appeared as the model for the Saviour.

Estelle Jussim points out that

> [Day's] presentation of himself as the crucified Messiah was the outcome of mystical preoccupations that consumed artists and writers as disparate as Paul Gauguin, Puvis de Chavannes, James Ensor, Odilon Redon, Remy de Goncourt

and William Butler Yeats. Seeking the spiritual in an age that denied it, believing in suffering as redemption, viewing the artist as a priest of the imagination, many artists of the 1890s were members of arcane secret cults whose rituals demanded an identification with Christ's suffering and whose attraction was a synthesis of longings for transcendent experience.[13]

It is not difficult to recognize in this quote some of the spiritual traits present in Darío and other *modernistas*. Both Fray Tomás and Day, beyond their many differences, show what happens when one misunderstands the power and limitations of the medium one employs. In one important aspect, the aim Darío assigns to his character and the goal of Day are extreme opposites: while the friar intends to prove a spiritual reality through the production of an undisputed visual representation, the American photographer re-enacts (or rather, fakes) a historical scene imbued with religious meaning to produce an artistic effect. They share, however, a similar failure: both Fray Tomás and Day achieve an image of Christ that does not shed light on his divine nature. Instead, the very medium that is supposed to reveal it ends up negating it.

"Verónica" shows a number of intertextual links with an essay Darío wrote about the shrine of Lourdes entitled "Diorama de Lourdes," included in *Mundo adelante*, a collection of largely unknown miscellaneous texts published in the 1955 edition of his *Obras Completas*. While the date of the essay is not given in this edition, it was originally published in *La Nación* on 21 March 1894, with the title "Diorama de Lourdes. Bernadette. Impresiones. Zola y su nueva novela."[14] The occasion was Emile Zola's latest novel, *Lourdes*, a literary study of popular faith in modern times. Though Darío employs a first-person narrator, as if he were witness to the events, the account is fictional, as he himself had not visited the shrine.[15]

In the first section of "Diorama de Lourdes," Darío sets up a contrast between the sublime vision of a religious ideal and the crass materialism of modern life. After branding the nineteenth century as "el siglo de la dinamita" [the century of dynamite], he explains,

> Esa visión de la pastora trajo a nuestra edad del progreso, de banalidad, de números, de infamias, un nuevo rayo del divino ideal. Los creyentes se fortalecieron; la Ciencia,

sorprendida y escéptica, puso su lente sobre esa celeste flor que se llama el milagro, y pudo advertir que no se riega con aguas de la tierra. (479)

[The shepherd's vision brought to our age of progress, of banality, of numbers, of infamies, a new ray of the divine ideal. Beliefs grew stronger; Science, astonished and skeptical, put its lens over that celestial flower called a miracle, and could notice that it does not grow with earthly waters.]

While religious vision rises above rational explanations, it is telling that science is understood as a misguided effort of visualization: science applies a lens—either a magnifying glass or a microscope, but also the lens of a photographic camera—to survey an object whose most important qualities go beyond its myopic scrutiny. As in "Verónica," where the mystical visions of Bernadette are paired with the visual technologies of the day in Fray Tomás's excited imagination, "Diorama" also brings together religious faith and modern technology, to the detriment of the latter. Moreover, the text explicitly refers to a photographer. In the third of its seven brief sections, we read about the masses of hopeful believers on their way to the shrine. In their midst, an American reporter appears. Two modes of social interaction clash in Darío's brief vignette: one represented by the American photographer, a foreigner catering to the modern need for news and information; the other embodied by the pilgrims, whose collective hope and devotion are underpinned by a practice of traditional values:

He oído, al son de las campanas místicas, los coros de los peregrinos, claras, limpias voces de muchachas vírgenes, voces de enfermos viejos, himnos, ruegos, plegarias. Cuando el reportero yanqui tomaba con su diminuta máquina detective sus instantáneas, iba un cura anciano camino de la fuente, sirviendo de apoyo a una niña pálida. (480)

[I have heard, while the mystical bells tolled, the choirs of pilgrims, the clear and pure voices of young virgins, voices of sick old people, hymns, supplications, prayers. When the

American reporter took his snapshots with his tiny detective camera, an old priest was walking to the spring, providing support to a pale girl.]

The reference to the reporter is brief and matter-of-fact, and the text does not elaborate on his presence at Lourdes, but it is clear that he is an anomaly in the spiritual environment described by the narrator. It connotes the surreptitious and essentially detached practice of the photographer, who does not join the procession and seems to spy on the believers with his small portable camera, a device in wide circulation by the early 1880s.[16]

Returning to the story, Fray Tomás's fate rehearses the Biblical theme of the temptation of Christ as well as the Faustian desire for ultimate knowledge as a present from the devil.[17] The notion of photography as a cursed gift seems pertinent as it represents the menacing advances of science and technology confronting a traditional religious worldview, even if by the end of the nineteenth century photography was already a well-established medium, with a sixty-year history of extensive use and experimentation. However, it was a technology that still provoked reactions of wonder, mystery, and fear, emotions that the film critic Tom Gunning associates with the occult and the supernatural, and which he describes in an essay about ghost photography with the concept of the uncanny, of future Freudian fame.[18] Photography was considered uncanny, as Gunning points out, due it to its ability "to fashion a visual double."[19] In the realm of fantastic fiction, he adds, uncanny situations were produced when "initial supernatural associations" were restored, such as "photographs that seem to change in relation to their subjects," which is the case in Darío's story.[20]

Darío writes on the threshold of modernity's media revolution. By the end of the century, photography became a mass medium for the production and consumption of images, thanks to inventions such as the Kodak camera in 1888 by George Eastman.[21] The Kodak, or Brownie as it was nicknamed, was an easy-to-use, small-format camera that employed a film of several dozen exposures. When Fray Tomás mentions, in reference to the mystical experience of Bernadette at Lourdes, how useful it would have been to take a snapshot of her visions, he points toward a widespread cultural practice that authenticated the existence of a contested reality.[22] This practice was well established by the end of the century in Argentina's capital, along with a thriving market of photographic products.[23]

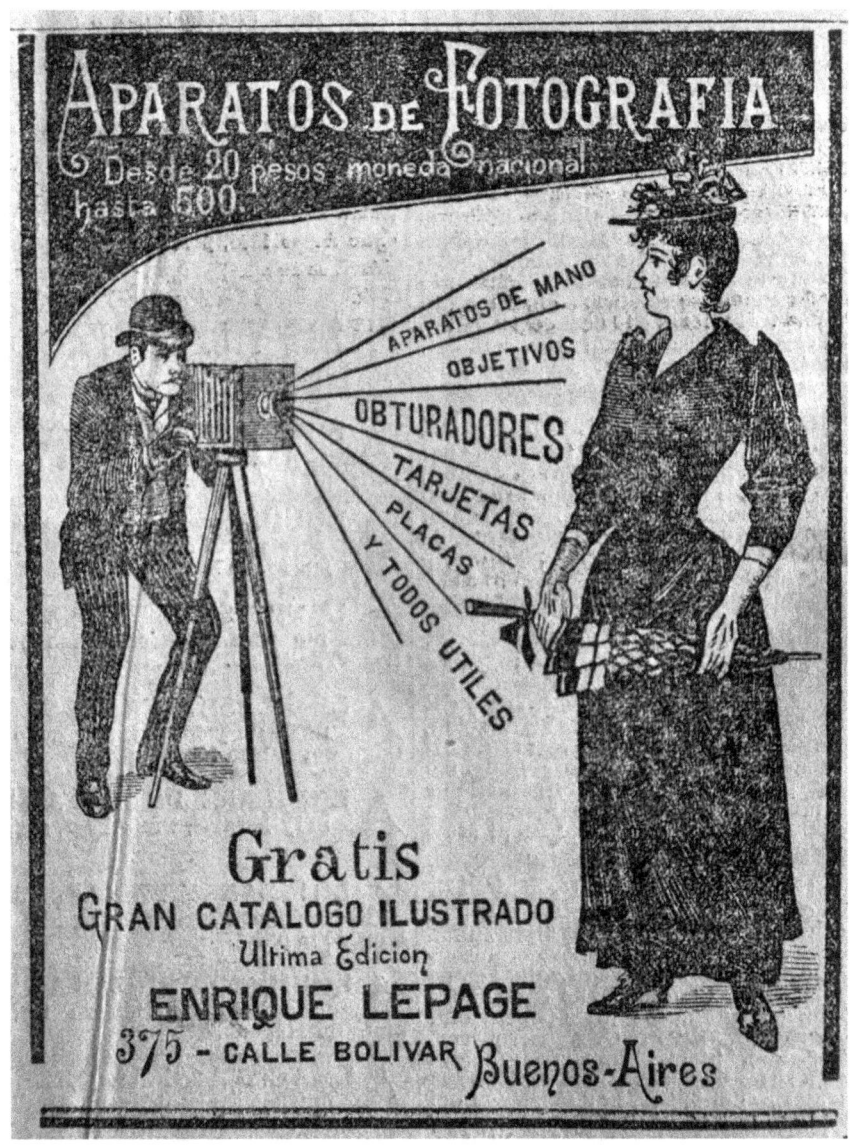

01 FIG 2: Advertisement of photographic equipment in *La Nación* (April 16, 1895).

However, the machine that Fray Tomás receives from the devil is not actually a photographic camera. It is indeed a portable device, like a Kodak, but its technology is in fact that of the X-ray. While photography captures on film the light that impacts photosensitive material, X-rays emit a radiation beam onto solid objects whose different degrees of opacity are registered on a sensitive plate. It is worth noting here how Darío kept up to date on scientific news. It was most likely through *La Nación*, the newspaper where he used to publish chronicles and short fiction even before his arrival in Buenos Aires, in 1893, that he learned about the X-ray. Reading the press of the day clarifies how Darío's short story reflects the assumptions and expectations of an invention that was deemed one of the great scientific events of the time. The German physicist Wilhelm Roentgen published the results of his research in December 1895. The first news arrived in Buenos Aires in a brief cable dated 8 January 1896, barely two weeks after Roentgen's announcement. Entitled "Notable descubrimiento—fotografía nunca vista" [Remarkable discovery—a photograph never seen before], the note refers briefly to the invention as a new way of taking photographs without a camera. It ends in a hyperbolic tone: "Se espera prodigios de este nuevo invento" [Miracles are expected from this new invention]. This item was the first of a steady stream of news from Europe on the novel technique and its applications, mainly in medicine but also in industry and the military. At the beginning, the invention was not referred to as X-ray, but as a kind of photography, since the new visual and cultural paradigm it introduced was yet to be understood and established. A detailed explanation of the functioning of Roentgen's invention was offered in a piece entitled "Fotografía de lo invisible—Un gran invento (Con motivo de una reciente noticia telegráfica)" [Photography of the invisible—a great invention (on occasion of a recent telegraphic news)], dated 12 February 1896. Three days later, *La Nación* published yet another text about "la fotografía á través de los cuerpos opacos" [photography through opaque bodies]. It included a picture, a rare occurrence since *La Nación* had few illustrations. It is an engraving based on the famous photographic plate of Mrs. Bertha Roentgen's hand.

The first successful test of X-rays in Buenos Aires took place on 12 March 1896, in the Faculty of Exact Sciences of the Universidad de Buenos Aires, by a photographer called Witmer (or Widmer). The plates would be

01 FIG 3: News about X-Rays in the *La Nación* (February 12, 1896).

on display the following day at the photographer's shop. "Verónica" was published three days after that, on March 16.

While photography had enabled the nineteenth-century observer to discern details not visible to the naked eye, as Benjamin would point out, the discovery of the X-ray produced yet another challenge to natural vision: it was an indisputable picture of the invisible inner structures of an object. In its conceptual fusion between the well-known photographic

technique and the recent invention of radiography, "Verónica" explores the possibility of an expanded field in which visual representations not only register the invisible but also aim to certify the existence of a spiritual realm. As Fray Tomás puts it, "si . . . se fotografiaba ya lo interior de nuestro cuerpo, bien podía pronto el hombre llegar a descubrir visiblemente la naturaleza y origen del alma" (418) [if the interior of our bodies could now be photographed, very soon it would be possible for man to discover visibly the nature and origin of the soul].

Fray Tomás embodies, despite his alleged heresy, the age-old impulse to visualize the divine. The seemingly misguided use of photographic techniques applied to that goal springs nonetheless from a central tradition in Western culture. As Belting points out,

> The desire to see the face of God was inherent in human nature and included the expectation of a personal encounter with the "Other." Christianity offered the hope for a preliminary vision of God, for eternal life was understood as a permanent vision of God. In the "genuine image," the earthly features of Jesus, which could be seen by human eyes, merged with the divine features of God, visible reality with an invisible mystery.[24]

Though the legend of Veronica—or *vera icona*, the true image—goes back to the first centuries of the Christian era, it became, as Belting explains, "the undisputed archetype of the sacred portrait" beginning in the thirteenth century.[25] With regard to the indexical nature of Veronica's veil, Belting points out that the cloth not only showed an image but was also a relic; therefore, it was "more authentic than any work of art, in that it did not rely on artistic imitation. It was authentic as a photograph."[26] This remark indicates that a photographic ideal is not entirely foreign to the desire to visualize the divine. One of the criteria in deciding that an image truly resembled Christ or the Virgin, and thus participated in their sanctity, was its acheiropoetic condition, that is, the assumption that the image was not hand-made, but rather was produced by a higher power.[27]

Darío is writing at the end of a century that produced such critics of religion as Dostoyevsky, Marx, Nietzsche, and Renan. It was also a critical moment in Catholicism with regard to the challenges posed by

modernism, understood in this context as the attempt to reconcile, from within the clerical institution, Catholic teaching and practice with science and a modern way of life—a trend that would be officially condemned by Pope Pius X in 1907.[28] While Darío's text signals back to the secular dispute between iconophilia and iconoclastia in Western culture, it also points forward to current cultural configurations. Much as the friar of the story wishes to prove the content of his faith by employing modern technology, passionate believers today may find such certitude in encounters of the effigy of Christ in damp patches or pieces of bread or fish. The historical logic that forbids the acceptance of factual photographs of Christ does not prevent legendary artifacts such as the veil of Veronica or the shroud of Turin from being considered as analogous or substitute photographs, due to their indexical nature.[29]

The cause of Fray Tomás's death is not made clear in the story. However, it is safe to see his demise as a divine punishment for transgressing the limits assigned to human knowledge.[30] The friar may have died because of the frightful impression produced by his own photographic creation, victim of a sort of "Medusa effect" that transfixes or paralyzes the beholder.[31] Moreover, his terror is compounded by the fact that the photograph captures a moment where Christ, beyond the nested representations in which his figure is embedded, unexpectedly shows signs of life. We read at the end of the story that, on the photographic plate retrieved from the floor by the archbishop, "se hallaba, con los brazos desclavados y una terrible mirada en los divinos ojos, la imagen de Nuestro Señor Jesucristo!" (419) [one could find, with his arms freed from the nails and a terrible look in his divine eyes, the image of Our Lord Jesus Christ]. In this respect, "Verónica" recreates the medieval tales in which images actually come alive, pointing to the iconographic tradition of the miraculous image and the enchanted portrait, staples of both popular imagination and fantastic literature.[32] While the X-rays, directed at the host, penetrate the sacred substance and show in its interior the effigy of Christ on the cross, the true miracle is not (only) the technical feat that produces in such conditions an image of Christ, but the fact that He has become physically animated and able to free himself from the cross.

The stern gaze of Christ, his "terrible mirada," (19) clearly chastises the friar's transgression.[33] The act of photographing the Saviour subverts the true understanding of religious practice, confusing the edification of

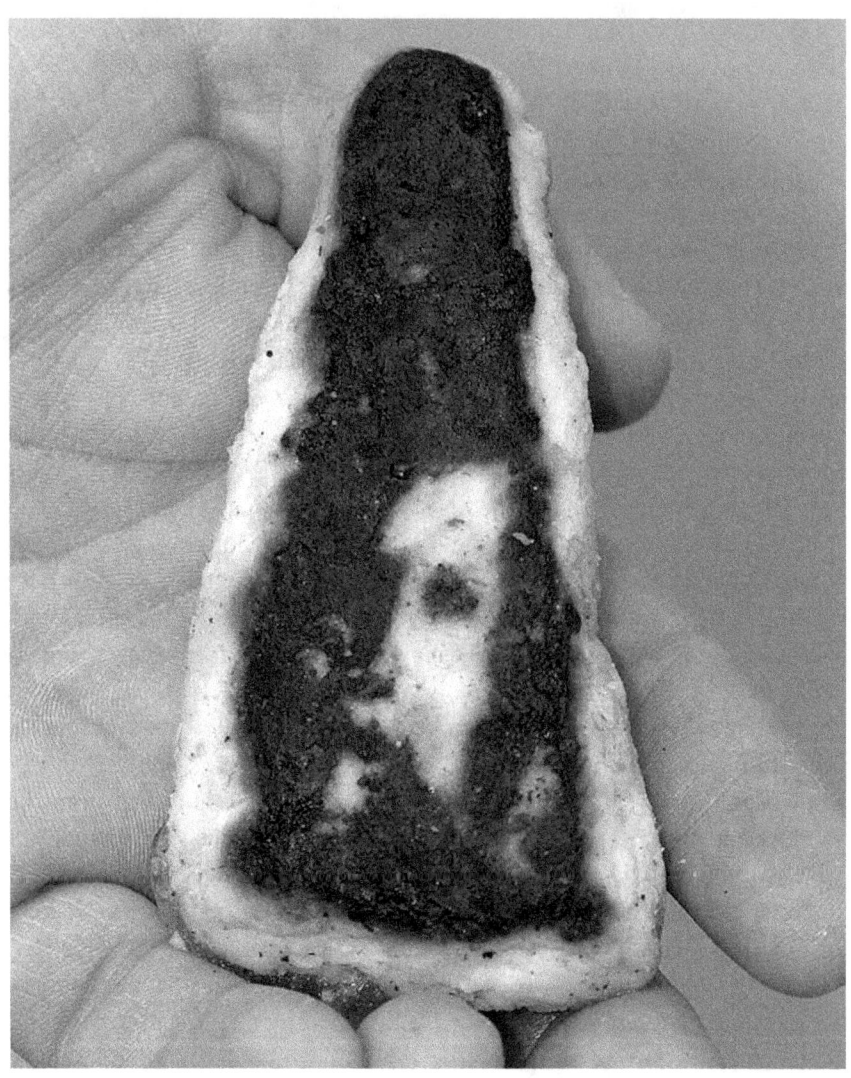

01 FIG 4: Effigy of Christ on a piece of fish. Ian MacAlpine / Kingston Whig – Standard / QMI Agency.

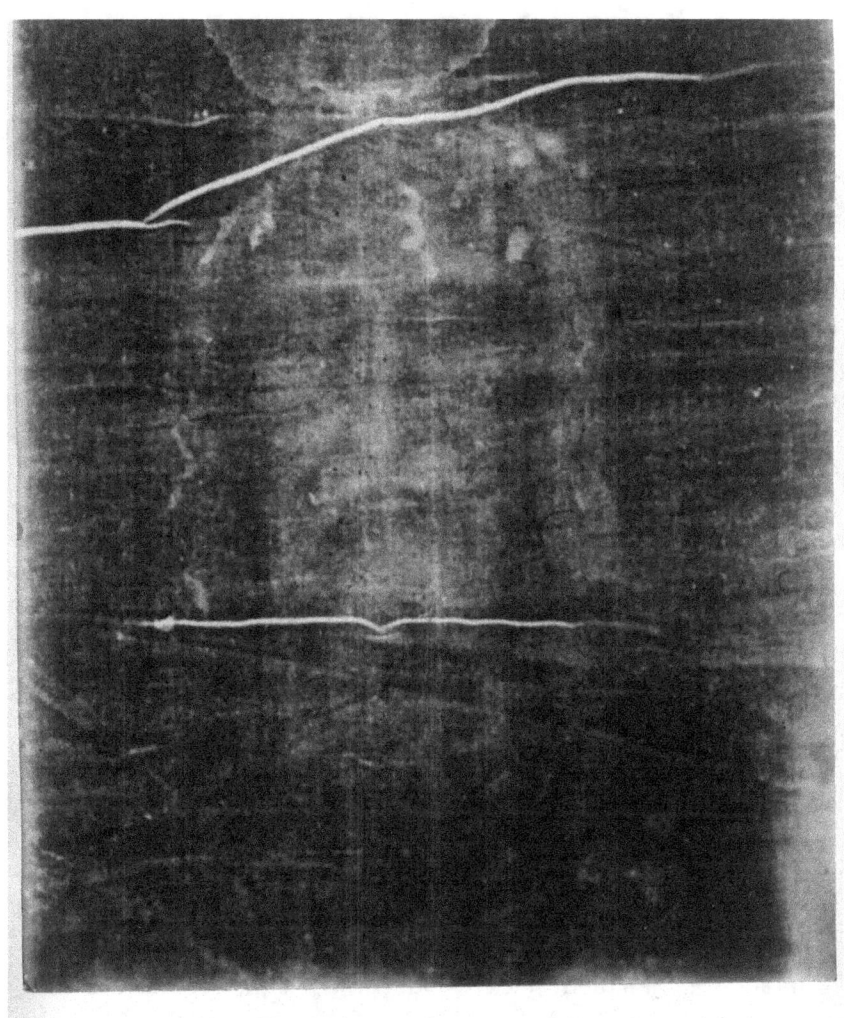

01 FIG 5: Reproduction of the Holy Shroud of Turin by Secondo Pia. Wikimedia Commons.

the soul with mere visual evidence. Moreover, the photographic act is in itself transgressive: to take a photograph of the host in search of a revelation (both photographic and spiritual) opens an unbridgeable gap between viewer and object and negates the act of incorporation, literal and symbolic, that defines the Eucharist. In another context, the fact that Fray Tomás transforms the elements of a sacred ritual into a mechanical and scopophilic act also points to the new role of the observer and the heightened sense and power of visualization that critics of modernity such as Jonathan Crary have highlighted.[34] The friar has fallen into the trap of a modern inclination, namely, that rendering visible something hidden implies that a deep meaning has been uncovered.[35]

Beyond the contest of gazes at the end of the story, the reference to Christ's arms, though seemingly marginal, opens a number of productive interpretive paths. First of all, the freeing of the arms, and by implication the hands, has a direct relation to the scientific context of the story, and in particular to the X-ray as a means to penetrate invisible realms. The connection among visible representation, invisible reality, and the hand comes to the fore in one of the first radiographic plates, an image that, according to Michael Frizot, became the "definitive image of radiography": the plate of the hand of Dr. Roentgen's wife.[36] Fray Tomás learns about this X-rayed hand when he reads the newspaper (417), and before photographing the host, he produces a plate of his own hand (418). Pasveer points out that "the X-ray image of Mrs. Bertha Roentgen's hand in Roentgen's first publication on the rays surely encouraged a principal reading of the images similar to the reading of other photographs: as the visual evidence of the presence, the existence, out there, of the phenomena depicted."[37] Further, historian of photography Vicky Goldberg writes that "It was the photographs even more than the significance of the discovery that created the great public stir about X-rays. Without photographs, the announcement of a new kind of ray that could penetrate aluminum but not lead would have been greeted as just another astonishing discovery in the physical sciences that no one could understand."[38] This media convergence and its cultural reception explain the conflation of photography and radiography in Darío's story. The similitude is also structural. Mary Warner Marien calls attention to the fact that "X-ray photographs were shadowgraphs like those made by Henry Fox Talbot decades earlier, though not created by light."[39]

It is telling that the plate produced by Fray Tomás does not represent the face of Christ, as the title of the story would suggest, but rather a figure on a cross (a textual fact generally overlooked by critics). Perhaps Darío intended to call attention to the ultimate suffering and sacrifice of Christ, neglected by Fray Tomás's scientific curiosity. The crucifixion also highlights the absolute reality of the body. In this sense, the freeing of the arms on the photographic plate could be interpreted as a symbol of liberation from the bondage of the flesh: an emblem of transcendence or a spiritual ideal that, even if captured in the friar's photograph, points beyond representation.

Though the impact of the stereoscope—an optical device that created the impression of tridimensionality—was waning by the end of the century, the unnailing of the arms involves an implicit stereoscopic effect.[40] The stereoscope produces an optical illusion "which makes surfaces look solid," in the words of Oliver Wendell Holmes.[41] The effect is so heightened, states Holmes, "as to produce an appearance of reality which cheats the senses with its seeming truth."[42] The stereoscope's "eerie paradox of tangibility, the illusion of an accessibility to touch, [and] the sense of the proximity of object to viewer" seems at work in the miraculous plate produced by the friar.[43] However, if the stereoscope, as Crary argues, "became a crucial indication of the remapping and subsumption of the tactile within the optical,"[44] Darío's story can be interpreted, on the contrary, as the persistence of the tactile beyond the visual. From the point of view of Fray Tomás, this prevalence can be read as a sign of repressed desire, in line with the environment of monastic seclusion and discipline in which the friar lives. The camera as a probing device, as well as the rhetoric of penetration that binds matter (tangible host) and spirit (transcendent divinity), points to a sublimated erotic dimension that Darío elides in the story. While, as noted before, the author's work integrates his own brand of Catholicism into a broader, inclusive worldview where the body and its sensual pleasures play a central role, Darío makes of Fray Tomás an exemplar of a narrow understanding of religious life. Not only does he lack religious values like the simplicity of spirit praised at the beginning of the story, but his overestimation of the act of visualization, detached from the other senses, leads him to death, the ultimate alienating experience.[45]

While the friar's drama revolves around the visual technology he misuses, the freed arms in the picture, and specifically the freed hands, seem

to call into question the predominance of the visual. The prodigious act that sets the arms free points toward the body's overcoming of its limitations through supernatural force. This act of liberation symbolizes the autonomy and ascendancy of the tactile, and the body in general, over the disembodied sense of sight. Thus, "Verónica" can be read as an allegory through which the sense of touch, beneath or beyond the probing power of visual technologies, gets its due. While the stereoscope was the predominant visual model that allowed an illusion of tactility, Darío's intuitive imagination explores a new model of visual power brought forth by the invention of the X-ray, one that enabled an in-depth look into things. The photograph of Christ ultimately becomes a means by which the sense of sight is subverted by the sense of touch.

W. J. T. Mitchell has written that "the tendency of artists to breach the supposed boundaries between temporal and spatial arts is not a marginal or exceptional practice, but a fundamental impulse in both the theory and practice of the arts."[46] We can extend this idea of a semiotic and aesthetic transgression to understand the links between the different regimes of representation displayed in the story. In "Verónica," a modern visual device transcends the boundaries of the naked eye and penetrates the invisible in search of the divine. Within the marvelous image produced by the machine, an even higher power is shown to transcend the boundaries of the physical reality that holds the body in place. The death of Fray Tomás could have been caused by an uncanny impression: seeing how the image of Christ at once exceeds the limits of the fixed, bidimensional image offered to the eye and enters the realm of the moving, temporal, bodily space signalled by the unnailed arms. Fray Tomás has been touched not by the Holy Spirit, but by a vision connoting a physical contact that drives him out of his mind. The name of the friar, alluding to the incredulous disciple of Jesus in the Gospel of John who needs the evidence of touch to truly believe, acquires thus an ironic meaning.[47]

This analysis of "Verónica" reveals the rich underpinnings in Darío's use of modern visual technologies. Specifically, photography becomes a tool that both probes the reality of the divine and puts in motion a contest between the senses. The emphasis on visualization—a strategy at the core of modern science's claim to truth and evidence—becomes a powerful means that nonetheless falls short of accounting for the complex and ambivalent religious dimension of existence as understood by Darío.

It is worth pointing out that attempts to "photograph the divine" in Latin American literature surface well into the twentieth century. Beyond the ideological and spiritual crisis of religious faith in Darío's time, Gabriel García Márquez and Julio Cortázar both employ a playful, ironic take on the issue. *Cien años de soledad* (García Márquez, 1967) opens with a blend of science and magic in the figure of the gypsy Melquiades, who brings to Macondo a number of marvelous inventions. José Arcadio Buendía, the family patriarch who is driven by a lively imagination as eccentric as his pursuit of scientific knowledge, falls under the spell of those inventions. After a plague of insomnia and an ensuing loss of memory threaten to devastate the town, Melquiades returns from the realm of the dead with a magical potion to restore memory to the people of Macondo. He also brings a camera and a laboratory, to make daguerreotypes, and photographs the Buendía family. As life goes on,

> Melquiades terminó de plasmar en sus placas todo lo que era plasmable en Macondo, y abandonó el laboratorio de daguerrotipia a los delirios de José Arcadio Buendía, quien había resuelto utilizarlo para obtener la prueba científica de la existencia de Dios. Mediante un complicado proceso de exposiciones superpuestas tomadas en distintos lugares de la casa, estaba seguro de hacer tarde o temprano el daguerrotipo de Dios, si existía, o poner término de una vez por todas a la suposición de su existencia. (145)

> [Melquiades had printed on his plates everything that was printable in Macondo, and he left the daguerreotype laboratory to the fantasies of José Arcadio Buendía, who had resolved to use it to obtain scientific proof of the existence of God. Through a complicated process of superimposed exposures taken in different parts of the house, he was sure that sooner or later he would get a daguerreotype of God, if He existed, or put an end once and for all to the supposition of His Existence. (53)][48]

José Arcadio will eventually abandon his photographic pursuit. In a later chapter, priest Nicanor Reyna, famous for rising a few inches off the ground

when he drinks a cup of hot chocolate, tries to convince José Arcadio of the virtues of religious faith. However, only the daguerreotype of God will be accepted as proof of His existence by the head of the Buendías. The irony resides in trying to seize that most elusive of entities through a machine known for the uncanny precision of its representations.[49] Photography in García Márquez's novel becomes yet another tool in its arsenal of magical realist devices.

In *Ultimo round* (volume 1, 1969), an illustrated volume of miscellaneous texts, Julio Cortázar includes a piece entitled "En vista del éxito obtenido, o los piantados firmes como fierro" ("Given the success achieved, or the nutcases firm as steel"). It is a review of a book authored by a Francisco Fabricio Díaz, a deranged Cuban "writer" who proposes, among other outlandish projects, to photograph Jesus Christ. Cortázar, who in true Surrealist fashion was fascinated by madness as the point of entry to an alternative worldview, examines with benevolent irony the nonsensical writings of Díaz. Díaz has sent a letter to the Queen of England, letting her know about his sublime photographic project. At the end of Cortázar's essay, the reader finds a photograph of the Royal Family. It covers two pages and it is accompanied by this caption: "Enterada por su cuñado y por doña Margarita Rosa del telegrama de Francisco Fabricio Díaz, la madrecita reina se apresura a informar al padrecito consorte y a los infantitos, en cuyos rostros es fácil advertir el entusiasmo provocado por las místicas posibilidades de captación de la lente."[50] [Having heard about Francisco Fabricio Díaz's telegram from her brother-in-law and Mrs. Margaret Rose, the little Queen Mother hurries to tell the little Father and the little royal children, in whose faces it is easy to notice the enthusiasm sparked by the mystic possibilities of the lens's reception.]

The caption recontextualizes the image of the Royal Family in terms of Fabricio Díaz's impossible desires and expectations. Its reference to the "místicas posibilidades de captación de la lente," which points to a recurrent *topos* in the theory of photography about the magical aspects of the medium, establishes a productive link between Díaz and Cortázar himself. By commenting on the aim Díaz pursues through photography, that is, the impossible quest to capture an image that bridges the conventional bounds of space and time (which is similar to the aim of Fray Tomás in Darío's text), Cortázar is alluding to a fantastic strategy that he himself employed extensively in his short stories.

Enterada por su cuñado y por doña Margarita Rosa del telegrama de Francisco Fabricio Díaz, la madrecita reina se apresura a informar al padrecito consorte y a los infantitos, en cuyos rostros es fácil advertir el entusiasmo provocado por las místicas posibilidades de captación de la lente.

01 FIG 06: Portrait of the British Royal Family with Cortázar's whimsical caption. Photo courtesy of Siglo XXI Editores.

Julio Cortázar

The issues raised about photographic representation in "Verónica," however meaningful as foil to the aesthetics of *modernismo*, do not find a sustained development in Darío's work. On the contrary, Julio Cortázar's engagement with photography plays a productive role in many of his writings and spanned most of his literary career. As a practice of image

production, a metaphor, a principle of textual organization (and disruption), photography becomes a privileged site through which Cortázar articulates tensions in his work among literature, aesthetics, and politics.

The following section begins with an examination of Cortázar's appropriation of key ideas and practices of modern photography in "Las babas del diablo," in the context of his avant-garde aesthetics of heightened attention. It then highlights the way photography channels the "technological uncanny," in the short stories "Las babas del diablo" (1959) and "Apocalipsis de Solentiname" (1977).[51] In both stories, photography performs in fantastic fashion a traumatic event that calls for a cure or redemption, an outcome that is not achieved. My analysis situates photography at the centre of a number of antagonistic relations: first, between media devices; second, between verbal and visual representations, and finally, as mediating the contested relation, already apparent in Darío's story, between visual representations and tactile (and, more generally, bodily) perceptions.

Roberto Michel, protagonist of "Las babas del diablo," embodies the popular tradition of the amateur photographer.[52] In his approach to urban landscape, he also articulates a number of insights that closely follow the street photography developed in Paris from the 1930s to the 1950s by André Kertész, Brassaï, and Robert Doisneau, among other photographers, who were interested in exploring the social landscape and the aesthetic dimensions of the modern city.[53] In the analogy that Cortázar draws between the short story and photography, he mentions the work of Henri Cartier-Bresson and Brassaï.[54] As noted by Sugano, it is telling how Cortázar applies to his poetics Cartier-Bresson's ideas on photography.[55] In this context, it is also revealing to compare what Roberto Michel says about photography in "Las babas del diablo" with the ideas put forth by Cartier-Bresson. For both, photographic practice is an exercise in vision and the capturing on film and in print of a privileged spatial and temporal order, where composition and rhythm are the central artistic values. Michel strives to achieve "la expresión que todo lo resume, la vida que el movimiento acompasa pero que una imagen rígida destruye al seccionar el tiempo, si no elegimos la imperceptible fracción esencial" (219) [the revealing expression, one that would sum it all up, life that is rhythmed by movement but which a stiff image destroys, taking time in cross section, if we do not choose the essential imperceptible fraction of it (123)].[56]

Cartier-Bresson, in his own words, "craved to seize the whole essence, in the confines of one single photograph, of some situation that was in the process of unrolling itself before my eyes."[57] Michel, giving expression to the central ethos of the street photographer, declares that "Cuando se anda con la cámara hay como el deber de estar atento" (216) "[when one is walking about with a camera, one has almost a duty to be attentive (121)]. For his part, Cartier-Bresson declares, "What I am looking for, above all else, is to be attentive to life."[58] It is a matter of sublating everyday experience through the photographic medium into a superior synthesis, as Lincoln Kirstein, commenting on Cartier-Bresson, points out: "the commonplace exists eternally to be discovered, uncovered, recovered. Subject matter is rarely the exotic. It is the ordinary, the banal, the vulgar that by reassociation and selection assumes a strangeness, a magic which reorganizes the commonplace into splendor."[59] Photography is closely related to the heightened sense of awareness that plays a central role in Cortázar's avant-garde aesthetics.[60]

Photography aims to transcend fragmented vision and may seem at first, even in its production of a partial view, a redemptive tool. Sharing in the utopian quest of modernist photography, Roberto Michel's effort goes beyond the contingencies of everyday perception through the composition of a picture underpinned by the necessity of its formal relations.[61] But this sublime moment of visual truth remains elusive, in part because even the perfected point of view of the photograph has to face the limitations of human vision. In a story about the extension, force, and drama of the gaze, Michel states that the act of looking is deeply implicated in falsity: "Creo que sé mirar, si es que algo sé, y que todo mirar rezuma falsedad, porque es lo que nos arroja más afuera de nosotros mismos." (217) [I think that I know how to look, if it's something I know, and also that every looking oozes with mendacity, because it's that which expels us furthest outside ourselves. (119)] By implication, photography also becomes an unreliable medium, even if its prosthetic power seems to challenge the fateful condition in which the act of looking is embedded. This challenge to "natural" vision seems to provide the means to select and fix, from among a wide variety of points of view, what Michel calls "la imperceptible fracción esencial" (219), that is, the decisive moment where ultimate visual meaning is revealed. However, this is never accomplished. As the ambiguous end of the story indicates, no such image is produced, as if the clouds and birds

that pass by the window or the viewfinder's field of vision symbolize, in their empty recurrence, the ever-receding hope of a redemptive vision.[62]

Far from offering a resolution, the story displays a wide range of anxiogenic effects, produced by a constant overstepping of boundaries: transgressions of social and moral propriety, the fantastic nature of visual media, the fractured narrative discourse, and intimations of a menacing otherworldly reality. "Las babas del diablo" performs a drama about the limits of the representable. Disjunction is at the centre of both the narrative structure and the drama of the protagonist. The story poses an impossible point of view that develops simultaneously in at least two places: a fifth-floor apartment in the Latin Quarter and the tip of the Île Saint-Louis. To this spatial disjunction should be added, as Volek points out, a temporal one, since the endpoint of the story is already present at the beginning and its repercussions crisscross the narration (which evinces at least two narrative voices).[63] Michel himself is divided between nationalities, languages, the dead and the living, the real and the fantastic—even his last name implies ambiguity, since it can refer to both a given and a family name.[64]

The photographic medium is a crucial element of a convoluted plot in which a breakdown of communication is performed, in the most literal way: the breakdown disrupts the structure of the text itself through the events the protagonist aims to describe and interpret. The broken narrative echoes the psychological and existential catastrophe that overtakes the protagonist. The strategy is an example of Cortázar's exploration of the dark side of the human psyche. It is also part and parcel of the "most radical transgressive function of the fantastic," according to Jackson, namely, the attack upon unified character.[65] Photography itself—understood both as act and image—performs, by its very definition, a breakdown in the temporal flow and spatial continuity. Agrammatical and fragmentary, it is the visual model that structures (or rather, de-structures) the text itself. If photography conventionally aspires to "capturing" reality, the events narrated in "Las babas del diablo" (as well as in "Apocalipsis") are finally framed by a kind of hyperreality or, better yet, surreality. Cortázar's interest in photography as an articulation of desire and violence, as a medium of shocking effects, and as a device that probes the depth underneath comforting appearances, corresponds to his Surrealist leanings.[66]

Like Fray Tomás in Darío's "Verónica," Michel is a lonely man who strives to discipline sight by means of a mechanical device. He seems at

first to develop a power to see beyond appearances, but from a psychological perspective, he might also be projecting his own desires and fears, perhaps to better guard himself against them. In the end, he falls prey to the (unconscious or otherworldly) forces that he has unwittingly unleashed.[67] Rather than sublimating desire through an aesthetic operation, Roberto Michel—his motives inevitably suspicious, his fate ambiguous—invokes precisely what he dreads by the very act of photographing the seduction scene between the woman and the boy at the tip of the island.[68]

With regard to the media featured in "Las babas del diablo," the text foregrounds two communication devices (the typewriter and the camera) engaged in an apparent duel. Metonymically, they represent the domains of the word and the image, articulated language and iconic representation. Their interaction shows the semiotic "tensions and resistances"—to use W. J. T. Mitchell's phrase—that emerge when different regimes of communication, even if figuratively, clash with one another.[69] The story deals with the complex struggle between the will to communicate and represent, and the material channels that allow, but also hinder, the occurrence of the communicative event.[70]

Typewriter and photographic camera prove inadequate means through which Roberto Michel strives to tame the disintegrating force he encounters, be it the devil of the story's title, a psychopathological condition, or unconscious desire. What has to be told is a void or a nothingness in the face of which the acts of picturing, describing, and narrating, even if extended by prosthetic means, remain powerless. By interfering with demonic forces while attempting to save an unsuspecting teenager, Michel has unwittingly trespassed the limits that set apart realms of existence.[71]

Beyond the theological dimension alluded to by the story's title, it is worth asking how the nature of the media Michel employs conditions the events that befall him—in McLuhan's terms, what the "message" of the story is in terms of the "media" it deploys, or, following Kittler, to what extent "the media determines the situation" of the protagonist.[72] While typewriter and photographic camera are anchored in a historical specificity—signalled in the text by the brand names Remington and Contax—they point to broader anxieties about our technological age and enduring myths about media, especially the overtaking of human capabilities by machines.[73] Not only are they vehicles that extend the power of the senses, but they become animate themselves. By acquiring a life of their own,

they resonate as examples of technological possession: they force upon their users their own representational limits and perceptual bounds.[74] Typewriter and camera resemble each other in several respects. They are individualized and (generally) portable devices meant to standardize the way representations are produced and reproduced. They form a communicative braid: the blindness imposed by the typewriter finds compensation in the visual insights provided by the speechless camera.[75] Both machines contain built-in features that imply a kind of semiotic violence: the strokes of the keyboard fix a text, and the pressing of a shutter fixes an image. The metaphor of weaponry has been applied to both.[76] Even though typewriter and camera could collaborate in explaining each other—since, as the text suggests, "a lo mejor puede ser que una máquina sepa más de otra máquina" (215) [it is possible that one machine may know more about another machine (115)]—the narrative structure of the text is marked by their interference.[77] They embody radically different forms of appropriating or copying the world: on the one hand, as Hillel Schwartz remarks, the typewriter operates as the typist goes along, "s/t/r/o/k/e/-/b/y/-/s/t/r/o/k/e, mechanically . . . [while] the photographer copies an ENTIRETY after the fact, implying the appropriation of a whole."[78] The communicative breakdown is highlighted by the fact that the typewriter fails to recount the story in standardized, conventional fashion, as well as by the failure of the photograph to capture "the entire picture," or by "fixing" it to a static moment.

The machines cannot escape their ambivalent nature: they are—or aspire to be—vehicles of semiotic redemption, mechanisms through which the protagonist tries to verbalize a broken equilibrium or to produce an image that would transcend the contingent condition of everyday perception. The typewriter, in a sort of mechanical cure, produces writing as catharsis, while the camera strives to fix a scene through a formally perfect composition. However, they enable the breakdown they are supposed to stave off. The flow of speech breaks down under the weight of the jolts of the typewriter, which literally falls to the ground when the characters pictured in the blown-up photograph begin to move. For its part, the photograph, by allowing Michel to leap from surface to spatial depth, opens up a haunted space in which his mental stability collapses.

From a narrative point of view, the plot proceeds as if assembled by a mechanical force, since no single, autonomous narrator seems to be in

control. The atmosphere of automatism that pervades "Las babas del diablo," with its violent cuts and sudden changes of points of view, dramatizes the independent life of machines. At the beginning of the story, a narrator expresses this wish, as if a machine could have agency of its own: "si se pudiera ir a beber un bock por ahí y que la máquina siguiera sola (porque escribo a máquina) sería la perfección" (214) [if one might go to drink a bock over there, and the typewriter continue by itself (because I use the machine), that would be perfection (114)]. By the end, once Michel has literally entered into the picture and confronted the man in black who first appeared when he took the picture of the couple, the point of view is the fixed perspective of the camera lens. The descriptions advance as if motion has been sliced into discrete parts, shattering the organic flow of "normal" vision. In this way the story highlights the lack of conscious control in a textual machine that "tells itself," commingling inertness and expressiveness, automatism and animation.[79]

With their rigid specifications, the way machines interact with the characters allows a reading of the story as a dark fable of freedom and entrapment. The photographer/hunter ends up hunted; the hero, who was supposed to free the boy from the clutches of sexual abuse, finally finds himself caught in a tight net. The topic of photography as a practice that encroaches on one's privacy, as the proverbial visual act that "captures" one's essence or soul, is at the centre of the story.[80] If the protagonist feels enclosed in physical and discursive spaces that he is at pains to describe, the reader is also trapped in the textual labyrinth of loose ends, unreliable information, impossible points of view, and transgressed narrative frames. At some point, a voice in the third person even warns the reader about the unreliability of the first-person narrator: "Michel es culpable de literatura, de fabricaciones irreales" (220) [Michel is guilty of making literature, of indulging in fabricated unrealities (124)]. In this regard, the meaning of the story is held hostage, striving to emerge from the literary ploy in which it is nested. The characters are also trapped. The boy at the tip of the island is bound to be a prisoner of the couple's intentions, while the woman and the boy themselves become prisoners within Michel's photographic image. She is particularly upset about this action, as if she has fallen unawares into a trap.[81] After Michel defends his right to take pictures in the public space against the woman's complaints, he leaves the scene, and the last thing he looks at—or thinks he sees—is her gesture: "el

clásico y absurdo gesto del acosado que busca la salida" (221) [the classical and absurd gesture of someone pursued looking for a way out (126)]. But roles switch dramatically once the photograph comes alive, and now it is Michel who finds himself trapped in the room where he is typing. He also becomes trapped in the very machine that was supposed to extend his powers of perception:

> De pronto el orden se invertía, ellos estaban vivos, moviéndose, decidían y eran decididos, iban a su futuro; y yo desde este lado, prisionero de otro tiempo, de una habitación en un quinto piso, de no saber quiénes eran esa mujer y ese hombre y ese niño, de ser nada más que la lente de mi cámara, algo rígido, incapaz de intervención. (223)

> [All at once the order was inverted, they were alive, moving, they were deciding and had decided, they were going to their future; and I on this side, prisoner of another time, in a room on the fifth floor, to not know who they were, that woman, that man, and that boy, to be only the lens of my camera, something fixed, rigid, incapable of intervention. (129–30)]

At the end, the man in black exacts his revenge for Michel's transgression. This happens, fittingly, through the power of his gaze, and his hollow eyes echo the constant allusions to nothingness made by the narrator.[82] As pointed out above, the scene has a powerful kinetic resonance, as if told from the point of view of a photographic camera shooting one frame after another. The description focuses on the jolted or fragmented movement of the camera as it captures, through successive shots, the elements that enter the viewfinder:

> y entonces giré un poco, quiero decir que la cámara giró un poco, y sin perder de vista a la mujer empezó a acercarse al hombre que me miraba con los agujeros negros que tenía en el sitio de los ojos, entre sorprendido y rabioso miraba queriendo clavarme en el aire, y en ese instante alcancé a ver como

un gran pájaro fuera de foco que pasaba de un solo vuelo delante de la imagen. (224)

[I turned a bit, I mean that the camera turned a little, and without losing sight of the woman, I began to close in on the man who was looking at me with the black holes he had in place of eyes, surprised and angered both, he looked, wanting to nail me onto the air, and at that instant I happened to see something like a large bird outside the focus that was flying in a single swoop in front of the picture. (130)]

The man's anger is signalled by a passing but meaningful detail: he wants to pin the photographer in the air, immobilize and lock him like an insect on a board. It is telling that immediately after Michel sees his gaze, he spots through the viewfinder a bird flying, an ironic symbol of his own impending doom. In this sense, the story's intermittent mentions of clouds and birds seem, from the protagonist's point of view, to be nostalgic tokens of lost liberty. Both fly freely in the open space and suggest to the beholder the endless possibilities that sheer distance triggers in the imagination.[83]

The narrative perspective forced upon the protagonist, incapable at the end of changing his point of view, stands in opposition to the final images he is left to behold. The amateur photographer who freely explores the city looking for images is, at the end of the story, transformed into the purely fixed gaze of a photographic lens that looks up to the sky, pining for unattainable freedom.

"Las babas del diablo" describes the process through which a photographic image is produced. Going beyond the verbal rendering of a visual representation, the story contextualizes its ekphrasis by exploring the aesthetic values, the photographer's psychological state, and even the cultural background that makes the photographic representation possible. While the narrator describes the process that leads to the photographic shot, he informs the reader about the choreographed movements of body, hand, and eye that are a necessary condition for achieving a successful picture.[84]

Roberto Michel is at the same time the verbal and the visual producer. As such, his privileged position allows him to flesh out the conditions that make possible the "ekphrastic hope" articulated in the text, that is, the utopian possibility of making the reader see through language and endow

the photographed objects with a concrete existence.[85] Nonetheless, neither he nor any other narrative voice offers a detailed description of the actual photograph he has taken. Rather than describing its features, Michel only refers in general terms to the few elements he has included within the frame. He even theorizes about the conditions that make a good photograph. He thus allows our ekphrastic hope as readers to posit from the outset the "unseen" photograph as an artistic achievement.

Blowing up the negative into a poster-size picture signals the impending transformation from still to moving image, further transgressing the boundaries that will place the protagonist "within" the picture he has taken.[86] In this crucial moment, the protagonist is overcome with fear, and even panic. The description acquires a special weight, as if he (and the reader along with him) were drawn inside by the centripetal power of the image. By entering into the pictured world, the difference between sign and referent collapses. As noted above, the description from inside the picture is marked by a syncopated rhythm, as if the passage were a hastily edited assemblage of disjointed parts. The description of this broken visual field fits well, as a climactic ending, with the broken narrative of the story as a whole:

> Creo que grité, que grité terriblemente, y que en ese mismo segundo supe que empezaba a acercarme, diez centímetros, un paso, otro paso, el árbol giraba cadenciosamente sus ramas en primer plano, una mancha del pretil salía del cuadro, la cara de la mujer, vuelta hacia mí como sorprendida iba creciendo, y entonces giré un poco, quiero decir que la cámara giró un poco. (223–24)
>
> [I think I screamed terribly, I screamed terribly, and at that exact second I realized that I was beginning to move toward them, four inches, a step, another step, the tree swung its branch rhythmically in the foreground, a place where the railing was tarnished emerged from the frame, the woman's face turned toward me as though surprised, was enlarging, and then I turned a bit, I mean that the camera turned a little. (130)].

Murray Krieger, W. J. T. Mitchell, and James Heffernan have pointed out the deep ambivalence triggered by ekphrasis, a figure that implies at the same time the desire and the dread that a verbal representation could make present the visual object it describes. In ekphrasis, Mitchell argues, language encounters its "semiotic other," namely, the visual, graphic, or plastic arts, so ekphrasis also points toward the "overcoming of otherness."[87] If ekphrastic hope and fear express our anxieties about merging with others, "Las babas del diablo" thoroughly exposes these anxieties, where the desire to merge is coupled with a strong resistance to doing so.[88]

As for the power of the moving image to draw the protagonist into its virtual domain, film critic Linda Williams has called attention to the concept of "attraction" as a way to explain "the basic, sensuous appeal of all moving pictures."[89] Cortázar plays with the literary possibilities of this cinematic solicitation, which is "an attraction not just of the eyes, but of the flesh."[90] In the story, this solicitation is two-fold, since the attraction of the moving image mirrors the previous seduction scene between the woman and the teenager. Cinematic attraction, according to Williams, "activates our entire sensorium in a synaesthetic manner with one bodily sense translating into another, and particularly, sight commuting to touch."[91] The transition from fixed to moving image allows the protagonist to inhabit a space that was, by the essential delimitation of a photographic representation, out of bounds. As Vivian Sobchack puts it,

> The photograph freezes and preserves the homogeneous and irreversible *momentum* of this temporal stream into the abstracted, atomized, and secured space of a *moment*. But at a cost. A moment cannot be inhabited. It cannot entertain in the abstraction of its visible space, its single and static *point of view*, the presence of a lived-body—and so it does not really invite the spectator into the scene (although it may invite contemplation *of* the scene.) In its conquest of time, the photographic constructs a space to hold and to look at, "thin" insubstantial space that keeps the lived-body out even as it may imaginatively catalyze—in the parallel but temporalized space of memory or desire—an animated drama.[92]

It is this "animated drama" that Cortázar both explores and explodes by positing an "unsituable cleavage," as Moran puts it,[93] between visual representations (first fixed and then moving) and the protagonist's perceptual, psychological, and interpretive skills.

The links between sight and touch are highlighted at the beginning of the passage where the fixed image becomes animated. It is the movement of the woman's hand, in itself meaningless, that trespasses an ontological threshold. It catches Michel's attention and becomes the starting point of his debacle:

> al fin y al cabo una ampliación de ochenta por sesenta se parece a una pantalla donde proyectan cine, donde en la punta de una isla una mujer habla con un chico y un árbol agita unas hojas secas sobre sus cabezas.
>
> Pero las manos ya eran demasiado. Acababa de escribir: *Donc, la seconde clé réside dans la nature intrinsèque des difficultés que les sociétés*—y vi la mano de la mujer que empezaba a cerrarse despacio, dedo por dedo. De mí no quedó nada. (222)
>
> [in the end an enlargement of 32 x 28 looks like a movie screen, where, on the tip of the island, a woman is speaking with a boy and a tree is shaking its dry leaves over their heads.
>
> But her hands were just too much. I had just translated: "In that case, the second key resides in the intrinsic nature of difficulties which societies . . ."—when I saw the woman's hand beginning to stir slowly, finger by finger. There was nothing left of me. (128)]

As in Darío's story, sight and touch interact and clash in uncanny fashion. Not only Michel's attention but his body is pulled into the virtual world of the photograph, as if the sense of sight is overcome by the sense of touch (and more generally, the sense of embodiment). The fact that the ensuing description develops from a hybrid perspective, merging a body in motion

with the point of view of a mechanic device, points both to the closeness and the impossibility of bridging the gap between senses and media.

The interaction of sight and touch is also at play in two references to the power of images to arouse a sexual response. In both cases, they can be interpreted as Roberto Michel's imaginary constructions about the life and fate of the teenager, as well as projections of his own anxieties regarding loneliness, desire, and sexual relations.[94]

While watching the couple at the tip of the island, Michel imagines the teenager's life in the alluring city. The young man, lonely and deprived of money but curious and free, enjoys his cheap food and cheap entertainment, which includes a "revista pornográfica doblada en cuatro." (218) [the pornographic magazine folded four ways (120)]. This *effet du réel* connotes adolescent desire and grounds the character in the social and psychological context of youth subculture. Promising illusory pleasures, the magazine stands in sharp contrast to the chance encounter with a real woman. Eventually, roles are reversed: the boy who gazes with desire at still images of women on the printed page ends up devoured by the hypnotizing gaze of the woman during their encounter. The fact that the magazine is folded in four sections points to the portability of printed material, an important feature of printed photographic images that contrasts with other visual arts and media. The folding of the magazine also suggests a need to conceal in the public space morally compromising images.[95]

A second reference to pornography appears once the magnified photograph has been set in motion. Michel arrives at the conclusion that the woman is just an accomplice, since the true master is the man in black waiting at a distance. As was the case when he first saw the couple, Michel essentially projects an imagined scene onto the blown-up image, the screen where the virtual events take place. He speculates that the boy is in danger of being abused. He then refers to what he fears, not by actually describing the scene of sexual violence, but by offering a succinct list of metonymic references to the alleged abuse. The reader has to fill in the blanks: "el resto sería tan simple, el auto, una casa cualquiera, las bebidas, las láminas excitantes, las lágrimas demasiado tarde, el despertar en el infierno." (223) [The rest of it would be so simple, the car, some house or another, drinks, stimulating engravings, tardy tears, the awakening in hell. (129)] The word "lámina" refers to an illustration, and more specifically to a glossy colour photograph, which is intended to enhance sexual arousal.

1 | Uncanny Visions in Darío, Cortázar, and Elizondo 49

In the protagonist's mind, pornography is a crucial element of the trap set by the evil man to lure the boy.

If we consider the story through the "ekphrastic principle" proposed by Murray Krieger—according to which, "visual arts are metaphors for the shaping of language into formal patterns that 'still' the movement of linguistic temporality"[96]—Cortázar provides a distorted, expressionist twist to this literary strategy: the still photograph may seem to fix the movement embedded in language, but its "content" is put into motion. Photography, which for Roberto Michel is meant to capture life in a decisive moment, performs a fundamental breakdown, opening a crevice that undermines any effort to fix or control the proliferation of representations. In "Las babas del diablo," ekphrasis, rather than fixing images with words, is a means with which to weave an anxiogenic textual trap that both protagonist and reader strive to disentangle.

"Apocalipsis de Solentiname," published almost twenty years after "Las babas del diablo," intertwines a fantastic plot with a chronicle of an actual undercover visit that Cortázar made to the community of Solentiname, Nicaragua, in 1976.[97] After the trip, the story's protagonist-narrator finds that the photographs he shot, rather than showing the paintings of Solentiname's peasant artists, feature scenes of violence he had neither recorded nor witnessed. As in "Las babas del diablo," the main character suffers in solitude his uncanny fate, in line with a sustained pattern in the work of Cortázar, where a lonely hero strives hopelessly to overcome an obstacle, usually falling prey to forces beyond his powers.[98]

In both "Apocalipsis de Solentiname" and "Las babas del diablo," two technologies of representation are pitted against each other: in the latter, there is the duel between visual and verbal artifacts; in the former, a modern visual technology is opposed to the traditional, handmade craft of painting. This opposition is stressed by the alleged "primitive" originality of the painted works, as cultural products of a rural community.

As for the material support and photographic specifications mentioned in each story, the artistic outlook of Roberto Michel requires his skill as an amateur developer, while the protagonist of "Apocalipsis de Solentiname" relies on the services of a commercial laboratory (this mediation opens the door for the possibility of misplaced film rolls, which would explain the unexpected scenes of violence during the slide show). In both stories, the materiality of the medium determines to a great extent the outlook of

the pictures. The scenes to be photographed require the use of a particular kind of film, and reciprocally, each kind of film imposes its own specifications on the photographed object. In "Las babas del diablo," the particular autumn light, the deserted streets, and the air of suspense calls for the evocative quality of black-and-white film. Stressing its artistic aspirations, and thus positing a hierarchy of cultural values, Roberto Michel purposefully works with this kind of material, the preferred medium of artistic photography throughout the twentieth century. In "Apocalipsis de Solentiname," the photographer chooses slides, a medium favored mostly by tourists and suited for family presentations. While projected slides establish a distance between image and viewer and lack the aesthetic prestige of prints, they are livelier in terms of colour and luminous display. In this context, the colours of the peasants' paintings are not only highlighted in the ekphrastic rendering the narrator offers, but also enhanced by the bright light of midday in which they were taken. The protagonist remarks that they will be enhanced even further when projected in his living room: "me los llevo todos, allá los proyectaré en mi pantalla y serán más grandes y más brillantes que éstos." (157) [I'm taking all of them, I'll show them on my screen back there and they'll be bigger and brighter then these. (123)][99] The slides of the colourful paintings also correspond to the brightness and lushness of the tropics, recreated in the context of the protagonist's all-too-civilized Parisian home. It should be said that the use of colour in Cortázar's texts is an abiding literary motif which makes him a kind of painterly writer. Beyond the pervading allusions to, and writings on, the visual arts in his work, Cortázar constantly plays with an ekphrastic dimension that stresses the chromatic qualities of objects, settings, and even moods. Besides playing with the abstract and symbolic dimensions of chromatic values, colour also connotes a field of signification linked to avant-garde aesthetics and a progressive political ideology. As opposed to the dullness of gray tones, color points to a utopian aspiration.[100] In this sense, the description of the colourful paintings of Solentiname provides a link, through their visual impact, between the purported "primal vision" of the peasants and a project of individual and collective fulfillment.

Photography's uncanny dimension is predicated on the infringement of the bounds of realist representation that helps advance the fantastic plot. In both stories the material channel through which a visual sign is produced betrays the intent of the photographer. In both texts a case of

illegitimate appropriation comes to haunt the private space of a beholder removed in the present from the scene of the alleged transgression. This takes place a significant time after the shots have been taken and the pictures developed, as in a delayed response before the onslaught of violence, recalling the deferred action that characterizes the structure of trauma according to Freud.[101]

"Apocalipsis de Solentiname" begins by acknowledging the differences between "Las babas del diablo" and Antonioni's 1966 movie *Blow-Up*. Beyond the use of one of Cortázar's common literary strategies, the nesting of representations,[102] the allusion introduces discrepancy or disjuncture as the framing device of the story:

> Hacía uno de esos calores y para peor todo empezaba enseguida, conferencia de prensa con lo de siempre, ¿por qué no vivís en tu patria, que pasó que *Blow-Up* era tan distinto a tu cuento, te parece que el escritor tiene que estar comprometido? (155)

> [It was one of those hot spells and to make things even worse it all got started right away, a press conference with the usual business, why don't you live in your own country, why was *Blow-Up* so different from your short story, do you think a writer must be involved? (119)]

The narrative and psychological breakdown displayed in "Las babas del diablo" finds its match in "Apocalipsis de Solentiname" with its many instances of dissociation. Photography is again the vehicle through which disjuncture takes place. A first example appears as the author marvels at the possibility of taking a Polaroid picture and watching appear in the print, quite unphotographically, something ostensibly different than what was shot. The protagonist emphasizes the point at the end of the story by suggesting ironically to his companion Claudine, after she fails to see the same images that he was appalled to witness a few moments earlier, that perhaps she saw Napoleon riding on a horse. Not only this is a material impossibility but of course a historical one, insofar as Napoleon died before the invention of photography. In a second example, the story highlights the difference between the photographs taken in Solentiname

and those projected in Paris (which in turn implies a discrepancy between a specific place, Solentiname, and the projected images, which portray scenes of political violence across Latin America).

Cortázar foregrounds in the story the mechanical devices that make photographic representations possible: the Polaroid camera and the slide projector. The Polaroid was not a new invention in the mid-1970s, but the existence of one at the house of his host in Costa Rica attests to the availability of this photographic technology even in cultural spaces far from metropolitan centres.[103] Before embarking for Solentiname, the protagonist marvels at the instant camera and describes the natural wonder produced when looking at the gradual appearance of an image on the glossy white paper.[104] This photographic magic is echoed—and contradicted, in a sort of chiasmic reversal—by an odd phenomenon, which makes the viewer's attention sway between the actual picture and the slight but decisive differences in the perceived surroundings where that picture has just been taken. A Polaroid picture highlights the distinction between visual representation, on the one hand, and reality as immediately perceived and remembered, on the other—what Roberto Michel in "Las babas del diablo" calls "la operación comparativa y melancólica del recuerdo frente a la perdida realidad" (221) [that gloomy operation of comparing the memory with the gone reality (126)]. From the photographer's point of view, even the seamless operation of a Polaroid camera "proves" the reality of the moment just lived, while at the same time opening an insurmountable gap between the visual representation and the moment of its creation:

> antes hubo fotos de recuerdo con una cámara de esas que dejan salir ahí nomás un papelito celeste que poco a poco y maravillosamente y polaroid se va llenando de imágenes paulatinas, primero ectoplasmas inquietantes y poco a poco una nariz, un pelo crespo, la sonrisa de Ernesto con su vincha nazarena, doña María y don José recortándose contra la veranda. A todos les parecía muy normal eso porque desde luego estaban habituados a servirse de esa cámara pero yo no, a mí ver salir de la nada, del cuadrito celeste de la nada esas caras y esas sonrisas de despedida me llenaba de asombro y se los dije, me acuerdo de haberle preguntado a Oscar qué pasaría si alguna vez después de una foto de familia el papelito celeste

> de la nada empezara a llenarse con Napoleón a caballo, y la carcajada de don José Coronel que todo lo escuchaba como siempre, el yip, vámonos ya para el lago. (156)
>
> [But first there were souvenir photographs with one of those cameras that let the little piece of sky-blue paper pop out right there and little by little and miraculously and Polaroid it fills up little by little images, first disturbing ectoplasms and little by little a nose, some curly hair, Ernesto's smile and his Nazarene headband, Doña María and Don José outlined against the porch. That seemed quite normal to all because, of course, they were accustomed to using that camera, but not to me, I was filled with amazement as I saw those faces and those good-bye smiles coming out of nothing and I told them so, I remember asking Oscar what would happen if sometime after a family snapshot the sky-blue paper started to fill up with Napoleon on horseback, and Don José Coronel's laugh, listening to everything as always, the Jeep, let's go to the lake now. (121)]

The description of the Polaroid picture echoes the odd spatial perspectives deployed in "Las babas del diablo." The "cuadrito celeste" recalls the play of nested visual frames featured in the 1959 story and, specifically, the ending with its vision of a sky framed by a square that could be a window, or a screen, or the viewfinder of a camera. As noted above, references to the void are prominent in "Las babas." Its open ending plays with nothingness, existential catastrophe, and anxiety, avoiding any kind of edifying closure.

The Polaroid picture also blends two cultural and political contexts: first, the (magical) realism of modern technologies of representation, and second, the modern history of American imperialist interventions in Latin America, displaced but clearly connoted by imagining, as the narrator does, the appearance of the French Emperor on a horse. This virtual photograph foreshadows the unexpected pictures of violence the narrator witnesses later, and it is also utilized to mark the difference between the apocalyptic vision of the protagonist[105] and the "normal" point of view of Claudine, which is closer to that of a naive tourist. Musing at the end of

the story about asking Claudine if she had seen a photograph of Napoleon on a horse—something impossible from a realist perspective—the protagonist points to the virtual nature of his own vision. While the irruption of the fantastic remains, as always, a possibility, what seems to happen is the irruption of "real" images in which horrific scenes of violence grip the viewer in a traumatic moment that, as in "Las babas del diablo," calls for a cure.

The strategies of photographic composition in "Las babas del diablo" and "Apocalipsis" are almost opposite, yet they both aim toward a similar redemptive end through aesthetic means. Roberto Michel is equipped with the intuition of an amateur photographer indebted to the aesthetic values of high modernism; for his part, the protagonist of "Apocalipsis de Solentiname" employs his camera mainly to achieve an exact match, in terms of framing, of photographs to paintings (he has taken other photographs during his trip, but the text focuses mainly on his reproductions of the peasants' pictures). Roberto Michel aims to construct a perfect image out of a chance encounter in an urban setting, whereas the protagonist of "Apocalipsis de Solentiname" has already found the object to be photographed, his aim being to technically reproduce the paintings as faithfully as possible. His main concern is not with creativity, but with centring the paintings in his viewfinder. The issue of an exact framing becomes crucial because his use of slides forbids any cropping. Indeed, both slides and Polaroids bypass the photographic negative and point to a similar "faithfulness," a perfect match between exposed film and final image. This use of photography, which emphasizes spatial precision, is enhanced by the fact that the protagonist happens to have a roll of film with the same number of shots as the number of paintings he intends to photograph. This controlling, precisionist, or Procrustean approach serves as foil to the violent explosion of images that splatter the screen during the slide show. The show enacts in literal terms the violent aperture through which Cortázar defined photography in his essay "Algunos aspectos del cuento"—but this time, there is no redeeming value, no aesthetic or spiritual interpretation. Rather, the raw nature of the slide show points to an exploration of physicality and bodily response in the face of danger and stress. Photography, through its sheer mimetic power, is the medium through which the body is directly affected.[106]

Both in "Las babas del diablo" and "Apocalipsis de Solentiname," Cortázar elaborates the theme of a traveller—*flâneur*, committed intellectual, acute observer—who, at the end of his trip, gets more than he bargained for. In each case, the adventure is transformed from visual exploration into an unexpected descent into physical and psychic violence. In both stories, the literary exorcism championed by Cortázar dramatizes the impossibility of taming the ultimate power of images.[107] These images play the role of haunting, phantasmatic presences that call for a verbal cure. In "Las babas del diablo," the story itself is presented as the urgent cure that Roberto Michel seeks through verbalization. In contrast, "Apocalipsis de Solentiname" ends with the retreat of the protagonist into silence. Rather than confronting his traumatic experience and contrasting it with Claudine's, he remains in a pensive, even sarcastic mood. The story concludes:

> Sentado en el suelo, sin mirarla, busqué mi vaso y lo bebí de un trago. No le iba a decir nada, qué le podía decir ahora, pero me acuerdo que pensé vagamente en preguntarle una idiotez, preguntarle si en algún momento no había visto una foto de Napoleón a caballo. Pero no se lo pregunté, claro. (160)

> [Sitting on the floor, not looking at her, I reached for my glass and drank it down in one swallow. I wasn't going to tell her anything, what could I tell her now, but I do remember that I vaguely thought about asking her something idiotic, asking her if at some moment she'd seen a photograph of Napoleon on horseback. But I didn't, of course. (127)]

This fatalistic silence implies a retreat into individual drama. The verbal cure of storytelling put in action in "Las babas del diablo," albeit insufficient, is no longer deemed adequate to confront the onslaught of traumatic images that comes rushing from the realm of contemporary history. Ekphrastic fear is the dominant note. In both texts, words function as screens as well as shields: as devices that conjure up images while defending the viewer from their fearsome effects. Verbal representations are thus turned against themselves, exemplifying a paradoxical impulse that both anchors and strives to transcend the specificity of their effects.

Salvador Elizondo

If the short stories by Darío and Cortázar bring to the fore the links between the extension of vision, the photograph as a haunted space, and the clash between the visual and the tactile, and embodiment in general, no other author in Latin America has explored these issues more thoroughly, and more poignantly, than Mexican Salvador Elizondo. This last section examines his novel *Farabeuf* (1965), arguably his best work of fiction. It begins by assessing photography's central role in Elizondo's poetics and then moves to interpret *Farabeuf* as an (oxymoronic) "photographic delirium." By examining key concepts in Elizondo's writing (fixity, violence, and memory) that are closely related to photography, my aim is to shed light on the way this visual medium is used in his work. I conclude by analyzing the way visual and verbal representations interact in the novel, as well as their links to tactile perception and the body.

Literature and photography are closely intertwined disciplines in Elizondo's artistic conception. In *Autobiografía precoz* (1966), written when he was thirty-two years old, he points out that as a writer he thinks of himself as a sort of photographer, not in the sense of practising this trade in addition to his literary endeavors, but as a means of understanding the task of writing and his own artistic ideals:

> Al final de cuentas, como escritor, me he convertido en fotógrafo; impresiono ciertas placas con el aspecto de esa [mi] interioridad y las distribuyo entre los aficionados anónimos. Mi búsqueda se encamina, tal vez, a conseguir una impresión extremadamente fiel de ese recinto que a todos, por principio, está vedado. (29)

> [In the final analysis, as a writer, I have become a photographer; I expose some plates with the features of my inner world, and I pass them around among anonymous *aficionados*. My search points, perhaps, towards achieving an extremely faithful exposure of that site which, as a matter of principle, is out of bounds to everyone else.]

By resorting to the metaphor of the mind as a sensitive plate where visual impressions are lodged,[108] photography articulates a wish to produce a picture of the unrepresentable space of consciousness and its operations, in line with the aesthetic goals of high modernism, a literary tradition with which Elizondo was well acquainted.

Visual arts and media are of central importance in Elizondo's work. Photography in particular becomes a paradigmatic practice: it is the medium that best manifests the essentially discrete, partial, or fragmentary condition of our modes of perception, intellection, and expression.[109] In photography, life is reduced to the representation of selected moments. From a formal point of view, perception and knowledge are always partial, a state of affairs that modernity has enhanced.[110] In Elizondo's worldview, the fragmented "photographic gaze" becomes a principle of perceptual organization and an artistic ideal. It is along the lines of his formalist aesthetics that we should understand his claim that "todo proferimiento creador tiene necesariamente pretensiones fotográficas."[111] Photography provides the model that articulates his reflections on the power of the image as a demonic or haunting sign.

The ostensible source of *Farabeuf* is a photograph depicting a Chinese torture and execution, the "Leng Tch'é" or "Death by a Thousand Cuts," which Elizondo drew from Bataille's *Les larmes d'Eros*.[112]

Inasmuch as this photograph depicts a most extreme case of sensory perception—extreme pain in the threshold between life and death—delirium is a useful concept through which to understand Elizondo's novel and overall literary endeavor. This concept recurs frequently in an early collection of essays entitled *Cuaderno de escritura* (1969). In "Teoría mínima del libro," delirium is closely linked to the workings of imagination. It is also used to articulate a phenomenological view of psychic violence and its depiction in the visual arts, as exemplified by the paintings of Mexican artist Alberto Gironella, whose works are for Elizondo "reflejos especulares de una obsesión o de un delirio" (420) [specular reflections of an obsession or a delirium]. Elizondo remarks that the painting entitled *El obrador de Francisco Lezcano* functions, in its "exacerbación barroca" (406) [baroque exacerbation], as a mirror that reflects "una metamorfosis delirante" (407) [a delirious metamorphosis]. Elizondo seems to be referring here not only to Gironella's painting but also to his own artistic leanings and literary strategies.[113]

01 **FIG 7**: Leng Tch'é, or Death by a Thousand Cuts (1905).

Farabeuf is a notoriously difficult novel to grasp, though it is precisely this difficulty that suggests a productive interpretive method. The text can be read as the hyperbolic transcription of a delirium, as if the author intended to show, rather than tell, the upheavals of a deranged mental functioning from up close. The novel, as Elizondo himself acknowledged, is meant to produce a shocking effect.[114] On the one hand, the text contains vividly rendered descriptions, as if the power of *enargeia*—a term of classical rhetoric closely linked to ekphrasis that refers to "the quality which appeals to the listener's senses, principally that of sight"—seeks to reproduce the visual force of a detailed, sharply focused photograph.[115] *Nitidez*—sharpness or clarity—is an aesthetic value Elizondo pursues in his writing.[116] On the other hand, these descriptions are framed in an incoherent narrative structure, a sort of photographic album assembled with no discernible order. The novel can profitably be read as a proliferating and obsessive array of perceptual and mnemonic acts whose overall

1 | Uncanny Visions in Darío, Cortázar, and Elizondo 59

narrative framework remains elusive.[117] In this context, the text has been understood in terms of the psychological realism practiced by contemporary French writers of the *Nouveau Roman*, as a literal register of states of consciousness.[118] By shattering time and plot, and by fragmenting the narrative in a proliferating gallery of unidentified voices, the text hinders the possibility of achieving any stable interpretation. Elizondo himself has indicated that "*Farabeuf* no sigue otro esquema que el de la ilación irracional metódica,"[119] [*Farabeuf* does not follow any blueprint but a methodical irrational connection] and delirium is explicitly mentioned in the text as a possible "explanation" for the temporal, spatial, and characteriological dissociation that crisscrosses the novel.[120] It is hard to identify the subject of *Farabeuf*'s narrative madness, but there are enough clues to surmise that the novel portrays the frightful delirium of a woman under extreme pain.[121] She embodies a number of shifting identities—an Ouija player, a nurse working in China called Mélanie Desaiggnes, a Parisian prostitute, even the tortured person pictured in the photograph.[122] As hinted in the last pages of the novel, the acts of recalling and looking that organize the fragments around which the plot revolves are "performed" upon a woman, in a sort of rape that points not only to sexual penetration but also to a perceptual and psychic assault, a gushing of images that overwhelms her mind.[123]

Photography provides a representational model where the key concepts of Elizondo's artistic vision coalesce. These interrelated notions—which provide the general framework for his literary, psychological, and aesthetic exploration—are fixity (as both an artistic ideal and psychic wish), the picturing of violence, and the workings of memory and obsession. I analyze their interactions in the following section.

Effects of fixity, stasis, and frozen time traverse the syncopated narration of *Farabeuf*.[124] Photography, inextricably linked from its inception to the rhetoric of the fixed image, becomes the preferred medium through which to "wrestle" a static moment out of the flow of time.[125] However, the effects of photography go beyond this representational fiction. By creating the illusion of reversibility and by making available for inspection in the present what remains irretrievably in the past, photographs not merely aid memory but end up creating a new psychic dimension of engagement with past events mediated by visualization.[126] Vicky Goldberg notes that "still photography does preserve details better than most minds and most

memories of a rapidly moving event."¹²⁷ Thus, the photographic medium fosters a thorough deepening of our capacity for retrieval, a premise that *Farabeuf* exploits to its furthest limits. Time, of course, never stops, but the slicing of the continuity of events by way of their iconic inscription creates the illusion and the desire that time itself *could* stand still. In this context, the epigraph by the Romanian-French philosopher E. M. Cioran that opens *Farabeuf* sums up the impossible project of reversing time, inextricably linking memory and violence: "Toute nostalgie est un dépassement du présent. . . . La vie n'a de contenu que dans la violation du temps. L'obsession de l'ailleurs, c'est l'impossibilité de l'instant; et cette impossibilité est la nostalgie même" (85) ["Every nostalgia is a transcendence of the present. . . . Life has a content only in the violation of time. The obsession of elsewhere is the impossibility of the moment; and this impossibility is nostalgia itself."¹²⁸].

The photographic act always entails a degree of violence: besides freezing time, it fragments space, flattens volume, and shrinks or expands size. For sitters, its practice can imply a burdensome standing still, and for the subjects photographed it can involve encroachment, surveillance, and threat.¹²⁹ A photograph that pictures an act of violence, such as the image of the Chinese execution, is a self-reflexive sign, an icon that poignantly exposes its own conditions of existence. This photograph recurs in Elizondo's work, attesting to its enduring power. In his essays from the 1960s, it becomes a complex semiotic space around which the Mexican author explores the relations among time, memory, personal identity, violence, and visual representation. Somewhat hyperbolically, he considers it one of those visions "capaces de subvertir y trastrocar cualquier concepción del mundo" [capable of subverting and inverting any worldview].¹³⁰

Fixity, violence, and memory are linked to the work of Jorge Luis Borges, a major presence in the writing of Elizondo.¹³¹ Of particular relevance is the short story "El milagro secreto," included in *Ficciones* (1944).¹³² The ultimate fate of the protagonist, Jaromir Hladík, is also the chronicle of an expanded, oneiric instant where the fixed image plays a crucial role. Among the similarities between *Farabeuf* and the short story by Borges, both Hladík and the tortured boxer are tied to a stake, as if they were living lightning rods through which a privileged vision is channelled up to the critical moment of their deaths. While putting them in the hands of their executioners, Elizondo and Borges use photography to reinforce the

idea of a violent capture, and in both cases, the threshold between life and death is mediated by a photographic act. Elizondo's novel is explicitly built around a photograph. In the case of "El milagro secreto," the protagonist ends up facing a firing squad as if he were posing for a photograph. Looking at the hesitant soldiers, the narrator says that Hladík "absurdamente, recordó las vacilaciones preliminares de los fotógrafos." ["Absurdly, Hladik was reminded of the preliminary shufflings-about of photographers."][133] The reference is ironic, because the soldiers who are about to kill him will "immortalize" him in effigy, as photographers are meant to do; however, the reference is also prescient, because the metaphorical photographic act that shoots Hladík will become, thanks to the intervention of God, a secret miracle that freezes physical reality and saves him (at least for a year). Thus, it is the entire material universe that has been transformed into a photograph, a snapshot in God's omnipotent vision.[134]

Delirium is in *Farabeuf* a destructuring move that shatters the conventions of realist prose. *Farabeuf* shares with the literature of the fantastic its subversive streak since, as Jackson explains, it threatens to disrupt or eat away at "the 'syntax' or *structure* by which order is made."[135] In this sense, Elizondo's strategy in the articulation of his literary delirium closely resembles the drama "Los enemigos," which Hladík had been composing before he was seized by the Nazi army. The drama represents the mental breakdown of his main protagonist, the forlorn Jaroslav Kubin. A kind of fictional delirium within the "real-life" delirium that Hladík faces before his upcoming execution, "Los enemigos" is the key to the author's redemption: the work that, he hopes, will justify his life.[136] This echoes the Chinese execution, where an ecstatic vision is supposed to redeem the boxer's life in a moment of absolute suffering. With regard to the literary texture of Hladik's drama and Elizondo's *Farabeuf*, they both deploy the minimalist precision of an array of concrete references within an ambiguous narrative framework. Both texts posit a kind of "psychic imperialism" where the events narrated and the confusing links between them are, on one side, the only things that happen and keep happening, in an endless circle; on the other, they are things that never truly happen, confirming the virtual nature of their mental—as well as literary—condition.

Elizondo points out in his *Autobiografía precoz* that the photograph of the execution became "una especie de zahir," (56) a notional entity that blends memory, fixity, and violence. By adopting Borges's fictional coin to

describe the effects of the photograph, Elizondo not only acknowledges the literary debt he owes to the Argentine writer; he also uses the term to bridge the gap between a fictional construction and a mental reality (as sometimes happens in Borges's own literary creations). The zahir, which gradually takes over the mind of a character called Borges, is described in the eponymous story as "una idea fija" [a fixed idea].[137] It is an image that colonizes mental functioning and its contents, becoming a burgeoning, intolerable presence whose intensity increases as time passes.[138] It also becomes a useful aesthetic model, given Elizondo's ideas about the links between art and mental disturbance, as sketched above. The Mexican author claims in his essay "El putridero óptico" that "la belleza es necesariamente obsesiva" (401) [beauty is necessarily obsessive], and *Farabeuf* is a perfect example of what he calls in the same text "reiteraciones empecinadas del espíritu" (401) [the mind's stubborn repetitions]. As if mimicking the psychic imperialism of the zahir, the overarching force of the photograph of the tortured man takes hold of the novel's characters, in particular the woman, who beholds it with a boundless, anxious attention (29 and 49). As for the reader, she is also lured to look at the photograph to partake in the "memorable image" that the characters obsessively pursue.

Fixity, violence, and memory are also linked to a discussion of traumatic childhood memories that Elizondo elaborates in his essay "Invocación y evocación de la infancia," included in *Cuaderno de escritura*. Elizondo points out the importance of the images that remain lodged in the mind for years, and which become points of reference for the creative work of the adult writer or artist.[139] In the essay, special attention is given to a children's book widely circulated in Germany at the beginning of the twentieth century—*Der Struwwelpeter* (1845), by Heinrich Hoffmann—which Elizondo, who spent some of his childhood in Nazi Germany, got to know.[140] The volume, illustrated by Hoffmann himself, is intended to provide pedagogical advice on the upbringing of children. Texts and illustrations highlight a consistent moral message: bad behavior leads to extreme physical pain, which is thought to be a deterrent. Elizondo paraphrases a story about little Conrad, with an ironic twist that evinces the anxiety about the effect this children's tale had on him. Conrad, "The little suck-a-thumb," is a boy who cannot avoid sucking his thumbs despite the stern warnings of his mother, who tells him that the tailor will come with his big scissors and will cut off his fingers. Once the mother leaves, the first

thing that Conrad does is suck his thumb. Suddenly the tailor appears out of nowhere and cuts off his two thumbs. The children's story ends with the image of Conrad crying hopelessly with his hands dripping blood.

Elizondo writes: "es indudable que todas las barbaridades contenidas en estas curiosas y alegres historietas no pueden dejar indiferente el alma de los niños que en un determinado momento las han leido con una fruición premonitoria" [It is clear that all the outrageous material contained in these interesting and merry children's stories cannot leave unimpressed the soul of the child who has read them, at one moment, with premonitory fruition].[141] The whole book, and particularly the story of "Little Suck-a-Thumb," has an important textual link with *Farabeuf*.[142] Both texts are about the imposition of actions upon a victim that strikes us as extreme and irrational. The child's punishment, as well as the Chinese execution around which the novel revolves, are actions that impose a ritual discipline defined by physical constraint and utter pain.[143] Both have a moralistic and didactic purpose: as Hoffmann's book aims to forcefully teach a lesson, the execution is a public performance intended to teach the people, through the display of utmost suffering, the consequences of criminal behaviour.

The persistence of childhood images in the mind of the adult writer can be seen in a reference in *Farabeuf* to the story of the mutilated child. In the presentation of Farabeuf's confusing "Instantaneous Theater," an unidentified voice recalls the episode:

> Tengo otros recuerdos de aquella velada: la Enfermera, además de los pequeños folletos del Doctor Farabeuf, ofrecía también otro libro de mayor tamaño y precio diciendo, '. . . o este entretenido libro de imágenes para los niños'. Era un libro con pastas de cartón. La Enfermera lo mostraba abierto en las páginas centrales. No he podido olvidar una de aquellas imágenes. Representaba a un niño a quien le habían sido cortados los pulgares. Las manos le sangraban y a sus pies se formaban dos pequeños charcos de sangre. (169)

> [I have other memories of that soirée: the Nurse, besides the small pamphlet by Doctor Farabeuf, was also selling another larger, more expensive publication, saying ". . . or this

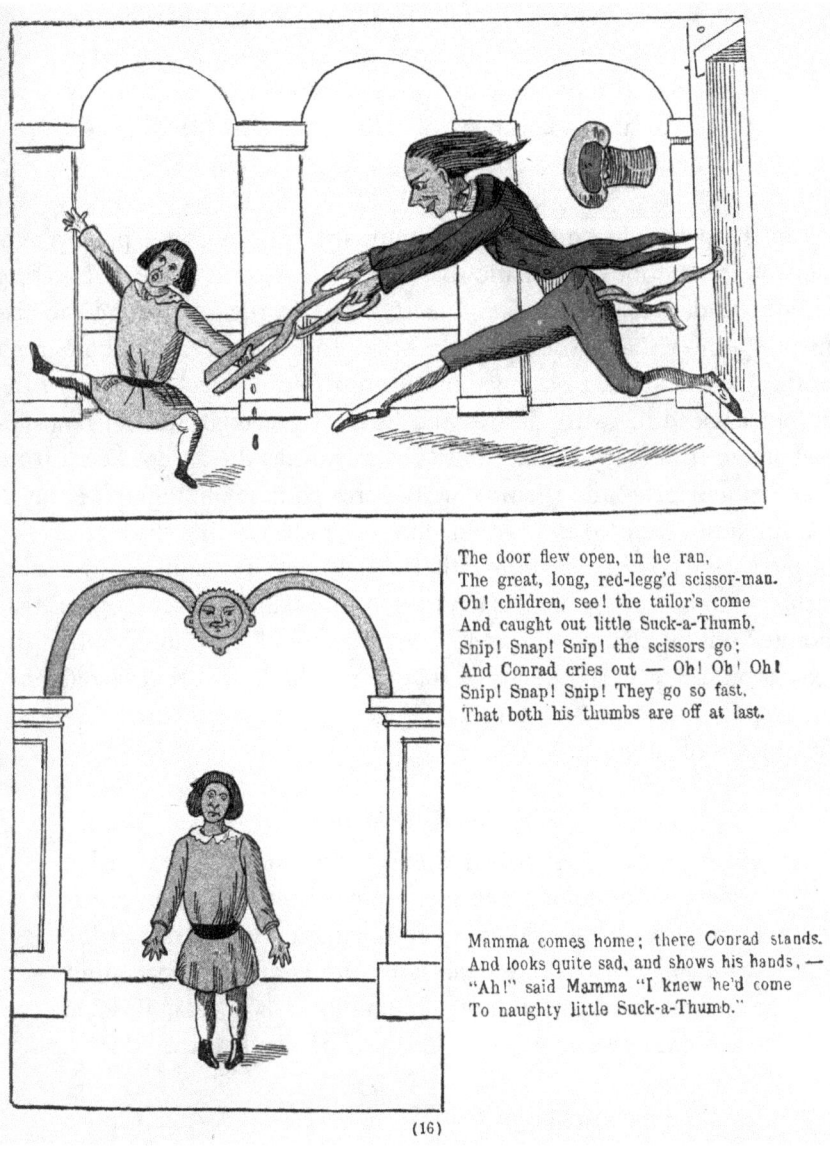

01 FIG 8: Illustration for "The Little Suck-a-Thumb" in *Der Struwwelpeter* by Heinrich Hoffmann.

entertaining picture book for children." It was a hardbound book, and the nurse held it open to the middle. I have never been able to forget one of those pictures. It showed a boy whose thumbs had been cut off. His hands were bleeding and two small pools of blood were forming at his feet. (83)][144]

As in the deforming mirror of a nightmare, the passage deploys a version of the author's traumatic memories. The novel, while elaborating childhood desires, fantasies, and fears, places in the foreground the disturbing power that those images possess. In this sense, the photograph of the Chinese torture becomes an uncanny found object that throws the author back to his early desires and fears, triggering a host of fantasies elaborated in literary form.[145] Both the memories the author keeps from *Der Struwwelpeter* and the way he uses the Chinese photograph point to a trauma not suffered in his own skin, but rather indirectly, by the relay of pictures. The intrinsic power that visual representations—and in particular, photographs—possess to upset the mind and shatter its stability is pointed out by Elizondo himself.[146] Writing about the photograph of the execution, he reverses the terms that define the links between reference and representation by making the image, and not the torture, the actual focal point of pain:

> La experiencia del dolor creo que es más, muchísimo más intensa imaginada que experimentada; yo creo en los extremos del dolor físico que están representados en la fotografía del torturado chino en la que me basé para escribir *Farabeuf*, el dolor que expresa esa fotografía es muchísimo muy superior en términos de literatura, claro está, al dolor físico que experimenta el chino que está siendo torturado.[147]
>
> [The experience of pain I believe is more, much more intense when imagined than experienced; I think that the extremes of physical pain represented in the photograph of the tortured Chinese on which I based *Farabeuf*, the pain expressed by that photograph is far more superior in terms of literature, of course, than the physical pain experienced by the Chinese man who is being tortured.]

Beyond its inconsistency, the statement should be understood considering the obsessive nature of images of pain as more permanent in the mind than the extreme, though limited, pain inflicted on the flesh. The photograph in question becomes less a specific testimony of human brutality than an emblematic image of suffering to which the author submits himself (and to which he submits the reader/viewer), in a movement that both stands up to violence and falls prey to its effects. The same interpretive/spectatorial move is performed in Sontag's *On Photography*, where she describes in these terms her reaction after looking at photographs of the Nazi death camps: "Nothing I have seen—in photographs or in real life—ever cut me as sharply, deeply, instantaneously . . . something went dead; something is still crying."[148] The traumatic element of photography is also present in the heuristic concept of *punctum* that Barthes employed in *Camera Lucida*: "*punctum* is . . . sting, speck, cut, little hole—and also a cast of the dice. A photograph's *punctum* is that accident which pricks me (but also bruises me, is poignant to me)."[149]

Violence as a literary topic in Elizondo's work belongs to the French literary tradition of the Marquis de Sade, Baudelaire, and especially Bataille, in its quest to probe and transgress the limits of rationality, representation, and identity. In Elizondo, this quest is less philosophical than rhetorical and stylistic. Violence points to a dimension of experience that yields a set of sensations both fascinating and harrowing, posing a challenge to the writer's ability to describe and narrate it. Despite Elizondo's (not so successful) efforts to theorize in metaphysical or phenomenological terms the notion of violence, his aim might be better understood as opening up a field of literary and aesthetic exploration in the context of modern Mexican literature.[150] In this sense, and in the face of a dialectics of perception that swings from shock to familiarity to indifference, *Farabeuf* intends to elicit a constant rekindling of sensation, a state that keeps alive "the desirous act of looking."[151] Contrary to real trauma, an image perceived as traumatic can point to the morbid willingness by an author to be affected as well as affect the reader/viewer, in a quest to fulfill the abiding "wish to see something gruesome."[152]

Among the paraphernalia of sadistic instruments deployed in Elizondo's work, sharp tools are a constant source of interest and anxiety. The scissors with which the tailor cuts off the thumbs of little Conrad recall the detailed description of surgical tools with which *Farabeuf* begins, as

well as the blades of the executioners in the Chinese torture. Louis Herbert Farabeuf, the famed specialist on amputations, can be interpreted as a paternal figure that stands for the image of the cruel tailor in Hoffmann's book. Besides representing, in an overblown fashion, the threat of castration, which is closely associated to the Freudian uncanny, both doctor and tailor embody a consistent trope in Elizondo's work.[153] The tailor uses his tools not to make a whole out of disparate parts, but to cut into pieces what remains irretrievable in its fragmentation, very much as Farabeuf practices a type of medicine that cuts body parts beyond recuperation.[154] The predilection of the author for sharp tools and weapons also points to the action of cutting or cropping that is at play in photographic practice, itself a slicing of space and time.[155]

Beyond this feature, the photograph of the execution, in all its gruesomeness, emblematizes an ideal of photographic representation, namely, to glimpse an ecstatic vision in the click of a moment. Doctor Farabeuf states that "la fotografía . . . es una forma estática de la inmortalidad" (98) [Photography . . . is a static form of immortality (12)]. As if performing a savage allegory, the photograph of the execution mirrors the fixity and violence performed by the photographer in the act of taking a picture, as well as the fixity and violence to which the sitter is submitted. By the end of the novel, the situation of the immobilized woman about to be sacrificed recalls the procedures to which sitters were subjected during the early years of photography, when lengthy exposures required the use of mechanical aids to keep the sitters still.[156] The woman's subjection is part of a sadistic ritual whose objective is to produce "esa imagen memorable" (205 [that memorable image (119)] in her mind. In the passage, the immobilized sitter is not about to be photographed in any conventional fashion; rather, it is her mind that becomes the sensitive plate where a horrific, sublime, "memorable" picture will be produced, an image that will be painfully inscribed with the quintessential photographic qualities of precision and permanence.

The inclusion in the novel of a reproduction of the photograph goes beyond the aim of illustrating the text: it is essential to the integrity of *Farabeuf* as a work of art.[157] Word and image cooperate in at least three ways in the construction of meaning and the production of aesthetic effects.

First, the novel can be read as an expanded ekphrasis of the photograph, as some critics have proposed.[158] The actual photograph is the ostensible source of the novel; that is, the text is the verbal unpacking of the image. This cooperative link between verbal and visual representations implies a kind of feedback loop between written text and photograph. The relation is articulated in such a way that the Chinese ideogram, the central written sign that structures the novel, and the photograph of the execution, can each be considered the model for the other: the photograph can be read, as it is in chapter 7, as the "dramatización de un ideograma" (173 ["the performance of an ideogram" (87)] in turn, the ideogram is a diagram of the elements that constitute the photograph.

The second way word and photograph cooperate has to do with the enhanced sense of visuality that they both promote. The pervasive and effective resort to *enargeia* in Elizondo's writing constantly puts "language at the service of vision," and the inclusion of the photograph is a direct appeal to vision.[159]

Third, both word and photograph move toward the same aesthetic goals, namely, the performance of violence and its aftermath: physical and psychic disintegration.

However, while text and image cooperate in the construction of meaning, they are also in competition. The contest between representations is set up in terms of their unassimilable specificities as distinct media. With regard to their forms of reception, the detailed, slow, and often confusing development of the plot stands in sharp contrast to the immediacy through which we perceive the photograph. The disciplined reading required to decode the novel's verbal maze is opposed to the fascinated (and horrified) gaze that appropriates the picture in one swift regard.[160] As text/image, *Farabeuf* repeatedly forces the reader/viewer to switch from one regime of reception to the other. In the face of its unstable verbal structure, the visual representation anchors the elusiveness of the referent, as if the only true certainty we have after reading the novel comes through the photographic image and its power to affect us.

Of the series of four photographs included in Bataille's *Les larmes d'Eros*, Elizondo chose the most dramatic in terms of visual impact, the one that most clearly choreographs the climax of the execution. The glossy, unframed reproduction in the first edition of *Farabeuf* covers the whole page, in an implicit editorial gesture indicating that the image is

on a par—in terms both of size and meaning—with the text proper. The photographic paratext complicates the relation between an image evoked purely by literary means and the actual reproduction included in the book. Rather than letting the reader/viewer reconstruct in her imagination the image rendered through ekphrasis, thus enveloping in a cloak of mystery the source and features of the actual photograph, Elizondo chooses to present the picture up front, endowing it with the privileged status of a shocking icon, impossible to miss. As Linfield points out, there is a common belief that "photographs bring home to us the reality of physical suffering with a literalness and an irrefutability that neither literature nor painting can claim."[161] The visual impact of the photograph is a crucial element in the aesthetics of effects that Elizondo, inspired by Poe and French symbolism, espouses.[162]

Chapter 7 of *Farabeuf* consists of a long ekphrastic passage that describes the photograph in detail. The inclusion of the reproduction in this chapter both reinforces and challenges its ekphrastic version. On the one hand, it lets the reader/viewer analyze closely the description provided by the author and compare it with the object described. The possibility of comparing "on-site" both verbal and visual representations yields a particular interpretive play: the verbal information allows the reader to deepen his understanding of the image, while the visual representation provides the inescapable evidence and the visceral impact lacking in the text. From another perspective, the reproduction is a challenge to its ekphrasis. It shows in all its obscenity the power of the image to affect the viewer beyond the means of verbal rendering. What ekphrasis loses in evocative power is gained by the visual shock produced by the photograph in its "immediate, viscerally emotional connection to the world."[163]

By allowing the reader to look at the iconographic source of the novel, Elizondo brings to the fore an important strategy of his novelistic recontextualization, namely, the possibility of reading a host of meanings into an image that are only virtually present, making the reader gauge the depth and efficacy of the author's elaboration—his attempts to gain, to use Heffernan's phrase, "mastery over the image."[164] The photograph also functions as a lure, a kind of provocation to the reader, echoing the effect the picture produces on the book's characters. It is thus implicated in a series of mirroring effects, most notably when the woman scrutinizes her true identity (114), and where the reader/viewer can also find exposed her own

hypocritical attention, both fascinated and horrified.¹⁶⁵ After all, the text suggests that the execution of the Chinese boxer is a ritual that actively involves the reader/viewer by means of her gaze. As we read in a dialogue of two unnamed interlocutors who speak about watching the execution as a kind of religious ceremony, one of them states that "el rito es nada más que mirarlo" (176) [the ritual merely consists of watching him (91)].

At one point, the ekphrasis of the photograph strives to capture the threshold between life and death that seems to be revealed in the picture. This is one of Elizondo's literary obsessions: the means by which writing can capture the "reality" of death, a topic in which photography has had a stake since its invention.¹⁶⁶ Farabeuf, a real doctor who is transformed into the author of a fictitious book about Chinese torture, is also fictionalized as the photographer of the execution (99). In this way, he visually probes that elusive moment where a living being passes away (99). Farabeuf's photographic practice becomes less a scientific tool or anthropological inquiry than a mystical quest that would uncover a moment of sheer plenitude through pain. The photograph thus represents "la esencia mística de la tortura" ["the mystical essence of torture"]¹⁶⁷: it points to an ideal of transcendence in the face of utter subjection, a sublime experience in the context of total annihilation.¹⁶⁸ This impossible quest leads to (literary) madness. It creates a representational space with no discernible order, a world unhinged where identities shift as in a nightmare or a delirium.

While the verbal and visual representations (the novel's text and the photograph) are the poles of a relation that is both co-operative and conflictual, these two types of representation can also be subsumed within the same interpretive field, one determined by sight. In this sense, verbal (i.e., readable) and visual (i.e., iconic) representations could both be considered in opposition to sensations conveyed by the sense of touch. This category should be expanded to include not only what the fingers can touch and the hands handle, but the sensations conveyed by the skin and even the muscles, and more generally, the body's overall sense of itself, or proprioception.¹⁶⁹ One hallmark of Elizondo's writing is the desire to make the verbal sign incarnate, that is, to make it touchable, a paradoxical impulse insofar as the work of literary art aspires to achieve a physical presence denied by the very specificity of its medium.

The visually precise, finely honed prose of Elizondo in *Farabeuf* leads the reader to picture with vividness the array of objects described. It also

appeals directly to the sense of touch.[170] There are many *effets du réel* that point to a range of tactile sensations, from the tight, disquieting grasp of things (the paws of a tiger or a chimera gripping a metal sphere, the handling of a starfish) to the fleetingness of forms (the writing of the ideogram on a steamed window, a sandcastle destroyed by the tide). Touch is invested throughout the novel with the power to excite, threat, and haunt. The most sinister reference is of course to wounded flesh, be it from amputation, torture, or rape. The children's story that obsesses Elizondo also dramatizes the tensions between sight and touch. The sucking of the thumbs is a temptation that little Conrad cannot resist. In that story, sight becomes the uncanny medium of a superhuman surveillance—a kind of superego tailor-made for children—that catches the boy committing the forbidden act, resulting in a merciless punishment that banishes the tactile by cutting off the thumbs (and emphasizing this absence makes the tactile even more haunting).

In this context, literature and photography both aim to recreate the realm of tactile sensations, as if trying to make concrete what reading a text or looking at a photograph keeps hopelessly virtual, namely, to put the reader/viewer literally in contact with the objects represented. Here photography plays an important role as medium, in a most literal sense: as the material sign that better mediates between the purely imaginary realm, produced by the literary word, and the "actual" or "real" objects that literary writing aspires to make concrete. This mediating role enabled by its concreteness has been pointed out by theorists of photography: Benjamin remarked that photographic reproduction "enables the original to meet the beholder halfway" and Bazin theorized that photography has a stake in both the mimetic illusion of the visual sign and the materiality of the picture itself.[171] This material condition is what allows photographs to stand so easily as substitutes for objects or persons, since they are seen as more or less transparent traces, simulacra or "emanations" of the object itself.[172]

Through the material support that makes it possible, the photograph appeals to touch more directly than the word, since the verbal sign, even if printed, is closer to the abstract auditory sense and the logocentric ontology of the "inner voice." Besides its intrinsic "analogical plenitude" on the plane of representation, a photograph included in a book is itself a thing. Photographs not only can be and are actually retouched, but are "manipulated" in a more literal sense: they have been part of cultural practices

and personal habits that essentially require handling. The malleability, reproducibility, and overall availability of the photographic sign depend on a material condition that makes photographs not only viewable but also touchable things.[173]

Photography becomes a paradigmatic sign through which vision impossibly aspires to embodiment. Applying to the fixed image what Linda Williams says about pornography in cinema, we do not touch the flesh that appears in the photograph, but "our senses 'make sense' of the vision of touch in our own flesh."[174] The aim of bridging the gap between sight and touch is found in much of Elizondo's work. His prose strives to push the limits of the flatness in which writing and reading take place toward a construction of space that evokes a sculptural or volumetric dimension. In this respect, Curley points out that "si *Farabeuf* desmiente la ilusión representativa y dramatiza la distancia infranqueable entre el signo y la realidad que representa, lo hace en busca de lo imposible, es decir, de regresar el signo a su literalidad original, al objeto o a la experiencia que intenta describir" [If *Farabeuf* contradicts the illusion of representation and dramatizes the unbridgeable distance between sign and the reality that it represents, it does so in a quest for the impossible, that is, to return the sign to its original literality, to the object or the experience that it strives to describe].[175] This literary strategy demonstrates a will to overcome the constraints of verbal representation in order to achieve the concreteness of the tactile through the use of intense sensory descriptions. Thus Elizondo's technical interest in *enargeia* results in a sharp prose style (to the detriment of plot development or psychological exploration). As writing strives to evoke spatial depth, Elizondo refers to photographs also in these same terms. In "Teoría mínima del libro," a Mallarméan reflection on the poetics of the book, Elizondo begins by listing some of the elements that are sources of the writer's endeavor:

> ¡Y las fotografías! ¡Qué tenebrosos precipicios se abren ante nosotros a veces con la visión de ciertas fotografías! Los personajes jamás identificados, las miradas cristalizadas sobre la superficie fluctuante y prístina de esas imágenes que nunca sabemos si son de metal o de cristal, de espejo o de luz congelada. (349)

> [And photographs! What gloomy precipices are opened to us sometimes while looking at photographs! The never-identified characters, the crystallized gazes on the fluctuating and pristine surfaces of those images which we cannot tell if they are metal or crystal, mirror or frozen light.]

The term "precipicios" [precipices], dramatized by the adjective "tenebrosos" [gloomy, dark, sinister], stands as fitting metaphor for the wish (and fear) of seeing pictures acquire depth and volume, that is, of bridging the gap between the bidimensional and the tridimensional, as was the case in the stories by Darío and Cortázar. In this sense, the photograph of the Chinese execution, while remaining a surface, points emphatically beyond the plane of the print. Echoing the cuts that pierce the victim in the picture (literally, the surface of his body), the photograph aims to wound the reader/viewer, to pierce the safety of his detached experience, a fitting gesture in a novel whose central topic is wounded flesh.

Given the pre-eminence of the sense of sight in Western culture, many critics have asserted that photography has become an especially important tool in extending the eye's abilities to probe, focus on, and examine an object or event.[176] If sight is "conceived to be the most objective and objectivizing of the senses," as Peter Brooks states, photography has in turn been considered the most objective and objectivizing of our visual technologies.[177] And if, as Brooks argues, "the visual inspection of reality, as the core component of the epistemophilic project, is doomed never to grasp its 'real' object, since that object is imaginary, impossible," photography is the paramount means by which we strive to overcome both the intrinsic limitations of vision and the impossibility of grasping the desired object.[178] In this context we should understand Elizondo's claim that visual representations can be as intense and powerful as the "real" objects or events they depict. His stance points to the abiding power photographic images exert over our mental life. Renowned photographers claim that photography can capture the "essence" of the photographed object.[179] Elizondo brings to its most extreme consequence this possibility of picturing through the photographic medium the "essence"—or its most faithful simulacrum—of a person, action, or event (in Elizondo's case, the apex of physical suffering).

Finally, another important link between sight and touch is the photograph's role as an aphrodisiac for the woman, a condition that points to the connection between sight and the triggering of a bodily—and specifically, sexual—reaction. The photograph not only becomes the vehicle of excitation, but also a visual model that provides directions on how to perform the ambiguous ritual—murder, theater, lovemaking, rape—suggested throughout the novel. Having been aroused by the image, the woman calls on Farabeuf to offer her body in the erotic/sadistic sacrifice that the photograph both anticipates and choreographs (91). This effect highlights the perversely delirious quality of the novel's diegetic universe, since presumably a "normal" reader/viewer would not feel sexually aroused by the photograph, but instead disgusted or horrified.

To conclude, a comparison of *Farabeuf* and "Las babas del diablo" is instructive. Both texts privilege the sense of sight, extended and magnified by the visual technology of photography. At the same time, both appeal to touch and embodiment as the ultimate or true realization of the space promised by vision. However, the gap between sight and touch is never bridged, but rather marked by the violence of fragmentation and disconnectedness, a violence whose power to destabilize is made apparent in the discursive structure of both texts. "Las babas del diablo" and *Farabeuf* are antirealist, experimental texts that challenge the stability of time, plot, and narrative voice. Almost contemporaneous, both employ photography—as practice and image—to open up a demonic space whose destructive energy ruptures the narrative coherence of the text itself. In both, the pervading anxiety has no remission or redemption, leaving the reader guessing about the "true" nature of events, which are felt throughout as sinister.

Given the common assumption of our culture about photography as a medium of realist representation, a photograph of torture makes available to the viewer the actual suffering in a way that cannot be achieved by non-photographic representations. Far from challenging the realist assumption ingrained in photography, Elizondo takes it to its most haunting extreme in order to paradoxically advance an antirealist narrative. His work becomes the impossible project of bridging the gap between regimes of representations. In *Farabeuf*, this impossibility points to the ideal of a mystical revelation that never happens, enmeshed in a text that mimics the violent exasperation of mental confusion.

2

FAMILY PORTRAITS: HORACIO QUIROGA, JUAN RULFO, SILVINA OCAMPO, AND VIRGILIO PINERA

Portraits, family pictures, and photo albums highlight, better than any other use, photography's personal dimension. As visual signs that trigger individual recall and repositories of collective memory, their formal features, social history, and the cultural conventions that underpin them have galvanized the interest of cultural and literary critics as well as art historians.[1] In texts by Horacio Quiroga ("La cámara oscura," 1920), Juan Rulfo (*Pedro Páramo*, 1955), Silvina Ocampo ("Las fotografías," 1959, and "La revelación," 1961) and Virgilio Piñera ("El álbum," 1944), I explore the literary potential of these cultural artifacts. Working within the conventions of family photography, these authors write about the preservation of the dead in the memories of survivors, the visual representation of ideals and aspirations, and the social ceremonies enabled by the act of taking and viewing pictures. The texts I study run the gamut of representational possibilities: while Quiroga writes in technical detail about the moment of taking a photograph and the photochemical process of its becoming, Rulfo, in a telling passage from *Pedro Páramo*, stresses the materiality of the worn-out picture and lets the reader unearth the significance of this symbolic object. Ocampo, in the first of her short stories I analyze, refers to a celebration as the setting for a photographic session gone awry, making use of

77

the trademark cruelty of many of her texts; in the second, she exploits the fantastic dimension of the medium. Finally, Piñera focuses on one of photography's prime moments of reception (the viewing of an album), elaborating an absurdist tale of imprisonment and impotence. In the same way that each family photograph potentially tells a story, these texts point toward the untold narrative hidden behind the images, thus deploying a narrative fold, a latent story within the one in which they are embedded. In their own way, the textual images, rendered mute as all photographs are, invite the reader to fill in the gaps and the critic to engage in an interpretative task. In the texts examined here, photography is used to proclaim the reality of death in a variety of guises. Even if photography seems to channel a strategy for transcending death, ultimately the photographic act seems to collude with, rather than overcome, the drive to annihilation.

Horacio Quiroga

It is fitting to begin this chapter with Horacio Quiroga's short story "La cámara oscura," included in *Los desterrados* (1926), given his pioneering engagement with modern visual technologies. Though not as well known as Quiroga's other short stories, "La cámara oscura" features some of the main concerns of his best known writings: life in the borderlands and the irruption of horror and death in the subtropical landscape of northern Argentina. In "La cámara oscura" Quiroga makes an explicit reference to photography, a technique with which he was well acquainted, in order to deploy the effect of dread he long pursued in his writing. As I will show, the use of the photographic medium can be read as a master metaphor that articulates Quiroga's central literary effect.

Before seriously considering a literary career, Quiroga was drawn to practical pursuits and showed a keen sense of curiosity regarding technology. Beatriz Sarlo sums up Quiroga's inclination for manual labor, experimentation, and modern machines by employing the term "pionerismo técnico," which she identifies as an important sociocultural trend in Argentina and Uruguay at the beginning of the twentieth century.[2] In her essay "Horacio Quiroga y la hipótesis técnico-científica," Sarlo traces the impact of a host of technical inventions on the middle and lower-middle classes and the

ensuing literary adoption of "lo maravilloso técnico," of which photography and cinema were foremost exemplars.[3] Quiroga began practising photography in his late teens.[4] By the 1890s, when new portable cameras and commercial concerns made it easier to market photographic equipment and chemical compounds, a new class of photographer appeared on the social scene.[5] The young Quiroga, like many amateurs around the world, enthusiastically adopted photography chiefly as a practical means of producing and collecting images, without any explicit artistic pretensions (photography had yet to be established as a fine art in its own right). According to his biographers, the subject of Quiroga's first photographs, now lost, consisted of picturesque scenes of the countryside.[6]

Quiroga had a darkroom in his family home, and his biographers explicitly mention the "kodacs" [sic] he owned.[7] The reference to this revolutionary invention proves that Quiroga, coming from a well-off family, was up-to-date on the photographic products and techniques available in Uruguay at the time. He even brought a camera with him on the unfortunate trip to Paris he made when he was twenty-one years old.[8] On his return to South America, his photographic hobby would serve him well. He would owe to this practice, albeit unexpectedly, his encounter with the subtropical forest of Misiones that would become inextricably linked to his literature and authorial image, and where he would settle from 1910 to 1916. Quiroga owed that trip to his closeness to Leopoldo Lugones, the leading *modernista* poet whom he first met in Buenos Aires in 1898. Lugones had been commissioned by the Minister of the Interior to inspect the state of the seventeenth-century buildings erected by the Jesuits in the borderlands of what are today Argentina, Brazil, and Paraguay. In June 1903 he undertook the trip with a small entourage, and after six months, Lugones wrote the administrative report that he would turn into a book—*El imperio jesuítico*—published in 1905. Foreseeing the possible criticism that his text could be read as a picturesque travel guide, Lugones points out in the introduction that he decided to add to the text a few drawings and maps. Only two photographs are included. Rather than featuring the Jesuit ruins or the natural landscape, they are of two wooden statues of saints, examples of the region's arts and crafts. The quality of the glossy, grainy black-and-white images, shown against a neutral background, is poor, and no credit is given to Quiroga for the pictures, in either the prologue or the text itself.

Quiroga was twenty-four years old in 1903 and his literary calling was beginning to emerge. Immersed in French symbolism, he published a novel in 1901, *Los arrecifes de coral*, but his signature themes and style were still to come. He was living with his sister in Buenos Aires, working as a teacher and school inspector. Significant among the reasons that took him to Argentina's capital was his attempt to put behind him the tragic episode of the death of his best friend, Federico Ferrando, whom Quiroga accidentally killed while they were examining a gun. He again met Lugones, with whom he had a close relationship. When he learned about the trip to the ruins, he convinced the poet to include him in the project, since there would be no photographer to document the expedition.[9] The young Quiroga competently performed his task as photographer, though it seems that he was no easy company. Despite his bouts of immaturity, the experience opened up a new horizon, an exciting world of natural beauty, exploration, and risk that would make him buy a plot of land and move to Misiones in 1910.[10]

Photography appears in a short story by Quiroga entitled "El retrato," published in 1910. The text clearly alludes to Poe's "The Oval Portrait," though its subject and development are almost diametrically opposed. Following the conventions of the Gothic novel, Poe's text involves an artist who sucks the life out of his model in order to create an enduring work of art. Quiroga's story relies on the codes of science fiction and decadent *modernismo* to elaborate on the ancient theory of extramission, the projection of rays from the eyes,[11] in order to summon the image of a dead woman and thus produce a photographic portrait. In Poe's short story, life must wither in order to become representation, while in Quiroga's text, the gaze strives to redeem a life already extinguished by magically projecting an image on photosensitized paper.

"La cámara oscura" belongs to a more mature stage of Quiroga's career. The story takes place in San Ignacio Miní, in Misiones, and is told by a first-person narrator-protagonist. It is about Malaquías Sotelo, the justice of the peace who has just returned, quite ill, from a long trip to Buenos Aires. The narrator then elaborates on the "asunto fotográfico" [the photographic affair] around which the story revolves. He decides to pay a visit to Sotelo, but at the very moment he enters Sotelo's hut he realizes that the judge is in the throes of death; the judge then passes away in his presence. Given his photographic expertise, the narrator is asked to take a portrait

02 fig 1: Illustration of the protagonist of "La cámara oscura," resembling Quiroga, in the process of developing a negative.

of Sotelo for the sake of his widow.[12] He complies, and after the burial he locks himself in the darkroom to develop the plate he has exposed. Full of apprehension, he manages to overcome his fears and "resurrects" the man out of the exposed negative. Once the lugubrious photographic scene is over, the narrator leaves the darkroom to wait for morning to break, beholding the lush scenery that surrounds him.

Although "La cámara oscura" lacks the tight structure of other texts by Quiroga, and its blend of technology and horror is not entirely effective, the story makes novel use of the photographic medium. Indeed, it is perhaps the first fictional text in modern Latin American literature that refers to the photochemical development process of a picture, a fact highlighted by an illustration that accompanied the text when it was first published in the magazine *El Hogar* in 1920.

The close links between Quiroga's life and his writing are well known, and the autobiographical elements in "La cámara oscura" are evident, from the natural setting to the social scene referenced in the text.[13] Quiroga's acquantance with the photographic medium is transposed onto the actions of the unnamed narrator, lending credibility to the plot. "La camara oscura" articulates the central theme of Quiroga's storytelling: unexpected death in its many guises.[14] However, it adds a metanarrative level absent from other stories: death is also rendered as representation. The protagonist-narrator has to face death three times, and twice the production of a graphic sign is involved: first, he witnesses the actual death of Sotelo; second, he makes a portrait of the judge before the burial; and third, he develops the plate in the darkroom. From the outset, the narrator confronts with ambivalence the task in which he is involved. He bitterly complains that Sotelo has died in his presence, yet he seems fascinated by the spectacle he has just witnessed. A perverse impulse lies at the root of his attitude toward death, an impulse that makes him gravitate towards horror, instead of fleeing or rejecting it.[15] Oftentimes, as a number of Poe's short stories attest, the perverse stands to harm not only the other but oneself, as if self-punishment is stronger than self-preservation. This same force is at play in "La cámara oscura." The perverse drive that left the narrator transfixed in the shack where Sotelo died is the same that lies at the centre of his photographic impulse. The way he articulates his impression of witnessing Sotelo's death manages to fuse and confuse the fictional plane with actual lived events, in typical Quiroguian fashion. The narrator, trying to verbalize

his morbid experience, says that a dead body is "una materia horriblemente inerte, amarilla y helada, que recuerda horriblemente a alguien que hemos conocido" (678) [a matter horribly inert, yellow and stone cold, that horribly reminds of someone we have known], thus literally channeling the author's well-known uncanny encounters with death.[16]

Despite his avowed resistance, the narrator finally agrees to produce a picture of Sotelo. This practice is one of the most established social uses since the invention of photography: the production of portraits of recently deceased loved ones.[17] However, this last token of remembrance for the sake of Sotelo's family, while constituting the central motive of the plot, will be somewhat forgotten. Instead, the harrowing effect that the photographic act has upon the protagonist is highlighted, shifting the focus from the visual sign as family token to the psychological effect of the photographic technique on the producer of the picture. With the memory of Sotelo still fresh in his mind, the narrator laments that he will have to "verlo de nuevo, enfocarlo y revelarlo en su cámara oscura" (679) [see him again, focus him and develop (or reveal) him in his camera obscura]. Then he goes on to describe in detailed fashion the inert countenance of the man as reflected through the lens of the camera in the very moment of the photographic act:

> bajo el velo negro tuve que empapar mis nervios sobreexcitados en aquella boca entreabierta más negra hacia el fondo más que la muerte misma; en la mandíbula retraída hasta dejar el espacio de un dedo entre ambas dentaduras; en los ojos de vidrio opaco bajo las pestañas como glutinosas e hinchadas; en toda la crispación de aquella brutal caricatura de hombre. (679)

> [under the black cloth I had to soak my overexcited nerves in that half-opened mouth blacker towards the back more than death itself; in the retracted jaw that left the space of a finger between the set of teeth; in the eyes of opaque glass under the eyelashes that looked glutinous and swollen; in all the exasperation of that brutal caricature of man.]

This ekphrastic moment takes place in a spatial and visual threshold: the in-between photographic space that both separates and joins the sitter and his final photographic representation. The action of looking through the viewfinder can be read allegorically, emblematizing the general perspective through which Quiroga articulates the pre-eminent topic of horror. The camera provides the author with a metaphor through which death in all its gruesome, material details is brought into sharper view. The encounter is enhanced by the mention of the black cloth employed by the photographer, an *effet du reél* that further enhances the sense of existential isolation and darkness. The realist elements of the description slip into the morbid as the inert bloatedness of the mouth, jaws, and eyes is emphasized, ending with an overall view of a face that has become a "brutal caricatura," a figure that points to a visual representation of a coarser, degraded order. While there is something forced and unnatural in Quiroga's description with its reference to glassy eyes and swollen eyelashes, it nonetheless effectively conveys the sheer uneasiness the photographer feels while preparing his shot.[18]

The third moment in which the narrator faces death happens following the burial. After some procrastination, he finally gathers the strength to develop the negative. The latent image of Sotelo's face then emerges from the glass plate where it was lodged:

> Lo hice por fin, tal vez a medianoche. No había nada de extraordinario para una situación normal de nervios en calma. Solamente que yo debía revivir al individuo ya enterrado que veía en todas partes; debía enterrarme con él, solos los dos en una apretadísima tiniebla; lo sentí surgir poco a poco ante mis ojos y entreabrir la negra boca bajo mis dedos mojados; tuve que balancearlo en la cubeta para que despertara de bajo tierra y se grabara ante mí en la otra placa sensible de mi horror. (680)

> [I finally did it, perhaps at midnight. There was nothing unusual for a normal situation under calm nerves. But the fact is that I had to revive the person already buried that I saw everywhere; I had to bury me with him, just the two of us in a very tight darkness; I felt him rise slowly before my

eyes and slowly open the black mouth under my wet fingers; I had to balance him on the tray for him to wake up from underground, and to fix him in the other sensitive plate of my horror.]

The narrative situation fits the conventions of the horror story inherited from Poe: it is midnight, the protagonist is alone, and he nervously confronts what he perceives as a looming danger. The scene is ambivalent and, as before, the imp of the perverse makes itself felt. Obsessed by Sotelo's death, or by the persistence of the man's image in his mind, the narrator forces himself to face him yet again. His fear is accompanied by an attraction not devoid of dark erotic undertones ("solos los dos en una apretadísima tiniebla") ["both alone closely pressed together in darkness"] as if an intimate link has been established between them.[19] What follows is the protagonist's description of the technical process that brings to light (and to life) the image of Sotelo, who seems magically resurrected on the glass plate. By gently rocking the negative in the chemical bath, a sense of vulnerability is suggested, as if the image itself were a frail creature, despite the lugubrious circumstance.[20] The slow emergence of the image leaves an impression of dread in the protagonist, as if the plate were a haunted mirror.

The magical properties that theorists of photography often attribute to the medium find in this passage a triple verification; first, when the latent image of Sotelo appears on the glass in slow, awe-inspiring fashion; second, on account of the vicarious coming to life of a dead person; and third, as a magical power that transforms the mind itself into a sensitive plate that registers a traumatic experience, recalling the rhetoric of spirit photography at the end of the nineteenth century.[21] While the photographic process remains unfinished (no paper print is produced, no delivery of a picture of her late husband takes place) the description of the development process is fraught with meaning. The face of Sotelo emerges on the plate beneath the wet fingers, and the first thing revealed by the image is a half-open mouth, as if something speaks, or strives to speak, through the hollow space. This reference stands for the voice, forever lost, of the dead. Mute by its very nature, the photograph of Sotelo (its ekphrastic construction) features this fateful condition by highlighting the mouth's void as the central focus of attention. By picturing the source of silence, it points to

an absence on the plate itself and, metaphorically, of meaning. Unable to utter a word from either the realm of the dead or the frozen negative, the mouth reproduces the silence with which the narrator was greeted when he first encountered Sotelo in the shack moments before he passed away. Then, no conversation took place, no exchange, not even a word of comfort or an expression of surprise. The unbridgeable gap between the living and the dead, between the mute image of a body and the speaking soul of the living, finds its graphic representation in the black space of the half-open mouth. In the contest between verbal and visual representations, the image of that gap overpowers any wish or hope to speak to, or with, the departed.[22]

It is worth pointing out the ekphrastic fear that underpins the scene. This fear is triggered by the power of the photographic image to enhance whatever it depicts, to the point that photographic illusionism can create a more powerful impression than the raw experience of the "real" itself. As in Elizondo, the photograph points to a kind of hyperreality, a visual sign that fixes an essence. In Quiroga's story, the hyperreal portrait enhances the demonic or phantasmatic aspect of the medium. In this sense, a photograph may succeed in fixing (as well as triggering) a traumatic experience in a way that may elude the actual perception of purported "facts." In the demonic space that photography conjures, Malaquías Sotelo comes to life and dies again even more poignantly in the image that captures him and that is offered to the fascinated gaze of the protagonist (and by extension, the reader).

Carlos Alonso has identified a recurring structure in many of Quiroga's short stories, namely, a gap between Quiroga's avowed theoretical approach to the short story and his literary praxis. In Alonso's words, "the rhetorical economy that supposedly should be centred on the conclusion is adulterated by the addition of a supplement, a kind of coda that is appended at the end before the closing of the narrative."[23] "La cámara oscura" fits neatly into this pattern. The text ends not at the high point in which horror makes its appearance in the darkroom, but with the protagonist leaving that haunted space and waiting for a new beginning. The ending can also be read allegorically, as if the narrator has found, on the brink of the abyss, a redemptive light. Redemption is a key element of Quiroga's ideological outlook. Understood as an existential rather than a religious notion, it is something his characters tragically strive for, though they fall prey to the

implacable force of fate or nature. There is no redemption for Malaquías Sotelo, not even in the virtual space of photographic representation where his effigy would live on. The protagonist, however, finds a way out of the dark hall of mirrors of the darkroom where he has found himself trapped. There is, it seems, a light at the end of the darkroom. Having developed the negative, the protagonist emerges to contemplate the forest, waiting for morning to break:

> Al salir afuera, la noche libre me dio la impresión de un amanecer cargado de motivos de vida y de esperanzas que había olvidado. A dos pasos de mí, los bananos cargados de flores dejaban caer sobre la tierra las gotas de sus grandes hojas pesadas de humedad. Más lejos, tras el puente, la mandioca ardida se erguía por fin erectil, perlada de rocío. Más allá aún, por el valle que descendía hasta el río, una vaga niebla envolvía la plantación de yerba, se alzaba sobre el bosque, para confundirse allá abajo con los espesos vapores que ascendían del Paraná tibio.
>
> Todo esto me era bien conocido, pues era mi vida real. Y caminando de un lado a otro, esperé tranquilo el día para recomenzarla. (680)

> [When I went outside, the open night gave me the impression of a sunrise full of motives of life and hopes that I had forgotten. Two steps away, the banana trees loaded with flowers dropped on the earth drops from their big leaves, heavy with moisture. Further, behind the bridge, the burnt mandioca tree finally stood still, beaded with dew. Further still, by the valley leading down to the river, a hazy fog enveloped the *yerba* plantation, towered over the forest and it blended down there with thick vapors that rose from the warm Paraná.
>
> All this was well known to me, as it was my real life. And walking from one side to another, I waited calmly for the day to break to start it anew.]

The conclusion posits nature as a redemptive space, but not in terms of a transcendent, mystical, or utopian space of universal harmony.[24] The

recurring motif of water in the passage not only describes the tropical environment, but connotes in its sheer materiality the dynamic that underpins nature's works, as if the natural world were suffused in sweat—both a visible and tangible testimony to its labours. The same applies to man. For Quiroga, who was not only a writer but also a pioneer and manual worker, redemption comes from hard labour in a constant struggle against a harsh environment. In the 1920 short story "Tacuara Mansión," Quiroga refers to the "epopeyas de trabajo o de carácter, si no de sangre" (646) [the heroic deeds of labour or temperament] of his fellow *desterrados* in the jungle of Misiones. That is the "real" life alluded to at the end of "La cámara oscura," where nature becomes not only the stage for survival and physical effort, but also the site where the haunted space of representation itself can be overcome. It is no coincidence that the protagonist not only possesses a photographic camera, but also carries at the beginning of the text "[una] azada al hombro" (677) [a hoe on his shoulder], in reference to his agricultural tasks. In the funereal context of the story, photography is a procedure that strives to overcome death by fixing the remains of life. Against the grain of the literary effect of horror it is supposed to produce, the story's ending outlines the hope of redemption beyond the fixation of the photographic act.

Juan Rulfo

Like Quiroga, Juan Rulfo was drawn not only to death in his writing, but to photography as a hobby. This aspect of his career has come to the fore since 1980, with the exhibition and publication of his pictures as part of a national homage to his life and work. His visual production has gained widespread attention. On a par with their aesthetic quality, his photographs have elicited an interest well suited to the austere and elusive nature of Rulfo's literary work and authorial image.[25]

Much like the protagonist of "La cámara oscura," Juan Preciado, a central character of *Pedro Páramo*, is in search of a sort of personal redemption. In Preciado's case, it concerns his mother, who has left behind a portrait of herself as a portable token of survival that will throw an unexpected light onto his quest. In this section, I show how this ekphrastically

constructed image can be read as a central emblem of Rulfo's novel, one that revolves around the idea of emptiness. I argue that the passage describing the portrait offers a productive example of the intersections between narrative and visual imagery: while photography is rendered in literary terms, the literary description introduces as a central issue the representational power and materiality of the photographic image. I also argue that a close reading of this "textual photograph" offers new insights into the cultural context and the contested regimes of representation it masks or takes for granted. Thus understood, photography plays a privileged role in literature as an interpretive tool that reveals practices specific to a given visual culture.[26]

In what follows, I provide a close reading and contextual interpretation of this passage and show its emblematic nature and overall significance in Rulfo's work. Related by Juan Preciado, it reads as follows:

> Sentí el retrato de mi madre guardado en la bolsa de la camisa, calentándome el corazón, como si ella también sudara. Era un retrato viejo, carcomido en los bordes; pero fue el único que conocí de ella. Me lo había encontrado en el armario de la cocina, dentro de una cazuela llena de hierbas; hojas de toronjil, flores de castilla, ramas de ruda. Desde entonces lo guardé. Era el único. Mi madre siempre fue enemiga de retratarse. Decía que los retratos eran cosa de brujería. Y así parecía ser; porque el suyo estaba lleno de agujeros como de aguja, y en dirección del corazón tenía uno muy grande donde bien podía caber el dedo del corazón. (68)

> [The picture of my mother I was carrying in my pocket felt hot against my heart, as if she herself were sweating. It was an old photograph, worn around the edges, but it was the only one I had ever seen of her. I had found it in the kitchen safe, inside a clay pot filled with herbs: dried lemon balm, castilla blossoms, sprigs of rue. I had kept it with me ever since. It was all I had. My mother always hated having her picture taken. She said photographs were a tool of witchcraft. And that may have been so, because hers was riddled with pinpricks, and at

the location of the heart there was a hole you could stick to your middle finger through. (16)]²⁷

Juan Preciado recalls the photograph on his way to Comala while walking alongside Abundio, the muleteer. The encounter with Abundio represents a critical moment, a threshold between the point of departure for Juan Preciado, which remains unknown to the reader, and the upcoming events at Comala, a town deserted yet teeming with the voices and whispers of departed souls. If one of the clearest remnants of the *regionalista* novel in *Pedro Páramo* is its willful shunning of the signs of modernization and urbanization sweeping countries like Mexico at the beginning of the twentieth century, the photograph of the mother is a token that signifies urban progress and technological modernity. By carrying a photograph to Comala, Juan Preciado brings with him a distinct specimen of a visual culture that is foreign to the town. The picture introduces a new economy of representations in a place where not even "traditional" visual media like painting or engraving seem to have any role.

The portrait functions as a reminder of the reason for Juan Preciado's pilgrimage. After all, it is his mother, Dolores Preciado, who lured him, through her memories as well as her bitterness, back to his hometown to claim what Pedro Páramo owed them. The photograph, as a material sign in Juan's possession, can also be interpreted as his inheritance from his mother. It is a gift fraught with irony, insofar as it is the only (visible) property that Dolores endows her son. As Juan Preciado explains in the next paragraph, the photograph is meant to be used as a link between himself, his mother, and his father—the portrait "es el mismo que traigo aquí, pensando que podría dar buen resultado para que mi padre me reconociera" (68) [I had brought the photograph with me, thinking it might help my father recognize who I was (16)]—as if the mimetic power of the image (the resemblance between mother and son) signalled a deeper familial bond that should also link him with Pedro Páramo.²⁸ The portrait as symbolic property substitutes metonymically for the mother herself. As Colina has put forward, in his fateful return to Comala Juan Preciado is looking for his mother as much as his father:

> La obsesión del hijo parece ser, más que ese hombre tan lejano que resulta casi abstracto, la misma madre, y se diría

que el viaje a Comala, después de la muerte de ésta, responde al deseo de encontrar la imagen viva de ella y de reunirse con su pasado. Del mismo modo que otros llevan al pecho la imagen de la Virgen o la de la mujer amada, Juan Preciado lleva el retrato de su madre. . . . Este amor de Juan Preciado por su madre, toma la forma de una identificación. (55–56) [29]

[The son's obsession seems directed, more to that distant man that becomes almost abstract, to the mother. It could be said that the trip to Comala, after her death, is motivated by the desire to find her living image and join her past. Similarly as others wear on their chest the image of the Virgin or a beloved woman, Juan Preciado carries the portrait of her mother. This love of Juan Preciado for his mother takes the shape of identification.]

The photograph is a prophetic sign, or to borrow the title of Elena Garro's novel, "un recuerdo del porvenir" [a memory from the future], a fatalistic emblem of things to come. It foreshadows the realm of the dead that Juan Preciado is about to enter. It shows, in the words of Barthes, "that rather terrible thing which is there in every photograph: the return of the dead."[30] This is one of the central concerns of the novel.

The photograph of the mother, nestled in Juan's shirt pocket, is also a guiding spiritual light that he, echoing his mother's apprehension of witchcraft, places close to his heart. The mother's portrait makes itself felt immediately after Juan asks Abundio who Pedro Páramo is. In one of the key moments of the novel, Abundio answers in lapidary fashion that Páramo is "un rencor vivo" [living bile (literally: a living rancour)]. In this context, Juan Preciado's act of recalling the presence of the photograph in his pocket functions as an amulet, a symbolic shield or protective device against the destructive force of hate and resentment.[31]

However, the photograph will soon prove ineffectual. This is particularly clear in the way the regimes of perception are deployed in the novel. *Pedro Páramo* features a clash between visual and auditory perceptions, in which the former overpower the latter. At the beginning of the novel, before arriving in Comala, Juan Preciado points out that "Yo imaginaba ver aquello a través de los recuerdos de mi madre; de su nostalgia, entre

retazos de suspiros. Siempre vivió ella suspirando por Comala, por el retorno; pero jamás volvió. Ahora yo vengo en su lugar. Traigo los ojos con que ella miró esas cosas, porque me dio sus ojos para ver." (66) [I had expected to see the town of my mother's memories, of her nostalgia—nostalgia laced with sighs. She had lived her lifetime sighing about Comala, about going back. But she never had. Now I had come in her place. I was seeing things through her eyes, as she had seen them. She had given me her eyes to see. (12–15)] Even if Juan Preciado returns to his native land ready to perceive it through the melancholic gaze of his mother, it is soon evident that there is little to see in town. The novel makes abundantly clear, as many critics have pointed out, that the phantasmagoric universe of Comala is populated by sounds, rumors, echoes, and silences.[32] Sounds prevail over sights. As Juan Preciado declares from beyond the grave, he himself has fallen prey to the power of sound: "Me mataron los murmullos" [The murmuring killed me]. The abstract, mysterious atmosphere that envelops the sense of hearing—typical of oral cultures, according to media critic Walter Ong[33]—overwhelms the concrete precision afforded by the dissecting eye. In this sense, the photograph becomes a useless token in a realm where visual perception is relegated to a secondary role.

The photograph as amulet, at the same time magical and sentimental, is related to religious imagery.[34] Carlos Monsiváis refers to the cultural weight of religious images on the collective imagination of the Mexican people in these terms: "el mínimo utensilio del culto, la estampita piadosa, termina por ser el compendio de la instrucción y la comprensión religiosas. Muros, láminas, maderas y papeles hacen las veces de paños de la Verónica" (124) [the minimal tool of worship, the pious holy card, ends up as the compendium of religious instruction and understanding. Walls, prints, wooden boards, and papers pass as Veronica's cloths]. Monsiváis also links one of the features of modernity (the mechanical reproduction of images) to the context of religious practice: "A las obras candorosas y de carácter único, las substituye la producción industrial de objetos de culto. . . . Son los cromos baratos y enceguecedores, las medallas que se acuñan por millones, las pequeñas esculturas." (126) [Naive and unique works are substituted by the industrial production of ritual objects. . . . They are the cheap, bright cards, the medals coined by the millions, the small sculptures.] In this sense, the photograph of Dolores, read as a protective shield,

achieves a seemingly unlikely conflation, that of the religious icon and the mass-produced image.

It is worth noting that we neither see nor read of any of the features of the mother's face depicted in the photograph. Ellipsis, the central strategy in Rulfo's rhetoric, leaves its mark in this most minimal of ekphrasis, as in many other descriptions in the novel. As the author himself has pointed out, "las gentes de *Pedro Páramo* no tienen cara y sólo por sus palabras se adivina lo que fueron" [people in *Pedro Páramo* are faceless and only through their words do we guess who they were].[35] However, even if this is clearly the case with the features of Dolores elided in her portrait, perhaps on a symbolic level the photograph is indeed a truthful picture of the mother, as if the effaced image captures more faithfully her inner being after years of eroding abandonment and resentment. While no features of the sitter are mentioned, we learn plenty about the accidents that affect the picture's material support. The little holes that pierce the portrait could be read as a representation of the mother's pain, and a clear enough sign that the mother's fear of black magic was not entirely unfounded. The photograph not only wounds, but is itself wounded, as if it represented in its own skin the *punctum* that Barthes elaborates in *Camera Lucida*.[36] It is not only for this reason that the photograph of the mother brings to mind this most cited text of modern photographic theory. *Camera Lucida* is a text explicitly written around photographic images of the author's mother. In both Rulfo and Barthes, the text grows out of a melancholic moment. In the case of the French critic, the most important photograph of the mother, the one that captures her truth, a picture of his mother-as-child, is purposefully excluded from the illustrated volume as a sign of respect for the utter privacy of remembrance, his intensely personal *punctum*.[37] In Rulfo's textually constructed photograph, the features of the mother are also purposefully omitted. After its brief appearance in the diegesis, the photograph itself will disappear from sight in the whirlwind of events that will befall Juan Preciado.[38]

Not only is the portrait punctured with needle holes but, most significantly, there is a hole in the place of the heart, an ominous harbinger of the desolation Juan Preciado is about to experience first-hand. It would seem that the portrait warms Juan Preciado's heart on his way to Comala, as if the symbolic temperature of the picture has increased the heat of an already hot day. But the heart, or its absence, becomes a symbol

of deprivation. The missing heart can be seen as the negative image of the Sacred Heart of Jesus, a symbol of Christ's enduring love. There are a couple of references in the novel to this particular Catholic devotion.[39] The Sacred Heart reflects the underlying popular religiosity in *Pedro Páramo* as well as an actual devotional practice that is quite extensive in Central Mexico. As is well known, Rulfo, essentially a non-religious man, was raised in southern Jalisco, a breeding ground for militant Catholicism during the Cristero rebellion in the late 1920s. With this in mind, critics such as Monsiváis and Villoro consider the dysfunctional religiosity of the Catholic Church as the background to the misery that afflicts Comala. For Villoro in particular, "Rulfo se adentra en el totalitarismo de la religión y registra los numerosos remedios de la Iglesia católica como renovadas formas del sufrimiento" [Rulfo delves into the totalitarianism of religion and records the many remedies of the Catholic Church as renewed forms of suffering] (413). Rulfo himself thought that the characters of *Pedro Páramo* have been emptied of their faith: "aunque siguen siendo creyentes, en realidad su fe está deshabitada" [though they are still believers, in truth their faith has been emptied].[40] In this respect, the hole in the mother's portrait summarizes in a fitting image the relentlessly heartless world that the characters of the novel inhabit, from Pedro Páramo's impossible love for Susana San Juan to Susana herself, who lost her mind after her hope of fulfilling her love for Florencio was dashed. Father Rentería, Miguel Páramo, and the crazy Dorotea, each suffering his or her own peculiar drama, live their lives with a central emotional lack.

An important reference to the symbolic weight of the heart in Rulfo's writing can be found in his letters to Clara Aparicio, his fiancée and, later, wife, written between 1944 and 1950, published under the title *Aire de las colinas*. They belong to a crucial period in Rulfo's personal and artistic development, when his first literary endeavors were bearing fruit and just before the publication of his two major works. The letters expose Rulfo under a raw light, producing a picture of a man that is far from the mythic image of detachment he will later embody. They show a young adult musing, with an extreme sense of propriety, over his daily travails, sentimental needs, and existential anguish. The correspondence displays an imaginary plenitude of feeling for which Rulfo constantly yearns, a state of being that *Pedro Páramo* will relentlessly negate. It is not a matter here of uncritically bridging the gap between life and work, biographical event and literary

text, but rather to suggest a common thread that links Rulfo's textual production in his personal letters with his canonical novel. Beyond the circumstantial situations conveyed in the letters, a signifier is repeated time and again (as many critics have pointed out, repetition is a discursive trait central to Rulfo's textual strategies). This signifier is the heart, a reference that throws an indirect but revealing light upon the missing heart in the portrait of Juan Preciado's mother.

In his letters, Rulfo's peculiar, sometimes unsophisticated style transfigures the object of his love. A common device is the use of the third person instead of the second when he refers to Clara. Rulfo often addresses her as "ella," as if even the use of the polite "usted" does not convey enough distance. Sometimes in the same paragraph, Clara is both herself and another person. Writing melancholically from the capital city, Rulfo makes explicit the figure he projects onto Clara, namely, his own mother. In letter 4, dated 10 January 1945, we read:

> Clara, mi madre murió hace 15 años; desde entonces, el único parecido que le he encontrado con ella es Clara Aparicio, alguien a quien tu conoces, por lo cual vuelvo a suplicarte le digas me perdone si la quiero como la quiero y lo difícil que es para mí vivir sin ese cariño que tiene ella guardado en su corazón.
>
> Mi madre se llamaba María Vizcaino y estaba llena de bondad, tanta, que su corazón no resistió aquella carga y reventó.
>
> No, no es fácil querer mucho.[41]

> [Clara, my mother died 15 years ago. Since then, the only person in whom I find a resemblance to her is Clara Aparicio, someone who you know. That's why I again beg you to tell her to forgive me if I love her the way I love her, and how hard it is for me to live without that affection she harbours in her heart.
>
> My mother was called María Vizcaino and she was full of kindness, so much of it, that her heart did not resist that burden and burst.
>
> No, it is not easy to love a lot.]

As the letters show, the memory of the absent mother and the image of the heart as a yearning for love converge in the figure of Clara.[42] A close reading reveals the heart as a motif that is often evident in Rulfo's emotions and attitudes. It is more than a conventional symbol of affection: the heart acquires a life of its own, becoming an idiosyncratic discursive formation, a cluster of personal signification around which many letters revolve. A passage in letter 72 (21 August 1949) sums up the deep emotions and unconscious resonance that Rulfo attributes to the heart. Addressing Clara as "muy querida madrecita" [very dear little mother], he writes: "Mi mejor apoyo es tu corazón; solamente allí me siento hombre vivo" (284) [My best support is your heart: only there I feel a living man].

The remark is telling, because in the passage about the mother's photograph, in *Pedro Páramo*, Rulfo produces a complete reversal of that statement: rather than the existential comfort the heart provides, Juan Preciado will experience a complete lack of emotional support. As though the image of the mother cannot fulfill any fortifying role, the life of the son will give way, plunging him into the realm of the dead.

The mother's photograph is not only a visual sign but a tactile one. By stressing the wear and tear on its surface, Rulfo highlights the materiality of the picture as well as its power, stemming from the popular belief around magical resemblance. Perhaps there is something obscene in Juan Preciado's remark that his middle finger—literally, "el dedo del corazón"—would fit in the large orifice of the photograph of his mother.[43] As with the little holes that pierce the picture, the reference stresses the materiality of the sign, but this time in order to overcome the gap between visual and tactile perceptions. The act of touching a photograph as if one wanted to get closer to someone always implies a paradoxical situation. Both a sign of desire and its defeat, touching a picture is an attempt to achieve an encounter with the other that is hindered by its very performance.

The perforated photograph belongs to the broader topic of the void in Rulfo's literary universe. The notional ekphrasis employed by the author makes the material support of the photograph an explicitly virtual or empty reality. In general, holes, as well as ruins, connote destruction, emptiness, and deprivation. *Pedro Páramo* offers many examples of these figures of negativity. To begin with, Comala is situated "en la mera boca del infierno" (67) [on the coals of the earth (16)]. As Bradu points out, this void has an ambiguous character, at the same time deadly and teeming

with activity.⁴⁴ The same could be said of Comala's own physical reality as described by Damiana Cisneros, who speaks to Juan from beyond the grave: "Este pueblo está lleno de ecos . . . tal parece que estuvieran encerrados en el hueco de las paredes o debajo de las piedras." (101) [This town is filled with echoes. It's like they were trapped behind the walls, or beneath the cobblestones.] Comala is a void in itself: it has been emptied of living beings and, like so many Mexican towns, ravaged by the upheavals of social violence and migration. Sometimes holes are nesting grounds, such as the graves from which the characters in the novel carry out their disembodied conversations. Sometimes they are nested one inside the other, as when Susana San Juan's traumatic descent into the mine shaft yields only a crumbling skull in her hands. Similarly, the broken relation between Donis and her sister is punctuated by the half-open roof of their miserable hut. Rulfo's narrative technique constructs a story full of empty spaces, and the lives of the main protagonists revolve around a central void that becomes impossible to repair. The crevice, the gap, and the hollow space are images with which critics describe the dominant structures of Rulfo's world. For Villoro, who considers that the desert is the location of Rulfo's literary dramas, the Mexican author "trabaja en una zona vacía" [works in an empty zone].⁴⁵ In a similar vein, Franco and Ortega have found in the void a useful image that ultimately explains the dysfunctional interactions among the moral, social, and spiritual contexts of the novel.⁴⁶ The empty spaces that fragment the story are central elements of its narrative structure. Their effects on the reader work by omission. Rulfo himself signalled that he expected the reader to fill those spaces (literally: "llenar esos vacíos").⁴⁷ Bradu writes that "Los blancos que separan los fragmentos son esto: puertas abiertas, rellenos de nada: marcan la transicion por su negación" [the blanks that divide the fragments are this: open doors, filled with nothing: they mark the transition by its negation].⁴⁸

From a biographical perspective, Rulfo's life and public persona also contain a number of holes. One example is his reluctance to acknowledge that, after his stay at the orphanage "Luis Silva," he had gone to a seminary in Guadalajara, where he stayed between 1933 and 1936.⁴⁹ According to Munguía Cárdenas, the reason for Rulfo's silence is that his uncle, David Pérez Rulfo, then a captain in the army and aware that the government was hostile to anything Catholic, made clear to his nephew the need to avoid any reference to his years in the seminary. This silence lasted all

of Rulfo's life. As Antonio Alatorre points out, "Juan se las ingenió para convertir dos años de su vida en un vacío perfecto, en un cero" (48) [Juan managed to turn two years of his life into a perfect void, a zero]. Habra acknowledges the importance of empty spaces in the existential quest of Juan Preciado. At the end of her essay, she interprets that quest in national terms, in a move that has become typical in the critical literature on Rulfo: "A partir de este acercamiento fragmentado a sus orígenes y al autoconocimiento, se puede extrapolar que el texto constituye un comentario existencial sobre la búsqueda continua de la identidad del mexicano." [From this fragmented approach to his origins and self-knowledge, it is possible to extrapolate that the text becomes an existential commentary about the constant search for the Mexican's identity.][50] While this interpretation is certainly valid, it could be argued that in Rulfo's world, the concept of the void is so fundamental that it ultimately trumps any socio-cultural interpretive frame, as if constructs such as the idea of national identity also fall prey to the all-encompassing emptiness.

To conclude, a significant anecdote shows how Rulfo was drawn to emptiness at an early age. The episode links the condition of being an orphan to the writing of the void.[51] Quoted by Elena Poniatowska, Rulfo mentions that "Mi padre murió cuando tenía yo seis años, mi madre cuando tenía ocho. Cuando mis padres murieron yo sólo hacia puros ceros, puras bolitas en el cuaderno escolar, puros ceros escribía." (51) [My father died when I was six years old, my mother when I was eight. When my parents died I only drew zeroes, only little circles in the school notebook, I wrote only zeroes.] In terms of textual evidence, Rulfo's act multiplies the anxiogenic emptiness that it is meant to overcome. It traces the figure of an unspeakable anguish with a poignant poetry that is at the core of his imaginary world. In this sense, the photograph of the mother—in its stillness, its wounded condition, its empty heart—becomes the emblem *par excellence* that encapsulates Rulfo's most meaningful writing.

Silvina Ocampo

While it is tempting to interpret the fictional writings of Silvina Ocampo from the perspective of the fantastic, a literary rubric that has proven so

productive in Argentine letters,⁵² her work does not easily fit into conventional categories. Even if her prose lacks the metaphysical architecture of Borges, the elliptical constructions of Bioy Casares, or the sinister symmetries of Cortázar, it nonetheless explores in original ways the play of female narrative voices, the shades of uncertainty and ambivalence, and the presence of disquieting objects and events in the everyday. Visual arts and media are recurring topics in her work. Besides her narrative fiction and poetry, Ocampo devoted herself from a young age to drawing and painting, and even studying briefly in Europe under the avant-garde artists Giorgio de Chirico and Fernand Léger.⁵³

In this section I analyze Silvina Ocampo's engagement with photography. The two short stories I examine belong to a fruitful period in her career: "Las fotografías," from *La furia y otros cuentos* (1959), and "La revelación," from *Las invitadas* (1961).⁵⁴ As with Elizondo, Quiroga, and Rulfo, links between photographic representation and death are paramount in her work. Resorting to ambiguity, as well as to an undercurrent of cruelty and pain that has been recognized as a hallmark of her writing, Ocampo aims to transgress both the social conventions and the representational codes of photography.⁵⁵ While Quiroga and Rulfo use the portrait as an emblem, a sign of identification loaded with meaning, Ocampo introduces a different register: the ritualized scene in which a series of family photographs are taken as the preliminary step to assembling that domestic token of collective identity, the photographic album. Disregarding photography as a realist document, she explores some of its dark facets.

For Ocampo, to take a picture is to hinder and interrupt: it is a disquieting event, even an act of violent intervention. In this context it is not purely anecdotal to mention that Ocampo, known for her reserve and shyness, did not like to be photographed. Her personal resistance to photography can be seen in full display in the book *Retratos y autorretratos*, published in 1973 by Argentine photographers Sara Facio and Alicia D'Amico. The volume is an album of the major Latin American writers of the day, from established masters such as Borges, Paz, and Neruda to the emerging writers of the literary "Boom" and others. It features, alongside each portrait, a brief text penned by that author. Silvina's portrait is certainly unusual: dressed in black, she is seated on the floor in a tense posture, her right arm extended toward the camera in a way that her palm covers the visual field of her face, making it unrecognizable.⁵⁶ By capturing

what appears to be a sudden gesture, the picture has the feel of a snapshot, a spontaneous statement of rejection, in stark opposition to a carefully posed scene. It is taken from a slightly downward angle, suggesting the power of the photographer over the sitter, who in turn defends herself by blocking the view. As presented to the reader, this portrait of sorts is ambiguous, as if the photographer (and the editor) has colluded in taking, selecting, and publishing an image that does not adhere to the conventions of standard portraiture.

The text that accompanies the picture is a long poem entitled "La cara," in which Ocampo meditates on the condition (and the awareness) of having a face, an exteriority both essentially hers and nonetheless alien.[57] Subjected to the equivocal images of mirrors and other surfaces, the face both recognizes and misrecognizes itself in its reflections and photographic portraits, to which the poem devotes a series of detailed descriptions. The poetic composition becomes thus a textual album that gathers, in its chain of brief ekphrases, the vicissitudes of a face during a lifetime. At the end of the poem, the face, protagonist of so many reflections, is the site of an antagonism where the self does not quite find itself.[58] It is interesting to compare the distance and reticence that both portrait and poem express, with the testimony contained in another book by Sara Facio, in which this photographer continued and updated her project of taking pictures of the Latin American literary establishment. In *Foto de escritor 1963/1973*, Facio acknowledges Ocampo's interest in matters of photographic technique but reiterates her resistance to being photographed, an attitude that Facio specifically calls "fotofobia" [photophobia].[59]

In "Las fotografías," photophobia becomes something close to photocide. Ocampo reinterprets the social ritual of the family party and its photographic commemoration in an ironic and even sarcastic light.[60] The plot of "Las fotografías" deals with a double celebration around Adriana, a disabled girl whose fourteenth birthday coincides with her recent release from the hospital after a long stay (the narrator alludes to an accident, while it is also mentioned that the girl has become paralyzed). The day is hot, and after a chaotic photographic session around the young girl, fatality strikes: a guest finds Adriana dead in her basket chair.

"Las fotografías" is a paradigmatic story within the body of Ocampo's work. It articulates one of her preferred subjects: cruelty in childhood (and by children). Also recurring is the use of a female narrator whose point

02 FIG 2: Portrait of Silvina Ocampo by Alicia D'Amico (1963). Courtesy of Alicia Sanguinetti and the Estate of Alicia D'Amico.

of view is conspicuously biased. This figure (which Matamoro, analyzing Ocampo's work in terms of social class, deems "la nena terrible" [the terrible little girl]) exposes and most often embodies furtive sadism as an undercurrent of the plot. Stories like "Las fotografías," Klingenberg argues, "set up a disjuncture between the 'voice' and the pathos of the events narrated, implying . . . that the narrators are somehow unable to understand fully either the tragic proportions of events or their own complicity in them."[61] The unnamed narrator constantly trashes a party's attendee—"la desgraciada de Humberta"—and jealously craves an introduction to a certain blond young man. Her selfish narrow-mindedness and indifference to the unfolding events perhaps point to a collective state that may explain the tragedy, because Adriana dies in the midst of the party's din, as she is carried from here to there in order to pose for the pictures. No one seems to notice her predicament.

The dominant trope of the story is irony, by which things become their opposite: joy is transformed into sadness, the party turns out to be a funeral. The photographer—whose name is Spirito—is in fact not a life-giving spirit, but an agent that brings about misfortune. The solemn moment that is supposed to commemorate a personal landmark (a birthday, the release from hospital) becomes an oppressive imposition that leads to suffering. Ambiguity is at play, too, because the ultimate cause of Adriana's death is not apparent.

If parties are the occasion of *carpe diem*, photographs have been read as *memento mori*.[62] In Ocampo's version, they become something more than reminders of death, more than registers of that which will never be again while projecting the shadow of its disappearance over the present: photographs actually bring about death. From the outset, photography is seen as a tool that hinders action, since the guests have to wait for the arrival of the photographer before eating from the buffet. Photography is thus a restraint, an impediment to the fulfillment of desire. It stands in the way of the party itself. The photographic session includes nine sittings, and its description accounts for the bulk of the narration. Reiterating the idea of photography as a medium that fragments and interrupts, the taking of photographs is tinged with the idea (and the threat) of cutting and slicing.[63] Spirito is a sort of modern-day Procrustes, as we read in the following dialogue in which everybody gives an opinion as to how best to place Adriana in front of the camera:

– Tendría que ponerse de pie – dijeron los invitados.

La tía objetó:

– Y si los pies salen mal.

– No se aflija – respondió el amable Spirito – , si quedan mal, después se los corto. (220)

["She should stand up," the guests said.

An aunt objected: "And if her feet come out wrong?"

"Don't worry," responded the friendly Spirito. "If her feet come out wrong I'll cut them off later."][64]

The supreme act of interruption will be, of course, Adriana's death. The story anticipates the tragic outcome through a number of seemingly trivial references.[65] At the beginning of the party, the narrator mentions that "aquella vocación por la desdicha que yo había descubierto en ella [Adriana] mucho antes del accidente, no se notaba en su rostro" (219) [That vocation for misfortune which I had discovered in her long before the accident was not evident in her face (25)]. The observation colours the profile of the unfortunate Adriana and announces her imminent demise. Even more important, the birds that appear repeatedly in the story function as premonitory signs. As traditional symbols of lightness, flight, and liberty, they serve as a foil to the immobile Adriana, as well as to the fixing power of photography, not unlike what happens in "Las babas del diablo." Further, the act of photographing the paralyzed girl functions as a rivet, as the fixing of something already fixed. There are three references to birds, and each represents and prefigures the upcoming disaster. In the first one, the children, hungry and impatient for the photographer to arrive, begin a game: "Para hacernos reir, Albina Renato bailó *La muerte del Cisne*. Estudia bailes clásicos, pero bailaba en broma." (219) [To make us laugh, Albina Renato danced "The Dying Swan." She studies classical ballet, but danced in a spirit of fun. (26)] The reference to ballet, a highbrow art,

places the story within the context of the upper social class familiar to Ocampo. The piece, whose image "is possibly the most ubiquitous in the history of ballet," after Camille Saint-Saens's *Le Carnaval des Animaux*, was made famous by Anna Pavlova at the beginning of the twentieth century.[66] The kids, inadvertently but no less poignantly, make fun of a lofty cultural icon.[67] Their joke foreshadows Adriana's death and perfectly encapsulate that blend of innocence, dark humour, suffering, and intuition of (some) children that constantly surfaces in Ocampo's literary universe.

The second reference to birds involves Spirito. Amid the noisy and asphyxiating environment, he prepares the sitters for the imminent photographic shot:

> Con santa paciencia, Spirito repitió la consabida amenaza:
>
> – Ahora va a salir un pajarito.
>
> Encendió las lámparas y sacó la quinta fotografía, que terminó en un trueno de aplausos. (220–21)
>
> [Patiently, Spirito repeated the well-known command: "Watch the birdie."
>
> He turned on the lamps and took the fifth photograph, which ended in a thunder of applause. (27)]

The word "amenaza" (literally "threat") does not quite describe what photographers actually say before pressing the shutter (it is rather a notice or warning). The word "amenaza" adds danger to an act that imposes a degree of control, but which is ultimately harmless. This choice of word again colours the scene with a tone of anticipated pain. The "pajarito que va a salir," as index of the imminent shot, is, like Spirito himself, a precursor of death. It is possible to read this commonplace as yet again an ironic gesture. The fake bird, trapped in its precarious mechanism, mimics the sitters in their future representation. The bird, typically an animal that is hunted, in this case helps to enable a vicarious hunting.[68] Finally, the third bird appears in a surreptitious but no less meaningful way. The narrator,

bent on speaking evil of her rival Humberta, blames her for Adriana's death. In the last photographic shot, Humberta has made her way to the front row. That makes the narrator lash out at her, making this over-the-top remark: "Si no hubiera sido por esa desgraciada la catástrofe no habría sucedido" (221) [If it had not been for that wretch the catastrophe wouldn't have happened (28)]. Seething with jealousy and rancour, the narrator does not forgive Humberta the fact that it was she who announced to the guests that Adriana—cold, motionless—was dead:

> La desgraciada de Humberta, esa aguafiestas, la zarandeó de un brazo y le gritó:
>
> – Estás helada.
>
> Ese pájaro de mal agüero, dijo:
>
> – Está muerta. (222)
>
> [That wretch Humberta, that party-pooper, jostled her by the arm and cried out to her: "You're frozen."
>
> Then that bird of ill omen said: "She's dead." (28)]

From the irrational logic of the narrator, the messenger is not merely a relay, but is directly responsible for the effects of the news she conveys. If Humberta discovers and announces that Adriana is dead, therefore Humberta is the cause of the girl's demise.

This same logic reinforces the magical conception that photographs, in their funereal fixity, are also the cause of the sitter's death, and not only visual signs through which she may live vicariously. Thus, it is understandable that Humberta becomes a "pájaro de mal agüero," similar in kind to the swan's death and the threat issued by Spirito, all harbingers of things to come.[69]

Photography is employed as a magical tool in the story "La revelación." Events are conveyed again by an unreliable narrator, presumably a cousin of the main protagonist (a child called Valentín Brumana). From

the outset, this child is introduced as if he were mentally retarded (again a child is presented as disabled and from the point of view of another child, who shows no mercy, respect, or consideration). The narrator points out how she and other kids found pleasure in teasing poor Valentín, though she also tells of her amazement when she discovered that Valentín "era una suerte de mago" (330) [was a sort of magician (13)], due to his quick intuition, a fact that made her respect him and even fear him.[70]

As many kids do, Valentín fancies himself a talent in several trades, photography among them. The narrator then lends him her camera (though without film). One day, Valentín falls fatally ill. As was the case with Adriana, Valentín lives in a familial environment where he is misunderstood. Both children are essentially orphans: no father or mother or authority figure seems to protect them. From his deathbed, Valentín welcomes a presence in the room that no one else can see. The family deems the child's attitude somewhat weird but understandable, given his dire situation. Valentín believes to such a degree that someone is in the room that he asks the narrator to photograph him with the invisible being:

> Con gran esfuerzo Valentín puso en mis manos la cámara fotográfica que había quedado en su mesa de luz y me pidió que los fotografiara. Indicaba posturas a quien estaba a su lado.
>
> – No, no te sientes así – le decía. . . .
>
> Temblando, enfoqué a Valentín que señalaba con la mano el lugar, más importante que él mismo, un poco a su izquierda, que debía abarcar la fotografía: un lugar vacío. Obedecí. (331–32)
>
> [With a great deal of effort Valentin gave me the camera that had been lying on his night table and asked me to take a picture of them. He showed his companion how to pose.
>
> "No, don't sit like that," he said to her. . . .

Trembling, I focused on Valentín, who pointed to the place, more important than he, a little to the left, which should also be in the picture: an empty space. I obeyed. (15)]

After the narrator gets the film developed and receives the prints from the photolab, she discovers among the familiar scenes a blurred picture that she does not remember taking. After clarifying the matter with the lab, she points out:

No fue sino después de un tiempo y de un detallado estudio cuando distinguí, en la famosa fotografía, el cuarto, los muebles, la borrosa cara de Valentín. La figura central, nítida, terriblemente nítida, era la de una mujer cubierta de velos y escapularios, un poco vieja ya y con grandes ojos hambrientos, que resultó ser Pola Negri. (332)

[It was only somewhat later and after careful study that I was able to make out the room, the furniture, and Valentín's blurry face in the famous photograph. The central figure—clear, terribly clear—was that of a woman covered with veils and scapularies, a bit old already and with big hungry eyes, who turned out to be Pola Negri. (16)]

The ending points back to the first sentence of the story, when the narrator says that "hablara o no hablara, la gente advertía en [la mirada de Valentín] la inapelable verdad: era idiota. Solía decir:—Voy a casarme con una estrella." (330) [Whether he opened his mouth or not, people guessed the inevitable truth from the way he looked: Valentín Bumana was an idiot. He used to say: "I'm going to marry a star." (13)] Little by little, Valentín's powers of anticipation are revealed. Here Ocampo plays with the photographic and spiritual connotations of the verb "revelar," which means both to develop and to reveal. The alleged invisible presence that Valentín managed to see was indeed a ghost. Once the film is developed and a print produced, it shows a figure that could be associated with death itself. The mysterious photograph that Valentín instructed the narrator to

take recalls the famous ghost photographs in fashion in Spiritist circles in the United States and Europe at the end of the nineteenth century.[71]

The picture of Valentín plays one of the essential roles attributed to photography: to certify an alliance, as if his were a wedding photograph. Even more, the picture can be seen as the virtual marriage to a star that Valentín had desired. The fantastic premise of the story asserts the supernatural projection of desire that the photographic medium, considered a sort of modern magic, makes possible. The name of Pola Negri, an actress famous for her roles as *femme fatale* during the silent movie period in Europe and the United States, and who worked under Ernst Lubitsch,[72] seems too specific given the opaqueness of the story's spatial, temporal, and overall cultural frames of reference. However, the naming of Negri points to an interesting fact about the narrator, the one who looks at and interprets the fuzzy image. From her particular point of view, she is able to identify the figure because of her own knowledge of cinema. It may be the case that this unreliable narrator projects her own desires and fantasies onto the picture, imposing on the blurred image a face drawn from the visual archive of the times. An element of uncertainty is thus added to the topic of pattern recognition and visual analogy that Ocampo explored in other writings.[73]

To conclude, it is worth comparing "La revelación" with Cortázar's "Apocalipsis de Solentiname." While very different in historical and political terms, both texts play with analogous themes and strategies, most notably a supernatural revelation mediated by a photographic technique. Photographs become the fantastic medium by which the bounds of space and time are breached. In both texts, the allegedly indisputable standard material process—shot, exposure, development, enlargement, and printing—is called into question. In both cases, the narrators check with the photo labs to determine whether a (human) mistake is responsible for the sudden appearance of unexpected images. Both stories postulate a realm of existence that surpasses in power and extension the bounds of realism that the photographic medium is supposed to confirm.

Virgilio Piñera

Quiroga, Rulfo, and Ocampo use the conventions of the family picture to explore the underlying uncanny, fantastic, or supernatural aspects of the medium. For his part, Cuban writer Virgilio Piñera (1912–1979) employs photography to reflect on aspects of human relations that parody and challenge social mores. In the short story "El álbum," originally published in *Poesía y prosa* (1944) and later included in *Cuentos fríos* (1956), Piñera makes use of the absurdist, parodic, and grotesque perspective that is a hallmark of his work, focusing on the narrative and visual experience of sharing a family album.[74]

The story features a man living in a boarding house who is coaxed by the janitor to buy a ticket to an event later in the afternoon: the public showing of a photographic album, organized by the owner of the house (a broad and imposing woman). It is his first day at the house, and also his first day at his job. Between the insistence of the janitor and the bothersome visits to his room by some of his fellow guests, the man will end up missing an appointment at his place of work. Without much enthusiasm, but hardly showing any resistance, he stays for the show. The photographic exhibition takes place in a dining room arranged as a small amphitheater, where the rich tenants are seated beside the landlady or occupy the first rows, while the poor boarders are seated at the back of the room, hardly able to see the pictures. These shows are famous for their unpredictable length, sometimes extending for weeks and even months. The tenants camp in the amphitheater, where they eat, sleep, and even defecate, while the woman, with her small husband at her side, digresses endlessly about the events featured in the album.[75]

The story showcases the dark humor and masochistic fantasies present in other texts by Piñera. The issue of the body submitted to harsh discipline, and especially physical immobility as a condition of attention and learning, prominent topics of his 1952 novel *La carne de René*, are all present at the main event described in "El álbum." The spectators are prisoners at the whim of the landlady, who is completely indifferent to her listeners and even to her own husband. The grande dame who organizes the event not only steals the show, but also stills it. One of the guests of the house, who had previously introduced herself to the protagonist,

literally embodies the utterly static condition that the participants of the show endure. She is a nameless character who is known as the "mujer de piedra" [stone woman], a disabled person who uses a cart to move about the boarding house and whose flesh is progressively hardening. The stone woman attests to Piñera's obsession with flesh considered not as a site of life, feeling, or desire, but as a field of physical resistance and anesthesia.[76]

The stone woman, who sits beside the landlady, will eventually die five months into the performance, foreshadowing the fate of the rest of the audience. Contrary to the stories and critical insights that place the murdering power of the photographic act at the centre of attention, Piñera builds a setting in which photography kills, or at least brackets life, through the collective act of sharing it with others. As with Ocampo, whose texts display a mismatch between the gravity of events and the way they are narrated, in Piñera's stories "un acontecimiento horrendo es relatado en un tono enteramente inconveniente a ese horror" [a horrible event is narrated in a tone entirely inconvenient to that horror].[77] Literary exploration of the moment of reception where a character shows a photo album to another is, if not unique, rare in the corpus of Latin American letters. There are few cases in which the encounter of a collection of photographs mediates between storyteller and diegetic listener.[78]

In "El álbum," the well-documented uses of the family album are turned inside out by Piñera.[79] While family albums serve, in the words of Sobchack, as "'memory banks' that authenticate self, other, and experience as empirically 'real' by virtue of the photograph's material existence," in Piñera's story the album is at the centre of an experience of individual alienation and collective disjunction.[80] The viewing of the family album, with its attending values of peaceful domesticity and attentive recollection of shared moments, is transformed into a public performance where spectators are required to listen to stories in which they have no stake at all. The sentimental connotations of a private collection are turned into a show from which the janitor tries surreptitiously to profit. More than an emotional bond between the audience and the host, who shows some crowning moments of her life, an air of Kafkaesque fatality keeps them bonded. The captive audience grudgingly agrees to be part of the performance. The show is arranged in such a way that not everybody can look at the pictures, as if the community who lives in the boarding house, neatly stratified into classes, reflects society at large.[81] The fact that the poor

souls at the outer edge of the amphitheatre cannot see the photographs corresponds to the role of the actual reader of the text, who cannot see the pictures either, and has to rely on the ekphrastic versions and unreliable memories that the matron deigns to offer.

Hirsch points out that "photography's social functions are integrally tied to the ideology of the modern family. The family photo both displays the cohesion of the family and is an instrument of its togetherness; it both chronicles family rituals and constitutes a prime objective of those rituals."[82] In Piñera, the family album as a token of familiality becomes upset. To begin with, the husband's more conspicuous role in the story is to carry, in a mockingly ceremonious way, the heavy album into the hall and assent to his wife's statements. He behaves more as a servant than a partner, and he hardly utters a word during the show. Moreover, no mention of this odd couple's children or relatives is made in the text. As if to emphasize the dysfunctional nature of family ties, there is no character (not even the married couple) who clearly indicates a stable family structure. The main protagonist and principal narrator lives alone. Minerva, one of the guests with whom the protagonist has exchanged some words, bears in her arms a crying baby and tells the man the story of her husband, who committed suicide in front of her. Later, the landlady will tell a couple of stories that underscore how family life can go awry. Both digressions are triggered by a photograph she is describing. (The first story is about a young woman who is forced by her father to marry a wealthy man so that he may escape bankruptcy. The landlady had advised the young woman not to marry the man. At the end, the father kills himself after learning that his daughter refused to marry. The second story involves the kidnapping, rape, and murder of the seamstress who embroidered the dress of a guest who attended the woman's wedding). The lurid details triggered by the pictures contradict the standard practice, noted by historians of photography, of assembling and editing family albums according to rules of propriety and ideals of social harmony that affirm above all the preservation of the family unit.[83] As Bourdieu points out, the family album is associated with the act of "solemnizing and immortalizing the high points of family life."[84] As a fitting touch of irony, the main photograph described by the woman features her as a bride cutting the cake during her wedding, a moment that she considers "el clímax de aquella inolvidable velada" (78) [the climax of that unforgettable evening]. The photograph of the woman

as a bride, conveniently chosen at random during her performance, is meaningful because it points to a new phase in her life. However, there is a sharp contrast between that momentous rite of passage from her younger years to her present married existence. While the photograph itself seems to glow in the same pure whiteness of her dress, the wedding cake, and the puffs of smoke released by the photographer's magnesium flash, her current life, in a crowded boarding house, with an ineffectual husband and her own overbearing photographic show, conveys a sense of a grey and stale existence. Piñera endows the wedding photograph, a visual sign in which social values and personal achievements coalesce, with an iconic status, but he also questions the traditions of family representation. In the words of Hirsch, who has studied the family album and questioned its ideological underpinnings, Piñera mocks this domestic practice since the album no longer "displays the cohesion of the family [itself]" nor is it "an instrument of its togetherness."[85] The photo session is an egocentric and theatrical affair. The haphazard community that gathers in the dining room is subservient to the will of the owner, whose monologic address embodies her undisputed authority. Her husband and the guests play only subaltern roles.

The Barthesian "adherence of the referent," the indexical status of photographic representation, acquires, in the description elaborated by the woman, an exaggerated importance.[86] Every detail in the picture is an occasion for an extended digression. The landlady cannot stop telling story after story, day after day, about the pictures. Ekphrasis, conveyed to the reader through the voice of a character, acquires here its fullest narrative potential, to the point of parody.

The woman's performance (as well as the text at large) displays the problematic interactions between verbal and visual representations. At the beginning of the story, we learn that the protagonist is getting ready to attend his first day of work. It turns out that his job has some resemblance to the performance of the woman herself. He works as a reader for a blind man, that is, he mediates between the signs on a page and someone else's imagination: his words are intended to make the other see with his or her mind's eye. His job foreshadows the situation of most of the audience (the poorer ones at least) during the performance: they can hear the stories but are unable to see the pictures. In this respect, the protagonist and the

landlady, as well as the author himself, perform a similar operation: rendering in verbal terms something that their audiences cannot see.

Both the spectators of the performance and the readers of the story share an ekphrastic hope according to which the images described will eventually incarnate and show themselves in their full presence. But Piñera, keen on frustrating the reader's expectations, includes a passage that points toward the limitations of signs in general. While describing her wedding photograph, the matron tells a comic story about one of the guests, who walked into a recently painted false door in the hall. The painted door represents a physical limit that is impossible to overcome. This metafictional fold points to the illusion of escaping the bounds of time and space. The woman who bumped her head on the wall found herself in the same situation as those who look at images in search of an entrance, albeit imaginary, to another realm. In its utter verisimilitude, the false door, as Balderston notes, represents art itself and, more generally, representation in general.[87] As any effective *trompe l'œil*, it stands for a limit that cannot be bridged physically while powerfully suggesting the existence of tridimensional space. That is not the only metafictional moment in the story. The matron comments on another element that appears in the wedding picture: a stuffed dog that was a gift from one Miss Dalmau. Whereas the stuffed animal is still around, Miss Dalmau has died a long time ago. The woman then reflects on the strange condition that makes things last longer than their owners. Of course, the album that triggers this reflection is also an object that will outlive its owner, as the text we are reading will outlive its author.

Piñera inverts an assumption common in our current visual culture. The photographic show does not perform "a profusion of images and a withholding of words,"[88] that is, an abundance of pictures paired by a lack of interpretation, but rather the opposite: a sole image, selected at random from a limited archive, triggers a verbal discourse with no end in sight. In this respect, "El álbum" shows parallels with Cortázar's "Las babas del diablo" not only in its references to entrapment, the nesting of representations, and existential pathos, but especially as it posits the photograph as an anxiogenic device that words cannot assail or exhaust.

At the beginning of her book about family albums, Hirsch asks, "Can words reveal, can they empower us to imagine what's behind the surface

of the image?"⁸⁹ In his fictional account, Piñera seems to answer in the affirmative, but given the absurdist slant of the plot, the assertion is not so straightforward. The story implies a hyperbolic structure in which spectators and readers find themselves trapped. Piñera suggests that penetration of the surface of an image, or retrieval of memories triggered by a picture, comes at a cost: namely, an extended narrative beyond the standard parameters that make a reading or a scene of contemplation tolerable. As in many of his texts, Piñera makes free use of hyperbole, but in a different sense than the one used by magical realists such as García Márquez. There is no magic in Piñera, but rather a cold realism, a willingness not only to shun verisimilitude, but also to twist it and to challenge the good manners and conventions of both social behaviour and literary expression.

3

POLITICS OF THE IMAGE: JULIO CORTÁZAR AND TOMÁS ELOY MARTÍNEZ

Photography is not only a window into uncanny or fantastic realms, or a visual token in the social construction of memory and identity; its referential power is deeply invested in the politics of images. Photographs are crucial elements in the structures of power, dominance, and struggle that underpin modern visual culture. This chapter explores the aesthetic and political dimensions of photography in selected texts from *La vuelta al día en ochenta mundos* (1967), *Ultimo round* (1969), and the short story "Apocalipsis de Solentiname" (1977), by Julio Cortázar, as well as Tomás Eloy Martínez's *La novela de Perón* (1985).[1]

Julio Cortázar

The enduring appeal of Julio Cortázar's engagement with photography stems mainly from his short stories "Las babas del diablo" and "Apocalipsis de Solentiname." Less attention has been paid to the ways the Argentine writer weaves words and photographic images in his illustrated books *La vuelta al día en ochenta mundos* and *Ultimo round*.[2]

The role photography plays in these collage-like volumes can be productively assessed by examining two dominant cultural discourses at work in Cortázar's literary production: first and foremost, illustrated journalism, and second, travel writing. It is through these discourses that Cortázar reflects on the links between photographic image and power in a broad sense. I argue that in the almost-twenty-year span from "Las babas del diablo" (1959) to "Apocalipsis de Solentiname" (1977), a dialogic exchange develops between these discourses and positions, and important chapters of *La vuelta al día en ochenta mundos* (1967) and *Ultimo round* (1969) are a product of these creative tensions. I show how Cortázar appropriates the main traits of news media (the task of reporting, a resort to visual testimony, the urgency in responding to current world events), and I conclude by reading "Apocalipsis de Solentiname" as the end point of a literary journey where the enactment of a kind of super-reportage takes place.

The use of the journalistic medium in Cortázar's work goes beyond the exploitation of a literary motif or a principle of textual organization. Some of the hallmarks of modern journalism—such as brevity, fragmentation, simultaneity, and mosaic-like design, highlighted by media critics as diverse as Benjamin and McLuhan—both inspire and echo Cortázar's literary style.[3] The very newness of news, the pressure that ever-increasing amounts of topical information exert upon consciousness as they are consumed and interpreted, as well as the ingrained tendency of modern journalism to sensationalize, parallel Cortázar's own quest for an aesthetic of heightened awareness.[4]

The imprint of journalism is at work not only as a transposition of themes and models from mass communication media to the domain of fiction, but as an ongoing struggle among media, where the demands of competing versions and distinct communicative regimes interact and seep through textual production. On the one hand, Cortázar's work consciously appropriates some of journalism's forms and topics; on the other, it is penetrated by the urgency of journalism's appeal and its specific epistemological framework.

Journalism provides a constant wealth of information that Cortázar incorporates in his writings. A well-known example of the dialogue between journalism and literature is *Libro de Manuel* (1973), constructed around a series of newspaper clippings of mostly political content, meant to guide young Manuel's future education. By including facsimiles of

actual clippings that become part of the fictional world of the characters, the book strives to lend credence to the truthfulness of extra-textual events.[5] More importantly, Cortázar wrote the novel under the pressure of unfolding political developments. At the beginning of the book, Cortázar highlights the quality of contemporaneity that came into play while he was writing the novel. He refers to the "frecuente incorporación de noticias de la prensa, leídas a medida que el libro se iba haciendo" [frequent inclusion of news stories that were being read as the book was taking shape].[6] External pressures such as the deadline, an essential feature of journalism, can be seen as determining the moral impulse behind the novel.[7]

This method of explicitly including current events and information in the text also appears in *La vuelta al día en ochenta mundos* and *Ultimo round*. The cover of *Ultimo round* provides a clever paratextual case of creative appropriation, one that owes as much to Cortázar as to Julio Silva, the designer of the book. It mimics the front page of a newspaper, or a general-interest periodical such as *Reader's Digest*, and reveals the author's playful attitude and flair for irony.[8]

Cortázar includes in this book his own "diario," a Spanish word that means both personal journal and daily newspaper. One of the first pieces, "Un día de tantos en Saignon," is a page of Cortázar's personal journal, presenting the events of the day as they unfold, peppered with reflections, literary allusions, and information about his private life.[9] *Rayuela* includes verbatim quotes from newspapers of the day,[10] while *Prosa del observatorio*, an illustrated prose poem that explores the Baudelairian notion of cosmic correspondence, opens with a reference to a newspaper article that is used, as are others in Cortázar's work, as both background information and creative spur.

Bakhtin's notion of dialogism helps to frame the impact of journalism—specifically as a vehicle of political and cultural news—in Cortázar's work. The biographical evidence drawn from both Cortázar's letters and his literary work show how news media form for him an arena of contested meanings, thus providing a clear example of what Bakhtin calls "the life and behavior of discourse in a contradictory and multi-languaged world."[11] By blending the impact of shocking news with its testimonial aspect, journalism also connects Cortázar's aesthetic leanings with his interest, beginning in the early 1960s and exemplified by "Apocalipsis de Solentiname," in the political and historical fate of the peoples of Latin

03 FIG 1 AND 03 FIG 2: Covers of *Ultimo round*, vols. 1 and 2. Photo courtesy of Siglo XXI Editores

JULIO CORTÁZAR

ÚLTIMO ROUND

TRABAJOS DE ESTIRAMIENTO

Gálvez patea de media cancha, la pelota da en el travesaño y cae en la sopera justo cuando la señora Delossi va a meter el cucharón para servir al escribano Torres que se queda con el plato hondo en la mano mirando fijo hasta que diversas señoritas de la acción católica se compadecen y le ponen monedas de cinco pesos que al final son cuatrocientos, suma con la que se podrá hacer frente al transporte entre mi casa y lo de la Tota que ha llamado por teléfono para clamar que el pescadito de color se le está quedando en el fondo de la pecera y que en la familia temen una intoxicación por exceso de cloro o algo así, de manera que durante el viaje que dura su buena media hora voy estudiando un plan de acción, lavaje de estómago con la bombilla del mate soplada a fondo, flexión de agallas y cambio del agua corriente por unos litros de pura Villavicencio nacida de manantiales andinos, patria chica de Gálvez que expulsado por el árbitro because paiada en culo centroforward adversario sale de la cancha arrancándose la camiseta y llorando como un hombre.

COSAS OÍDAS

En el consultorio externo de la Facultad de Agronomía y Veterinaria de Buenos Aires.

Dos señoras con sendos perros enfermos:

— Yo siempre digo, uno a estos animalitos los tiene para matizar la vida.

Poco después:

— Ojalá a su perrito se lo atienda el doctor Carlitos, que le dicen aquí. A mí cuando la Diana se me enfermó de nostalgia, me la curó en seguida.

En otro banco:

— Le juro, la perra y la gatita eran como hermanas. Las viera sentaditas en la puerta de casa, usté se acuerda que tiene una verja de esas artísticas...

Last but not least:

— Yo pensaba que era el empacho por la cosa de las almóndigas, pobre ángel, pero de golpe se me vislumbró la antena: era que estaba en estado por la culpa del pomerania de mi cuñado.

LA PROSA CON LA QUE SE ENGRUPE A MÁS DE CUATRO

Since there would probably not be enough time for the Committee to consider all the draft resolutions submitted, he (the Rapporteur) intended to submit another draft resolution to the Committee recommending that it should invite the Executive Secretary of the Conference to transmit those draft resolutions and draft amendments to the competent organs of the United Nations for further consideration. (A / CONF. 32 / C. 2 / SR. 11).

Conferencia Internacional sobre Derechos Humanos, Teherán, 1968.

✧✧✧✧✧✧✧✧✧✧✧✧✧✧

POESÍA PERMUTANTE

ANTES, DESPUÉS

como los juegos al llanto

como la sombra a la columna

el perfume dibuja el jazmín

el amante precede al amor

como la caricia a la mano

el amor sobrevive al amante

pero inevitablemente

aunque no haya huella ni presagio

El redactor en jefe de este diario es Caballero de la Orden de Mark Twain.

Se aceptan discos de Eduardo Falú.

siglo
veintiuno
editores
sa

118 TEXTUAL EXPOSURES

JULIO CORTÁZAR
ÚLTIMO ROUND

Hay que soñar, pero a condición de creer seriamente en nuestro sueño, de examinar con atención la vida real, de confrontar nuestras observaciones con nuestro sueño, de realizar escrupulosamente nuestra fantasía. (LENIN).

AVISOS CLASIFICADOS

JUGUETES

¿A la nena se le rompió la muñeca? Sin compromiso, consulte p. 248, tomo I.

AUTOS

¿Se le descarga la batería? Consulte nuestro servicio diurno y nocturno, p. 204, tomo I.

BICICLETAS

Más cosas hay en una bicicleta de las que imagina tu filosofía, Horacio. Información en p. 192, tomo II.

MOTOS

Veranee como lo que usted realmente es, o en todo caso aprenda mirando a los que ya son. Para esto de las miradas, consulte p. 192, tomo II.

● ●

Convergencias

La biblioteca ideale a cui tendo è quella che gravita verso il fuori, verso i libri « apocrifi », nel senso etimologico della parola, cioè i libri « nascosti ». La letteratura è ricerca del libro nascosto lontano, che cambia il valore dei libri noti, è la tensione verso il nuovo testo apocrifo da ritrovare o da inventare. ITALO CALVINO

Sur la rétine de la mouche
dix mille fois le sucre
JEAN COCTEAU

LA REVOLUCIÓN NO ES UN JUEGO

Joven amigo: ¿Se siente revolucionario? ¿Cree que la hora se acerca para nuestros pueblos? En ese caso, proceda CON SERIEDAD. La revolución no es un juego. Cese de reír. NO SUEÑE. Sobre todo NO SUEÑE. Soñar no conduce a nada, sólo la reflexión y la seriedad confieren la ponderación necesaria para las acciones duraderas. Niéguese al delirio, a los ideales, a lo imposible. Nadie baja de una sierra con diez machetes locos para acabar con un ejército bien armado; no se deje engañar por informaciones tergiversadas, no le haga caso a Lenin. La revolución será fruto de estudios documentados y de una larga paciencia. SEA SERIO. MATE LOS SUEÑOS. SEA SERIO. MATE LOS SUEÑOS. SEA SERIO. MATE LOS SUEÑOS.

Silvia

Vaya a saber cómo hubiera podido acabar algo que ni siquiera tenía principio, que se dio en mitad y cesó sin contorno preciso, esfumándose al borde de otra niebla; en todo caso hay que empezar diciendo...

I speak for hawks. Gary Snider.

America. In view of the imprint of journalism on Cortázar's literary enterprise, the photographic medium becomes a privileged vehicle where his avant-garde aesthetics converge with the political currency of visual testimony.

The array of images included in the *La vuelta al día en ochenta mundos* and *Ultimo round* forces the critic to question the parameters of interpretation of composite works, what W. J. T. Mitchell calls the problem of the "image/text," namely, the "heterogeneity of representational structures within the field of the visible and readable."[12] Sugano reads these illustrated books as ways of opening up closed literary and artistic generic distinctions. Dávila, following Cortázar's cue, calls them "almanaques posmodernos" [postmodern almanacs] and interprets the images and the books' layout not as mere illustrations or ornaments, but as structural features. For Perkowska, their hybridity invites the reader to question the hierarchies that set apart high and popular cultures.[13]

Cortázar's playful, informal, and anarchic approach can be seen in the use of captions that subvert the conventional links between images and the words that are supposed to contextualize them, as is the case with the piece "En vista del éxito obtenido," already addressed in chapter 1.[14] Besides this case of irony as a trope in verbal/visual interactions, what we find is a collage of literary strategies and communicative registers. At the centre of this array is the revelatory power of the photographic image and its testimonial use.

Three pieces—"Vuelta al día en el Tercer Mundo," from *La vuelta al día en ochenta mundos*, and "Album con fotos" and "Turismo aconsejable," from *Ultimo round*—explore the links among travel writing, social critique, the workings of memory and trauma, and the power of photography. Through these texts, I argue, Cortázar (or the narrator who employs his voice), reinterprets the role of the traveler by becoming a witness and, increasingly, a photo-reporter.

In "Vuelta al día en el Tercer Mundo,"[15] Cortázar explores foreign lands not as tourist destinations, as he does in texts like "Acerca de la manera de viajar de Atenas a Cabo Sunion," a biographical reflection on travel and memory from the vantage point of a tourist. This time, traveling—both real and virtual—takes him to sites of social injustice, political struggle, and moral outrage. The piece departs drastically from the playfulness and poetic flair of previous sections of the book, informing

the reader about the gloomy nature of ongoing world events. This "trip around the day" includes two brief texts. In both, references to photography play a central role as visual signs that lend a special intensity to the news conveyed. The first text chronicles the dire situation of civilians, and children in particular, in war-torn Vietnam; the second deals with the disappearance and mutilation of children in Venezuela. They both become poignant *exposés* of realities affecting the Third World that only investigative reportage could uncover. In the text on Vietnam, the authorial voice disappears, as if the main role of the author was to select and present to the reader in the most neutral fashion the news of the moment. The text literally quotes a news article that in turn refers at length to an illustrated piece that appeared in the progressive Catholic journal *Ramparts* in January 1967. Penned by William Pepper, director of the Children's Institute for Advanced Study and Research at Mercy College in New York, the article in *Ramparts* contains a witness report on civilian casualties and the health conditions of the South Vietnamese population since the war began in 1961, focusing mainly on the plight of children. It concludes with a collection of photographs of maimed, mutilated, and burned children. (It is not clear in "Vuelta al día en el Tercer Mundo" if Cortázar actually saw the issue of *Ramparts* and its photographs—described as "atroces" [atrocious]—or if he is only quoting the newspaper article.)

By framing the news from Vietnam as a "vuelta al día" [turn around the day], Cortázar links the text explicitly to the travelling theme of the book. This "vuelta" points, more than any other piece in the volume, to traveling as a trip to hell where the war machine is the ultimate producer of pain and death. The circumstance is even more harrowing because it affects the most defenceless of civilians. Cortázar, as both author and individual, was deeply drawn to childhood; he cherished its creative exuberance and the challenge it poses to normative reason.[16] In the text, the news he chooses to quote reflects this sensitivity. Between the pages that feature the news from Vietnam and the report from Venezuela, a grainy black-and white photograph covers the two pages entirely. No reference is given as to the source of the image, though it most likely appeared in a newspaper or magazine of the day. (It does not belong to the article in *Ramparts*.) In the foreground, a Vietnamese woman—her head covered with a scarf, her face showing signs of distress and fatigue, her gaze downward—drags along a child with her left arm and is barely carrying another

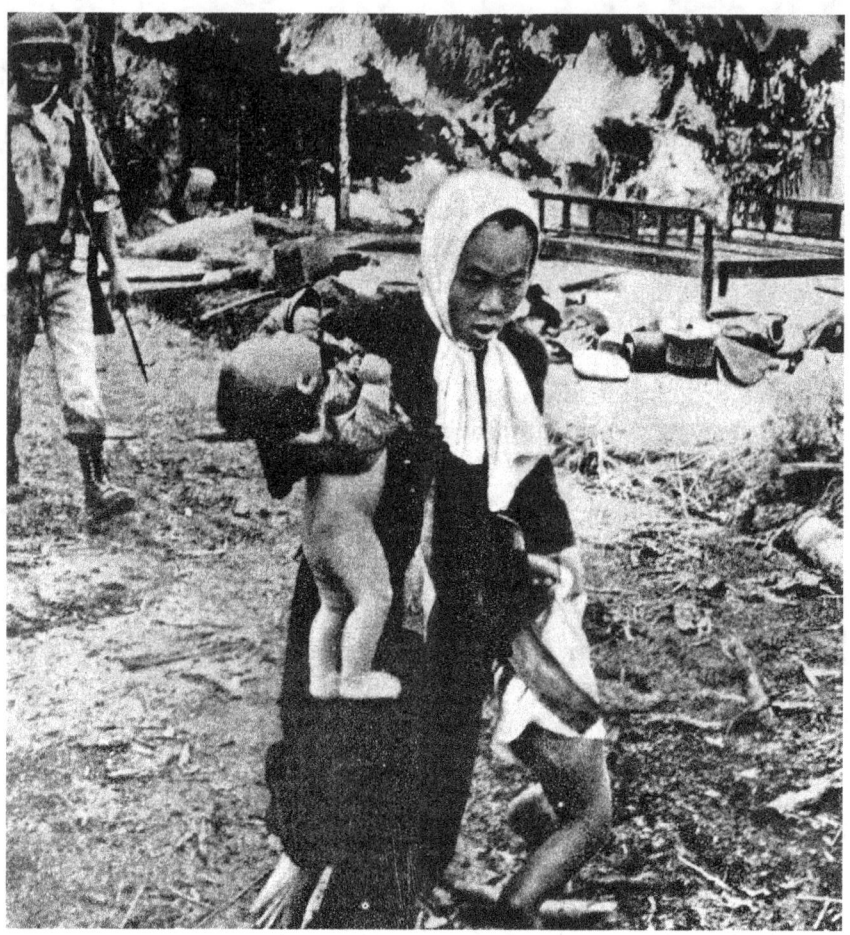

03 FIG 3: Vietnamese woman with children in a war zone. Photo courtesy of Siglo XXI Editores

child, smaller and naked, in her right arm. Behind her, a Vietnamese soldier marches on, while in the background, scattered remains and ruins stand in front of burning huts.

Besides functioning as visual testimony of the ongoing war, the image can be read as an emblem of the social catastrophe and despair in which millions of human beings live in the Third World. In the face of the physical destruction of their environment and the watchful, threatening

presence of a repressive military force, the woman and her children walking towards a hopeless future are a raw symbol of victimization.[17]

The pairing of the texts about Vietnam and Venezuela with the photographic image, even if they do not actually belong to the same publication or cultural context, recall the conventions of illustrated journalism. As Scott remarks, "many news photos are not significant in themselves but are emblematic, or representative: they have the task of establishing a news item, authenticating it rather than depicting it."[18] In *La vuelta al día*, text and image cooperate in the construction of meaning by providing the "truth" about an event, even if it is only by analogy. Bridging time and space, but suggesting the same continuity of injustice and pain, the photograph of the Vietnamese woman anticipates the photographs of violence in Latin America that the protagonist of "Apocalipsis de Solentiname" will see projected during the uncanny slide show in his Parisian apartment. This is a prime example of the dialogic exchange through which Cortázar appropriates the conventions of illustrated journalism to highlight, in a collection of miscellaneous texts, a political issue.

Though *La vuelta al día en ochenta mundos* and *Ultimo round* can be read as the first and second installments of the same literary project, there is a shift in aesthetic and political terms from the first to the second book.[19] *La vuelta al día* explores a multiplicity of arts and media, and it features many texts that revolve around playfulness, humour, and the poetic character of artistic creation. *Ultimo round* also delves into poetry and imagination, but includes more—and more poignant—political and socially-oriented texts, as if the two years that separated the publication of these works—a time span that included Che Guevara's death, an eye-opening trip to India, and the events of May 1968—had the effect of sharpening and hardening Cortázar's political stance.[20]

The topics of social violence and child abuse reappear in *Ultimo round* in a brief poem entitled "Album con fotos,"[21] where ekphrasis transforms the actual images of poor children into those of angels.[22] The text ironically plays with the assumption of safe domesticity provided by the photographic album and the editorial conventions that organize the plethora of images in magazines and almanacs around the category of "the year in pictures." A link is implied between the "atroces fotografías" [atrocious photographs] alluded to in "Vuelta al día en el Tercer Mundo," which illustrate the article from *Ramparts*, and the theme developed in "Album

con fotos." Even if the actual pictures in *Ramparts* produce horror, disgust, and moral outrage, while the ones described in "Album con fotos" trigger instead the reader's pity and compassion, both highlight the testimonial aspect of the photographic medium as irrefutable proof of human suffering. Both texts mention the ongoing war in Vietnam and the use of napalm by American forces. The reference brings to mind one of the icons of twentieth-century photography, the picture taken in 1972 by Nick Ut of children fleeing an American napalm strike.[23] However, the actual photographs from the original texts—the article in *Ramparts* and the photographic album that served as inspiration for the poem—do not accompany the pieces by Cortázar; they are only mentioned. Despite this absence, both pieces emblematize the shift in the evolution of Cortázar's work toward the use of photojournalistic techniques to make a political and social statement.

Cortázar rehearses in "Album con fotos" one of the preferred tropes in the critical literature about photography, namely, the image as a haunting visual sign. The empathetic viewer, rather than exerting control over an inert picture, ends up wounded by the image, a victim of its traumatic power, as seen in the texts explored in chapter 1. The testimonies of Susan Sontag and Roland Barthes are revealing insofar as they show how even the sophisticated, supposedly detached critic can fall prey to the raw intensity of a photograph.[24] The "rhetoric of the image" can persuade, or seem to persuade, the viewer in more immediate and compelling terms than any verbal construction or conceptual argumentation, since photographs appeal primarily to emotion, and the realist assumption usually associated with them lends more poignancy to the pain, despair, or destruction depicted by the image.[25]

Despite its undertone of despair, "Album con fotos" toys with the possibility of redeeming children from poverty and neglect. The photographs—or rather, their ekphrastic counterparts—fix the children's plight and aspire to save them, at least symbolically, from hopelessness. In contrast to this hope, "Turismo aconsejable" is set up explicitly as a chronicle of damnation.[26]

The text draws from Cortázar's second trip to India, in 1968 while working for the United Nations.[27] The importance of this trip cannot be overstated. It coincided with—and encouraged—Cortázar's rising

consciousness as an intellectual engaged in a political and social mission. His experience of the visit was a mix of dazzle and horror, with the latter dominating the letters he wrote to friends about his stay.[28] Cortázar writes to his editor Francisco Porrúa that in India "hay un horror permanente que sólo pueden ignorar los que viajan por cuenta de American Express y duermen en hoteles de lujo" [there is a permanent horror that only those who travel on an American Express account and sleep in five-star hotels can ignore].[29] In this same letter Cortázar describes his visit to Howra Station in Calcutta, which is the subject of "Turismo aconsejable":

> Quise conocer Calcutta, y todavía no he conseguido lavarme de esa impresión. Creer que estamos en la edad moderna, después de una visión semejante, es ser hipócrita o imbécil. En la estación de ferrocarril y las plazas adyacentes (por darte un ejemplo) viven permanentemente millares de familias sentadas en el suelo, en los andenes, las calles, entre dos vías de tranvía, al borde de los charcos de agua podrida.... No sé de una imagen mejor del infierno que la de una familia viviendo al aire libre, entre dos vías de tranvía y rodeada de otros centenares de grupos análogos, mientras una inmensa muchedumbre camina incesantemente de un lado para otro, sin trabajo, sin dinero, mirándose unos a otros con esa insondable mirada de los indios.[30]

> [I wanted to visit Calcutta, and I am still unable to wash away that impression. To think that we live in the modern age, after such a sight, is to be a hypocrite or imbecile. In the train station and the adjacent squares, to give you an example, thousands of families live on a permanent basis, seated on the floor, the platforms, the streets, between two tramway tracks, at the edge of the puddles of rotten water.... I don't know a better image of hell than that of a family living in the open air, between two tracks and surrounded by hundreds of similar groups, while a huge crowd walks from here to there, without work, without money, looking at each other with that unfathomable gaze of the Indians.]

The reference to hell echoes the utter despair on display in "Las babas del diablo" and "Apocalipsis de Solentiname," with their allusions to unleashed satanic forces and the impotence of innocent victims to confront violence and suffering. "Turismo aconsejable" plays with autobiography disguised as fiction, a strategy that Cortázar favours in his writings about photography. Though we can distinguish, from a critical perspective, between biographical facts and their fictionalized dimension (and between the figure of the author, and the author as character in his work), Cortázar purposefully blends these domains, as if he expects the reader to embrace, and not resist, the convergence of the existential and the literary (as happens in the writings of Horacio Quiroga). In "Turismo aconsejable," the literary inflection of the piece is conveyed from the outset by a narration that employs the formal second person, which addresses the reader directly and produces an effect of both closeness and distance. As for closeness, it brings the reader into the scenes described and the actions narrated as if she herself were the astonished tourist walking among the crowd. But the text also distances the reader: first, through the unusual use of this narrative device, since the reader is perfectly aware that she has not experienced first-hand what the narration tells; and second, through the use of the formal ("usted"), rather than informal ("tu"), second-person narrator. This rhetorical strategy adds a peculiar stress to the anecdote by imposing the "impossible" point of view of the reader being the witness of the events narrated.

The title—"Advice for Tourists"—serves as both an ironic gesture and an indictment. Visiting Howra Station is likely the last thing a "usual" tourist would do, which is precisely the reason a tourist should be advised to visit the place. Irony again plays out in the text when the narrator mentions that his tourist guide describes the spectacle of the crammed, poverty-stricken square of the Station as "pintoresco" [picturesque],[31] a pseudo-romantic description with which the author slyly agrees, and which he repeats at the end of the text as a form of sarcastic closure. The piece stands in sharp contrast to the leisurely distraction usually associated with travel by Westerners to faraway places. The reader must confront the urgent and generally hidden economic and social realities of the places tourists visit. The text switches the point of view from that of a detached, well-off European traveller to that of the horrified chronicler. This is done through a discursive shift from travel writing, commodified in the Murray

tourist guide mentioned in the text, to a documentary prose that does not shy away from emotional remarks. Despite the implicit allusions to India's colonial past and its present dependence on the metropolitan flow of capital and visitors, the author chooses to focus not on issues of national or international history, but on the present human disgrace he witnesses. The text describes the inhabitants of the square, highlighting the destitution, dangers, and hopelessness of their situation: from the old trolley crossing barely a foot away from the crowd, to a poor old couple, a fateful symbol of things to come for the oblivious children that play around them.

"Turismo aconsejable" dramatizes a social situation by following the model of news coverage. The text can be read as an illustrated article in a newspaper or magazine, very much as the article in *Ramparts* documents the tragedy of children in Vietnam. The photojournalistic model is apparent in the matching of text to photographs, the first-hand account, and the moral underpinnings of a "story of human interest." The photographs provide a visual support to the text, despite the fact that there is no indication that they picture Howra Station or its square (they are actually stills from the 1967 documentary film *Calcutta* by Louis Malle). As was the case with the photograph of "Vuelta al día en el Tercer Mundo," the pictures that accompany the text do not actually correspond to the events described and narrated, thus performing an emblematic role.[32] There is, however, a meaningful reference in the text to the photographic medium, providing an *effet du réel* that connotes both the tourist gaze and visual reportage. The mention of "la correa de su Contaflex" (140) [the strap of his Contaflex] indicates that the protagonist is carrying a camera on his visit to the station and is ready, at least potentially, to snap some pictures. In any case, there is no mention of taking any photograph, as if something prevents the visitor from using the camera: the paralysis provoked by fear or shock, the self-consciousness of attracting attention in a potentially threatening setting, or the impropriety of an act that connotes the mastery of the image-producer in a context of utter despondency. It is meaningful that even in the absence of a photograph taken by the protagonist, the author stresses the visual quality of the experience. By the end of the piece, author and reader are symbolically merged, and visibility is rhetorically employed to provide a dramatic proof of the events "we" have witnessed. It also burdens the viewer with the moral responsibility attached to a traveller who has entered a damned social space:

> el infierno es ese lugar donde las vociferaciones y los juegos y los llantos suceden como si no sucedieran, no es algo que se cumpla en el tiempo, es una recurrencia infinita, la Howra Station en Calcutta cualquier día de cualquier mes de cualquier año en que usted tenga ganas de ir a verla, es ahora mientras usted lee esto, ahora y aquí, esto que ocurre y que usted, es decir yo, hemos visto. (146)

> [hell is that place where shouts and games and crying happen as if they didn't happen, it is nothing that happens in time, it is an infinite recurrence, Calcutta's Howra Station any day of any month of any year when you would have the desire to go and visit, it is now while you read this, here and now, this that happens and that you, I mean I, have seen.]

Caught between the temptation to see and the wish not to attract the attention of the surrounding crowd, everything that the protagonist perceives in the square affects him with mute horror. One of the most poignant scenes is the discovery of an old woman lying on the floor. She is completely still. The narrator's first reaction is to surmise that she is sleeping (136), but later he realizes that she might be dead (140). Seeing becomes a painful experience, not only because it swamps the viewer with a pressing, proliferating, and anxious state of affairs, but also because once the complexities and ambiguities of the scene seem to be resolved, the resolution turns out to be dreadful. With regard to this sleeping or dead woman, the narrator experiences a delay in his response, as if the eye that perceives cannot fathom, in the immediacy of perception, the existential weight and implicit violence that teems behind appearances. The gap between manifest view and latent assumption is conveyed graphically by the reproduction in the book of the same photograph of a lying, shrouded body, first as a positive image, and two pages later, as a negative.

This strategy of belated awareness is typical of Cortázar. Both in "Las babas del diablo" and "Apocalipsis de Solentiname," there is an uncanny mismatch between the actual scenes captured by the camera and the images that are finally viewed by the spectator, a delayed action that critics of photography consider a crucial aspect of photography itself and which can be related, as indicated in chapter 1, to the experience of trauma.[33]

03 FIG 4 AND 03 FIG 5: Positive and negative images of a shrouded body, from Louis Malle's 1967 documentary *Calcutta*. Photo courtesy of Siglo XXI Editores

"Turismo aconsejable" amounts to a dark page in Cortázar's many writings about travel: his short stories and novels point to the joys and risks of real displacements, as well as to the amazement and shock of a fantastic rupture in the thread of (supposedly) normal continuity. *Rayuela* (1963) is of course the foremost example of a trip across geographical, literary, cultural, psychological, and metaphysical boundaries. From its very title, *La vuelta al día en ochenta mundos* points to a classic work on travel literature and situates the author as a traveler across spaces, genres, and styles. *Prosa del observatorio* revolves around the idea of a hidden link

between eels travelling across the Atlantic and the heavenly journey of the stars. This volume owes its existence to the same trip Cortázar made to India in 1968. In the prologue to the book of photographs *París, ritmos de una ciudad* (1981), Cortázar recaptures the adventurous gaze of the *flâneur* who explores the city for the first time. *Los autonautas de la cosmopista* (1984)—a quirky travelogue written with his then wife, Carol Dunlop, and illustrated with his photographs—attests to Cortázar's desire to travel even in his old age. He was a tourist by calling as well as a professional traveler. Working for UNESCO, he made frequent trips across Europe, Asia, and the Americas. He took advantage of these professional commitments to explore the countries where he stayed, and he greatly cherished the freedom his work as a freelance translator afforded him.[34]

The reinterpretation of travel writing in "Turismo aconsejable" flies in the face of the usual reasons that a tourist records her trip using photographs.[35] It also foreshadows the literary strategies Cortázar will employ in "Apocalipsis de Solentiname." Both texts portray a traveler on a hurried visit to a foreign land and exemplify, even if in a limited fashion, a variation of what Mary Louise Pratt calls the writing in "contact zones," defined as the "social spaces where disparate cultures meet, clash, and grapple with each other, often in highly asymmetrical relations of domination and subordination."[36] Nothing seems further from Cortázar's (personal and authorial) intentions than acting as a colonizer or imperialist agent. The link between the protagonist and the local population in each text does not involve coercion or intractable conflict, but it does showcase radical inequality, one of the features at play in "contact zones" according to Pratt.[37] It is true that Cortázar's position as a privileged observer stems from an asymmetrical power relationship quite independent from the writer's intentions. However, the attitude of the protagonist in each text remains ambivalent. Even if sympathetic, his condition as outsider is at the forefront of his experience. Voyeurism, even if mixed with moral outrage and compassion, can be seen as the primary motif of the visitor who ventures to Howra Station. In the case of "Apocalipsis de Solentiname," by photographing the peasants' naive landscape paintings, in itself a gesture of appropriation, Cortázar seems to rehearse, in the arena of representation, the "standard elements of the imperial trope," namely, "the mastery of the landscape, the estheticizing adjectives, the broad panorama anchored in the seer."[38] Even the host, the Nicaraguan poet and community

leader Ernesto Cardenal, appearing as a character in the story, interprets the act of photographing the paintings as an act of infringement, an act that imposes a sharp socio-cultural hierarchy. The protagonists in both texts know all too well that their visit will be short, concluding with a safe passage back home; the question of a more or less permanent stay or a conversion to the condition of the other is never entertained.[39]

In "Apocalipsis de Solentiname," the slide show that suddenly transforms naive paintings infused with bucolic connotations into crude scenes of political violence also changes the regime of communication in which the pictures are embedded. Personal keepsakes are transformed into graphic testimony that a photojournalist could have produced.[40] Crucially, Cortázar exploits in "Apocalipsis de Solentiname" a form of visual reporting that was implicitly rejected in "Las babas del diablo" twenty years before. Roberto Michel, the highly conscious amateur, calls into question the truth-value of photographic reportage when he expounds in a professorial tone about the aesthetic values of photography. He takes care to distinguish the photographic act in search of a visual truth from "the lies" that reporters chase:

> Entre las muchas maneras de combatir la nada, una de las mejores es sacar fotografías, actividad que debería enseñarse tempranamente a los niños pues exige disciplina, educación estética, buen ojo y dedos seguros. No se trata de estar acechando la mentira como cualquier repórter. (216)
>
> [One of the many ways of contesting level-zero, and one of the best, is to take photographs, an activity in which one should start becoming an adept very early in life, teach it to children since it requires discipline, aesthetic education, a good eye, and steady fingers. I'm not talking about waylaying the lie like any old reporter. (117)]

Michel dismisses, almost outright, a cultural figure (the photo-reporter) and a practice (visual reportage) that will become increasingly important in Cortázar's literature. This emergence has taken shape after Cortázar's embrace of the political impact and the social value of the photographic image in *La Vuelta al día en ochenta mundos* and especially in *Ultimo*

round.⁴¹ The divide in Cortázar's career between an epoch preoccupied mainly with literary and aesthetic concerns and another, more politically oriented period, beginning in the early 1960s with a galvanizing interest triggered by the Cuban Revolution, can be gauged by the evolution of the figure of the photographer in his work.⁴²

Cortázar's deep and long attachment to journalism as both a source of information and a textual/visual model reaches a critical point in the slide show of "Apocalipsis de Solentiname." It pits the hallucinatory experience of the protagonist against the all too real issues of social injustice and political violence.⁴³ While resorting to a fantastic or demonic intervention in everyday experience—a staple of his work—the Argentine writer also points to a dimension in which a kind of super-reportage is enacted and that reveals a deeper state of affairs, beyond the limitations of direct personal involvement. This is in line with comments by Cortázar, who considered his own text as "un cuento de los más realistas que haya podido imaginar o escribir" [one of the most realist story that I could have imagined or writen] because it was based on his experience and was rendered as truthfully and clearly as possible.⁴⁴ In the lectures he gave at Berkeley in 1980, the irruption of the fantastic at the story's end becomes, in his eyes, not a departure from "reality," but rather a way to drive home its critical moments: "es un poco llevar las cosas a sus últimas consecuencias para que lo que quiero decir, que es una visión muy latinoamericana de nuestro tiempo, llegue al lector con más fuerza, de alguna manera le estalle delante de la cara y lo obligue a sentirse implicado y presente en el relato." [It's a bit like taking things to their extreme consequences; thus, what I want to say, which is a very Latin American vision of our time, will reach the reader more forcefully, in a way that it will blow in his face and will force him to feel implicated and present in the story.]⁴⁵

By including scenes that belong explicitly to different Latin American countries in a sort of "televisual" collage of social violence, the author gestures to a kind of political universality that finds its coherence in widespread oppression and violent death.

In particular, the pictures of the slide show belong to the photographic tradition of the photo-reporter who worked for illustrated publications through some of the most decisive conflicts of the twentieth century: the Spanish Civil War (Robert Capa), World War II (W. Eugene Smith), the Korean and Vietnam wars (David Douglas Duncan and Larry Burrows).⁴⁶

The images are modeled after the work of "concerned photographers," to use Cornell Capa's expression, in line with the work of photographers contemporary to Cortázar like Susan Meiselas, who documented the Sandinista revolution in Nicaragua and the civil war in El Salvador in the late 1970s. Applying to the protagonist of "Apocalipsis de Solentiname" what Coleman says about Meiselas, Cortázar's intent in the story is "not only witnessing but bearing witness to some of the major social crises of our time."[47]

The shift from an "artistic" conception of photography to a form of visual reporting that highlights political conflicts allows Cortázar to raise questions about the role of the intellectual/writer/artist in society. The conflict between "art" and "life," explicitly thematized in "Apocalipsis de Solentiname," points to both the intellectual climate of the day and the political and moral issues that occupied Cortázar since the mid-1960s. In the story, the protagonist looks for a dialectical resolution to the conflict. Speaking to himself in his Parisian apartment in order to decide which slides to show first, as if this temporal precedence implied an axiological and moral choice, the protagonist finally chooses to begin with the slides of the paintings, asserting that "art" and "life" are ultimately the same:

> era grato pensar que todo volvería a darse poco a poco, después de los cuadritos de Solentiname empezaría a pasar las cajas con las fotos cubanas, pero por qué los cuadritos primero, por qué la deformación profesional, el arte antes que la vida, y por qué no, le dijo el otro a éste en su eterno indesarmable diálogo fraterno y rencoroso, por qué no mirar primero las pinturas de Solentiname si también son la vida, si todo es lo mismo. (158)

> [It was pleasant thinking that everything would be revealed to me again little by little, after the paintings from Solentiname I would go through the boxes with the Cuban photographs, but why the paintings first, why the professional deformation, art before life, and why not, the one said to the other in their eternal unresolvable fraternal and rancorous dialogue, why not look at the Solentiname paintings first since they're life too, since it's all the same. (124)]

The distinction between art and life, while continuing a tradition of romantic and post-romantic attempts to bridge the ontological divide of the alienated soul, remains undeveloped in the story.[48] One way to transcend the conflict between these seemingly opposite domains is to blur their boundaries, to think in terms of an undifferentiated realm that would overcome a contradictory state of affairs: to posit, as Cortázar does in the story, that "todo es lo mismo" [it's all the same]. Nonetheless, the slide show itself is a reminder of how intractable the distinction can be. The pictures transform the peaceful, harmonious art into all-pervasive violence, shattering any synthesis and stressing, rather than overcoming, the gap between art and life. The slide show itself is a visual exercise in differentiation, deploying a series of discontinuous scenes. Not only does each slide refer, in swift succession, to distinct situations and geographical settings, but the violence featured in each slide stresses physical disintegration.

If its textual/visual model of photoreportage is straightforward, "Apocalipsis de Solentiname" remains a text riddled with ambivalence. On the one hand, as the slide show proceeds, it grows into a dark ekphrastic space through which the reader watches violence out of control. This kind of super-reportage, rendering both diegetic viewer and reader as stunned, passive spectators, can be read as a failed attempt to promote change, as an acceptance of defeat in the face of political conflict.[49] On the other hand, even if the slides present images that may well belong to the genres of photojournalism and press photography, the context of reception of the show—private and even hallucinatory—is located at the opposite end of the essentially public condition of journalism.

One way to interpret this discrepancy is to consider the screen as a haunted space, projecting the unfulfilled desire of the protagonist to become a heroic figure of photojournalism, an ideal that echoes the condition of the "hero writer" attributed by Jean Franco to some of the authors of the Latin American Boom.[50] The slide show, seen from the safe distance of Paris, may be projecting the guilt of not participating fully in the social struggle, of not standing "close enough" to the action, as Robert Capa's famous statement about photojournalists proclaimed.[51]

In short, what began in "Las babas del diablo" as a suspicion of news reporting based on aesthetic grounds ends up at the core of Cortázar's literary and political preoccupations. The shift follows a vocational path in his career—from artistically minded writer to socially concerned

chronicler and exasperated public intellectual.[52] In "Las babas del diablo," Roberto Michel goes out to photograph Paris while taking care to avoid the posture of the reporter. Ten years later, *La vuelta al día en ochenta mundos* and *Ultimo round* not only are organized explicitly according to a journalistic model, but also contain many references to actual news and to image/texts that can be read as reportage. Finally, in "Apocalipsis de Solentiname," the photographs the protagonist brings home transcend the scenes of the little Nicaraguan community as they explode upon the screen in a Parisian apartment. They become, through the power of photographic images, burning news of a continent in turmoil.

Tomás Eloy Martínez

In previous chapters I have examined the ways photography is used in literary texts to explore the power and limitations of the fixed image. In this last section I show how *La novela de Perón* (1985), by Tomás Eloy Martínez, is a paradigmatic text in the way it incorporates the classic *topoi* regarding the uses of photography, especially its semiotic dimension and political impact. Throughout the novel, the Argentine author explores the nature of this visual medium as public sign, as testimony of historical truth, and as rhetorical weapon. The novel constantly probes the abiding human need to produce the "image that will stick" in the minds of individuals as well as in the collective memory. To fix a meaningful pose— one of photography's classic roles—becomes of paramount importance in a media environment in which messages constantly vie for attention. Photography mediates in the plot of the novel between past and present, memory and perception, the contingent and the ideal. More importantly, it becomes the model for the variety of visual signs deployed in the narrative. Photographic images are awarded a privileged place in the novel's general economy of representations.

Photographs play a paradoxical role: they are fictions within a fiction, but they purport to certify the authenticity of events. They provide a range of *effets du réel* that anchor discourse in referential illusions. At the same time, the novel's abundant ekphrastic moments also show the power of photography to fictionalize its diegetic reality. In other words, both the

reader and the characters in the text take for granted the "analogical plenitude" of the photographs, but these same photographs shape, edit, distort, magnify, or idealize the purported reality that generates them as signs.

La novela de Perón stages a contest among communication media. It can be read as a semiotic spectacle, an arena in which competing versions of events clash and the tensions of verbal and visual representations come to the surface. In this sense, the novel is about how a political figure is socially constructed. On the level of production, circulation, and reception of representations, words and images interact in pursuit of the "truth" of the main character.

The book has mainly been interpreted as a fictionalization of historical events or as a novelistic version of twentieth-century Argentine politics.[53] It explores the links among historical truth, literary fiction, and journalism, falling into a category that Linda Hutcheon calls "historiographic metafiction," in which fictional texts "foreground the productive, constructing aspects of their acts of representing."[54] Though underpinned by biographical information, it is not a biography of Juan Perón, but a cross-section of his personal and social background, his ideas, his ascent to power, and his exile and fateful return to Argentina in 1973.[55]

Published in 1985, in the aftermath of the Dirty War that plagued Argentina from 1976 to 1983, *La novela de Perón* can be read as a reflection on the immediate past. It is certainly not a commentary on the political and social plight of Argentines in those years, but it provides a useful historical background.[56] The novel avoids references to the core of Perón's political career—his two presidential terms, from 1946 to 1955—but it constantly alludes to the military institution from which he rose to prominence and which dominated Argentine politics since the 1930s. While portraying the last days of Perón, who is unable to tame the social tensions and political struggles after his long exile, the text can be read as an indictment of sorts. Perón's pathetic legacy—represented by the short term of office headed by the inept Isabel Martínez, Perón's third wife, and the Machiavellian José López Rega, his personal secretary—contained the seeds of the imminent social anarchy and subsequent military junta that seized power in 1976. In this sense, *La novela de Perón* traces the long historical shadow of his leadership and the effects of his crumbling authority.

The story begins on 20 June 1973. Millions of Argentines gather for the long-awaited return of Perón from exile. The narrative skillfully

weaves together the lives of the protagonists, all converging along with the welcoming multitude at Ezeiza airport, and culminates in the murderous purge of leftist Peronist groups by police and paramilitary forces.

La novela de Perón begins and ends with references to two fixed images. The first is a billboard featuring Isabelita, under which Arcángelo Gobbi, a thug working for Perón's personal secretary, López Rega, awaits the leader's arrival. The second is a television image of the body of Juan Domingo Perón, broadcast during his wake. From the outset, billboard and television screen provide the grounds for an ironic interplay between sign and referent: the meaningless, ineffectual Isabelita acquires monumental proportions, while the larger-than-life Perón ends up trapped in a plastic box beaming a bluish light. These images signal one of the salient features of the novel: its wide range of interactions between realms of meaning and representation.

Billboard and television image express the pictorial wish to fix and preserve the semblance of the absent, while also circulating it in the public domain. There is a photographic component to both images. On the one hand, portraits on billboards, which rely on realistic codes, are drawn from carefully selected photographs.[57] On the other hand, Peron's last television image points toward photographic representation in two ways: first, he remains paralyzed in death, and second, the camera shot does not change. Both in billboard and television image, the medium magnifies, multiplies, and ends up freezing a countenance.

Bracketing the proliferation of images the novel contains, billboard and television image point toward the variety of roles played by visual artifacts. Images acquire a life of their own, brought to light by ekphrastic strategies. In this respect, the persistent life of the dead has been a constant topic in Martínez's work. He has penned essays on the "necrophiliac" aspects of Argentine culture, and his novel *Santa Evita* (1995) can be read as an extended parable on the power of the dead over the living, of the passive image over the active mind.[58] As André Bazin might have said, Evita the mummy is suggestive of photography, insofar as she is fixed in a pose for eternity.[59] As seen in chapter 1, the practice and theory of photography have always been linked to the memorializing of the dead and a mournful or melancholic outlook on life. This imaginary but poignant link to death pervades *La novela de Perón*.

The book is a veritable album of ekphrastic moments. Few Latin American novels contain so many explicit allusions to photography, from mere snapshots to doctored images, from postcards to family albums to posters. This wealth of references highlights the variety and force of the interactions between human beings and photographic signs. In this verbal fabric teeming with photographic allusions, the author constantly exploits ekphrastic hope. Isabel, whom Perón says "tenía la virtud de ver sólo la superficie de las personas" (12) [had the virtue of seeing only the surface of people (4)], kills time looking at a picture magazine while on the plane that brings the Peróns back to Argentina. In Madrid, some weeks before, while the tension of the imminent trip is building, Perón takes a melancholic stroll around his house and, on the balcony, fancies himself in front of a cheering crowd waving "photographs and placards" from the Plaza de Mayo (6). Photographs of the first Peronist regime adorn the dining room of the home (93). Cámpora, elected president as Perón's deputy, pays a visit to the leader in Madrid. He looks at the photographs and thinks, with nostalgia, that "todo era más claro en aquel pasado" (98) [everything was clearer in those days (93)], as if glimpsing the turmoil that the failure of Perón's upcoming regime will bring about. As the plot unfolds, photography chronicles both achievements and failures. Examples abound: the young Perón receives a photographic album the day he graduates from the military academy, as a token of triumph after harsh training. On his way to the desolate fields of Patagonia, where his father had decided to move and make a living, Perón looks in awe at the photographs of the failed expedition to the South Pole by Scott, thinking that one day Argentines will accomplish the feat. Photography plays a crucial role in the capture of General Lonardi, who was caught spying on the Chilean army in 1938. Lonardi, who would head the military coup to unseat Perón in 1955, was then a newly appointed military attaché at the Argentine embassy, replacing Perón. Zamora, the journalist who is covering Perón's life for a special issue of the magazine *Horizonte*, learns the details of the case from the embittered widow of Lonardi. Chapter 12 opens with the journalist visiting the woman: "Zamora la ha imaginado como ya no es. Ha esperado encontrarse con el rostro frágil e imperial que asomaba en las fotografías de 1955" (225) [Zamora had imagined her as she no longer is. He had anticipated the same fragile, imperious features of the 1955 photographs (221)]. According to the widow, who shares with Zamora her notes

and diaries, Perón left the plot ready to unfold, only to see it explode in Lonardi's hands when Lonardi was discovered in flagrante, photographing secret documents, by the Chilean intelligence service.

The day Perón is scheduled to return from Madrid, some of his relatives, mostly elders who have not seen him for decades, have been invited to welcome him at the airport. Their comments have been included in the special issue of *Horizonte*, entitled "La vida entera de Perón / El Hombre / El Líder / Documentos y relatos de cien testigos" (69) [Perón: His Entire Life / Documents and Photos of One Hundred Witnesses (63)]. Bored and frustrated, they pass the time reading the magazine, discovering their own stories in its pages. Sometimes cheerily, but most often with awe, nostalgia, or disgust, they look at their personal photographs displayed in a public medium. Powerless to control the images already printed in the magazine, they are also powerless in the hallways of the airport. Mistreated by the security personnel who anxiously await Perón's arrival, the relatives board a bus that takes them away, to the outskirts of the airport. During the short trip, Benita, wife of one of Peron's cousins, discovers a photograph of herself as a teenager on a torn page of the magazine lying on the floor of the bus. For this group of ailing, unwilling, unsuspecting witnesses of Perón's life, photography is almost all that is left of life. It emblematizes a graphic register of decadence, a visible inscription of the tragic flow of time. This impression is reinforced by the sheer indifference with which the "distinguished guests" are treated—first by the staff of the magazine, then by the police forces—as if they have already vanished and been forgotten, very much like old images in a discarded publication.

Another classic *topos* of photographic representation—the iconic sign that serves as substitute for the living, the vicarious presence of an absence that Hans Belting situates at the heart of all images[60]—is exploited by the dubious sorcery of López Rega (nicknamed "el brujo" [the sorcerer]) and José Cresto, Isabelita's godfather. For these characters, plainly convinced of the powers of magic and espousing a hodgepodge of spiritualist beliefs and superstitions, photography is a medium in the esoteric sense, a channel that eerily communicates the disparate worlds of bodies and spirits. Photographs are galleries of ghosts waiting to become incarnate. Cresto, the pathetic counselor of Isabelita, is also the director of the Escuela Científica Basilio, a spiritual centre where candles illuminated "las fotos

de los espíritus que hacían penitencia en la casa" (27) [the photographs of spirits that were doing penance in the house (18)].

López Rega employs photographs as a means of magical influence and possession. He used to court luck by printing postcards of Perón and Isabelita that he would send all over the world (129). When he arrives in Madrid in 1966, he spares no effort to gain influence over the gullible Isabelita. After settling in Spain's capital, he engages in a quest to eliminate the obscure Cresto. Both he and the spiritual counselor vie for Perón's favors, embarking on a contest of sorcerers' tricks. López Rega manages to set a trap into which Cresto finally falls, by cunningly employing a photograph that pits the lame godfather against the General. López Rega learns that Perón hated a man called Marcelino Canosa, a peasant with whom his widowed mother had an affair. The secretary manages to get a photograph where Canosa and Perón's mother pose together and retouches the image in such a way that the features of the man resemble those of Cresto. Then he puts the doctored image in Perón's hands, suggesting, as the narrator puts it, that Cresto "había tomado posesión del espíritu de Canosa" (139) [had taken possession of Canosa's spirit (133)]. After this successful case of "magic antipathy," Perón conflates the two men and gets rid of Cresto.

References to spiritual possession and soul transfusion point to a worldview espoused by López Rega that is satirized by the narrator. They are also a symbol of political power. The novel shows López Rega surrounding himself with images in his quest to snatch the essence of his victims (253). This is manifest in his delirious project of soul grafting, from Evita's mummy to Isabel's body in the attic of the house in Madrid. The eternally frozen corpse of Perón's second wife—very much as a photograph—is a visual sign at the mercy of whoever wants to endow it with words, fantasies, or "spiritual" power.

Many more references to photography can be found.[61] This wealth of allusions emphasizes—to use the title of David Freedberg's book—the power of images. Freedberg embarks on a criticism based not on concepts from art history, but from the responses of people to images as determined by psychology, cognition, and culture in order to understand the complexity of the links between individuals and groups, and visual signs. Images are created, circulate in society, and produce a sphere of influence of their own. One of the privileged arenas in which images assert their power is the realm of ritual.[62]

The ritual use of photography in *La novela de Perón* takes the form of uncanny doubles, monumentalized icons, and idealized effigies. The billboard under which Arcangelo Gobbi stands guard—a sign that is being built as the plot unfolds—has a primarily scenographic function. It sets the political stage and establishes, in the best (or worst) tradition of personality cults, the figures of authority. The billboard can be seen as a portrait's last stage of magnification. If, as John Barnicoat points out, "an element of fantasy is introduced at the sight of a perfectly normal image that has become giant,"[63] billboards convey a sense of unreality, making a myth out of the features of a public figure.[64] Isabel's portrait emblematizes the power of secular deities, a charged zone where the attention of the crowd converges. In Gobbi's case, the image also connotes protection and familiarity. During his childhood as an orphan, he was obsessed with Isabelita's visage, which he confused in dreams with the Virgin Mary's. Gobbi is both sheltering and being sheltered by the image of his patron saint, whom he faithfully serves as soldier (his first name is, conspicuously, Arcángelo). From his vantage point, Gobbi looks at a photograph of Perón on a stage that the narrator explicitly calls an "altar" (17). Later in the day, when the *montoneros* attack the box from which Perón is expected to speak to the masses, the narrator endows the billboard with religious powers. Thus, "la foto jubilosa de Isabel" (288) [Isabel's jubilant photograph] will pour "el diluvio de su protección" (288) [the flood of her protection (285)] on Arcángelo.[65]

I have noted the ritual use of photographs in Jose Cresto's spiritual institution. By striving to invoke and appease souls through magical practices that capitalize on contemporary technology, photography links popular faith—esoteric and premodern—with the material changes introduced by modernization.[66] As I mentioned in chapter 1, the rhetoric of magic has accompanied perceptions of photography since its origins.

Besides trying to transform Isabelita into a new Eva Perón, López Rega also engages in a practice of soul snatching, at play as he rewrites Perón's memoirs, adding, dropping, and "correcting" experiences the General never actually lived.[67] Before he met Perón in Madrid, López Rega learned his books by heart (129), and after becoming his secretary, his increasing familiarity and immediacy pushes him to fuse his voice with that of his master. His schemes are graphically exposed in one of the last passages of the novel. In a press conference broadcast on television just after Perón's

arrival, the Argentine leader appears on screen, but the viewers notice something strange, as if his lips were out of sync with the voice they hear. The audience notices that Perón speaks, but following López Rega's whispering words. Insofar as a living subject speaks in place of a lifeless effigy, ventriloquism becomes a master metaphor in this and other scenes. This strategy is present not only among the characters (Perón ventriloquizing Prussian military strategists, the group of *montoneros* adopting the voice of Che Guevara and other revolutionary heroes) but in the author, the master ventriloquist who endows his characters—whether imagined or based on real-life individuals—with a voice.

Another fixed image on television is employed to establish a ritual scene. In a tiny home in a shantytown called, ironically, Villa Insuperable, the neighbours ("comadres," or close friends) have placed a television set on top of some boxes and a blanket as a makeshift altar (they do this after hearing that the weavers of Pergamino decided to hold a wake over a poster of Perón in the local union). Neighbours stop by to pay their respects to the General. At Perón's funeral, the camera shot captures his visage, as if it were a photographic portrait, before he and the image on the screen fade away completely. The novel ends when a poor woman climbs on top of the improvised altar and embraces the television set. She implores the General to rise from the dead, in an uncanny blend of sentimentality, popular faith, and technological imagery. In this context, it is remarkable that television is employed in the scene as ersatz photography. While photography is commonly described as "slicing" time or "freezing" an instant, the television image seems to be performing the opposite, as time flows uninterrupted. However, the stress on the passage lies not on motion but on the permanence of the fixed image (doubly fixed, since it depicts a dead body). The passage shows the ambivalence between television's flow and photography's fixity, resolved ultimately by a fade-out. In this regard, *La novela de Perón* can be read as a gesture towards the vanishing empire of the photographic image, insofar as the novel mourns not only a historical figure but a historical age in the emerging regime of television, where the fleeting nature of video images, harnessed by corporate or government channels of communication, becomes the new authoritative norm.[68]

One could also speculate about the shift from billboard to television—from a painted sign in the public space to the electronic proliferation of information; from monumental and scenographic imagery to the neatly

boxed, bounded, and increasingly private consumption of images—as an indicator of a historical shift in the way public figures are represented. Nonetheless, this divide is not so clear-cut in the novel, insofar as the billboard of Isabelita has a deep personal meaning to Arcángelo Gobbi. At the same time, television, though essentially a domestic appliance, functions in the scene not primarily in a private context but as a gathering site, a locus of public assembly.

Besides its ritual functions, photography plays a major role in the search for the truth about the figure of Perón. The novel shows how words and images compete on a semiotic level to pin down his character and history. The struggle is deployed in two main stages: first, the memories fashioned by the General with the insidious help of López Rega, and second, Zamora's journalistic quest to get to the bottom of Perón's life.

Photography, as an artifact that strives to overcome forgetfulness, to master time, and to control history, is very much present in Perón's old age. Sensing the proximity of death, he tries to channel his energies into writing his memoirs, and López Rega constantly triggers Perón's recollections with the help of photographs. Ironically, these pictures feature events the General attended but does not always recall (172). In this respect, photography participates in a series of narrative folds that exploit the fuzzy limits between literary writing, journalistic research, and historical knowledge.

While Cortázar used a fantastic version of a visual reportage to frame historical events in "Apocalipsis de Solentiname," Martínez abides strictly by realist codes in his portrayal of journalism. The best example of the conjunction between factual information and novelistic fiction is provided by the appearance of Tomás Eloy Martínez as a character in his own novel. The very day of Perón's arrival, Zamora interviews Martinez. Zamora, a colleague of Martínez in the story, can be interpreted also as an alter ego of the author, as both are engaged in writing Perón's story. In the chapter entitled "Primera persona," the character Tomás Eloy Martínez decides to speak his mind. Even though his words pretend to be a confession, they really mask and deflect his own motivations regarding his pursuit of the truth. Nonetheless, his first move is straightforward: he shows Zamora some snapshots as a confirmation of the truthfulness of his account (256). The referential illusion is stressed grammatically by the use of the imperative mood—"Vea estas fotografías" (259) [Take a long look at these snapshots (256)]—as well as by the sharp, brief ekphrasis: "Somos Perón

y yo, un día de primavera, en Madrid, conversando" (259) [Perón and me, one spring day in Madrid, chatting (256)]. Before becoming a novelist, Tomás Eloy Martínez worked as a journalist for the weekly *Primera Plana* in Buenos Aires. He was engaged in journalism from then on, contributing regularly to newspapers such as *La Nación* in Argentina and *El País* in Spain. In fact, *La novela de Perón* was first published as a newspaper serial between August 1984 and June 1985 in *El periodista de Buenos Aires*, an independent periodical.[69] Chapters were published weekly, and the serialization was illustrated with photographs and political cartoons. Most of the photographs feature scenes from the lives of Perón and other Argentine public figures. Martínez got the pictures himself from public archives in the cities of Comodoro Rivadavia and Camarones, in the province of Chubut, and from Benita Escudero, wife of a cousin of Perón and included as a character in chapter 3 ("Las fotos de los testigos").[70]

As is common practice in print journalism, the author had no input into the text that introduced the serialized novel, the graphic material, or its layout. *El periodista de Buenos Aires* debuted in 1984, in the aftermath of the military regime and the reestablishment of democratic rule in Argentina under the elected president Raúl Alfonsín. The periodical, which was critical of the military dictatorship, had popular appeal and benefited from the newly acquired freedom of the press. Publication of the novel in serial form suggests an implicit authorial intention. Martínez's portrait of one of Argentina's foremost historical figures echoes one of the nation's foundational texts, *Facundo* by Domingo Sarmiento, which was also published in serial form, in 1845 in Santiago de Chile.[71] Despite their many differences, both texts aim to inscribe in the national imaginary an unofficial version of a political leader through literary fiction. Both texts, by merging biography and history, also intend to provide a critical assessment of the political practices and institutions of their age through the portrait of a "caudillo" or strong man, a figure who has dominated the political culture of Argentina, and Latin America in general, since its independence.[72]

Martínez interviewed Perón in March 1970 for *Panorama*, another Argentine weekly. Notes taken during their encounters were eventually published in a book entitled *Las memorias del General* (1996) and incorporated in *La novela de Perón* as Peron's (fictitious) memoirs. As a character in the novel, Martínez recalls that interview and reflects on his mixed

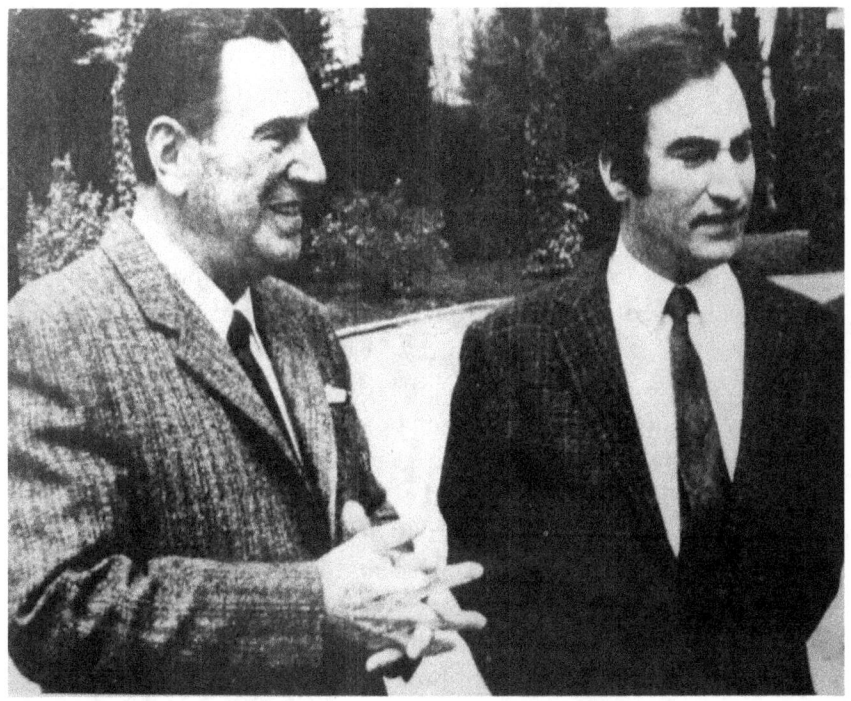

03 FIG 6: Juan Domingo Perón (left) and Tomás Eloy Martínez in Madrid. Courtesy of Fundación Tomás Eloy Martínez.

feelings about Perón's persona. Though Perón is the momentous incarnation of twenty years of Argentine history, he appears to Martínez mostly as a skillful political actor, an expert in the art of manipulation, and also as a mere mortal. Even in this context, photography functions as a weapon, a critical wedge, since it provides proof against a dubious claim. This is the case with a picture that Martínez has in his possession, in which Perón appears with a triumphant smile, on the footrest of the car of General Uriburu during the *coup d'état* in 1930, a compromising document that Perón, as well as López Rega, strives to deny or reinterpret.

The possibility of representing "what it is" and of capturing the truth of a given scene has been a central concern in the theory of photography. From the realism of the photographic image espoused by theorists such as Bazin and (early) Barthes to the extreme fictionality of photography practiced by postmodern photographers such as Joan Fontcuberta and

Cindy Sherman, photography has been inextricably implicated in the debate about the truthfulness of representations. The link between a narrative that mixes fact and fiction, and the constant allusions in the plot to photography as a primary source of information is meant as a strategy for establishing verisimilitude. Those references also highlight our abiding need to seek and find evidence in visual signs, even if they are illusory constructions.[73]

In the novel, journalism provides the most meaningful context for the interactions between word and image. The special issue of the illustrated magazine *Horizonte* epitomizes the collaborative tensions between the two. Zamora assembles a collage meant to show Perón's entire life. Mirroring the novel in which it is embedded, the magazine presents the psychological, familial, and social background that may serve to explain Perón's behavior, ideas, and political career.[74] Zamora distrusts the whole project, which was imposed on him by the editor of the magazine. What his boss calls the "truth about Perón" seems to Zamora nothing more than a flashy title and a ploy to lure readers. Zamora, less an enterprising reporter than a man caught between his moral scruples and the cogs of a news organization, manages to assemble a story, but one that he finally disavows. He sometimes looks like a victim of circumstances, doubtful of his own skills and the trade he has chosen, an attitude underscored by the fact that he misses the chance to witness firsthand the bloody events at Ezeiza on the day Perón returns to Argentina. Humiliated, he learns about the debacle later in the day, as it is reported on television (350).

The issue of *Horizonte* is a narrative construction in a competing arena of narrative constructions. Perón's "entire life"—which we and the characters of the novel cannot but read in bits and pieces—is a compilation of verbal and visual sources. Perón's memoirs have a similarly fragmented structure. Both the magazine and the memoirs try to recapture the complexity and uncertainty of the past, but they do so from contrasting perspectives. While the totalizing effort of the biographical scrutiny in *Horizonte* is targeted to a mass audience, Perón and López Rega are busy fashioning in the intimate space of their retreat a version whose virtual audience is none other than "History." Whereas the witnesses who were interviewed for the issue complain about the distortions and half-truths they find in the magazine, López Rega is eager to sculpt a heroic, monolithic portrait in the wishful belief that it will outlast the revisions

of historical writing. López Rega, disillusioned with Perón's recollections and his seemingly unconcerned attitude, strives to magnify and glorify his portrait through editing, reinterpretation, and outright distortion of the material. Perón says, in a gesture meant to stress his authoritarianism, that men, with their "senseless passion for truth," will ultimately adopt his version of affairs. This attitude has to do with his elusive ideological stance and his adept embracing of contradictory political positions, a strategy situated at the very core of Peronism.

Journalism is regarded as a privileged space for the production of meaning, but the novel is also highly critical of the profession. Faced with the pretentious story in *Horizonte*, the witnesses oppose their own intimate memories, and the group of *montoneros* put forward their own "antimemoirs." Nun Antezana, the guerrilla cell leader, who pinpoints the ideological distortions of the publication, considers the too human portrait of Perón "porquerías mercenarias" (69) [commercial crap (63)], a pack of lies about the patriarch and leader. Even Zamora sees the project as "la glorificación cloacal del periodismo argentino" (39) [the apotheosis of Argentinean cesspool journalism (32)]. The widow of Lonardi, after reading old reports from *Horizonte* about her husband's espionage in Chile, complains to Zamora, "¿Así, con esta clase de harapos, escriben la historia ustedes: los periodistas?" (234) [Is this the kind of drivel you newspapermen pass off as history? (231)] Finally, Martínez, himself a journalist in the novel, declares that "el periodismo es una profesión maldita" (260) [the profession of journalism is fiendish (257)]. The remark, as do so many other passages, drips with dark humor. After all, it was precisely because of his trade that the author was forced to flee Argentina in 1975, threatened by the Triple A paramilitary group run by none other than López Rega. It must be added that, thanks to his journalism contacts, the author managed to escape and earn a living abroad.[75]

The proliferation of points of view, each in search of the "truth," finds a symbol in the figure of the fly. The insect evokes a super-vision with its hundreds of eyes, but its elusive pattern of flight also points toward the difficulty of "securing the truth." There is no better emblem than the fly to connote expiration and decomposition (even more so in a novel dealing with personal and social decadence). If the eyes of the fly embody a multitude of perspectives, flies themselves are figures of unbounded, bothersome multiplication. In chapter 10, entitled "Los ojos de la mosca" [The

Fly's Eye], disconnected events are linked by the sudden appearance of a fly in each scene. In one passage, Zamora is driving his car to Buenos Aires from Ezeiza and passes some groups of faithful Peronistas marching to the airport. He notices a fly on the side mirror, and he says to himself that

> Bajo la mosca, en el espejo del Renault, cabe la entera postal del peronismo: las vinchas, los blue-jeans de ruedo acampanado, las remeras cantando que Perón Vuelve y Vence. (192)

> [The entire postcard of Peronism fits on the mirror underneath the fly; the headbands, bell-bottom jeans, T-shirts singing "Perón Comes Back and Conquers." (188)]

Again, Martínez uses photography as a metaphor to capture the traits typical of a given situation. The postcard of Peronism that Zamora reads in the mirror points less to the movement's historical roots in the 1940s than to the galvanizing power of the old leader to breathe life into a political movement in Argentina in the early 1970s. The scene can also be read as an allegorical snapshot of an individual trying to make sense of the entanglements of history. Only a rear-facing mirror allows Zamora—traveling away from the day's historical event—to see a future ambiguously modeled on past conquests.

If the fly—with its fragmentary, proliferating vision—is living proof of the impossibility of reaching "the truth," perhaps another image, carefully composed, could substitute for the unmanageable multiplication of perspectives. That is the role of the "portrait" of Perón in his memoirs. In the writing process, López Rega advises Perón: "Sea más histórico, mi General, ¿Lo ve?, ponga un poco de mármol en el retrato." (107) [Be more historic, General. Do you know what I mean? Try to make the image look a little more like marble. (102)] The "stuff" of which Perón's portrait is made functions as a metaphor of majesty and firmness, but also connotes fixity and coldness. To add marble to the portrait also points towards the tridimensional nature of sculpture and architecture, and more specifically, to national monuments and funerary statues.[76] Also, in his interview with Zamora, the character Martínez describes Perón in terms of a raw material—"Es un hombre de mercurio" (259) [He is a man of mercury

(257)]—implying a lack of substance and feelings in Perón, as well as malleability and elusiveness (mercury is also a poisonous substance).[77] In the same passage, the visual arts provide yet another metaphor: Perón, according to Martínez, "carece de dibujo" [has no contours], an ironic statement from the author of a novel devoted to painting, profiling, or x-raying Argentina's foremost leader.[78]

The reference to portraiture in the quotation above is particularly meaningful. As a written portrait, the thrust of the novel is to produce and assemble a set of images that would encode the life of the General. In the variety of interactions in which they are engaged, words and images collaborate with and compete against each other. Ekphrastic strategies pit the visual against the verbal, as in the passage where Martínez uses a photograph as a piece of evidence contradicting a statement by Perón. In other cases, they point towards the same goal: words can be used to describe a destiny, while images can be made to sketch it.

One of the basic assumptions of the novel is that the truth about a character is found in visual artifacts that picture—or try to picture—his or her essence.[79] There is no better example of this use of imagery than the poster of Perón included in *Horizonte*. This is also the best example of the fictionalization of a fiction that is turned on its head and thereby stands as undisputed truth.

Nun Antezana, on his way to the command centre, picks up a copy of the magazine at a newsstand. Again the whole title is mentioned—"Perón: His Entire Life / Documents and Photos of One Hundred Witnesses"—reinforcing the magnificent, almost epic achievement of Argentine journalism in the wake of Perón's return. At this point we learn that the issue contains "un poster gigante del susodicho, sonriente como un águila guerrera" (68) [a giant poster of the aforementioned, smiling like a warrior eagle (62)].[80] It is ironic that Antezana, the leader of the guerrilla cell, is the character presenting the reader with the poster: Perón's smile and majestic gesture can be read as a bad omen. In light of the upcoming massacre of leftist groups at Ezeiza, Perón's pose is indeed sarcastic.

The poster is both portable and imposing, combining features of the conventional standard-size photograph and the public billboard. While its mention in the plot can be read as a narrative fold, opening up the possibility of new storylines, the poster itself is literally folded into the magazine. Presumably stapled at the very centre of the verbal/visual artifact in

which it is embedded, this single image aspires to synthesize the life and myth of Perón in one graphic stroke, much as the readers of the magazine will consider the poster as a visual summary of the verbal description of events, memories, and anecdotes. The poster is a gift or supplement that happens to function as the ultimate emblem of its subject.

The mention of an eagle endows the image with mythical power and, as already noted, references a powerful symbol of national culture. It enhances the scope of Perón's stature, as if the description was a matter of course or a widely accepted assessment, and not an individual opinion. The "águila guerrera" also points to the tradition of war posters dating from the World War I,[81] as well as to the symbols and iconography of twentieth-century authoritarian regimes.[82] The reference to the gigantic size of the poster reinforces the impression of a larger-than-life personality. The large-format reproduction resonates with the banners and spectacular images placed in the streets in preparation for the president's arrival. Moreover, it is probable that the very poster included in the magazine is the one that the weavers of Pergamino hang and venerate when Perón dies (though no explicit link is made in the text). The image of the warrior eagle also parallels the fact that Perón, in the present of the diegesis, is flying on his way to Argentina. In light of the events and the profile of the aging Perón, the poster of a victorious effigy transpires both irony and sadness.

In conclusion, the ekphrastic strategies used in the novel endow the photographic image with a prominent role in the production of meaning and the struggles in the politics of representation. Even though words and images are mutually implicated in the representation of the world and are both prone to distortion and manipulation, images tend to function as "the last word" on a person or event. They are like seals of permanence, lending consistency to the fleetingness of events and personal decay as well as providing an anchor for the unbounded proliferation of representations. Michel Frizot refers to the evidentiary power of photographs as "the authenticity of a typological model."[83] Both in the fictitious space of the novel and in the general economy of representations of our visual culture, photographic images serve as visual epigrams through which a person's essence is fixed, emblematized, and remembered.[84]

A final point can be made about the pertinence of not including actual photographic images in the book. The authorial and editorial decision to exclude pictures of the protagonists—especially the widely photographed

Perón and Evita—enhances rather than weakens the fictional impact of the work (as opposed to its testimonial and reportorial dimensions). While constantly creating in the reader the illusion of looking—and looking at people looking—at visual signs charged with meaning, the text forces the reader to fill in the spaces and picture by herself the array of photographic allusions. As this section has shown, this ekphrastic strategy is not incidental, but a fundamental aspect of the novel. The frequency, density, and scope of the descriptions of photographic images foreground the increasing importance of the interactions among heterogeneous means of representation. Beyond the formalist commonplace that holds that literary texts always allude to other literary texts, *La novela de Perón* points to an emerging visual culture and media environment that traditional literary studies have overlooked, as W. J. T. Mitchell points out.[85] By setting a stage on which word and image constantly cooperate, compete, and contradict, the novel exemplifies how—in an historical age where the mechanically reproduced image has pervaded all aspects of culture—the construction of historical figures, the unfolding of political struggles, and the mediation between personal experience and social context are inextricably bound to the realm of visual communication.

CONCLUSION

We are on the cusp of an epochal change that is witness to the digitalization of picture making, the convergence of verbal, visual, and aural media in new supports and platforms that eschew paper in favour of electronic devices, and the consolidation of new forms of production, distribution, and storage of information in the computerization of everyday life. These developments seem to put a definitive end to the "Age of the Photograph," to use an expression Barthes coined three decades ago and was already investing with a mournful aura.[1] As Mulvey points out, by the 1990s "the digital, as an abstract information system, made a break with analogue imagery, finally sweeping away the relation with reality, which had, by and large, dominated the photographic tradition."[2] The current crisis of the photographic sign may perhaps be its last, but it should be pointed out that photography has had many deaths since its inception. Even today, when film photography is in its last throes, we still speak of digital *photography*, thus keeping alive its *noeme* (to use Barthes' term) and thus preserving not an "essence" but a cluster of practices of image production and dissemination, above and beyond its many specific incarnations.

While the photograph has lost the currency it once enjoyed as a cultural token and key metaphor, the need to fix images has not and will not disappear with the emergence of video and digital technologies. Moreover, photographs, in whatever form they may be created and distributed, will still be a privileged means by which to relate to past events and document

the present—to fulfill the abiding human need to make sense of our existence through time.

Only when a cultural epoch fades and a new one emerges are the displaced (but not yet forgotten) cultural institutions, practices, and assumptions of the old cultural regime brought into sharper relief. The case studies in this book are meant to help us better understand this historical shift in modern media by analyzing literary texts in the context of the visual culture of their times.

Photography's many uses are reflected, and put into creative use, in the literature created during the medium's inception, development, growth, and decline, as the anthologies assembled by Jane M. Rabb show. The wealth of texts I have explored attests to the productive interactions between Latin American literature and photography in the twentieth century. This creative dialogue indicates that many canonical writers show an interest in this visual medium, and it shows the variety of imaginative approaches that they employ to achieve their literary effects.

The historical arc spanning from Darío's "spiritual" critique of modern visual technology at the end of the nineteenth century to Tomás Eloy Martínez's realist rendition of photography's many uses and instances covers a broad panorama of twentieth-century visual culture, showing photography's productive interactions with other technologies of representation (X-rays, cinema, television), communication media (print journalism), and a variety of social and cultural practices, from portraiture and family albums to travel photography.

While each chapter highlighted a number of concerns common among the featured authors, the overarching thread that unites the texts is this: photography is a medium that, when rendered in works of literature, constantly strives to surpass its representational bounds. From Darío's, Cortázar's, and Elizondo's fantastic or uncanny plunging into the menacing depths of the body or the mind, to Rulfo's, Piñera's, and Martínez's use of photographs as narrative folds (visual signs within a story that codify and trigger more stories), photography is endowed with an excess of signification. In this sense, photographs—ekphrastically constructed—encapsulate a power that strives to transcend the verbal context that makes them possible. More often than not, with their power to convince, fascinate, excite, or haunt, they function as representations of last resort.

What is the future of the photographic motif in literature when "traditional" practices and institutions of the medium are being phased out, if not already obsolete? We have seen the migration of paper-based images to computer screens, the rise of Photoshop effects that make a painterly palette of a photographic image, and the bankruptcy of enterprises such as Eastman Kodak, the iconic company closely associated with the rise and dissemination of photography as an everyday practice in modern times.[3]

Brunet considers the movement towards autofiction, "a genre of fictionalized autobiography often accompanied by photographs," as a shift in the hybridization of literature and photography in recent decades.[4] This trend has gained prominence since the 1980s and is epitomized by the commercial and critical success of writers such as W. G. Sebald. However, Brunet notes, "it is too early to tell whether they signal a durable pattern, especially as cyberliterature starts to offer another, more radical, alternative to traditional fiction writing."[5]

Works by Latin American novelists address the question of the place of photography in narrative fiction in the twenty-first century. *Sueños digitales* (2000), by Edmundo Paz-Soldán, is a case in point. The novel centres on Sebastián, a graphic designer who works for a newspaper in the fictitious city of Río Fugitivo, in an unnamed South American country. He has abandoned photography altogether, mastering instead the marvels of Photoshop. His main accomplishment is the creation of digital collages that fuse incongruous personalities through their body parts, such as the head of Che Guevara grafted onto the body of Raquel Welch. Eventually his skills get noticed by the Ministry of Information, and he is recruited to alter the visual record of the authoritarian regime and present a sanitized historical version of the dictator Montenegro. Along with a love story that goes sour, the plot of political intrigue and personal alienation will leave Sebastián in a wasteland and, ultimately, lead him to suicide. From the personal and intimate to the collective and political, the photographic image in *Sueños digitales* becomes too pliable a tool. The novel explores the new management of images in Latin America's peripheral modernity in a moment of cultural transition dominated by neoliberal policies. It could be framed in terms of Paz-Soldán's own commentary on the seminal novel *La invención de Morel* (1940), by Adolfo Bioy Casares. Paz-Soldán writes that the aim of the novel in the twenty-first century could be, given the new challenges facing literary fiction, to "redefinirse como

un instrumento narrativo capaz de representar la multiplicidad de medios presente en la sociedad contemporánea, como una práctica discursiva que puede ayudar a entender la relación del individuo con este cambiante universo mediático" [redefine itself as a narrative instrument able to represent the multiplicity of media in contemporary culture, as a discursive practice that can help understand the relation between the individual and that changing media universe].[6]

Sueños digitales is a contribution in this direction.[7] However, while the novel captures the anxieties, dislocations, and melancholy ushered in by a new media environment, it is perhaps too much a novel of manners, too aware of "the way we live now," too close to the events and moods it purports to document. Some cultural distance may be needed before delving into a more subtle or imaginative literary exploration of our rapidly changing technological age.

It would be unwise to forecast the shape that interactions between literary word and photographic image will take in the digital age. However, if an assessment can be ventured, it is this: the future of photography as a literary motif lies in its multifaceted past, in its perhaps inextricable relation to nostalgia, history, and visual discovery.[8] On the one hand, readers and scholars will find plenty of photographs written in the texts of authors, big and small, who worked in the historical period bracketed by the invention of photography, in the first third of the nineteenth century, and its gradual demise, at the end of the twentieth. Like so many shoebox collections hidden in chests and closets, this wealth of textual photographs will become an abiding source of discovery, mystery, awe, and interpretation. On the other hand, the massive photographic archive of the nineteenth and twentieth centuries will provide plenty of inspiration and ideas to writers who wish to weave stories around photographs and photographers. This need not be restricted to the medium's indexical or documentary nature, but it will allow new imaginative directions. A canonical text provides a case in point. Its use of photography, seemingly marginal, nonetheless plays an important role in the narrative. Moreover, while literally or historically mistaken, its reference to photography can be considered a stroke of literary insight. In *Aura* (1962), Carlos Fuentes weaves a fantastic story about the preservation of life against the ravages of time. Consuelo Llorente lures a young historian, Felipe Montero, into her darkened abode in downtown Mexico City in order to make him write the story of her late husband,

magically conjuring both his spirit and her lost youth. By the end of this task of writing the life of General Llorente—all the while fascinated by the alluring presence of Aura (the emanation of Consuelo herself)—Felipe finds in Consuelo's trunk a trove of photographs. This is a key moment in the story. The manifest wish of Consuelo is to persuade Felipe to write and publish her husband's memoirs, but his textual discovery comes to an end when he finds these visual documents of Consuelo and the general. The moment of anagnorisis comes when he sees himself pictured in the old images of General Llorente. In this sense, the photograph functions as a magical mirror that reveals a shocking, overwhelming reality:

> Y detrás de la última hoja, los retratos de ese caballero anciano, vestido de militar: la vieja fotografía con las letras en una esquina: *Moulin, Photographe, 35 Boulevard Haussmann* y la fecha 1894. Y la fotografía de Aura: de Aura con sus ojos verdes. . . . Aura y la fecha 1876, escrita con tinta blanca y detrás, sobre el cartón doblado del daguerrotipo, esa letra de araña: *Fait pour notre dixième anniversaire de mariage* y la firma, con la misma letra, *Consuelo Llorente*. Verás, en la tercera foto, a Aura en compañía del viejo, ahora vestido de paisano, sentados ambos en una banca, en un jardín. La foto se ha borrado un poco: Aura no se verá tan joven como en la primera fotografía, pero es ella, es él, es . . . eres tú. (58)

> [And after the last page, the portraits. The portrait of an elderly gentleman in a military uniform, an old photograph with these words in one corner: "*Moulin, Photograph, 35 Boulevard Haussmann*" and the date "*1894.*" Then the photograph of Aura, of Aura with her green eyes. . . . Aura and the date "*1876*" in white ink, and on the back of the daguerreotype, in spidery handwriting: "*Fait pour notre dixième anniversaire de mariage,*" and a signature in the same hand, "*Consuelo Llorente.*" In the third photograph you see both Aura and the old gentleman, but this time they're dressed in outdoor clothes, sitting on a bench in a garden. The photograph has become a little blurred: Aura doesn't look as young

as she did in the other picture, but it's she, it's he, it's . . . it's you. (135–37)][9]

The narrator mentions a daguerreotype, which could be read as a metonymy for any old photograph, but taken in its strict sense its use is a blatant anachronism. The production of daguerreotypes had been totally discarded and replaced by less cumbersome and more affordable techniques well before 1876, when the couple's photograph was supposedly taken. However, the mistaken reference is interesting within the context of the story. In a text that explores the prodigious possibility of survival beyond the normal span of a lifetime, the daguerreotype becomes the visual token of a past that does not die, of a past where even discarded technologies are still in use. Even more, daguerreotypes were made of shiny metal sheets on which viewers could see, at a certain angle, their own features reflected, as in a mirror. In this sense, nothing is more suited to picture Felipe's moment of truth than the visual dialectics afforded by a daguerreotype.

While photography's epistemic claims are now diminished, its traditionally salient aspects—its referential power and its visual impact—will still inspire writers to summon the past and keep telling stories.

BIBLIOGRAPHY

Alatorre, Antonio. "La *persona* de Juan Rulfo." *Casa del tiempo* 7, no. 82 (2005): 45–52.
Aldarondo, Hiram. *El humor en la cuentística de Silvina Ocampo*. Madrid: Editorial Pliegos, 2004.
Allende, Isabel. *Paula*. Barcelona: Plaza y Janés, 1994.
Alonso, Carlos J. *The Burden of Modernity: The Rhetoric of Cultural Discourse in Spanish America*. New York: Oxford University Press, 1998.
Amelunxen, Hubertus von, Stefan Iglhaut, and Florian Rötzer, eds. *Photography after Photography: Memory and Representation in the Digital Age*. [Amsterdam]: G+B Arts, 1996.
Amorím, Enrique. "La fotografía." In *Antología crítica del cuento hispanoamericano del siglo XX*. vol. 1, texts selected by José Miguel Oviedo, 97–101. Madrid: Alianza Editorial, 1992.
Anderson, Thomas F. *Everything in Its Place: The Life and Works of Virgilio Piñera*. Lewisburg, PA: Bucknell University Press, 2006.
Anderson Imbert, Enrique. *La originalidad de Rubén Darío*. Buenos Aires: Centro Editorial de América Latina, 1967.
———. "Rubén Darío and the Fantastic Element in Literature." In *Rubén Darío Centennial Studies*, edited by Miguel Gonzalez-Gerth and George D. Schade, 97–117. Austin: Dept. of Spanish and Portuguese, Institute of Latin American Studies, University of Texas at Austin, 1970.
Ansón, Antonio. *Novelas como álbumes: Fotografía y literatura*. Murcia: Mestizo A.C., 2000.
Baer, Ulrich. *Spectral Evidence: The Photography of Trauma*. Cambridge, MA: MIT Press, 2002.
Bakhtin, Mikhail. "Discourse in the Novel." In *The Dialogic Imagination*, edited by Michael Holquist, translated by Caryl Emerson and Michael Holquist, 259–422. Austin: University of Texas Press, 1981.

Balderston, Daniel. "Los cuentos crueles de Silvina Ocampo y Juan Rodolfo Wilcock." *Revista Iberoamericana* 125, no. 49 (1983): 743-52.
———. "Lo grotesco en Piñera: Lectura de 'El álbum.'" *Texto crítico* 34-35 (1987): 174-78.
———. "The Twentieth-Century Short Story in Spanish America." In *The Cambridge History of Latin American Literature*, vol. 2, edited by Roberto González Echevarría and Enrique Pupo-Walker, 465-96. Cambridge: Cambridge University Press, 1996.
Baler, Pablo. *Los sentidos de la distorsión*. Buenos Aires: Ediciones Corregidor, 2008.
Barnicoat, John. *A Concise History of Posters: 1870-1970*. New York: Harry N. Abrams, 1972.
Barthes, Roland. *Camera Lucida*. Translated by Richard Howard. New York: Farrar, Straus and Giroux, 1981.
———. "The Photographic Message." In *Image Music Text*, translated by Stephen Heath, 15-31. New York: Farrar, Straus and Giroux, 1977.
———. "Rhetoric of the Image." In *Image Music Text*, translated by Stephen Heath, 32-51. New York: Farrar, Straus and Giroux, 1977.
Bartsch, Shadi, and Jaś Elsner. "Introduction: Eight Ways of Looking at an Ekphrasis." *Classical Philology* 102, no. 1 (January 2007): 1-6.
Bataille, Georges. "Eye." In *Visions of Excess: Selected Writings, 1927-1939*, translated by Allan Stoekl, with Carl R. Lovitt and Donald M. Leslie, Jr., 17-19. Minneapolis: University of Minnesota Press, 1985.
———. *Les larmes d'Eros*. Paris: Jean-Jacques Pauvert, 1961.
Baudelaire, Charles. *Fleurs du Mal*. Translated by Richard Howard. Boston: David R. Godine, 1982.
———. "L'Etranger." In *Le Spleen de Paris: Œuvres complètes*, 231. Paris: Gallimard, 1961.
Bazin, André. "The Ontology of the Photographic Image." In *What Is Cinema?*, vol. 1, translated by Hugh Gray, 9-16. Berkeley: University of California Press, 1967.
Becquer Casaballe, Amado, and Miguel Angel Cuarterolo. *Imágenes del Río de la Plata: Crónica de la fotografía rioplatense, 1840-1940*. 2nd ed. Buenos Aires: Editorial del Fotógrafo, 1985.
Bellatín, Mario. *Shiki Nagaoka: Una nariz de ficción*. Buenos Aires: Editorial Sudamericana, 2001.
Belting, Hans. *Likeness and Presence: A History of the Image before the Era of Art*. Translated by Edmund Jephcott. Chicago: University of Chicago Press, 1994.
———. "Toward an Anthropology of the Image." In *Anthropologies of Art*, edited by Mariët Westermann, 41-58. Williamstown, MA: Sterling and Francine Clark Art Institute, 2005.
Benítez, Fernando. "Conversaciones con Juan Rulfo." In *Juan Rulfo: Homenaje nacional*, 11-18. Mexico City: Instituto Nacional de Bellas Artes y Secretaría de Educación Publica, 1980.
Benjamin, Walter. "On Some Motifs in Baudelaire." In *Illuminations*, edited by Hannah Arendt, translated by Harry Zohn, 155-200. New York: Schocken Books, 1968.

——. "The Work of Art in the Age of Mechanical Reproduction." In *Illuminations*, edited by Hannah Arendt, translated by Harry Zohn, 217–51. New York: Schocken Books, 1968.
Berger, John. *About Looking*. New York: Pantheon Books, 1980.
Billeter, Erika. "Juan Rulfo: Imágenes del recuerdo." In *México: Juan Rulfo fotógrafo*, 39–43. Barcelona: Lunwerg Editores, 2001.
Bioy Casares, Adolfo. *La aventura de un fotógrafo en La Plata*. Buenos Aires: Emecé Editores, 1985.
——. *La invención de Morel*. Madrid: Ediciones Cátedra, 1984.
Black, Alexander. "The Amateur Photographer." In *Photography: Essays and Images. Illustrated Readings in the History of Photography*, edited by Beaumont Newhall, 149–53. New York: Museum of Modern Art, 1980.
Bolaño, Roberto. *Los detectives salvajes*. Barcelona: Anagrama, 1998.
——. *Estrella distante*. Barcelona: Anagrama, 1996.
——. "Fotos." In *Putas asesinas*, 197–205. Barcelona: Anagrama, 2001.
Borges, Jorge Luis. "El Aleph." In *El Aleph: Obras completas*, vol. 1, 617–27. Buenos Aires: Emecé Editores, 1996.
——. "El milagro secreto." In *Ficciones: Obras completas*, vol. 1, 508–13. Buenos Aires: Emecé Editores, 1996. Translated by Andrew Hurley as "The Secret Miracle" in *Collected Fictions* (New York: Penguin Books, 1998), 157–62.
——. "La otra muerte." In *El Aleph: Obras completas*, vol. 1, 571–575. Buenos Aires: Emecé Editores, 1996.
——. "Tlon, Uqbar, Orbis Tertius." In *Ficciones: Obras completas*, vol. 1, 431–43. Barcelona: Emecé Editores, 1996.
——. "El zahir." In *El Aleph: Obras completas*, vol. 1, 589–95. Barcelona: Emecé, 1996.
Bourdieu, Pierre. "The Cult of Unity and Cultivated Differences." In *Photography: A Middle-Brow Art*, translated by Shaun Whiteside, 13–72. Cambridge: Blackwell, 1990.
Bradu, Fabienne. "Ecos de Páramo." In *La ficción de la memoria: Juan Rulfo ante la crítica*, edited by Federico Campbell, 215–41. Mexico City: Universidad Nacional Autónoma de México / ERA, 2003.
Brennan, Teresa. "'The Contexts of Vision' from a Specific Standpoint." In *Vision in Context: Historical and Contemporary Perspectives on Sight*, edited by Teresa Brennan and Martin Jay, 217–28. New York: Routledge, 1996.
Brignole, Alberto J., and José M. Delgado. *Vida y obra de Horacio Quiroga*. Montevideo: Claudio García, 1939.
Brook, Timothy, Jérôme Bourgon, and Gregory Blue. *Death by a Thousand Cuts*. Cambridge, MA: Harvard University Press, 2008.
Brooks, Peter. *Body Work: Objects of Desire in Modern Narrative*. Cambridge, MA: Harvard University Press, 1993.
Brunet, François. *Photography and Literature*. London: Reaktion, 2009.
Bryant, Marsha, ed. *Photo-Textualities: Reading Photographs and Literature*. Newark: University of Delaware Press / London: Associated University Presses, 1996.
Burgin, Victor. *Thinking Photography*. London: Macmillan, 1982.
Cabrera Infante, Guillermo. *Tres tristes tigres*. Barcelona: Seix Barral, 1981.

Cadava, Edward. *Words of Light: Theses on the Photography of History*. Princeton, NJ: Princeton University Press, 1997.
Campbell, Federico. "Prólogo." In *La ficción de la memoria: Juan Rulfo ante la crítica*, edited by Federico Campbell, 11–16. Mexico City: Universidad Nacional Autónoma de México / ERA, 2003.
Canfield, Martha L. "Transformación del sitio: verosimilitud y sacralidad de la selva." In *Todos los cuentos*, by Horacio Quiroga, edited by Napoleón Baccino Ponce de León and Jorge Laforgue, 1360–78. Madrid: ALCA XX / Fondo de Cultura Económica, 1996.
Capa, Cornell, ed. *The Concerned Photographer: The Photographs of Werner Bischof, Robert Capa, David Seymour ("Chim"), André Kertész, Leonard Freed, and Dan Weiner*. New York: Grossman, 1968.
Cardenal, Ernesto. *Las ínsulas extrañas: Memorias 2*. Madrid: Editorial Trotta, 2002.
Cartier-Bresson, Henri. *The Mind's Eye: Writings on Photography and Photographers*. New York: Aperture, 1999.
Casanova, Rosa, and Olivier Debroise. *Sobre la superficie bruñida de un espejo: Fotografía del siglo XIX*. Mexico City: Fondo de Cultura Económica, 1989.
Cavell, Stanley. *The World Viewed: Reflections on the Ontology of Film*. Cambridge, MA: Harvard University Press, 1979.
Chejfec, Sergio. *Los planetas*. Buenos Aires: Alfaguara, 1999.
Cioran, Émile M. *A Short History of Decay*. Translated by Richard Howard. New York: Viking Press, 1975.
Clark D'Lugo, Carol. *The Fragmented Novel in Mexico*. Austin: University of Texas Press, 1997.
Colás, Santiago. *Postmodernity in Latin America: The Argentine Paradigm*. Durham, NC: Duke University Press, 1994.
Coleman, A. D. "Documentary, Photojournalism, and Press Photography Now: Notes and Questions." In *Depth of Field: Essays on Photography, Mass Media, and Lens Culture*, 35–52. Albuquerque: University of New Mexico Press, 1998.
Colina, José de la. "Susana San Juan: El mito femenino en Pedro Páramo." In *La ficción de la memoria: Juan Rulfo ante la crítica*, edited by Federico Campbell, 55–60. Mexico City: Universidad Nacional Autónoma de México / ERA, 2003.
Collins, Jo, and John Jervis. "Introduction." In *Uncanny Modernity: Cultural Theories, Modern Anxieties*, edited by Jo Collins and John Jervis, 1–9. New York: Palgrave Macmillan, 2008.
Cortázar, Julio. "Acerca de la manera de viajar de Atenas a Cabo Sunion." In *La vuelta al día en ochenta mundos*, vol. 1, 13th paperback ed., 95–98. Madrid: Siglo XXI Editores, 1979.
———. "Album con fotos." In *Ultimo round*, vol. 1, 7th paperback ed., 156–57. Mexico City: Siglo XXI editores, 1984.
———. "Algunos aspectos del cuento." 1962–1963. Reprinted in *Obra crítica*, vol. 2, edited by Jaime Alazraki, 365–84. Mexico City: Alfaguara, 1994.
———. *Alto el Perú*. With photographs by Manja Offerhaus. Mexico City: Editorial Nueva Imagen, 1984.
———. "Apocalipsis de Solentiname." In *Alguien que anda por ahí y otros relatos: Cuentos completos*, vol. 2, 155–60. Mexico City: Alfaguara, 1996. Translated by

Gregory Rabassa as "Apocalypse at Solentiname" in *A Change of Light and Other Stories* (New York: Alfred A. Knopf, 1980), 119–27.

———. *Buenos Aires, Buenos Aires*. With photographs by Sara Facio and Alicia D'Amico. Buenos Aires: Editorial Sudamericana, 1968.

———. "Carta del viajero." In *Territorios*, 136–41. Mexico City: Siglo XXI editores, 1979.

———. *Cartas 1937–1983*. Edited by Aurora Bernárdez. 3 vols. Buenos Aires: Alfaguara, 2000.

———. *Clases de literatura: Berkeley, 1980*. Edited by Carles Álvarez Garriga. Mexico City: Alfaguara, 2013.

———. "Del sentimiento de no estar del todo." In *La vuelta al día en ochenta mundos* vol. 1, 13th paperback ed., 32–42. Madrid: Siglo XXI editores, 1979.

———. "El ídolo de las Cícladas." In *Final del juego: Cuentos completos*, vol. 1, 329–35. Mexico City: Alfaguara, 1996.

———. "En vista del éxito obtenido, o los piantados firmes como fierro." In *Ultimo round*, vol. 1, 7th paperback ed., 224–47. Mexico City: Siglo XXI editores, 1984.

———. "Estrictamente no profesional." In *Territorios*, 91–100. Mexico City: Siglo XXI editores, 1979.

———. "La muñeca rota." In *Ultimo round*, vol. 1, 7th paperback ed., 248–71. Mexico City: Siglo XXI editores, 1984.

———. "Las babas del diablo." In *Las armas secretas. Cuentos completos*, vol. 1, 214–24. Mexico City: Alfaguara, 1996. Translated by Paul Blackburn as "Blow-Up" in *Blow-Up and Other Stories* (New York: Pantheon, 1985), 114–31.

———. *Libro de Manuel*. Mexico City: Alfaguara, 1994. Translated by Gregory Rabassa as *A Manual for Manuel* (New York: Pantheon Books, 1978).

———. "Luz negra." In *Papeles inesperados*. Edited by Aurora Bernárdez and Carles Alvarez Garriga, 397–98. Mexico City: Alfaguara, 2009.

———. *París, ritmos de una ciudad*. Photographs by Alecio de Andrade. Barcelona: Edhasa, 1981.

———. *Prosa del observatorio*. Barcelona: Lumen, 1972.

———. *Rayuela*. Critical ed. by Julio Ortega. Nanterre, France: ALLCA XXe., 1991.

———. *Territorios*. Mexico City: Siglo XXI editores, 1979.

———. "Turismo aconsejable." In *Ultimo round*, vol. 1, 7th paperback ed., 123–46. Mexico City: Siglo XXI editores, 1984.

———. *Ultimo round*. vols. 1 and 2. 7th paperback ed.. Mexico City: Siglo XXI editores, 1984.

———. "Vuelta al día en el Tercer Mundo." In *La vuelta al día en ochenta mundos*. vol. 2. 13th paperback ed., 114–19. Madrid: Siglo XXI editores, 1979.

———. *La vuelta al día en ochenta mundos*. 13th paperback ed.. Madrid: Siglo XXI editores, 1979.

——— and Carol Dunlop. *Los autonautas de la cosmopista o un viaje atemporal París—Marsella*. Buenos Aires: Muchnik editores, 1983.

Crary, Jonathan. *Techniques of the Observer: On Vision and Modernity in the Nineteenth Century*. Cambridge, MA: MIT Press, 1992.

Cristofani Barreto, Teresa. "Los cuentos fríos de Virgilio Piñera." *Hispamérica* 24, no. 71 (1995): 23–33.

Cross, F. L., and E. A. Livingstone, eds. "Lourdes." *The Oxford Dictionary of the Christian Church*, 3rd ed., 998–99. London: Oxford University Press, 1997.
Curley, Dermot. *En la isla desierta: Una lectura de la obra de Salvador Elizondo*. Mexico City: Fondo de Cultura Económica, 1989
Darío, Rubén. *Autobiografía: Oro de Mallorca*. Madrid: Mondadori, 1990.
———. *Crónicas desconocidas: 1901–1906*. Critical ed., introduction and notes by Günther Schmigalle. Managua: Academia Nicaragüense de la Lengua / Berlin: Edition Tranvía, 2006.
———. "Diorama de Lourdes." In *Mundo adelante: Obras completas*, vol. 4, 479–84. Madrid: Afrodisio Aguado, 1955.
———. *El mundo de los sueños*. Edited with an introduction and notes by Angel Rama. Barcelona: Editorial Universitaria, 1973.
———. *La caravana pasa*. Book 1. Critical ed., introduction and notes by Günther Schmigalle. Managua: Academia Nicaragüense de la Lengua / Berlin: edition tranvía, 2000.
———. "La extraña muerte de Fray Pedro." In *Cuentos completos*, edited by Ernesto Mejía Sánchez, 397–401. Mexico City: Fondo de Cultura Económica, 1983.
———. "Verónica." In *Cuentos completos*, edited by Ernesto Mejía Sánchez, 416–19. Mexico City: Fondo de Cultura Económica, 1983.
Dávila, María de Lourdes. *Desembarcos en el papel: La imagen en la literatura de Julio Cortázar*. Rosario, Argentina: Beatriz Viterbo Editora, 2001.
da Vinci, Leonardo. *Paragone: A Comparison of the Arts*. With an introduction by Irma A. Richter. Translated by Irma A. Richter. London: Oxford University Press, 1949.
de Armas, Frederick A. "Simple Magic: Ekphrasis from Antiquity to the Age of Cervantes." In *Ekphrasis in the Age of Cervantes*, edited by Frederick A. de Armas, 13–31. Lewisburg, PA: Bucknell University Press, 2005.
Debroise, Olivier. *Fuga mexicana: Un recorrido por la fotografía en México*. Mexico City: Consejo Nacional para la Cultura y las Artes, 1994. Translated in collaboration with the author by Stella de Sá Rego as *Mexican Suite: A History of Photography in Mexico* (Austin: University of Texas Press, 2001).
———, Elisabeth Sussman, and Matthew Teitelbaum. *El corazón sangrante / The Bleeding Heart*. Boston: Institute of Contemporary Art, 1991.
di Bello, Patrizia. "Albums." In *The Oxford Companion to the Photograph*, edited by Robin Lenman and Angela Nicholson. Oxford: Oxford University Press, 2006. doi: 10.1093/acref/9780198662716.001.0001.
Donoso, José. "Santelices." In *Cuentos*, 303–36. Santiago: Alfaguara, 1998.
Dubois, Phillipe. *L'acte photographique*. Brussels: Editions Labor, 1983.
Durán, Manuel. *Tríptico mexicano: Juan Rulfo, Carlos Fuentes, Salvador Elizondo*. Mexico City: SepSetentas / Secretaria de Educación Pública, 1973.
Durand, Régis. "How to See (Photographically)." In *Fugitive Images: From Photography to Video*, edited by Patrice Petro, 141–51. Bloomington: Indiana University Press, 1995.
Elizondo, Salvador. *Autobiografía precoz*. Mexico City: Editorial Aldus, 2000.
———. "De la violencia." In *Cuaderno de escritura: Obras*, vol. 1, 393–96. México City: El Colegio Nacional, 1994.

———. "Ein Heldenleben." In *Camera Lucida: Narrativa completa*, 539–47. Mexico City: Alfaguara, 1997.
———. "El putridero óptico." In *Cuaderno de escritura: Obras*, vol. 1, 399–411. México City: El Colegio Nacional, 1994.
———. *Farabeuf*. In *Narrativa completa*. Mexico City: Alfaguara, 1997. Translated by John Incledon as *Farabeuf* (New York: Garland, 1992).
———. "Francisco Corzas." In *Cuaderno de escritura: Obras*, vol. 1, 413–21. México City: El Colegio Nacional, 1994.
———. "Gironella." In *Cuaderno de escritura*, 67–84. Guanajuato: Universidad de Guanajuato, 1969.
———. "Invocación y evocación de la infancia." In *Cuaderno de escritura: Obras*, vol. 1, 355–73. México City: El Colegio Nacional, 1994.
———. "Los continentes del sueño." In *Cuaderno de escritura: Obras*, vol. 1, 423–30. México City: El Colegio Nacional, 1994.
———. "Mnemothreptos." In *Camera Lucida: Narrativa completa*, 451–60. Mexico City: Alfaguara, 1997.
———. "Morfeo o la decadencia del sueño." *Revista S.NOB*. 7 (October 1962): 2–9. Facsimile ed. Mexico City: Editorial Aldus, 2004.
———. "Teoría mínima del libro." In *Cuaderno de escritura: Obras*, vol. 1, 349–354. México City: El Colegio Nacional, 1994.
Elkins, James. *The Object Stares Back: On the Nature of Seeing*. New York: Simon and Schuster, 1996.
———. "On the Complicity between Visual Analysis and Torture: A Cut-by-Cut Account of *Lingchi* Photographs." In *Representations of Pain in Art and Visual Culture*, edited by Maria Pia Di Bella and James Elkins, 75–87. New York: Routledge, 2013.
———. *Pictures of the Body: Pain and Metamorphosis*. Stanford: Stanford University Press, 1999.
———, and Maria Pia Di Bella. "Preface." In *Representations of Pain in Art and Visual Culture*, edited by Maria Pia Di Bella and James Elkins, 11–13. New York: Routledge, 2013.
Englekirk, John E. *Edgar Allan Poe in Hispanic Literature*. New York: Instituto de las Españas, 1934.
Facio, Sara. *Foto de escritor, 1963/1973*. Buenos Aires: La Azotea Editorial Fotográfica, 1998.
———. *La fotografía en la Argentina desde 1840 a nuestros días*. Buenos Aires: La Azotea Editorial Fotográfica, Buenos Aires, 1995.
——— and Alicia D'Amico. *Retratos y autorretratos*. Buenos Aires: Ediciones Crisis, 1973.
Ferré, Rosario. *Cortázar: El romántico en su observatorio*. San Juan, Puerto Rico: Editorial Cultural, 1990.
Filer, Malva. "Salvador Elizondo and Severo Sarduy: Two Borgesian Writers." In *Borges and His Successors*, edited by Edna Aizenberg, 214–26. Columbia: University of Missouri Press, 1990.
Foster, Hal. *Convulsive Beauty*, Cambridge, MA: MIT Press, 1997.

Foucault, Michel. *Discipline and Punish: The Birth of the Prison*. Translated by Alan Sheridan. New York: Vintage Books, 1995.
Frampton, Hollis. "Impromptus on Edward Weston: Everything in Its Place." *October* 5 (1978): 49–69.
Franco, Jean. "Comic Stripping: Cortázar in the Age of Mechanical Reproduction." In *Julio Cortázar: New Readings*, edited by Carlos J. Alonso, 36–56. Cambridge: Cambridge University Press, 1998.
———. "The Crisis of the Liberal Imagination and the Utopia of Writing." In *Critical Passions: Selected Essays*, edited by Mary Louise Pratt and Kathleen Newman, 257–84. Durham, NC: Duke University Press, 1999.
———. "El viaje al país de los muertos." In *La ficción de la memoria: Juan Rulfo ante la crítica*, edited by Federico Campbell, 136–55. Mexico City: Universidad Nacional Autónoma de México / ERA, 2003.
Fraser, Benjamin. "Problems of Photographic Criticism and the Question of a Truly Revolutionary Image: The Photographs of Mario Algaze, Juan Rulfo, and Manuel Alvarez Bravo." *Chasqui* 33, no. 2 (2004): 104–22.
Fraser, Howard M. *In the Presence of Mystery: Modernist Fiction and the Occult*. Chapel Hill, NC: Dept. of Romance Languages, University of North Carolina, 1992.
Freedberg, David. *The Power of Images: Studies in the History and Theory of Response*. Chicago: University of Chicago Press, 1989.
Freud, Sigmund. "The Uncanny." In *The Standard Edition of the Complete Psychological Works of Sigmund Freud*, vol. 17, translated by James Strachey, 217–56. London: Hogarth, 1955.
Frizot, Michel. "The All-Powerful Eye: The Forms of the Invisible." In *A New History of Photography*, edited by Michel Frizot, 272–92. Cologne: Könemann, 1998.
———. "States of Things: Image and Aura." In *A New History of Photography*, edited by Michel Frizot, 371–85. Cologne: Könemann, 1998.
Fuentes, Carlos. *Aura*. Mexico City: Editorial Era, 1998. Translated by Lysander Kemp as *Aura*. New York: Farrar, Straus and Giroux, 1965.
Gabara, Esther. *Errant Modernism: The Ethos of Photography in Mexico and Brazil*. Durham, NC: Duke University Press, 2008.
Gallo, Max. *The Poster in History*. New York: W. W. Norton, 2001.
Ganduglia, Silvia. "La representacion de la historia en *La novela de Perón*." *Ideologies and Literature: Journal of Hispanic and Lusophone Discourse Analysis* 4, no. 1 (1989): 271–97.
García Canclini, Néstor. *Culturas híbridas: Estrategias para entrar y salir de la modernidad*. Mexico City: Grijalbo, 1990.
García Krinsky, Emma Cecilia, ed. *Imaginarios y fotografía en México: 1839–1970*. Barcelona: Lunwerg, 2005.
García Márquez, Gabriel. *Cien años de soledad*. Madrid: Ediciones Cátedra, 1996. Translated by Gregory Rabassa as *One Hundred Years of Solitude*. New York: Harper Collins, 2003.
———. *La increible y triste historia de la cándida Eréndira y su abuela desalmada*. Barcelona: Editorial Bruguera, 1981.
Garrels, Elizabeth. "El *Facundo* como folletín." *Revista Iberoamericana* 44, no. 143 (1988): 419–47.

Gautrand, Jean-Claude. "Photography in the Spur of the Moment." In *A New History of Photography*, edited by Michel Frizot, 233–41. Cologne: Könemann, 1998.
Genette, Gerard. *Paratexts: Thresholds of Interpretation*. Translated by Jane E. Lewin. Cambridge: Cambridge University Press, 1997.
Gernsheim, Helmut. *Creative Photography: Aesthetic Trends, 1839–1960*. New York: Dover, 1991.
——— and Allison Gernsheim. *The History of Photography: From the Camera Obscura to the Beginning of the Modern Era*. New York: McGraw-Hill, 1969.
Glantz, Margo. "Los ojos de Juan Rulfo." In *México: Juan Rulfo fotógrafo*, 17–21. Barcelona: Lunwerg Editores, 2001.
———. "Poe en Quiroga." In *Aproximaciones a Horacio Quiroga*, compilation by Angel Flores, 93–118. Caracas: Monte Avila editores, 1976.
———. *Repeticiones: Ensayos de literatura mexicana*. Xalapa, Mexico: Universidad Veracruzana, 1979.
Goldberg, Vicky. *The Power of Photography: How Photography Changed Our Lives*. New York: Abbeville, 1991.
Golden, Eve. *Golden Images: 41 Essays on Silent Film Stars*. Jefferson, NC: McFarland, 2001.
Goloboff, Mario. *Julio Cortázar: La biografía*. Buenos Aires: Seix Barral, 1998.
González, Aníbal. *Journalism and the Development of Spanish American Narrative*. Cambridge: Cambridge University Press, 1993.
González Aktories, Susana, and Irene Artigas Albarelli, eds. *Entre artes entre actos: Ecfrasis e intermedialidad*. Mexico City: Universidad Nacional Autónoma de México / Bonilla Artigas Editores, 2011.
González Echevarría, Roberto. "*Los reyes*: Mitología de la obra literaria de Cortázar." In *Julio Cortázar: La isla final*, edited by Jaime Alazraki, Ivar Ivask and Joaquín Marco, 199–221. Barcelona: Ultramar Editores, 1989.
Gorodischer, Angélica. "La cámara oscura." In *Técnicas de supervivencia*, 89–105. Rosario: Editorial Municipal, 1994.
Grenville, Bruce, ed. *The Uncanny: Experiments in Cyborg Culture*. Vancouver: Vancouver Art Gallery / Arsenal Pulp Press, 2001.
———. "The Uncanny: Experiments in Cyborg Culture." In *The Uncanny: Experiments in Cyborg Culture*, edited by Bruce Grenville, 13–48. Vancouver: Vancouver Art Gallery / Arsenal Pulp Press, 2001.
Grossvogel, David I. "Blow-Up: The Forms of an Esthetic Itinerary." *Diacritics* 2, no. 3 (Fall 1972): 49–54.
Grote, Heiner. "Lourdes." In *The Encyclopedia of Christianity*, vol. 3, edited by Erwin Fahlbusch et al., translated by Geoffrey W. Bromiley, 339. Grand Rapids: Wm. B. Eerdmans/Leiden, Netherlands: Brill, 1999.
Grundberg, Andy. *Crisis of the Real: Writings on Photography*. New York: Aperture, 1999.
Gubern, Román. *Patologías de la imagen*. Barcelona: Anagrama, 2004.
Guerrero, Fernando. *Farabeuf a través del espejo*. Mexico City: Ediciones Casa Juan Pablos, 2001.
Gumbrecht, Hans Ulrich. *In 1926: Living at the Edge of Time*. Cambridge, MA: Harvard University Press, 1997.

Gunning, Tom. "Phantom Images and Modern Manifestations: Spirit Photography, Magic Theater, Trick Films, and Photography's Uncanny." In *Fugitive Images: From Photography to Video*, edited by Patrice Petro, 42–71. Bloomington: Indiana University Press, 1994.

———. "Uncanny Reflections, Modern Illusions: Sighting the Modern Optical Uncanny." In *Uncanny Modernity: Cultural Theories, Modern Anxieties*, edited by Jo Collins and John Jervis, 68–90. New York: Palgrave Macmillan, 2008.

Gutiérrez Mouat, Ricardo. "'Las babas del diablo': Exorcismo, traducción, voyeurismo." In *Los ochenta mundos de Cortázar: Ensayos*, edited by Fernando Burgos, 37–46. Madrid: EDI, 1987.

Habra, Hedy. "Recuperación de la imagen materna a la luz de elementos fantásticos en *Pedro Páramo*." *Chasqui* 33, no. 2 (2004): 90–103.

Hagstrum, Jean. *The Sister Arts: The Tradition of Literary Pictorialism and English Poetry from Dryden to Gray*. Chicago: University of Chicago Press, 1958.

Hahn, Oscar. *El cuento fantástico hispanoamericano en el siglo XIX. Estudios y textos*. Mexico City: Ediciones Coyoacán, 1997.

Halperín Donghi, Tulio. "El presente transforma el pasado: El impacto del reciente terror en la imagen de la historia argentina." In *Ficción y política: La narrativa argentina durante el proceso militar*, 71–95. Buenos Aires: Alianza / Minneapolis: Institute for the Study of Ideologies and Literature, University of Minnesota, 1987.

Hammond, Anne. "Naturalistic Vision and Symbolist Image: The Pictorial Impulse." In *A New History of Photography*, edited by Michel Frizot, 293–309. Cologne: Könemann, 1998.

Heath, Stephen. *The Nouveau Roman: A Study in the Practice of Writing*. Philadelphia: Temple University Press, 1972.

Heffernan, James A. W. *Museum of Words: The Poetics of Ekphrasis from Homer to Ashbery*. Chicago: University of Chicago Press, 1993.

———. "Preface." In *Space, Time, Image, Sign: Essays on Literature and the Visual Arts*, 11–19. New York: Peter Lang, 1978.

Henighan, Stephen. *Sandino's Nation: Ernesto Cardenal and Sergio Ramírez Writing Nicaragua, 1940–2012*. Montreal and Kingston: McGill-Queen's University Press, 2014.

Henríquez Ureña, Max. *Breve historia del modernismo*. Mexico City: Fondo de Cultura Económica, 1954.

Hernández Busto, Ernesto. "Una tragedia en el trópico." Introduction to *El no*, by Virgilio Piñera, 7–25. Mexico City: Editorial Vuelta, 1994.

Hirsch, Marianne, ed. *The Familial Gaze*. Hanover, NH: Dartmouth College, 1999.

———. *Family Frames: Photography, Narrative, and Postmemory*. Cambridge, MA: Harvard University Press, 1997.

Hoffmann, Heinrich. *Struwwelpeter, or, Merry Stories and Funny Pictures*. London: Blackie, [1928?].

Hollander, John. "The Poetics of Ekphasis." *Word and Image* 4 (1988): 209–19.

Holmes, Oliver Wendell. "The Stereoscope and the Stereograph." In *Classic Essays on Photography*, edited by Alan Trachtenberg, 71–82. New Haven, CT: Leete's Island Books, 1980.

Horstkotte, Silke, and Nancy Pedri, eds. "Introduction: Photographic Interventions." *Poetics Today* 29, no. 1 (2008): 1–29.
Hughes, Alex, and Andrea Noble. "Introduction." In *Phototextualities: Intersections of Photography and Narrative*, edited by Alex Hughes and Andrea Noble, 1–16. Albuquerque: University of New Mexico Press, 2003.
Hutcheon, Linda. *The Politics of Postmodernism*. London: Routledge, 1989.
Huysmans, Joris-Karl. *Down There: A Study in Satanism [Là-bas]*. Translated by Keene Wallis. Evanston, IL: University Books, 1958.
Jackson, Rosemary. *Fantasy: The Literature of Subversion*. London: Methuen, 1981.
Jara, René. *Farabeuf: Estrategias de la inscripción narrativa*. Xalapa, Mexico: Universidad Veracruzana, 1982.
Jay, Martin. *Downcast Eyes: The Denigration of Vision in Twentieth-Century French Thought*. Berkeley: University of California Press, 1994.
Jeffrey, Ian, ed. *The Photo Book*. London: Phaidon, 1997.
Jenkins, Henry. *Convergence Culture: Where Old and New Media Collide*. New York: New York University Press, 2006.
Jiménez, José Olivio. "Prólogo." In *Cuentos fantásticos*, by Rubén Darío, 7–23. Madrid: Alianza Editorial, 1976.
Jitrik, Noé. *Horacio Quiroga: Una obra de experiencia y riesgo*. Buenos Aires: Ediciones Culturales Argentinas, 1959.
José, Alan. *Farabeuf y la estética del mal: El tránsito entre realidad y ficción*. Mexico City: Ediciones sin nombre / Consejo Nacional para la Cultura y las Artes, 2004.
Jrade, Cathy Login. "La respuesta dariana a la hegemonía científica." *Crítica hispánica* 27, no. 2 (2005): 161–78.
———. *Rubén Darío and the Romantic Search for Unity: The Modernist Resource to Esoteric Tradition*. Austin: University of Texas Press, 1983.
Jussim, Estelle. *The Eternal Moment: Essays on the Photographic Image*. New York: Aperture, 1989.
———. *Slave to Beauty: The Eccentric Life and Controversial Career of F. Holland Day*. Boston: David R. Godine, 1981.
Kirstein, Lincoln. "Henri Cartier-Bresson." In *The Photographs of Cartier-Bresson*, 1–7. New York: Grossman, 1963.
Kittler, Friedrich A. *Grammophon, Film, Typewriter*. Translated by Geoffrey Winthrop-Young and Michael Wutz. Stanford: Stanford University Press, 1999.
Klingenberg, Patricia Nisbet. *Fantasies of the Feminine: The Short Stories of Silvina Ocampo*. Lewisburg, PA: Bucknell University Press / Associated University Press, 1999.
Kracauer, Siegfried. "Photography." In *The Mass Ornament*, edited and translated by Thomas Y. Levin, 47–63. Cambridge, MA: Harvard University Press, 1995.
Krauss, Rosalind. "Corpus Delicti." *October* 33 (Summer 1985): 31–72.
———. "Notes on the Index: Part I." *The Originality of the Avant-Garde and Other Modernist Myths*, 87–188. Cambridge, MA: MIT Press, 1996.
———. "The Photographic Conditions of Surrealism." *October* 5 (Summer 1978): 48–69.
Krieger, Murray. *Ekphrasis: The Illusion of the Natural Sign*. Baltimore: Johns Hopkins University Press, 1992.

Ladagga, Reinaldo. *Literaturas indigentes y placeres bajos: Felisberto Hernández, Virgilio Piñera, Juan Rodolfo Wilcock*. Rosario, Argentina: Beatriz Viterbo Editora, 2000.
La Nación (Buenos Aires). "La fotografía á través de los cuerpos opacos." 15 February 1896, 6.
———. "Fotografía de lo invisible—Un gran invento (Con motivo de una reciente noticia telegráfica)." 12 February 1896, 3.
———. "Notable descubrimiento—fotografía nunca vista." 8 January 1896, 3.
Langford, Martha. *Suspended Conversations: The Afterlife of Memory in Photographic Albums*. Montreal and Kingston: McGill-Queen's University Press, 2001.
Laplanche, Jean, and J. B. Pontalis. "Trauma (Psychical)." *The Language of Psycho-Analysis*. Translated by Donald Nicholson-Smith, 465–69. New York: Norton, 1973.
Leal, Rine. "Piñera todo teatral." Introduction to *Teatro completo* by Virgilio Piñera. Compilation, arrangement and introduction by Rine Leal, 5–33. Havana: Editorial Letras Cubanas, 2002.
Lemus, Silvia. "El más allá de la escritura: Una entrevista con Salvador Elizondo." *Nexos* 238 (1997): 65–69.
Leys, Ruth. *Trauma: A Genealogy*. Chicago: Chicago University Press, 2000.
Lida, Raimundo. "Los cuentos de Ruben Darío." In *Letras hispánicas*, 200–259. Mexico City: Fondo de Cultura Económica and El Colegio de México, 1981.
Linfield, Susie. *The Cruel Radiance: Photography and Political Violence*. Chicago: University of Chicago Press, 2010.
Linkman, Audrey. *Photography and Death*. London: Reaktion, 2011.
López Estrada, Francisco. *Rubén Darío y la Edad Media*. Barcelona: Editorial Planeta, 1971.
López Velarde, Ramón. "Humildemente." In *Zozobra. Obras*, edited by José Luis Martínez, 180. México: Fondo de Cultura Económica, 1971.
Luciani, Frederick. "The Man in the Car/In the Trees/Behind the Fence: From Cortázar's 'Blow-Up' to Oliver Stone's *JFK*." In *Julio Cortázar: New Readings*, edited by Carlos Alonso, 194–207. Cambridge: Cambridge University Press, 1998.
Lugones, Leopoldo. *Cuentos fantásticos*. Edited by Pedro Luis Barcia. Madrid: Clásicos Castalia, 1987.
———. *El imperio jesuítico*. Buenos Aires: Editorial de Belgrano, 1981.
MacAdam, Alfred. *El individuo y el otro: crítica a los cuentos de Julio Cortázar*. Buenos Aires: La Librería, 1971.
Mackintosh, Fiona J. *Childhood in the Works of Silvina Ocampo and Alejandra Pizarnik*. Woodbridge, UK: Tamesis, 2003.
Mancini, Adriana. *Silvina Ocampo: Escalas de pasión*. Buenos Aires: Grupo Editorial Norma, 2003.
Marien, Mary Warner. *Photography: A Cultural History*. London: Lawrence King, 2002.
Marks, Laura U. *The Skin of the Film: Intercultural Cinema, Embodiment, and the Senses*. Durham, NC: Duke University Press, 2000.
Martin, Gerald. *Journeys through the Labyrinth*. London: Verso, 1989.
Martínez, Patricia. Introduction to *El mirón [Le voyeur]* by Alain Robbe-Grillet, translated by Patricia Martínez. Madrid: Ediciones Cátedra, 1987.

Martínez, Tomás Eloy. "Ficción e historia en *La novela de Perón*." *Hispámerica: Revista de literatura* 17, no. 49 (1988): 41–49.
———. *Lugar común la muerte*. Buenos Aires: Editorial Planeta, 1998.
———. *Las memorias del General*. Buenos Aires: Editorial Planeta, 1996.
———. *La novela de Perón*. Buenos Aires: Editorial Planeta, 1991. Translated by Asa Zatz as *The Perón Novel*. New York: Pantheon, 1988.
———. *Requiem por un país perdido*. Buenos Aires: Aguilar, 2003.
———. *Santa Evita*. Buenos Aires: Editorial Planeta, 1995.
———. *El sueño argentino*. Buenos Aires: Editorial Planeta, 1999.
Matamoro, Blas. *Oligarquía y literatura*. Buenos Aires: Ediciones del Sol, 1975.
McDuffie, Keith. "La novela de Perón: Historia, ficción, testimonio." In *La historia en la literatura iberoamericana: Memorias del XXVI Congreso del Instituto Internacional de Literatura Iberoamericana*, edited by Raquel Chang-Rodríguez and Gabriella de Beer, 296–305. New York: Ediciones del Norte, 1989.
McLuhan, Marshall. *Understanding Media: The Extensions of Man*. Cambridge, MA: MIT Press, 2001.
McMurray, George R. "Salvador Elizondo's 'Farabeuf.'" *Hispania* 50, no. 3 (1967): 596–601.
Meiselas, Susan. *El Salvador: Work of Thirty Photographers*. New York: Writers and Readers, 1983.
———. *Nicaragua: June 1978–July 1979*. New York: Pantheon, 1981.
Méndez, Lenina. "La incursión de Rubén Darío en la literatura de terror." *Espéculo: Revista de estudios literarios* 13, no. 5 (1999). http://www.ucm.es/info/especulo/numero13/rdario.html.
Menton, Seymour. *Latin America's New Historical Novel*. Austin: University of Texas Press, 1993.
Metz, Christian, "Photography and Fetish." In *The Critical Image*, edited by Carol Squiers, 155–64. Seattle: Bay Press, 1990.
Meyer, Pedro. *Verdades y ficciones: Un viaje de la fotografía documental a la digital*. Mexico City: Casa de las Imágenes, 1995.
Meyer-Minnemann, Klaus, and Daniela Pérez y Effinger. "La narración paradójica en 'Las babas del diablo' y 'Apocalipsis de Solentiname.'" In *La narración paradójica: "Normas narrativas" y el principio de la "transgresión,"* edited by Nina Grabe, Sabine Lang, and Klaus Meyer-Minnemann, 193–207. Madrid: Iberoamericana / Frankfurt: Vervuert, 2006.
Mitchell, W. J. T. *Iconology: Image, Text, Ideology*. Chicago: University of Chicago Press, 1986.
———. *Picture Theory: Essays on Verbal and Visual Representation*. Chicago: University of Chicago Press, 1994.
———. *What Do Pictures Want? The Lives and Loves of Images*. Chicago: University of Chicago Press, 2005.
Moholy-Nagy, László. "From Pigment to Light." In *Photographers on Photography: A Critical Anthology*, edited by Nathan Lyons, 73–80. Englewood Cliffs, NJ: Prentice-Hall, 1966.
Molloy, Silvia. "Simplicidad inquietante en los relatos de Silvina Ocampo." *Lexis* 2, no. 2 (1978): 241–51.

Money, Keith. *Anna Pavlova: Her Life and Art*. New York: Knopf, 1982.
Monsiváis, Carlos. *Maravillas que son, sombras que fueron: La fotografía en México*. Mexico City: Ediciones ERA / Consejo Nacional para la Cultura y las Artes / Museo del Estanquillo, 2012.
———. "'No me mueve mi Dios para pintarte' (De la reubicación de los signos de la fe)." In *El corazón sangrante / The Bleeding Heart*, by Olivier Debroise et al., 122–30. Boston: Institute of Contemporary Art, 1991.
Moran, Dominic. *Questions of the Liminal in the Fiction of Julio Cortázar*. Oxford: Legenda, 2000.
Moreiras, Alberto. *Tercer espacio: Literatura y duelo en América Latina*. Santiago: LOM ediciones, Universidad Arcis, 1999.
Mraz, John. *Looking for Mexico: Modern Visual Culture and National Identity*. Durham, NC: Duke University Press, 2009.
Mulvey, Laura. *Death 24x a Second: Stillness and the Moving Image*. London: Reaktion, 2006.
Munguía Cárdenas, Federico. "Antecedentes y datos biográficos de Juan Rulfo." In *La ficción de la memoria: Juan Rulfo ante la crítica*, edited by Federico Campbell, 465–84. Mexico City: Universidad Nacional Autónoma de México / ERA, 2003.
Musselwhite, David. "Death and the Phantasm: A Reading of Julio Cortázar's 'Babas del diablo.'" *Romance Studies* 18, no. 1 (June 2000): 57–68.
Nancy, Jean-Luc. *The Ground of the Image*. Translated by Jeff Fort. Bronx: Fordham University Press, 2005.
Newhall, Beaumont. *The History of Photography: From 1839 to the Present Day*. New York: Museum of Modern Art, 1997.
Nochlin, Linda. *The Body in Pieces: The Fragment as a Metaphor of Modernity*. New York: Thames and Hudson, 1994.
Norfleet, Barbara P. *Looking at Death*. Boston: David R. Godine, 1993.
Ocampo, Silvina. "La boda." In *Las invitadas: Cuentos completos*, vol. 1, 345–47. Buenos Aires: Emecé Editores, 2006.
———. "La cara apócrifa." In *Amarillo celeste. Poesía completa*, vol. 2, 124–29. Buenos Aires: Emecé Editores, 2003.
———. "La cara en la palma." In *Las invitadas: Cuentos completos*, vol. 1, 396–98. Buenos Aires: Emecé Editores, 2006.
———. "Las fotografías." In *La furia y otros cuentos: Cuentos completos*, vol. 1, 219–22. Buenos Aires: Emecé Editores, 2006. Translated by Daniel Balderston as "The Photographs" in *Leopoldina's Dream*, 25-30. Markham, ON: Penguin, 1988.
———. "El impostor." In *Autobiografía de Irene: Cuentos completos*, vol. 1, 99–147. Buenos Aires: Emecé Editores, 2006.
———. "Los objetos." In *La furia y otros cuentos: Cuentos completos*, vol. 1, 230–32. Buenos Aires: Emecé Editores, 2006.
———. "La paciente y el médico." In *La furia y otros cuentos: Cuentos completos*, vol. 1, 272–76. Buenos Aires: Emecé Editores, 2006.
———. "La revelación." In *Las invitadas: Cuentos completos*, vol. 1, 330–32. Buenos Aires: Emecé Editores, 2006. Translated by Daniel Balderston as "Revelation" in *Leopoldina's Dream*, 13-16. Markham, ON: Penguin, 1988.

———. "Los sueños de Leopoldina." In *La furia y otros cuentos: Cuentos completos*, vol. 1, 259–63. Buenos Aires: Emecé Editores, 2006.
———. "La última tarde." In *La furia y otros cuentos: Cuentos completos*, vol. 1, 252–55. Buenos Aires: Emecé Editores, 2006.
Onetti, Juan Carlos. "El álbum." In *Cuentos completos*, 175–88. Madrid: Alfaguara, 1983.
———. "El infierno tan temido." In *Cuentos completos*, 213–26. Madrid: Alfaguara, 1983.
———. "La cara de la desgracia." In *Cuentos completos*, 227–54. Madrid: Alfaguara, 1983.
Ong, Walter. *Orality and Literacy: The Technologizing of the Word*. London: Routledge, 1996.
Orgambide, Pedro. *Horacio Quiroga: Una biografía*. Buenos Aires: Planeta, 1994.
Orloff, Carolina. *The Representation of the Political in Selected Writings of Julio Cortázar*. Woodbridge, UK: Tamesis, 2013.
Ortega, Julio. "Enigmas de *Pedro Páramo*." In *La ficción de la memoria: Juan Rulfo ante la crítica*, edited by Federico Campbell, 337–41. Mexico City: Universidad Nacional Autónoma de México / ERA, 2003.
Osborne, Peter. *Travelling Light: Photography, Travel and Visual Culture*. Manchester, UK: Manchester University Press, 2000.
Panizza, Héctor. *Medio siglo de vida musical: Ensayo autobiográfico*. Buenos Aires: Ricordi Americana, 1952.
Parodi, Cristina. "Ficción y realidad en *La novela de Perón* de Tomas Eloy Martínez." *Nuevo Texto Critico* 4, no. 8 (1991): 39–43.
Pasveer, Bernicke. "Representing or Mediating: A History and Philosophy of X-Ray Images in Medicine." In *Visual Cultures of Science: Rethinking Representational Practices on Knowledge Building and Science Communication*, edited by Luc Pauwels, 41–62. Hanover, NH: Dartmouth University Press, 2006.
Paz, Octavio. "El caracol y la sirena: Rubén Dario." In *Obras completas*, vol. 2, 837–86. Barcelona: Galaxia Gutenberg / Círculo de Lectores, 2000.
———. *El laberinto de la soledad*. In *Obras completas*, vol. 5, 45–250 Madrid: Galaxia Gutenberg/Círculo de Lectores, 2002. Translated by Lysander Kemp as *The Labyrinth of Solitude*. New York: Grove, 1985.
———. "El signo y el garabato." *Obras completas*, vol. 3, 498–505. Barcelona: Galaxia Gutenberg / Círculo de Lectores, 2001.
———. "Paisaje y novela en México: Juan Rulfo." In *Obras completas*, vol. 3, 476–77. Madrid: Galaxia Gutenberg / Círculo de Lectores, 2001.
Paz-Soldán, Edmundo. "La imagen fotográfica, entre el aura y el cuestionamiento de la identidad: una lectura de 'La paraguaya' y *La invención de Morel*." *Revista Iberoamericana* 73, no. 221 (2007): 759–70.
———. *Sueños digitales*. Madrid: Alfaguara, 2000.
Pepper, William. "The Children of Vietnam." *Ramparts: The National Catholic Journal* 5, no. 7 (January 1967): 44–68.
Perkowska, Magdalena. *Pliegues visuales: Narrativa y fotografía en la novela latinoamericana contemporánea*. Madrid: Iberoamericana / Frankfurt: Vervuert, 2013.
Pezzoni, Enrique. "Silvina Ocampo: La nostalgia del orden." Introduction to *La furia y otros cuentos*, by Silvina Ocampo, 9–23. Madrid: Alianza Tres, 1982.

Picón Garfield, Evelyn. "A Conversation with Julio Cortazar." *Review of Contemporary Fiction* 33, no. 3 (Fall 1983): 5–21.
———. *Cortázar por Cortázar*. Xalapa, Mexico: Universidad Veracruzana, 1978.
———. *¿Es Julio Cortázar un surrealista?* Madrid: Editorial Gredos, 1975.
Piñera, Virgilio. "El álbum." In *Cuentos completos*, 64–68. Madrid: Alfaguara, 1999.
———. *El álbum*. In *Teatro completo*. Compilation, arrangement and introduction by Rine Leal, 361–74. Havana: Editorial Letras Cubanas, 2002.
———. *La boda*. In *Teatro Completo*. Compilation, arrangement and introduction by Rine Leal, 99–145. Havana: Editorial Letras Cubanas, 2002.
———. *La carne de René*. Barcelona: Tusquets, 2000.
———. *El no*. In *Teatro Completo*. Compilation, arrangement and introduction by Rine Leal, 375–431. Havana: Editorial Letras Cubanas, 2002.
———. *Pequeñas maniobras. Presiones y diamantes*. Madrid: Ediciones Alfaguara, 1985.
Poe, Edgar Allan. "The Imp of the Perverse." In *Complete Tales and Poems of Edgar Allan Poe*, 280–84. New York: Vintage, 1975.
———. "The Oval Portrait." In *Complete Tales and Poems of Edgar Allan Poe*, 290–92. New York: Vintage, 1975.
Poe Lang, Karen. "Vera Icona (Lectura de un cuento de Rubén Darío)." *Káñina: Revista de artes y letras de la Universidad de Costa Rica* 28, no. 1 (2004): 55–62.
Poniatowska, Elena, "¡Ay vida, no me mereces! Juan Rulfo, tú pon la cara de disimulo." In *Juan Rulfo Homenaje nacional*, 49–60. Mexico City: Instituto Nacional de Bellas Artes / SEP, 1980.
———. *Tinísima*. Mexico City: Editorial Era, 1992.
Pratt, Mary Louise. *Imperial Eyes: Travel Writing and Transculturation*. London: Routledge, 1992.
Praz, Mario. *The Romantic Agony*. Translated by Angus Davidson. Oxford: Oxford University Press, 1951.
Preminger, Alex, and T. V. F. Brogan, eds. "Ekphrasis." In *The New Princeton Encyclopedia of Poetry and Poetics*, 320–21. Princeton, NJ: Princeton University Press, 1993.
———. "Enargeia." In *The New Princeton Encyclopedia of Poetry and Poetics*, 332. Princeton, NJ: Princeton University Press, 1993.
Price, Derrick, and Liz Wells. "Thinking about Photography." In *Photography: A Critical Introduction*, edited by Liz Wells, 11–54. London: Routledge, 1997.
Quiroga, Horacio. *Diario y correspondencia. Obras*, vol. 5, edited by Jorge Lafforgue and Pablo Rocca. Buenos Aires: Editorial Losada, 2007.
———. "El retrato." In *Todos los cuentos*, edited by Napoleón Baccino Ponce de León and Jorge Laforgue, 986–89. Madrid: ALCA XX / Fondo de Cultura Económica, 1996.
———. "La cámara oscura." *El hogar* 17, no. 582 (3 December 1920): 13–14.
———. "La cámara oscura." In *Todos los cuentos*, edited by Napoleón Baccino Ponce de León and Jorge Laforgue, 674–80. Madrid: ALCA XX / Fondo de Cultura Económica, 1996.
———. "Tacuara Mansión." In *Todos los cuentos*, edited by Napoleón Baccino Ponce de León and Jorge Laforgue, 646–51. Madrid: ALCA XX / Fondo de Cultura Económica, 1996.

Rabb, Jane M., ed. *Literature and Photography: Interactions, 1840 –1990*. Albuquerque: University of New Mexico Press, 1995.

———, ed. *The Short Story and Photography, 1880's-1980's*. Albuquerque: University of New Mexico Press, 1998.

Rama, Angel. "Prólogo: Sueños, espíritus, ideología y arte del diálogo modernista con Europa." In *El mundo de los sueños*, by Rubén Darío, edited, with a prologue and notes by Angel Rama, 5–61. Barcelona: Editorial Universitaria, 1973.

Ramírez, Sergio. *Mil y una muertes*. Madrid: Alfaguara, 2004.

Ríos, Valeria de los. *Espectros de luz. Tecnologías visuales en la literatura latinoamericana*. Santiago: Editorial Cuarto Propio, 2011.

Ritchin, Fred. *After Photography*. New York: W.W. Norton, 2009.

———."Close Witnesses: The Involvement of the Photojournalist." In *A New History of Photography*, edited by Michel Frizot, 590–611. Cologne: Könemann, 1998.

———. *In Our Own Image: The Coming Revolution in Photography*. New York: Aperture, 1999.

Rivera, Jorge B. "Profesionalismo literario y pionerismo en la vida de Horacio Quiroga." In *Todos los cuentos*, by Horacio Quiroga, edited by Napoleón Baccino Ponce de León and Jorge Laforgue, 1255–73. Madrid: ALCA XX / Fondo de Cultura Económica, 1996.

Rivera Garza, Cristina. *Nadie me verá llorar*. Mexico City: Tusquets, 2000.

Robillard, Valerie K., and Else Jongeneel, eds. *Pictures into Words: Theoretical and Descriptive Approaches to Ekphrasis*. Amsterdam: VU University Press, 1998.

Rodríguez Monegal, Emir. *Genio y figura de Horacio Quiroga*. Buenos Aires: Editorial Universitaria de Buenos Aires, 1967.

———. "Relectura de Pedro Páramo." In *La ficción de la memoria: Juan Rulfo ante la crítica*, edited by Federico Campbell, 121–35. Mexico City: Universidad Nacional Autónoma de México / ERA, 2003.

Roffé, Reina. *Espejos de escritores*. Hanover, NH: Ediciones del Norte, 1985.

Romero, Rolando J. "Ficción e historia en *Farabeuf*." *Revista Iberoamericana* 56, no. 151 (April–June 1990): 403–18.

Rosenblum, Naomi. *A World History of Photography*. New York: Abbeville, 1997.

Royle, Nicholas. *The Uncanny*. New York: Routledge, 2003.

Ruby, Jay. *Secure the Shadow: Death and Photography in America*. Cambridge, MA: MIT Press, 1995.

Ruffinelli, Jorge. "Salvador Elizondo: *Farabeuf* y después." In *El lugar de Rulfo y otros ensayos*, 155–69. Xalapa, Mexico: Universidad Veracruzana, 1980.

Rulfo, Juan. *Aire de las colinas: Cartas a Clara*. Introduction by Alberto Vital. Barcelona: Plaza y Janés, 2000.

———. *Pedro Páramo*, edited by José Carlos González Boixo. Madrid: Ediciones Cátedra, 2004. Translated by Margaret Sayers Peden as *Pedro Páramo* (Austin: University of Texas Press, 2002).

Russek, Dan. "Borges' Photographic Fictions." *Hispanic Journal* 31, no. 2 (2010): 67–80.

———. "Ekphrasis and the Contest of Representations in *La Novela de Perón* (1985) by Tomás Eloy Martínez." In *Double Exposure: Photography and Literature in Latin America*. edited by Marcy Schwartz and Mary Beth Tierney-Tello, 173–91. Albuquerque, NM: New Mexico University Press, Albuquerque, 2006.

———. "Photographing Christ: Technology and Representation in Rubén Darío's 'Verónica'." *Revista Canadiense de Estudios Hispánicos* 34. no. 2 (2010): 359–78.
———. "Rulfo, Photography and the Vision of Emptiness." *Chasqui* 37, no. 2 (2008): 15–27.
———. "Verbal/Visual Braids: On the Photographic Medium in the Work of Julio Cortázar." *Mosaic* 37, no. 4 (2004): 71–86.
Sanjinés, José. *Paseos en el horizonte: Fronteras semióticas en los relatos de Julio Cortázar*. New York: Peter Lang, 1994.
Santí, Enrico Mario. "Carne y papel: El fantasma de Virgilio." In *Virgilio Piñera: la memoria del cuerpo*, edited by Rita Molinero, 79–94. San Juan, Puerto Rico: Editorial Plaza Mayor, 2002.
Sarduy, Severo. "Escrito sobre un cuerpo." In *Obra completa*, vol. 2, coordinated by Gustavo Guerrero and François Wahl, 1119–37. Nanterre, France: ALLCA XX, 1999.
Sarlo, Beatriz. *Escenas de la vida posmoderna: Intelectuales, arte y videocultura en la Argentina*. Buenos Aires: Ariel, 1994.
———. "Horacio Quiroga y la hipótesis técnico-científica." In *Todos los cuentos*, by Horacio Quiroga, edited by Napoleón Baccino Ponce de León y Jorge Laforgue. 1274–92. Madrid: ALCA XX / Fondo de Cultura Económica, 1996.
———. *La imaginación técnica: Sueños modernos de la cultura argentina*. Buenos Aires: Ediciones Nueva Visión, 1992.
Scarry. Elaine. *The Body in Pain: The Making and Unmaking of the World*. Oxford: Oxford University Press, 1985.
Schwartz, Hillel. *The Culture of the Copy: Striking Likenesses, Unreasonable Facsimiles*. New York: Zone Books, 1996.
Schwartz, Marcy. "Cortazar under Exposure: Photography and Fiction in the City." In *Latin American Literature and Mass Media*, edited by Edmundo Paz-Soldán and Debra Castillo, 117–38. New York: Garland, 2001.
———. "Writing against the City: Julio Cortázar's Photographic Take on India." In *Double Exposure: Photography and Literature in Latin America*, edited by Marcy Schwartz and Mary Beth Tierney-Tello, 117–37. Albuquerque: University of New Mexico Press, 2006.
———. *Writing Paris: Urban Topographies of Desire in Contemporary Latin American Fiction*. Albany: State University of New York Press, 1999.
——— and Mary Beth Tierney-Tello, eds. *Double Exposure: Photography and Literature in Latin America*. Albuquerque: University of New Mexico Press, 2006.
Scott, Clive. *The Spoken Image: Photography and Language*. London: Reaktion, 1999.
Sebald, W. G. *Austerlitz*. Translated by Anthea Bell. Toronto: Vintage Canada, 2001.
Sekula, Allan. *Photography against the Grain: Essays and Photo Works, 1973–1983*. Halifax: Press of the Nova Scotia College of Art and Design, 1984.
Shaw, Donald. *Nueva narrativa hispanoamericana*. Madrid: Ediciones Cátedra, 1999.
———. *The Post-Boom in Spanish American Fiction*. Albany: State University of New York Press, 1998.
Shloss, Carol. *In Visible Light: Photography and the American Writer, 1840–1940*. New York: Oxford University Press, 1987.
Shua, Ana María. *El libro de los recuerdos*. Buenos Aires: Sudamericana, 1994.

Snyder, Joel. "What Happens by Itself in Photography?" In *Pursuits of Reason: Essays in Honor of Stanley Cavell*, edited by Ted Cohen, Paul Guyer, and Hilary Putnam, 361–73. Lubbock: Texas Tech University, 1993.

Sobchack, Vivian. "The Scene of the Screen: Envisioning Cinematic and Electronic 'Presence.'" In *Materialities of Communication*, edited by Hans Ulrich Gumbrecht and K. Ludwig Pfeiffer, 83–106. Stanford: Stanford University Press, 1994.

Sommer, Doris. *Foundational Fictions: The National Romances of Latin America*. Berkeley: University of California Press, 1991.

Sommers, Joseph. "Los muertos no tienen tiempo ni espacio (un diálogo con Juan Rulfo)." In *La ficción de la memoria: Juan Rulfo ante la crítica*, edited by Federico Campbell, 517–21. Mexico City: Universidad Nacional Autónoma de México / ERA, 2003.

Sontag, Susan. *On Photography*. New York: Doubleday, 1977.

———. "Photography: A Little Summa." In *At the Same Time: Essays and Speeches*, edited by Paolo Dilonardo and Anne Jump, 124–27. New York: Farrar, Straus and Giroux, 2007.

———. *Regarding the Pain of Others*. New York: Farrar, Straus and Giroux, 2003.

Spence, Jo, and Patricia Holland, eds. *Family Snaps: The Meanings of Domestic Photography*. London: Virago, 1991.

Spitzer, Leo. "The 'Ode on a Grecian Urn,' or Content vs. Metagrammar." In *Essays on English and American Literature*, edited by Anna Hatcher, 67–97. Princeton, NJ: Princeton University Press, 1962.

Stephens, Mitchell. *History of News: From the Drum to the Satellite*. New York: Viking, 1988.

Sugano, Marian Zwerling. "Beyond What Meets the Eye: The Photographic Analogy in Cortazar's Short Stories." *Style* 27, no. 3 (Fall 1993): 332–51.

Tagg, John. *The Burden of Representation*. Amherst: University of Massachusetts Press, 1988.

Taylor, Diana. *Disappearing Acts: Spectacles of Gender and Nationalism in Argentina's "Dirty War."* Durham, NC: Duke University Press, 1997.

Tejada, Roberto. *National Camera: Photography and Mexico's Image Environment*. Minneapolis: University of Minnesota Press, 2009.

Teresa, Adriana de. *Farabeuf: Escritura e imagen*. Mexico City: Universidad Nacional Autónoma de México, 1996.

Tittler, Jonathan. "Los dos Solentinames de Cortázar." In *Lo lúdico y lo fantástico en la obra de Cortázar*, vol. 2, 111–17. Poitiers, France: Centre de Recherches Latinoamericaines, Université de Poitiers / Madrid: Editorial Fundamentos, 1986

Torres, Alejandra. "La Verónica modernista: Arte y fotografía en un cuento de Rubén Darío." In *Ficciones de los medios en la periferia: Técnicas de comunicación en la literatura hispanoamericana moderna*, edited by Wolfram Nitsch, Matei Chihaia, and Alejandra Torres, 73–83. Cologne: Universitäts- und Stadtbibliothek Köln, 2008.

Torres, Carmen L. *La cuentística de Virgilio Piñera: Estrategias humorísticas*. Madrid: Editorial Pliegos, 1989.

Trachtenberg, Alan. "Introduction." In *Classic Essays on Photography*, edited by Alan Trachtenberg, 7–13. New Haven, CT: Leete's Island Books, 1980.
Ulla, Noemí. *Encuentros con Silvina Ocampo*. Buenos Aires: Editorial Leviatán, 2003.
Valerio-Holguín, Fernando. *Poética de la frialdad: La narrativa de Virgilio Piñera*. New York: University Press of America, 1997.
Varnedoe, Kirk, and Adam Gopnik. *High and Low: Modern Art and Popular Culture*. New York: Museum of Modern Art, 1991.
Vázquez, María Esther. *Borges: Esplendor y derrota*. Barcelona: Tusquets, 1996.
Villoro, Juan. "Lección de arena: Pedro Páramo." In *La ficción de la memoria: Juan Rulfo ante la crítica*, edited by Federico Campbell, 409–20. Mexico City: Universidad Nacional Autónoma de México / ERA, 2003.
Vital, Alberto. *Noticias sobre Juan Rulfo*. Mexico City: Ediciones RM, 2003.
Volek, Emil. "'Las babas del diablo,' la narración policial y el relato conjetural borgeano: Esquizofrenia crítica y creación literaria." In *Los ochenta mundos de Cortázar: ensayos*, edited by Fernando Burgos, 27–35. Madrid: EDI, 1987.
Wade, Nicholas J. *A Natural History of Vision*. Cambridge, MA: MIT Press, 1998.
Wagner, Peter. "Introduction: Ekphrasis, Iconotexts, and Intermediality—The State(s) of the Art(s)." In *Icons, Texts, Iconotexts: Essays on Ekphrasis and Intermediality*, edited by Peter Wagner, 1–40. Berlin: Walter de Gruyter, 1996.
Walsh, Rodolfo. "Fotos." In *Los oficios terrestres*, 21–53. Buenos Aires: Ediciones de la flor, 1997.
Watriss, Wendy, and Lois Parkinson Zamora. *Image and Memory: Photography from Latin America, 1865–1992*. Austin: University of Texas Press, 1997.
Webb, Ruth. "Ekphrasis Ancient and Modern: The Invention of a Genre." *Word and Image* 15, no. 1 (1999): 7–18.
———. *Ekphrasis, Imagination and Persuasion in Ancient Rhetorical Theory and Practice*. Surrey, UK: Ashgate, 2009.
Weinzierl, Erika. "Modernism." In *The Encyclopedia of Christianity*, vol. 3, edited by Erwin Fahlbusch et al., translated by Geoffrey W. Bromiley, 607–11. Grand Rapids: Wm. B. Eerdmans / Leiden, Netherlands: Brill, 1999.
Westerbeck, Colin, and Joel Meyerowitz. *Bystander: A History of Street Photography*. New York: Bulfinch, 2001.
Williams, Linda. "Corporealized Observers: Visual Pornographies and the 'Carnal Density of Vision.'" In *Fugitive Images: From Photography to Video*, edited by Patrice Petro, 3–41. Bloomington: Indiana University Press, 1994.
———. *Hard Core: Power, Pleasure and the "Frenzy of the Visible."* Berkeley: University of California Press, 1999.
Williams, Raymond. L. *The Postmodern Novel in Latin America: Politics, Culture, and the Crisis of Truth*. Basingstoke, UK: Macmillan, 1995.
Zamora, Lois Parkinson. "Movement and Stasis, Film and Photo: Temporal Structures in the Recent Fiction of Julio Cortázar." *Review of Contemporary Fiction* 3, no. 3 (1983): 51–65.
———. "Novels and Newspapers in the Americas." *Novel: A Forum on Fiction* 23, no. 1 (1989): 44–62.
———. "Voyeur/Voyant: Julio Cortázar's Spatial Esthetic." *Mosaic* 14, no. 4 (1981): 45–68.

———. *Writing the Apocalypse*. Cambridge, MA: Cambridge University Press, 1989.
Zanetti, Susana. *Rubén Darío en* La Nación *de Buenos Aires 1892–1916*. Buenos Aires: Eudeba, 2004.
Ziolkowski, Theodor. *Disenchanted Images. A Literary Iconology*. Princeton: Princeton University Press, 1977.
———. *Fictional Transfigurations of Jesus*. Princeton, NJ: Princeton University Press, 1972.
Zola, Emile. "The Experimental Novel." In *The Experimental Novel, and Other Essays*, translated by Belle M. Sherman, 1–54. New York: Haskell House, 1964.
———. *Lourdes*. Translated by Ernest A. Vizetelly. London: Chatto and Windus, 1894.

NOTES

NOTES TO INTRODUCTION

1. Price and Wells, "Thinking about Photography," 26; see Scott, *Spoken Image*, 14.
2. See Meyer, *Verdades y ficciones*; Amelunxen, Iglhaut, and Rötzer, eds., *Photography after Photography*; Ritchin, *In Our Own Image: The Coming Revolution in Photography* (1999) and *After Photography* (2008); and Grundberg, *Crisis of the Real*.
3. Jenkins, *Convergence Culture*, 14.
4. Trachtenberg, "Introduction," xiii.
5. In her first anthology, Rabb included Pablo Neruda's poem "Tina Modotti is Dead" (327–29) and Octavio Paz's composition "Facing Time," on the photographs of Manuel Alvaréz Bravo (484–87), only in translation.
6. See Brunet, *Photography and Literature*, 85.
7. Collections of scholarly essays on literature and photography—such as *Photo-Textualities: Reading Photographs and Literature*, edited by Marsha Bryant—share the cultural and linguistic limitations of Rabb's anthologies. The same applies to the illuminating *Photography and Literature* by François Brunet and the special issue of *Poetics Today* devoted to photography in fiction edited by Silke Horstkotte and Nancy Pedri.
8. Balderston, "Twentieth-Century Short Story," 478.
9. The parallel in modernity between word and photographic image was celebrated by Hungarian avant-garde photographer and theorist László Moholy-Nagy, who famously declared that "The illiterate of the future will be ignorant of the pen and the camera alike" (quoted in Lyons, 80).
10. Shloss, *In Visible Light*, 14.
11. Zola, "The Experimental Novel," 7; see Rabb, ed., *Literature*, xxxviii. As Brunet points out, this debate

dates back some decades: "Since 1850 the daguerreotype and photography had been associated by conservative critics with the rise of the new literary school alternatively called 'realism' or 'naturalism'. Writers of this obedience—such as Flaubert and especially Théophile Gautier— were called 'photographic', with distinct nuance of abuse, by self-styled defenders of the 'ideal'" (*Photography and Literature*, 71).

12 Bazin, "Ontology," 9; Barthes, *Camera Lucida*, 31; McLuhan, *Understanding Media*, 201.

13 Nicaraguan author Sergio Ramírez states that "Uno puede imaginarse toda una historia a raíz de una foto" [One can imagine an entire story based on one photograph] (quoted in Perkowska, *Pliegues visuales*, 74).

14 Burgin, *Thinking Photography*, 144.

15 Genette, *Paratexts*, 3.

16 Rabb, *Literature*, xxxix. Clive Scott asserts the close links between literature and photography, stating that "Writers are often photographers," and further, that "our assessment of photography, and in particular our ways of talking about it, are often generated by literature: for example, even when they are writing about photography, Benjamin, Sontag and Barthes remain essentially literary critics" (*Spoken Image*, 12). See Brunet, *Photography and Literature*, 79.

17 Photographs of Bioy Casares are included in María Esther Vázquez's biography of Borges, *Borges: Esplendor y derrota*.

18 *Cartas 1937–1983*, vol.1, 105; *Cartas 1937–1983*, vol.3, 1605; Goloboff, *Julio Cortázar*, 155.

19 Picón Garfield, *Cortázar por Cortázar*, 33. The full quotation reads: "[D]esde muy joven, cuando empecé a trabajar y tuve dinero para comprar un pequeño aparato fotográfico muy malo, empecé a sacar fotos de manera bastante sistemática tratando de perfeccionarme. Y luego tuve una segunda cámara que era un poco mejor. Con ésa ya hice buenas fotos en la época. El motivo no te lo puedo explicar. Yo pienso que en el fondo es un motivo bastante literario. La fotografía es un poco la literatura de los objetos. Cuando tú sacas una foto, hay una decisión de tu parte. Tú haces un encuadre, pones algunas cosas y eliminas otras. Y el buen fotógrafo es ese hombre que encuadra mejor que los otros. Y además que sabe elegir al azar y allí entra el surrealismo en juego. Cada vez que yo he tenido una cámara en la mano y he visto juntarse dos o tres elementos incongruentes, por ejemplo, un hombre que está de pie y por un efecto de sol la sombra que proyecta en el suelo es un gran gato negro, pues eso me parece maravilloso si uno puede fotografiarlo. En el fondo estoy haciendo literatura, estoy fotografiando una metáfora: el hombre cuya sombra es un gato. Yo creo que es por el camino literario que fui a la foto." (45). [When I was

very young and began to work and had some money to buy a very poor camera, I began to take photos in a very systematic way, trying to perfect my technique. Later, my second camera was a little better. With it I took good pictures. I don't know how to explain to you the reason for that interest. Down deep I think it was a literary one. Photography is sort of a literature of objects. When you take a photo, you make a decision. You frame some things and eliminate others. A good photographer is one who knows how to frame things better. And besides he knows how to choose by chance and there's where surrealism comes into play. It has always seemed marvelous to me that someone can photograph two or three incongruous elements, for example, the standing figure of a man who, by some effect of light and shade projected onto the ground, appears to be a great black cat. On a profound level, I am producing literature, I am photographing a metaphor: a man whose shadow is a cat. I think I came to photography by way of literature (Picon Garfield, "A Conversation with Julio Cortazar," 12)].

20. For a list of authors and works in this field, see Perkowska, *Pliegues visuales*, 33–36.
21. Price and Wells, "Thinking about Photography," 50–51.
22. Barthes, "The Photographic Message," 18.
23. For a useful survey on Plato's and Aristotle's theories on mimesis, and the tradition of *ut pictura poesis* stemming from Horace, see Hagstrum, *Sister Arts*, 1–35.
24. Spitzer, "The 'Ode on a Grecian Urn,'" 72.
25. Krieger, *Ekphrasis*, 6; Mitchell, *Picture Theory*, 154.
26. Mitchell, *Picture Theory*, 152.
27. Wagner, "Introduction," 14. See also Hagstrum, *Sister Arts*, 18, 29, 35; Heffernan, *Museum of Words*, 1; Preminger and Brogan, eds., *Princeton Encyclopedia*, "Ekphrasis," 320–21; Bartsch and Elsner, "Introduction," i–vi; and Robillard and Jongeneel, eds., *Pictures into Words*. The original meaning of the term "ekphrasis" in classical rhetoric is "a speech that brings the subject matter vividly before the eyes," regardless of subject matter (Webb, *Ekphrasis, Imagination*, 1). It is closely related to the notion of *enargeia*, defined as the "vivid description addressed to the inner eye" (Hagstrun, *Sister Arts*, 11, 29; Krieger, *Ekphrasis*, 7; Webb, *Ekphrasis, Imagination*, 5). Webb traces the evolution of ekphrasis from its classical roots to its modern sense, showing its elevation in literary criticism from an obscure technical term to a literary genre, a move that she attributes to Spitzer (*Ekphrasis, Imagination*, 5–7, 28–38). De Armas provides a typology of ekphrases in "Simple Magic," 21–24. Wagner, striving to go beyond the classical "sister arts" analogy between poetry and painting, proposes the concept of intermediality to deal with

the variety of relations between verbal and visual representations ("Introduction," 17). In the Latin American context, *Entre artes entre actos: Ecfrasis e intermedialidad*, edited by Susana González Aktories and Irene Artigas Albarelli, is a collection of essays that explore ekphrasis with regard to a variety of arts beyond the visual.

28 Krieger, *Ekphrasis*, xv.
29 Barthes, "The Photographic Message," 19.
30 Hollander, "The Poetics of Ekphasis," 209.
31 Heffernan, "Preface," xv. See also Hagstrun, *Sister Arts*, 66; Mitchell, *Iconology*, 47; Wagner, "Introduction," 26, 28.
32 Da Vinci, *Paragone*, 49–65.
33 Mulvey, *Death 24x a Second*, 55.
34 Freud, "The Uncanny," 220.
35 A sample of works would include Anthony Vidler's *The Architectural Uncanny: Essays in the Modern Unhomely* (1992), Hal Foster's *Convulsive Beauty* (1997), David Ellison's *Ethics and Aesthetics in European Modernist Literature: From the Sublime to the Uncanny* (2001), the essays in the art catalog *The Uncanny: Experiments in Cyborg Culture* (2001) edited by Bruce Grenville, Nicholas Royle's *The Uncanny* (2003) and the collection of essays *Uncanny Modernity. Cultural Theories, Modern Anxieties* edited by Jo Collins and John Jervis (2008).
36 Freud, "The Uncanny," 251.
37 Perkowska, *Pliegues visuales*, 23–24, 96n14; Ríos, *Espectros de luz*, 27–28.
38 A noteworthy exception is Sugano, "Beyond What Meets the Eye."
39 These works can be considered part of what Perkowska calls, acknowledging the depth of the Argentine writer's contributions, the *proyecto-Cortázar*, namely, "distintas variantes de construcción textual tipo *collage*, en la que las fotografías nunca ocupan un lugar inferior (suplementario, ilustrativo, ornamental) con respecto al texto" [variations of a collage-type textual construction, in which photographs never occupy a subordinate role (supplemental, illustrative, ornamental) with respect to the text] (*Pliegues visuales*, 34).
40 See Schwartz, "Writing against the City."
41 These texts include prologues to the books *Buenos Aires, Buenos Aires* and *Humanario*, both photographs by Sara Facio and Alicia D'Amico. The latter is about the living conditions in a mental institution in Buenos Aires, and Cortázar's prologue was included in *Territorios* with the title "Estrictamente no profesional." Also included in *Territorios*, see "Carta del viajero," on the photographs of Fréderic Barzilay. See also *Paris, ritmos de una ciudad*, with photographs by Alecio de Andrade, and *Alto el Perú*, with photographs by Manja Offerhaus. A brief commentary on

photographs by Antonio Galvez, entitled "Luz negra," is included in Cortázar's posthumous *Papeles inesperados*. In general, these texts are free, poetic meditations on memory, travel, the power of the gaze, and the exploration of urban space triggered by images. Marcy Schwartz has analyzed how Cortázar renders or recycles his aesthetic insights in these collaborative works; see Schwartz, "Cortazar under Exposure."

42 Cortázar, "Algunos aspectos del cuento," 371. See also Cortázar, *Clases de literatura*, 30–31.

43 In Chapter 109 of *Rayuela*, a narrator refers to the fictional writer Morelli, who poses yet another schematic distinction between photography (representing the unavoidable fragmentariety of knowledge) and film (the deceiving coherence of continuity).

44 I am also excluding *Tinísima* by Poniatowska, a novel based on the life and works of photographer and political activist Tina Modotti, since the work does not fit my theoretical framework. A collection of Monsiváis's essays on Mexican photography, entitled *Maravillas que son, sombras que fueron*, was published in 2012. For a list of authors who have explored the links between the journalistic chronicle and photography, see Perkowska, *Pliegues visuales*, 35.

45 References to photography and photographers appear in Allende, *Paula*; Amorím, "La fotografía"; Bellatín, *Shiki Nagaoka*; Bioy Casares, *La invención de Morel* and *Las aventura de un fotógrafo*; Borges, "Tlon, Uqbar, Orbis Tertius," "La otra muerte," "El milagro secreto," and "El Aleph"; Cabrera Infante, *Tres tristes tigres*; Chejfec, *Los planetas;* Donoso, "Santelices"; Fuentes, *Aura*; García Márquez, "La increible y triste historia" and *Cien años de soledad*; Gorodischer, "La cámara oscura"; Onetti, "El álbum," "El infierno tan temido," and "La cara de la desgracia"; Ramirez, *Mil y una muertes*; Rivera Garza, *Nadie me verá llorar*"; Roberto Bolaño, *Los detectives salvajes*, *Estrella distante*, and "Fotos"; Shua, *El libro de los recuerdos*; and Walsh, "Fotos." On the presence of photography in Borges's short fiction, see Russek, "Borges' Photographic Fictions." For more references, see Perkowska, *Pliegues visuales*, 24–25, and Ríos, *Espectros de luz*, 19–20.

1 | UNCANNY VISIONS IN DARÍO, CORTÁZAR, AND ELIZONDO

1 Poe Lang, in "Vera Icona," examines the historical and semiotic dimensions of the photographic sign deployed in the text, though she gives scant attention to the crucial role the X-rays play in the story. The same can be said of Ríos, *Espectros de luz*, 30–31,"] and A. Torres, "La Verónica modernista."

2 See Hahn, *Cuento fantástico*, 85; Anderson Imbert, "Rubén Darío," 106; H. M. Fraser, *In the Presence*, 35.

3. Paz, "Caracol," 845.
4. H. M. Fraser, *In the Presence*, 74; Ríos, *Espectros de luz*, 51–52.
5. With regard to American and European literatures, Brunet refers to a "history of literary discoveries of photography," of which the first moment "is centred around 1900 and the 'graphic revolution', and manifests itself, above all, in the emergence of photography as a topic for fiction. Whereas up until 1880 'serious' fiction had been slow to incorporate photographs and photographers, in the following decades both topics became frequent" (*Photography and Literature*, 78–79). In the Latin American context, Darío proved to be at the avant-garde of this development.
6. Unless otherwise noted, all translations are my own.
7. In his study about the modern literary versions of Jesus Christ, Ziolkowski notes that "the effect of this genre depends in large measure upon the intentional anachronism, the glaring incongruity between past and present" (*Fictional Transfigurations*, 21).
8. Anderson Imbert, "Rubén Darío," 101–2. See also Rama, "Prólogo," 20–31, and Hahn, *Cuento fantástico*, 75.
9. Jrade, *Rubén Darío*, 10.
10. Jrade, "Respuesta dariana," 167.
11. Ziolkowski, *Fictional Transfigurations*, 19.
12. Hammond, "Naturalistic Vision," 293–309; Gernsheim, *Creative Photography*, 131–48; Jussim, *Slave to Beauty*, 6–10; Newhall, *History of Photography*, 141–58.
13. Jussim, *The Eternal Moment*, 202–3.
14. In the index to Zanetti's otherwise helpful edition on Darío's collaborations with *La Nación*, the first word of the title is misspelled: instead of "Diorama," it says "Drama" (*Rubén Darío*, 142, 177).
15. It is not clear when Darío did visit Lourdes. See Russek, "Photographing Christ," 364, 373n7.
16. Darío's reference to the reporter reflects a contemporary practice. Mraz quotes a passage from fellow Mexican *modernista* poet and essayist Manuel Gutiérrez Nájera, who cast doubts on the moral integrity of the reporter, who in turn represents the burgeoning values of crass American pragmatism: "The chronicle has died at the hands of the reporters. Where else could reporters have come from if not from the country of revolvers, where the repeating journalist, instant food, and electricity flourish? From there we got the agile, clever, ubiquitous, invisible, instantaneous reporter who cooks the hare before trapping it" (*Looking for Mexico*, 43–44). As I show in chapter 3, Cortázar also dismisses the attitude of the reporter as suspect in "Las babas del diablo." About the figure of the reporter, see Newhall, *History of Photography*, 128, and Rosenblum, *World History of Photography*, 446. Gumbrecht devotes a chapter to the practice of the reporter in

the 1920s. He points out that "the restless life of the reporter and his surface view of the world are linked with the collective—and often repressed—fear that ultimate truths are no longer available," thus encapsulating the shifting ground that modernity brings forth regarding knowledge and certainty (*In 1926*, 188).

17 Commenting on Lugones's scientific stories, Howard M. Fraser points out that his "investigators, Faustian scientists all, become victims of their own creations and their *idée fixe*" (*In the Presence*, 109). The same applies to Fray Tomás's tragic fate. The "knowledge" that the friar strove to achieve was not restricted to modern positive sciences, but included the occult lore of ancient traditions (Pythagoreanism, Platonism, Neoplatonism, Kabbala, etc.), reinterpreted in late-nineteenth-century France by the likes of Mme. Blavatsky and Papus. We read in the text that Fray Tomás, among his many interests, "había estudiado las ciencias ocultas antiguas" (416) [had studied the occult sciences]. On the important influence of the esoteric tradition on Darío's work, see Anderson Imbert, *Originalidad*, 62; H. M. Fraser, *In the Presence*, 33; Jiménez, "Prólogo," 17; Jrade, *Rubén Darío*, 9; and Rama, "Prólogo," 25–31. Fray Tomás could be seen as embodying an attitude that Raimundo Lida considers central to Darío's work, namely, the "afán de abismarse . . . en la más sombría entraña del universo" [a will to (. . .) plunged into the deepest recesses of the universe] ("Cuentos de Rubén Darío," 253). Lida, in reference to "La extraña muerte de Fray Pedro," a second version of the story published in 1913, brings to the fore the fundamentally religious act of venturing into the Unknown, albeit with tragic consequences. After all, "Fray Pedro suspira por apresar en la placa fotográfica la figura de Dios, del mismo modo que el Edison de *La Eva futura* ansía grabar en el disco Su palabra. Y el fraile logra al fin su objeto. Satán ha cumplido. El terrible misterio de las cosas está de verás allí, presente y active" [Fray Pedro wishes to capture God's image in the photographic plate, as Edison wishes to record on a disc His Word in *Tomorrow's Eve*. And the friar achieves his goal at the end. Satan has kept his word. The terrible mystery of things is truly there, present and active] (Ibid.).

18 Gunning, "Phantom Images," 42. Darío referred to this kind of photography in a text entitled "La ciencia y el más allá," published on 9 February 1906 and later included in *El mundo de los sueños*. At the beginning of this article, he mentions a photograph of a ghost that appeared in the Parisian press and the scientific experiments on spirits lead by "un sabio y cuerdo profesor, M. Richet" (*El mundo*, 83). The idea of photographing apparitions had already been mentioned in *Down*

There by Huysmans (an author Darío admired. and even quoted in "Verónica"), the protagonist of the novel, Durtal, meditating on the abiding mystery that surrounds the realm of spirits, refers to the experiments of the British physicist and chemist William Crookes in these terms: "the apparitions, doppelgänger, bilocations—to speak thus of the spirits—that terrified antiquity, have not ceased to manifest themselves. It would be difficult to prove that the experiments carried on for three years by Dr. Crookes in the presence of witness were cheats. If he has been able to photograph visible and tangible specters, we must recognize the veracity of the mediaeval thaumaturges" (Huysmans, *Down There*, 211). Crookes, both a Nobel Prize winner, in 1907, and a believer in Spiritism, is also mentioned in "Verónica." On Crookes, see Darío, *La caravana pasa*, 175n399. On the links between nineteenth-century photography and the Spiritualist movement, see Mulvey, *Death 24x a Second*, 43–44, and Gunning, "Phantom Images."

19 Gunning, "Uncanny Reflections," 83.
20 Ibid.
21 Newhall, *History of Photography*, 129.
22 In 1858, a young peasant girl, Bernadette Soubirous, had visions of the Virgin Mary at Lourdes, which soon became an important magnet for the faithful. A local feast of the apparition of Our Lady of Lourdes was sanctioned in 1891 (Cross and Livingstone, "Lourdes," 999.) Given the roots in popular religion of the belief in Bernadette's apparitions, as well as its links to the "devout understanding of simple folk and children" (Grote, "Lourdes," 339), it is interesting that Fray Tomás rejects the basic simplicity of faith in order to probe the depths of religious belief through empirical means.
23 The first daguerreotypist to set up shop in Buenos Aires was an American called John Elliot, in 1843. By 1860, there were fifty photographic studios in the city, most of them run by foreigners who catered to the upper classes. The *carte-de-visite* format democratized the photographic portrait by lowering the cost of producing sets of pictures. As in Europe and the United States, photographic portraiture would usurp the traditional place of the painter and soon become widespread. Besides portraiture, social scenes, civic ceremonies, landscape, and architecture were photography's main subjects, making the photographer a common sight. Newspapers such as *La Prensa* (founded in 1869) and *La Nación* (1870) would incorporate illustrations in the form of etchings. Photogravure, based on the halftone process, was introduced in 1897, beginning the displacement in the news section of handmade illustrations. For the history of photography in Latin America, see Becquer Casaballe

and Cuarterolo, *Imágenes del Río de la Plata*; Debroise, *Fuga mexicana*; Facio, *Fotografía en la Argentina*; García Krinsky, *Imaginarios y fotografía*; and Watriss and Zamora, *Image and Memory*.

24 Belting, *Likeness and Presence*, 209.
25 Ibid., 208.
26 Ibid., 221.
27 Ibid., 49. See Dubois, *L'acte photographique*, 22, and Gubern, *Patologías de la imagen*, 84. Barthes explicitly refers to the aqueiropoetic nature of photography in *Camera Lucida*, 82.
28 Weinzierl, "Modernism," 608); Ziolkowski, *Fictional Transfigurations*, 40, 83–84.
29 Relics and photographic images can become intertwined. Commenting on a public exhibition of the holy shroud of Turin in May 1898, Frizot writes, "Secondo Pia, a photographer who was also a lawyer, was authorized to make a photographic reproduction of the shroud. He found, when developing his glass negatives, that they gave a 'real' picture of Christ, whereas the original was difficult to see. People were inclined to think that the imprint visible on the holy shroud was something like a 'negative image,' by analogy with the photographic negative. Its reversal to a positive image by photography rendered its contours perfectly *legible*. This discovery gave a new theological value to the shroud. Its possible authenticity, corroborated by photography, took on a very different resonance. The shroud itself could be considered as a sensitive plate upon which the emanations of a body had left their impression" ("The All-Powerful Eye," 282–83).
30 Méndez, "La incursión de Rubén Darío."
31 Mitchell, *What Do Pictures Want?*, 36; Dubois, *L'acte photographique*, 141.
32 Freedberg, *Power of Images*, xxiv; Ziolkowski, *Disenchanted Images*, 81; Gubern, *Patologías de la imagen*, 69.
33 In the second version of the story, "La extraña muerte de Fray Pedro," Christ's gaze has become "dulce" (401) [sweet], as if Darío, close to his death and suffering physically and psychologically, retouched the image of the Savior under a more compassionate light. A number of commentators have pointed out the weakness of the second version's ending; see Anderson Imbert, "Rubén Darío," 106, and Hahn, *Cuento fantástico*, 84.
34 Crary, *Techniques of the Observer*, 19.
35 Mraz considers that this attitude follows the "logic of modernity, which was finally based on the inductive principles of the Enlightenment, that 'truth' was to be discovered from observation of the world rather than through abstract philosophizing" (*Looking for Mexico*, 46). Sontag points out that "In the modern way of knowing, there have to be images for something to become 'real'" (*On Photography*, 125). This conception dovetails with one of

the traits of fantastic literature, according to Jackson: "making visible the un-seen" (*Fantasy*, 48).
36 Frizot, "The All-Powerful Eye," 281.
37 Pasveer, "Representing or Mediating," 42.
38 Goldberg, *Power of Photography*, 48–49.
39 Marien, *Photography: A Cultural History*, 216.
40 Crary, *Techniques of the Observer*, 127.
41 Holmes, "The Stereoscope," 74.
42 Ibid.
43 Williams, *Corporealized Observers*, 12–13.
44 Crary, *Techniques of the Observer*, 62.
45 Crary describes the alienated condition of what he calls the "nineteenth century observer" in terms that may fit Fray Tomás's fetishistic obsession with the picture of Christ: "Empirical isolation of vision . . . enabled the new objects of vision (whether commodities, photographs, or the act of perception itself) to assume a mystified and abstract identity, sundered from any relation to the observer's position within a cognitively unified field" (*Techniques of the Observer*, 19).
46 Mitchell, *Iconology*, 98.
47 See John 20:24–29.
48 Translation from *One Hundred Years of Solitude* is by Gregory Rabassa.
49 Newhall, *History of Photography*, 16–17. Mraz points out that "the 'prodigious exactitude' with which the daguerreotype portrayed the visible world signalled the onset of a culture built around the credibility of technical images" (*Looking for Mexico*, 18).
50 Cortázar, *Ultimo round*, vol. 1, 246–47.
51 Mulvey, *Death 24x a Second*, 27; Collins and Jervis, "Introduction," 1.
52 Critics have seen in Roberto Michel a symbol of the artist (Zamora, "Voyeur/Voyant," 51; MacAdam, *El individuo*, 124). The amateur photographer, however, is a more ambiguous, disengaged figure, since he can situate himself in the margins of artistic conventions and institutions while still producing (conventionally sanctioned) works of art. This modern approach to image production—de-centred, democratic, and unpretentious—is central to the idea of photography (Scott, *Spoken Image*, 30). Michel's attitude and practice bring to mind what Westerbeck and Meyerowitz have remarked about the nature of urban photography by the late nineteenth century, epitomized by the life and work of Atget: "Working often in streets that were deserted, but courting the kind of surprise compositions and curiosities of framing that would become common later, the best photographers of the time set the stage for the drama that would unfold in the street photography of Cartier-Bresson, Walker Evans, or Robert Frank" (*Bystander*, 105).
53 Marcy Schwartz remarks that "Cortázar's short fiction perpetuates a contemporary version of the Parisian *flâneur*

moving among metropolitan crowds in search of alternative experience.... Cortázar uproots his *flâneurs* from the street and displaces them in urban interstices such as windows and corridors to emphasize fantastic otherness and the betweenness of Latin American urban cultural identity" ("Writing against the City," 30). Sontag links the *flâneur* to the photographer, and both to voyeurism (*On Photography*, 24, 55). See also Gutiérrez Mouat, "'Las babas del diablo,'" 39.

54 Cortázar, "Algunos aspectos del cuento," 371.

55 Sugano, "Beyond What Meets the Eye," 335–36.

56 Translations of "Las babas del diablo" are from "Blow-Up," translated by Paul Blackburn.

57 *The Mind's Eye*, 42. See also Scott, *Spoken Image*, 63.

58 *The Mind's Eye*, 66.

59 Kirstein, "Henri Cartier-Bresson," 4. See Shloss, *In Visible Light*, 7.

60 The perceptual, and even "spiritual" and metaphysical, disponibility—or, to borrow a key concept in Cortázar's writings, this openness or aperture, heir to the tradition of fantastic literature (Jackson, *Fantasy*, 22)—is a key feature in Cortázar (Sugano, "Beyond What Meets the Eye," 334). In the essay "La muñeca rota," included in *Ultimo round*, he speculates about the creative wealth of coincidences that, given the proper state of attention, coalesce around an event (vol. 1, 248). See also *Prosa del observatorio*, 49. This central attitude finds a graphic parallel in the way the photographic image ends up magnified, literally and figuratively, in "Las babas del diablo." Michel blows up a first print when he returns from his stroll to the island, and he finds it so good that he repeats the procedure. The poster-size picture will eventually appear like a movie screen on which events uncannily unfold. Thus, the enlargement in size leads to a new, heightened regimen of representations: from fixed to moving image. A similar strategy is employed in "Apocalipsis de Solentiname." Sugano writes that this story is "a blow-up of 'Blow-up,' politically, socially, and historically speaking" ("Beyond What Meets the Eye," 345).

61 Kirstein, "Henri Cartier-Bresson," 3.

62 Moran points out the irony of Michel's "misjudgments, baseless conjectures, and the multiple and inconclusive angles from which he has viewed events" while he simultaneously expects "to capture the 'naked' truth in a single, apodictic gesture" with his camera (*Questions of the Liminal*, 98).

63 Volek, "'Las babas del diablo,'" 32.

64 See Gutiérrez Mouat, "'Las babas del diablo,'" 43; Meyer-Minnemann and Pérez y Effinger, "Narración paradójica," 200; Moran, *Questions of the Liminal*, 13, 95; and Sugano, "Beyond What Meets the Eye," 342.

65 *Fantastic*, 83. Musselwhite explains the dissolution and "death" of

the singular self in the story in terms of the psychoanalytical concept of the phantasm, and the scattered narrative positions as a sort of psychosis ("Death and the Phantasm," 63). Luciani reads the plot in terms of a mental breakdown too ("The Man in the Car," 187). See also Zamora, "Voyeur/Voyant," 49. Photography articulates the topic of mental breakdown in other writings by Cortázar: see his prologue to the book of photographs *Humanario* by Sara Facio and Alicia D'Amico entitled "Estrictamente no profesional."

66 The links between photography and Surrealism have been highlighted by many critics. Sontag declared that, at the very "heart of the photographic enterprise," and its interest in producing a reality in the second degree, lies Surrealism as a constitutional factor (*On Photography*, 52). Scott argues that "given that the speed of the shutter is what marks photography off from all other visual media, chance is crucial to any 'aesthetic', and indeed any expressitivity, associated with photography, even at its most deliberately posed. In this regard, photography has aesthetic affinities with Surrealism, for the Surrealists not only looked upon chance as the instigator of images . . . they also believed in 'le hasard objectif' ('objective chance'), that magical way in which external reality often fulfills the desires and impulses projected into it, a preordained coincidence" (*Spoken Image*, 18). Rosalind Krauss remarks that the photographic code captures better the surrealist aesthetic than the critical concepts drawn from traditional painting. She claims that the notion of reality-as-representation, which "lies at the very heart of surrealist thinking," was best conveyed through the manipulations of spacing and doubling that surrealist photographers produced ("Corpus Delicti," 112). For a thorough investigation of the links among the Surrealist project, the Freudian uncanny, and photography, see Foster, *Convulsive Beauty*.

67 Moran points out that in Cortázar's stories, "the return of the repressed is almost without exception destructive, even lethal" (*Questions of the Liminal*, 16). González Echevarría refers to the "juego mortal" [mortal game] and the "violento ritual" [violent ritual] implied in Cortázar's literary strategies ("*Los reyes*: Mitología," 204).

68 For Krauss, "to produce the image of what one fears, in order to protect oneself from what one fears—this is the strategic achievement of anxiety, which arms the subject, in advance, against, the onslaught of trauma, the blow that takes one by surprise" ("Corpus Delicti," 64).

69 Mitchell, *Picture Theory*, 285.

70 Through these mechanical tools, Cortázar also calls attention to the links among media devices, fictional writing, and personal

experience. He himself was using a typewriter and a photographic camera by the time he wrote the story, and even before—since his youth in Argentina. Among the many letters containing references to his photographic practice, see *Cartas 1937-1983*, vol. 1, 105. His loyalty to the typewriter would be in full display until the end of his career, as shown in *Los autonautas de la cosmopista*.

71 In his essay on "Las babas del diablo," Gutiérrez Mouat includes as an epigraph a line from the opening poem of Baudelaire's *Les fleurs du mal*, "Au Lecteur" ["To the Reader"]: C'est le Diable qui tient les fils qui nous remuent! (183) [The Devil's hand directs our every move! (5)]. The verse encapsulates the demonic dimension of Cortázar's text. Meyer-Minnemann and Pérez y Effinger suggest that the transgression of ontological boundaries leads to the death of the transgressor ("Narración paradójica," 199). Jackson points out that nineteenth-century fantastic literature was reformulating the demonic, shedding its supernatural dimension and considering it an "an aspect of personal and interpersonal life, a manifestation of unconscious desire" (*Fantasy*, 55). Cortázar, who was heir to that tradition, adds to the mid-twentieth century a layer of ambiguity by allowing a supernatural reading of the text.

72 McLuhan, *Understanding Media*, 7; Kittler, *Gramophon, Film, Typewriter*, xxxix.

73 See Grenville, "The Uncanny," 13–48.

74 Michel himself is aware that media devices impose their own representational bias: "Michel sabía que el fotógrafo opera siempre como una permutación de su manera personal de ver el mundo por otra que la cámara le impone insidiosa" (216) [Michel knew that the photographer always worked as a permutation of his personal way of seeing the world as other than the camera insidiously imposed upon it (117–18)]. The camera is thus an instrument of human dispossession. Scott spells out one version of this outcome that deprives agency to man through his own inventions: "Our relationship with photography seems, at first sight, to be one of personal dispossession. . . . [W]hatever the nature of the photographer's preparations and the viewer's responses, the camera takes the photograph, and in so doing ousts both the photographer and the viewer. The viewer cannot intervene in the image: it is past. The viewer cannot debate the meaning of the image: it has its own pre-emptive actuality. . . . The photographer, for his part, is superseded by his own product, or cast in the role of foster parent" (*Spoken Image*, 78–79).

75 Kittler, *Grammophon, Film, Typewriter*, 203.

76 See Kittler on the typewriter as machine gun (ibid., 181) and Sontag on the camera as predatory weapon (*On Photography*, 14). In "Apocalipsis de Solentiname," the repetitive sound of the slide projector's magazine echoes that of a machine gun.

77 Grossvogel explores the idea of the breakdown of telling and the frustration of seeing in Cortázar's work ("Blow-Up").

78 Schwartz, *Culture of the Copy*, 223.

79 For Freud, the "impression of automatic, mechanical processes at work behind the ordinary appearance of mental activity" is one of the marks of the uncanny ("The Uncanny," 226).

80 The rhetoric of capturing or seizing is pervasive in theories of photography. See Barthes, *Camera Lucida*, 92, and Sontag, *On Photography*, 3–4.

81 Michel describes her reaction in this way: "ella [estaba] irritada, resueltamente hostiles su cuerpo y su cara que se sabían robados, ignominiosamente presos en una pequeña imagen química" (220). [She was irritated, her face and body flat-footedly hostile, feeling robbed, ignominiously recorded on a small chemical image. (124)]

82 González Echevarría identifies the linguistic markers of this nothingness and considers them as signs of the dissolution of individuality: "la *o* juega un papel fundamental en los nombres de muchos de los personajes de Cortázar: N*o*ra, W*o*ng, Oliveira, R*o*land, R*o*mero, R*o*berto. Esa *o* o cero, es el grafismo que designa la ausencia, la disolución de la individualidad, la esfera que delimita la nada" [the *o* plays a key role in the names of many of Cortázar's characters: N*o*ra, W*o*ng, Oliveira, R*o*land, R*o*mero, R*o*berto. That *o*, or zero, is the grapheme that designates an absence, a dissolution of individuality, a sphere demarcating nothingness.] ("*Los reyes*: Mitología," 217–18). Meyer-Minnemann and Pérez y Effinger point out that the man in black who approaches Michel "lleva la máscara de la muerte" ("Narración paradójica," 200).

83 The clouds may point again to Baudelaire and his short prose fiction "Les nuages," included in his *Petit Poems en Prose*. Baudelaire himself moved in 1843 to the Hôtel de Lauzun, on the Île Saint-Louis, a residence mentioned by Michel while he walks towards the tip of the island (quoted in Gutiérrez Mouat, "'Las babas del diablo,'" 46).

84 Again, Cartier-Bresson provides a useful background. He writes in his essay "The Decisive Moment": "the world is movement, and you cannot be stationary in your attitude toward something that is moving. . . . You must be on the alert with the brain, the eye, the heart, and have a suppleness of body" (*The Mind's Eye*, 24).

85 On the notions of ekphrastic hope, fear, and indifference, see Mitchell, *Picture Theory*, 152–56.

86 Zamora, "Movement and Stasis," 52.

87 Mitchell, *Picture Theory*, 156. See also Heffernan, *Museum of Words*, 7.

88 To sum up this paradoxical situation, it could be said that, on the one hand, the photograph of the woman and the boy points to a seduction scene where the woman (or the man waiting in the car) is meant to (sexually) merge with the teenager, though this encounter ends up in a separation caused by the very act of picture-taking. On the other hand, the photographic print, a visual sign that opened a distance between Michel and the actual events unfolding, ends up merging in fantastic fashion distinct realms of existence.

89 *Corporealized Observers*, 290.

90 Ibid.

91 Ibid. Marks has also developed the concept of a haptic visuality, highlighting the tactile (and multisensory) nature of visual representations (*The Skin of the Film*, 159). Nancy refers to an ingrained eroticism of images, since their seduction is "nothing other than their availability for being taken, touched by the eyes, the hands, the belly, or by reason, and penetrated" (*The Ground of the Image*, 10).

92 Sobchack, "Scene of the Screen," 92.

93 Moran, *Questions of the Liminal*, 12.

94 Commenting on Freud's "The Uncanny," Jackson writes that what is experienced as uncanny by the protagonist of E. T. A. Hoffmann's "The Sandman," Nathanael, is "an objectification of the subject's anxieties, read into shapes external to himself" (*Fantasy*, 67). The same pattern is discernible in Roberto Michel's thoughts and reactions.

95 Another image folded in four that inscribes forbidden desire appears in chapter 14 of *Rayuela*, when Wong shows Oliveira a sheet that contains a series of photographs of a Chinese torture. The photographs, made famous by Bataille's *Les larmes d'Eros*, have had a productive intertextual fate in Latin American letters. They are the topic of an extended commentary by the Cuban writer Severo Sarduy in "Escrito sobre un cuerpo" (1125–37), as well as the main leitmotif of Salvador Elizondo's novel *Farabeuf*, which I examine below. See also Baler, *Sentidos de la distorsión*, 127–34.

96 Mitchell, *Picture Theory*, 158.

97 Cortázar, *Clases de literatura*, 110. Goloboff, *Julio Cortázar*, 261; Cardenal, *Insulas extrañas*, 421; Henighan, *Sandino's Nation*, 289.

98 The protagonist of "Apocalipsis de Solentiname," modeled after Cortázar himself, meets and chats with real-life Costa Rican and Nicaraguan friends of the author before heading to Solentiname and later with his partner Claudine, in Paris, but the climax of the story unfolds while he is by himself.

99 Rosenblum points out that "Color positive films (transparencies) still are preferred by many professionals because they have a finer grain and are therefore sharper than corresponding color negative film"

(*World History of Photography*, 606).

100 Cortázar compares erotic fulfillment to the colour green: "Un clímax erótico final es siempre verde. . . . [Y]o creo que he utilizado en poesía o en prosa la idea del orgasmo como una especie de enorme ola verde, una cosa que sube así, que crece, una cresta verde" [A final erotic climax is always green. . . . I think I have used in poetry or prose the idea of the orgasm as a kind of huge green wave, something that rises like this, that grows, a green crest] (Picón Garfield, *Cortázar por Cortázar*, 87). Opposition between colour and grey tones can be found in the introduction to "Noticias del mes de Mayo," where Cortázar praises "el color que asalta los grises anfiteatros" [the colour that takes by storm the grey amphitheatres] (*Ultimo round*, vol. 1, 88). Explicit references to colour appear in chapters 36, 56, 64, 88, and 133 of *Rayuela*.

101 Leys points out that, "according to the temporal logic of what Freud called *nachträglichkeit*, 'deferred action,' trauma was constituted by a relationship between two events or experiences—a first event that was not necessarily traumatic because it came too early in the child development to be understood and assimilated, and a second event that also was not inherently traumatic but that triggered a memory of the first event that only then was given traumatic meaning and hence repressed" (*Trauma*, 20). Mulvey defines this deferred action as "the way the unconscious preserves a specific experience, while its traumatic effect might only be realized by another, later but associated, event" (*Death 24x a Second*, 8). In *Sprectral Evidence*, Baer approaches a photograph "not as the parceling-out and preservation of time but as an access to another kind of experience that is explosive, instantaneous, distinct—a chance to see in a photograph not narrative, not history, but possibly trauma" (6).

102 Sanjinés, *Paseos en el horizonte*, 24; Tittler, "Dos Solentinames de Cortázar," 112.

103 Invented in 1948 by Edwin Land, the Polaroid camera made instant one-step photography possible. It became popular thanks to technological improvements in the 1960s (Rosenblum, *World History of Photography*, 603–4).

104 A rhetoric of magic and wonder has accompanied photomechanical processes since photography was invented (Newhall, *History of Photography*, 18). In the twentieth century, critics of photography who employ this rhetoric include Bazin ("Ontology," 11), Sontag (*On Photography*, 155) and Cavell (*The World Viewed*, 18). Writing in the late 1970s, Barthes saw photography as an "emanation of *past reality*: a *magic*, not an art" (*Camera Lucida*, 88). Similarly, Gunning points to a widespread phenomenon of our "enlightened"

modernity: "new technologies on first appearance can seem somehow magical and uncanny, recalling the wish fulfillments that magical thought projected into fairy tales and rituals of magic" ("Uncanny Reflections," 68, 79, 85). Critics such as Kracauer ("Photography," 53), Sekula (*Photography against the Grain*, 10), and Snyder ("What Happens by Itself," 371) argue against the interpretation of photography as a miraculous technology, stressing its cultural and ideological conditions. See also Brunet, *Photography and Literature*, 30.

105 Zamora, *Writing the Apocalypse*, 87.

106 One of the reactions of the dazed protagonist after the display of violence on the screen is to go to the bathroom and, perhaps, vomit. Claudine arrives home after the show has concluded, and the protagonist remains silent and transfixed in his shock: "sin explicarle nada porque todo era un solo nudo desde la garganta hasta las uñas de los pies, me levanté y despacio la senté en mi sillón y algo debí decir de que iba a buscarle un trago. En el baño creo que vomité, o solamente lloré y después vomité o no hice nada y solamente estuve sentado en el borde de la bañera dejando pasar el tiempo." (159)] [without explaining anything because everything was one single knot from my throat down to my toenails, I go up and slowly sat her down in my chair and I must have said something to her about going to get her a drink. In the bathroom I think I threw up or didn't do anything and just sat on the edge of the bathtub letting time pass. (126)]. Effects on the stomach, this most sensitive of human organs, are also alluded to in "Las babas del diablo," where anxiety is closely linked to physicality, and words are entrusted to provide catharsis (214–15).

107 Volek, "'Las babas del diablo,'" 27; Gutiérrez Mouat, "'Las babas del diablo,'" 37.

108 The idea of the mind as a photographic device where images become permanently inscribed was also developed in the short stories "El retrato" (1910) and "La cámara oscura" (1920) by the Uruguayan writer Horacio Quiroga. See chapter 2.

109 Elizondo points out that "la fotografía es un *leitmotiv* más reiterado en casi toda mi obra que el espejo [*sic*]" [photography is a more recurrent *leitmotiv* in most of my work than the mirror] (Glantz, *Repeticiones*, 33).

110 Fragmentation is a mark, as Linda Nochlin states, of the experience of the modern: "a loss of wholeness, a shattering of connection, a destruction or disintegration of permanent value" (*The Body in Pieces*, 22–23). Photography has a privileged role in this context since, as she adds, it is the "primary source of modern visual culture" (ibid., 24). In her study of the fragment in contemporary Mexican literature, Clark D'Lugo points out that "One

interpretation of the prevalence of the fragmentation in twentieth-century fiction is that it serves symbolically as a representation of the world as we experience it. The control and unity associated with the world prior to World War I have crumbled" (*The Fragmented Novel*, 10). On the fragmentariness of photography see Sontag, *On Photography*, 17, and Perkowska, *Pliegues visuales*, 103.

111 *Cuaderno de escritura*, 423.

112 Sontag writes that Bataille "kept a photograph taken in China in 1910 [sic] of a prisoner undergoing 'the death of a hundred cuts' on his desk, where he could look at it every day.... 'This photograph' Bataille wrote, 'had a decisive role in my life. I have never stopped being obsessed by this image of pain, at the same time ecstatic and intolerable'" (*Regarding the Pain*, 98). For the source of the photographs used by Bataille, see Romero ("Ficción e historia," 411). The photograph was first used by Elizondo in an essay entitled "Morfeo o la decadencia del sueño," published in October 1962 in *S.NOB*, a literary magazine of which he was director. For a history and legal context of Chinese torture and execution, and the corresponding Western understanding, see Brook, Bourgon, and Blue, *Death by a Thousand Cuts*. Textual and iconographic materials about the Leng Tch'é, or *lingchi*, can be found online; see "Chinese Torture / Supplice Chinois: Iconographic, Historical and Literary Approaches of an Exotic Representation," Jérôme Bourgon, editorial director, accessed 15 August 2014, http://turandot.chineselegalculture.org. Elkins questions the entrenched Bataillean interpretation of the photographs when he asserts that "It was widely assumed by Westerners that the *lingchi* was an operation intended to produce pain. There is no evidence for that in the Chinese texts. Rather it appears that the purpose was to ensure that the man could not take his place with the ancestors because he would be given an improper burial" ("On the Complicity," 81). Elizondo's novel is named after a real-life French medical doctor, Louis Herbert Farabeuf (1841–1910), an eminent surgeon who wrote a treatise on amputations entitled *Précis de manuel opératoire* (1881), illustrated with high-quality engravings, which Elizondo discovered in his thirties (Lemus, "Más allá," 67).

113 In his essay "El putridero óptico," on Gironella, Elizondo writes, "Toda obra de arte es el origen de un delirio. Si no lo es, ha fracasado." (408) [Every work of art is the origin of a delirium. If it isn't, it has failed.] An aphorism included in the section "La esfinge perpleja" states, "Fin de la obra de arte (quizá): expresar las fuentes del delirio." (*Cuaderno de escritura*, 454) [Aim of the work of art (perhaps): to express the sources of delirium.] An aesthetics of

psychological upheaval dominates Elizondo's view on the origins of art. Rimbaud's "self-conscious sensual derangement" (Jay, *Downcast Eyes*, 238) also comes to mind as one of Elizondo's literary sources.

114 Lemus, "Más allá," 68.
115 Preminger and Brogan, "Enargeia," 332. See also Webb, "Ekphrasis Ancient and Modern," 13.
116 Ríos, *Espectros de luz*, 72.
117 Guerrero argues that "Se narra desde un espejo, donde el 'nosotros' es el reflejo de todas las imágenes e instantes que se han posado en él" [Narration proceeds from a mirror, where the "we" is the reflection of the all the images and moments that have sat on it] (*Farabeuf a través del espejo*, 47. The claim is only partially supported by the text, and ultimately undecidable. Rather than trying to pin down the abstruse narrative structure of the novel, I claim that the uncertainty enveloping the events lies at the centre of the author's literary intention. As a kind of literary contagion, Elizondo's brand of literary delirium has produced some scholarly interpretations which seem no less delirious. René Jara's heavy-handed structuralist interpretation (*Farabeuf*), and Alberto Moreiras's deconstructionist essay ("Ekphrasis y signo terrible en *Farabeuf*"), rather than elucidating the novel, immerse the reader in a conceptual instability similar—but, poetically, less appealing—to the one produced by the novel. See also José, *Farabeuf y la estética del mal*.

118 Stephen Heath points out that in the novels of this movement "all the insistence is on the specificity of the text and the activity of its reading" (*The Nouveau Roman*, 30), as is the case with *Farabeuf*. Patricia Martínez delineates the following defining features of the *nouveau roman*, which are also shared by *Farabeuf*: emphasis on description and primacy of the visual; phenomenological description of mental processes; the literary work understood as a self-sufficient, closed system; fiction as a theme of fiction; the creation of effects of dispersion, deception, and defamiliarization through the multiplication of perspectives; and the juxtaposition of unrelated sequences (Introduction to *El mirón*, 22–39). See also McMurray, "Salvador Elizondo's 'Farabeuf,'" 597.
119 Quoted in Shaw, *Post-Boom*, 169–70.
120 For example, an unidentified narrator, addressing the woman, comments on "ese compromiso ineludible que has concertado con tu pasado, con un pasado que crees que es el tuyo pero que no te pertenece más que en el delirio, en la angustia que te invade cuando miras esa fotografía" (36) [the ineluctable compromise you have made with your past, a past you think is yours but which in fact belongs to you only in your delirium, in the anguish that invades you when you look at that

photograph (19)]. See also pp. 20, 93, 128 and 148.

121 See Sarduy, "Escrito sobre un cuerpo," 1136, and Curley, *En la isla desierta*, 135. In perhaps the most cogent review of *Farabeuf*, McMurray points out that "the work could have various interpretations, but it assumes greater plausibility if one supposes that the woman is insane (that is suggested more than once) and that all the action (partly real, partly imagined and partly anticipated) takes places in her mind. The obscure question that she asks of the Ouija board and the Chinese puzzle turns out to be '¿Quién soy?' Thus the novel chronicles a deranged woman's search for identity by evoking an obsessive 'instante,' a fabulous moment of simultaneous orgasm and death or of physical love and dissection" ("Salvador Elizondo's 'Farabeuf,'" 597). Manuel Durán has suggested that the "true" instant toward which all the others converge in the novel is the moment when a tormented woman dies (*Tríptico mexicano*, 153). This privileged instant echoes other moments where the extremes of sensory perception—and the limits between life and death, literally and figuratively—are at play: the death of the Chinese boxer, lovemaking, a surgical operation, and a ritual sacrifice. See Filer, "Salvador Elizondo," 216.

122 Elizondo re-elaborates in *Farabeuf* the topic of violence against women that stems from the writings of the Marquis de Sade and the tradition of French Romanticism leading up to the Surrealists. See Curley, *En la isla desierta*, 137, and Praz, *The Romantic Agony*, chap. 3. The topic also appears in Elizondo's semi-fictional *Autobiografía precoz* (72–73), where the narrator, in a fit of violence against his wife, cynically lends a measure of support to acts of aggression against women.

123 The proliferation and piling up of violent scenes leads to a traumatic onslaught, defined in psychoanalysis in economic terms: "an influx of excitations that is excessive by the standard of the subject's tolerance and capacity to master such excitations and work them out psychically" (Laplanche and Pontalis, , "Trauma (Psychical)," 465)." See note 101 in this chapter and note 33 in chapter 3.

124 Curley, *En la isla desierta*, 104. See also Ríos, *Espectros de luz*, 76.

125 As the author stated in an interview with Jorge Ruffinelli, "un aspecto que para mí resulta fundamental no sólo en *Farabeuf* sino en casi todos mis libros, relatos y otras cosas que he escrito: eso es, más que el orden de la instantaneidad, el orden de la *fijeza*, que se caracteriza tangiblemente en la narración por la aparición inevitable de la noción de fotografía" [One aspect that for me is crucial not only in *Farabeuf* but in almost all of my books, stories and other writings: that is, more than the realm of instantaneity, the realm of *fixity*, which manifests

itself in the narrative by the unavoidable appearance of the notion of photography] (Ruffinelli, "Salvador Elizondo," 155). Sobchack describes in these terms the investment of the photograph with fixity and the irretrievable past: "The photographic—unlike the cinematic and the electronic—functions neither as a coming-into-being (a presence always presently constituting itself) nor as being-in-itself (an absolute presence). Rather, it functions to fix a being-that-has-been (a presence in the present that is always past). Paradoxically, as it objectifies and preserves in its act of possession, the photographic has something to do with loss, with pastness, and with death, its meanings and value intimately bound within the structure and investments of nostalgia" ("Scene of the Screen," 93). One of Elizondo's favorite poetic images, from the poem "Humildemente…" included in the book *Zozobra* (1919) by Mexican poet Ramón López Velarde, points to a moment when continuous action is paralyzed, as if captured in a snapshot: "Mi prima, con la aguja/en alto, tras sus vidrios,/ está inmóvil con un gesto de estatua" (180) [My cousin, with the needle/up high, behind her glasses,/ keeps still with the gesture of a statue]. (Elizondo, personal communication from the author, June 15, 2002).

126 Sontag notes that "when it comes to remembering, the photographs [have] the deeper bite [compared to the "nonstop imagery" of cinema, television, and video]. Memory freeze-frames; its basic unit is the single image" (*Regarding the Pain*, 22). As Hughes and Noble point out, photographs "perform as metaphor for the process of perception and memory" and are "analogues of memory" ("Introduction," 5). Nonetheless, the late Roland Barthes, who acknowledges the power of photographs to arrest time, argues that photographs actually block memory (*Camera Lucida*, 91). For Kracauer, photographic and mnemonic images are at odds, in terms of the specificities of their production: "Photography grasps what is given as a spatial (or temporal) continuum; memory images retain what is given only insofar as it has significance" ("Photography," 50).

127 *Power of Photography*, 218.
128 Cioran, *Short History of Decay*, 31.
129 Sontag, *On Photography*, 13.
130 "Elizondo, *Cuaderno de escritura*, 404. See also *Autobiografía precoz* (56). The first edition of *Cuaderno de escritura* (1969) includes a reproduction of a painting by Gironella whose model is the photograph of the execution ("Gironella", 70). The essay "Gironella" appears in *Obras* under the name of "El putridero óptico".
131 Curley acknowledges the influence of Borges, but in reference to a couple of seemingly secondary issues: "el azar y la realidad exterior" [chance and outside reality] (*En la isla desierta*, 17, 25).

Donald Shaw writes that "A pesar de su erotismo, entonces, *Farabeuf* es una novela esencialmente metafísica, cuyo tema fundamental nos recuerda más que nada el de 'La escritura de Dios' de Borges" [Despite its eroticism, *Farabeuf* is essentially a metaphysical novel, whose main subject reminds us above all of "The Writing of the God" by Borges] (*Nueva narrativa hispanoamericana*, 335). As I show below, those topics and that story are not at the centre of Elizondo's literary universe.

132 As Filer remarks, "The flow of anticipatory images of death attributed to this protagonist and the 'mental drama' of Dr. Farabeuf also echo Borges's story 'The Secret Miracle': Jaromir Hladik, after living through hundreds of deaths before being executed, during one year that elapses only within his mind concluded a drama that does not take place except as 'the circular delirium' interminably lived and relived by the character Kubin" ("Salvador Elizondo," 216–17).

133 Borges, "El milagro secreto," 512.

134 See Russek, "Borges' Photographic Fictions," in which I analyze the role of photography in "Tlön, Uqbar, Orbis Tertius," "La otra muerte," "El zahir," "El Aleph," and "El milagro secreto."

135 *Fantasy*, 72. In *The Ground of the Image*, Jean-Luc Nancy describes violence as "a stubborn will that removes itself from any set of connections and is concerned only with its own shattering intrusion"

(16). This describes well the inner dynamics of delirium as deployed in the novel.

136 Borges, "El milagro secreto," 511.

137 Borges, "El zahir," 592.

138 Ibid., 594. In an essay devoted to the poetry of Borges, Elizondo refers to the zahir as "la posibilidad de un tiempo capaz de conjugar un número infinito de espacios en la dimensión obsesiva de la memoria personal" [the possibility of a time capable of blending an infinite number of spaces in the obsessive dimension of personal memory] (*Cuaderno de escritura*, 389). In truth, the zahir represents not an infinite number of spaces (as is the case with its fictional twin, the aleph), but a single mental space that ends up absorbing all others.

139 Praz quotes a passage from Baudelaire, in reference to Edgar Allan Poe, expressing this idea: "Le caractère, la genie, le style d'un homme est formé par les circonstances en apparence vulgaires de sa première jeunesse. Si tous les hommes qui ont occupé la scène du monde avaiant noté leurs impressions d'enfance, quel excellent dictionnaire psychologique nous posséderions!" (*Romantic Agony*, 184n174) [The personality, the genius, the style of a man is formed by the seemingly vulgar circumstances of his early youth. If all men who have occupied the world stage had written down their childhood impressions, what an excellent psychological dictionary we would possess!]. "Ein Heldenleben,"

written when Elizondo was in his fifties, explores a childhood recollection involving a violent episode against a defenceless Jewish boy in Nazi Germany (*Camera Lucida*, 539–47).
140 *Autobiografía*, 22, 25; see also Jackson, *Fantasy*, 48; Lemus, "Más allá," 65.
141 *Cuaderno de escritura*, 370.
142 Ibid., 369.
143 According to Foucault, "one of the primary objects of discipline is to fix," and discipline "arrests or regulates movements" (*Discipline and Punish*, 218, 219).
144 Spanish passages from *Farabeuf* are taken from the version published in *Narrativa completa* translations are from *Farabeuf*, translated by John Incledon.
145 The persistence of these images are for Elizondo "un ejemplo de lo que puede ser el retorno a la infancia llevado a sus extremos críticos. Un hecho es importante: el de que las imágenes que han poblado nuestras mentes infantiles jamás se borran. A ellas acudimos siempre que queremos evocar ese período de nuestra vida, y es justamente por esto por lo que la literatura de nuestra infancia puede jugar, llegado el caso, un papel tan inmensamente importante" [an example of what the return to childhood can mean when taken to its critical extreme. One fact has to be borne in mind: the images that have inhabited our mind during childhood never go away. We resort to them when we want to evoke that period of life, and it is because of this that the literature of our childhood can play, in some cases, such an immensely important role] (*Cuaderno de escritura*, 371).
146 Ibid., 404.
147 Quoted in Curley, *En la isla desierta*, 49–50.
148 Sontag, *On Photography*, 20.
149 Barthes, *Camera Lucida*, 27. Linfield makes the point that photographs bring us closer to the experience of suffering than art or journalism (*Cruel Radiance*, xv).
150 See the essay "De la violencia," which closely follows the later work of Georges Bataille.
151 Freedberg, *Power of Images*, 19. See also Brooks, *Body Work*, 9.
152 Sontag, *Regarding the Pain*, 96.
153 Freud, "The Uncanny," 231.
154 Clark D'Lugo claims that the thorough disintegration deployed in the novel leads to a final synthesis: "In *Farabeuf* one sign leads to another that, in turn, reflects a third, *ad infinitum* building a totally unified whole. ... All is one in a giant equation of equivalencies that eventually returns to the starting point" (147). On the contrary, I argue, there is no unified whole in *Farabeuf*, no final resolution to the enigmatic linkage of the recurring narrative fragments—unless, as Paz suggests, we consider death ("la respuesta definitiva y universal" [the ultimate and universal answer) as the ultimate unifier ("El signo y el garabato," 502). The nature of *Farabeuf*'s photographic delirium implies that no ultimate stable

framework can be found to make sense of the text as a whole.

155 In the context of world cinema, the scene of the cutting of the eye at the beginning of *Un chien andalou*, the short film by Dalí and Buñuel, is explicitly considered by Elizondo as one of the quintessential violent images produced in the twentieth century (*Cuaderno de escritura*, 404). For Bataille, this image shows "to what extent horror becomes fascinating" ("Eye," 19). For more cutting blades, see Elizondo's short fiction "Mnemothreptos."

156 Gernsheim and Gernsheim, *History of Photography*, 117.

157 The picture is included in all the editions of the novel, signaling its paratextual importance. However central the role of the photograph is, not all critics have highlighted its presence. For example, Shaw points out the purposes of the book without even mentioning the picture (*Post-Boom*, 169–70). Clark D'Lugo acknowledges that the photograph is central to the meaning of the novel, but she refers to the image as a "photograph of a human being undergoing dissection," when the torture would be better described as a vivisection (*The Fragmented Novel*, 145). See also Curley, *En la isla desierta*, 146; Glantz, *Repeticiones*, p.17 p.17 p.1 17; and Williams, *The Postmodern Novel*, 25.

158 Sarduy, "Escrito sobre un cuerpo," 1135; Moreiras, *Tercer espacio*, 329.

159 Mitchell, *Picture Theory*, 153.

160 Curley, *En la isla desierta*, 49.

161 Linfield, *Cruel Radiance*, 39.

162 See Lemus, "Más allá," 68; Teresa, *Farabeuf*, 18.

163 Linfield, *Cruel Radiance*, 22.

164 Heffernan, *Museum of Words*, 7.

165 Elkins and Di Bella allude to this interpellation by the photograph when they state that "no understanding of images of pain can be complete without an interrogation of the viewer's interests and even the viewer's pleasure" ("Preface," 13).

166 No commonplace in the theory of photography is more enduring than the notion of the photograph as a fixed and frozen image, and photography as a medium that both arrests life and deceptively preserves the perishable and vanishing. Art historian Martha Langford writes about the "provocative ambiguity" at the heart of the medium: "to be photographed is somewhat akin to dying; to photograph is an act of soft murder; to be photographed is an act of self-perpetuation" (*Suspended Conversations*, 27). On the many links between photography and death, see Barthes, *Camera Lucida*, 14, 31, 92; Bazin, "Ontology," 9–10; Cadava, *Words of Light*, 27; Linfield, *Cruel Radiance*, 65; Metz, "Photography and Fetish," 157–58; Sobchack, "Scene of the Screen," 93; and Sontag, *On Photography*, 70, and *Regarding the Pain*, 24. See also Linkman, *Photography and Death*, and Ruby, *Secure the Shadow*.

167 Elizondo, *Autobiografía precoz*, 56–57.

168 Regarding this sense of completion in the midst of suffering, Elaine Scarry writes that "torture aspires to the totality of pain" (*Body in Pain*, 55).

169 Elkins, *The Object Stares Back*, 136–37.

170 Even the author acknowledged a tendency to sensationalize this domain of experience (Ruffinelli, "Salvador Elizondo," 155). He also pointed out that "El escenario de *Farabeuf* es la epidermis del cuerpo. Todo lo que pasa allí, pasa en un nivel sensible" [The stage in *Farabeuf* is the body's epidermis. Everything that happens there, happens on a sensitive level]. (quoted in Glantz, *Repeticiones*, 28).

171 Benjamin, "Work of Art," 220; Bazin, "Ontology," 13–14.

172 About these theoretical positions, see, respectively, Krauss, "Photographic Conditions of Surrealism," 110, and *Notes on the Index*, 203; Bazin, "Ontology," 14; and Barthes, *Camera Lucida*, 80.

173 The photograph that obsesses the woman in *Farabeuf* is not displayed on a wall, that is, it is not meant exclusively to be seen. It is a print placed between the pages of a book and stored in a drawer, a circumstance that implies a functional link with tactility. The photograph has also been printed in a newspaper, which offers yet another instance of a medium that requires handling.

174 Williams, *Corporealized Observers*, 290.

175 Curley, *En la isla desierta*, 92.

176 Benjamin, "Work of Art," 235–36; McLuhan, *Understanding Media*, 3; Jay, *Downcast Eyes*, 3, 7, 133.

177 Brooks, *Body Work*, 96.

178 Ibid., 100.

179 Edward Weston, for one, asserted that "the discriminating photographer can reveal the essence of what lies before his lens in a close-up with such clear insight that the beholder will find the recreated image more real and comprehensible than the actual object" (quoted in Frampton, "Impromptus on Edward Weston," 68).

2 | FAMILY PORTRAITS IN QUIROGA, RULFO, OCAMPO, AND PIÑERA

1 See Hirsch, *Family Frames*; Spence and Holland, eds., *Family Snaps*; and Langford, *Suspended Conversations*.

2 Sarlo, "Horacio Quiroga," 1285. See also Rivera, "Profesionalismo literario," 1262, and Alonso, *Burden of Modernity*, 115.

3 Sarlo, "Horacio Quiroga," 1278.

4 Brignole and Delgado, *Vida y obra*, 58. Biographical information is drawn from the 1939 biography of Quiroga by Alberto Brignole and José Delgado, who were friends of the writer. See also Orgambide, *Horacio Quiroga*.

5 Black, "Amateur Photographer," 149–53; Gautrand, "Photography," 233–41; Gernsheim and Gernsheim, *History of Photography*, 413–15, 422–25; Newhall, *History of Photography*, 128–29;

Rosenblum, *World History of Photography*, 259, 442–48.

6 Brignole and Delgado, *Vida y obra*, 59.

7 Ibid, 60. On the cultural importance of the Kodak, see references in chapter 1.

8 In a journal entry dated 17 April 1900, Quiroga writes about the prospect of photographing Teide, the volcano towering over Tenerife: "Esta mañana se ve el Tenerife [sic], al Oeste, a distancia de 15 ó 20 lenguas. Se distingue entre brumas, su cono enorme, casqueado de nieve. La mitad inferior está oculta por montes y serranías lejanas. Veré de tomar a mediodía una instantánea." [This morning the Tenerife [sic] is visible, fifteen or twenty leagues to the west. It is noticeable through the haze, its huge peak, covered with snow. The lower part is hidden by hills and distant ranges. I will see to take a snapshot by noon.] (*Diario y correspondencia*, 31) References in his *Diario* to his camera shed indirect light on his Parisian adventure, which would turn sour after a few weeks. Quiroga, dreaming of a bohemian life, found himself alone and bored after a few weeks and soon ran out of money. Unable to let his family know about his dire straits, after a month in Paris he was forced, desparate and humiliated, to pawn his bicycle and his camera to feed himself (Ibid., 58–59).

9 Brignole and Delgado, *Vida y obra*, 142. See also Orgambide, *Horacio Quiroga*, 51.

10 Brignole and Delgado, *Vida y obra*, 152–53; Henríquez Ureña, *Breve historia del modernismo*, 248.

11 See Brennan, "'The Contexts of Vision,'" 219–20; Wade, *Natural History of Vision*, 11–15.

12 This was an important token of remembrance, at a time when modern visual culture was emerging and the symbolic and emotional value of pictures of this sort was higher than it is today. Regarding the late nineteenth century, Linkman points out that in the West, "for those denied the 'privilege' of attendance at the deathbed, a post-mortem portrait may have offered a form of proxy admission to the theatre of death and so provided some measure of consolation" (*Photography and Death*, 16).

13 Rodríguez Monegal, *Genio y figura*, 137–38.

14 Jitrik, *Horacio Quiroga*, 111–29.

15 See Poe's "The Imp of the Perverse." On Poe's influence on Quiroga, see Alonso, *Burden of Modernity*, 113–14; Englekirk, *Edgar Allan Poe*; and Glantz, "Poe en Quiroga."

16 Rodríguez Monegal points out that "las alucinaciones de su [Quiroga] adolescencia aparecen superadas ahora en un relato de horror que echa sus raices en la realidad misma" [the hallucinations of Quiroga's adolescence are now overcome in a horror story that has its roots in reality itself] (*Genio y figura*, 138). The Freudian uncanny, "that class of the frightening which leads back to what is known of old and long familiar," applies quite

literally to the episode Quiroga describes (Freud, "The Uncanny," 220).

17 Goldberg, *Power of Photography*, 11; Linkman, *Photography and Death*, 18; Norfleet, *Looking at Death*, 12.

18 Quiroga's description, by pursuing a literary effect, goes against the conventional norms of portraiture of the times. Linkman remarks that "photographers were clearly expected to aim for an expression that was free of any suggestion of pain, and which could convey a reassuring sense of peace and serenity" (*Photography and Death*, 24). Against the notion of an idealized picture, Quiroga's point is precisely to highlight a crude realism.

19 The scene recalls another of Poe's favorite subjects, the premature burial. See Royle, *The Uncanny*, 159, and Freud, "The Uncanny," 244.

20 If the photographic process of soaking a glass or paper in a chemical bath can be "likened to a birth process," Quiroga is figuratively giving birth to death (Hirsch, *Family Frames*, 173).

21 Gunning, "Phantom Images," 52.

22 Cortázar, literary kin to Quiroga in his probing of the dark side of the human soul, also invokes an ominous half-open mouth (that of the man in black), at the end of "Las babas del diablo" as a graphic representation of the threshold between life and death (224).

23 Alonso, *Burden of Modernity*, 118.

24 As Canfield claims; see "Transformación del sitio," 1365.

25 For a critical reassessment of Rulfo as photographer, see Russek, "Rulfo, Photography." For a survey of critical literature on the subject, see Benjamin Fraser, "Problems of Photographic Criticism." Brunet writes that "The practice of photography by writers—from Giovanni Verga, G. B. Shaw, J. M. Synge or the young William Faulkner, to Jerzy Kozinsky, Richard Wright or Michel Tournier—became almost banal, though in most cases it did not come to light or prominence until the 1970s or 1980s, as in the example of Eudora Welty, long known as a storyteller before her photography of the rural American South in the 1930s was publicized" (*Photography and Literature*, 125).

26 For all the interest Rulfo's photography has recently generated, few critics have stopped to closely examine this passage. Commentators such as Margo Glantz ("Ojos de Juan Rulfo," 18) and Erika Billeter ("Juan Rulfo," 39) have quoted it in relation to Rulfo's photographic production without considering its significance in the broader context of the novel. An exception to this approach is the essay "Recuperación de la imagen materna a la luz de elementos fantásticos en *Pedro Páramo*" by Hedy Habra, who points out the importance of the photograph in the overall structure of the text (91–92). See my comments on this essay below.

27 Spanish passages from Pedro Páramo are taken from the version edited by José Carlos González Boixo; translations are from *Pedro Páramo*, translated by Margaret Sayers Peden.

28 In the quotation, the verb "reconocer" has a polysemic dimension, referring to visual, legal, and even emotional recognition.

29 Habra has also highlighted the figure of the mother in her study of the fantastic elements in the novel. By stressing the importance of female figures as doubles of the mother, she argues that the search of Juan Preciado for his true self leads him to identify with his mother, not his father ("Recuperación de la imagen maternal," 91). Rodríguez Monegal sees in the mother the driving force behind Juan's actions ("Relectura de Pedro Páramo," 132). On the role of the mother in the novel, see also Franco ("Viaje al país," 144) and Bradu ("Ecos de Páramo," 228).

30 Barthes, *Camera Lucida*, 9.

31 Metz points out that "The familiar photographs that many people always carry with them obviously belong to the order of fetishes in the ordinary sense of the word" ("Photography and Fetish," 161).

32 Bradu, "Ecos de Páramo," 227; Campbell, "Prólogo," 241; Franco, "Viaje al país," 142, and Poniatowska, "¡Ay vida!," 523.

33 Ong, *Orality and Literacy*, 72.

34 Sontag, *On Photography*, 16.

35 Benítez, "Conversaciones con Juan Rulfo," 15.

36 Barthes, *Camera Lucida*, 27.

37 Ibid., 73. See Brunet, *Photography and Literature*, 64.

38 The holes in the photograph also represent the limits (and pitfalls) of memory itself. Marianne Hirsch explains thusly her use of the notion of "postmemory," which is "connected to Henri Raczymow's 'mémoire trouée,' his 'memory shot through with holes,' defining also the indirect and fragmentary nature of second-generation memory. Photographs in their enduring 'umbilical' [Barthes] connection to life are precisely the medium connecting the first- and second-generation remembrance, memory and postmemory. They are the leftovers, the fragmentary sources and building blocks, shot through with holes, of the work of postmemory. They affirm the past's existence and, in their flat two-dimensionality, they signal its unbridgeable distance" (*Family Frames*, 23).

39 The first one is a childhood scene, where the young Pedro picks up some coins from "la repisa del Sagrado Corazón" (76) [the shelf where the picture of the Sacred Heart stood (27)] to run an errand at the request of his grandmother. The second is alluded to by González Boixo, editor of the novel, who explains a passage where Ana, Father Rentería's niece, tells her uncle that many women came to look for him while he was in Contla. González Boixo points out that the reason so many women came to see the priest was because

"el primer viernes de cada mes está dedicado al Sagrado Corazón de Jesús; son días de especial devoción" (*Pedro Páramo*, 128n80 [the first Friday of every month is dedicated to the Sacred Heart of Jesus; they are days of solemn devotion].

40 Sommers, "Los muertos," 520.

41 Other letters refer to Clara explicitly as mother and to himself as her son. See, for example, letters 11, 71, 73, and 79. In letter 68 (dated 4 September 1948), Rulfo writes to Clara: "Madre: Pronto nos veremos, tal vez el sábado, y quiera Dios que todo salga bien y nos ayude. (. . .) Acuérdate de tu hijo que te ama mucho y te da muchos besos y toda su vida" (271) [Mother, we'll see each other soon, maybe Saturday. God will help us and see that everything turns out fine. . . . Remember that your son loves you with all his heart, sends you kisses and will do anything for you.]. As anecdotal evidence, the orphanage "Luis Silva," where Rulfo stayed from 1927 to 1932, was originally named "Orfanatorio del Sagrado Corazón de Jesús" (Vital, *Noticias sobre Juan Rulfo*, 48).

42 References to the heart appear, in some form, in forty-nine of the eighty-one published letters.

43 In an essay published in the catalogue for an exhibit of contemporary Mexican art, Olivier Debroise links devotion and deviance when he points out that the traditional cult of the Sacred Heart "planteaba . . . un serio problema al dogma, puesto que la incontrolable crudeza de las representaciones de las llagas y del corazón de Cristo sugerían desbordamientos sensuales que colindaban en lo obsceno" [raised serious problems for Catholic dogma, since the out-of-control rawness of the representations of stigmata and the heart of Christ evoked a sensual overflowing that border on the obscene] (*Corazón Sangrante*, 16).

44 Bradu, "Ecos de Páramo," 216.

45 Villoro, "Lección de arena," 411.

46 Franco, "Viaje al país," 155; Ortega, "Enigmas de Pedro Páramo," 388.

47 Benítez, "Conversaciones con Juan Rulfo," 15.

48 "Ecos de Páramo," 236. Bradu goes on to say that "Cada recinto, cada fragmento es, para Rulfo, una fotografía, una instantánea cuya duración no está dada por el paso del tiempo sino por una minuciosa evocación de su contenido" [each enclosure, each fragment is, for Rulfo, a photograph, a snapshot whose duration does not depend on time's passing, but on a detailed evocation of its content], apparently suggesting that the quality of his descriptions is as minute and precise as a photograph (ibid.). However, it is doubtful that Rulfo's descriptions are in fact "minuciosas" [detailed, meticulous]. Moreover, she contradicts this photographic quality of Rulfo's writing when she states that "sus personajes no tienen cara ni fisonomía y muy escasas caracteristicas visuales" [his characters don't have a face

nor physiognomy and very few visual features] (ibid., 241). By contrast, Octavio Paz didn't think that Rulfo's writing was akin to photography or any other visual art, but rather expressed a mythic vision that reached a layer beyond representation: "Juan Rulfo . . . no nos ha entregado un documento fotográfico o una pintura impresionista sino que sus intuiciones y obsesiones personales han encarnado en la piedra, el polvo, el pirú. Su visión de este mundo es, en realidad, visión de *otro mundo*" [Juan Rulfo . . . has not given us a photographic document or an impressionist painting; instead, his personal obsessions and intuitions are embodied in the stone, the dust, the *pirú*. His vision of this world is really a vision of *another world*] ("Paisaje y novela," 477).

49 Munguía Cárdenas, "Antecedentes y datos biográficos," 479–80; Roffé, *Espejos de escritores*, 67.

50 Habra, "Recuperación de la imagen maternal," 102.

51 At the end of *El laberinto de la soledad*, Octavio Paz points out that "*orphanos* no solamente es huérfano, sino vacío. En efecto, soledad y orfandad son en último término, experiencias del vacío" (245–46) [*orphanos* means both "orphan" and "empty." Solitude and orphanhood are similar forms of emptiness] (*Labyrinth of Solitude*, translated by Lysander Kemp, 207).

52 Molloy, "Simplicidad inquietante," 245; Pezzoni, "Silvina Ocampo," 17.

53 Klingenberg, *Fantasies of the Feminine*, 14; Ulla, *Encuentros con Silvina Ocampo*, 34. Interest in the visual arts was a family affair for Ocampo. Her husband, Adolfo Bioy Casares, not only explored the realm of the visual in his novels *La invención de Morel* (1940), *Plan de evasión* (1945), and *La aventura de un fotógrafo en La Plata* (1985), but also took up photography in his forties. According to their close friend, the writer María Esther Vázquez, "por esos años, Bioy se pasaba el día con la cámara en la mano, sorprendiendo a su familia, a sus huéspedes y a todo el mundo" [in those years, Bioy spent all day with the camera in his hand, catching by surprise his family, his guests, and everybody else] (Vázquez, *Borges*, 233).

54 In his survey of the short story in Latin America literature, Balderston mentions these two stories in reference to photography ("Twentieth-Century Short Story," 478). They are not the only ones in which this medium appears in Ocampo's work, as I show below.

55 Balderston, *Cuentos crueles*, 747; Aldarondo, *El humor*, 14; Pezzoni, "Silvina Ocampo," 13; Mancini, *Silvina Ocampo*, 28, Ulla, *Encuentros con Silvina Ocampo*, 45.

56 D'Amico and Facio, *Retratos y autorretratos*, 119.

57 Ibid., 115–18.

58 A version of this poem appears in her book *Amarillo celeste* (1972) with the title "La cara apócrifa" [The apocryphal face] (124–29). A footnote to the poem directs the

reader to other compositions by Ocampo that have the face as a main theme.

59 Facio, *Foto de escritor*, p. 26.
60 Mackintosh points out that "Being photographed is (...) a frequent symbol of initiation in Ocampo's work" (*Childhood in the Works*, 104). Moreover, social rites of passage and celebrations turn out to be occasions for misfortune or frustration, as if the high point of an event leads inevitably to catastrophe. See, for example, the stories "Los objetos," in *La furia y otros cuentos*, and "La boda," in *Las invitadas*.
61 MacKintosh, *Childhood in the Works*, 217.
62 Sontag, *On Photography*, 15.
63 See the section on Elizondo in chapter 1.
64 Translations of "Las fotografías" are from "The Photographs," translated by Daniel Balderston.
65 Mancini, *Silvina Ocampo*, 65.
66 Money, *Anna Pavlova*, 71.
67 Pavlova visited Buenos Aires in 1918 and 1928 (ibid., 266–67, 379). The Ocampos most likely attended the latter performance.
68 The rhetoric of seizing or capturing is a recurring trope that describes the photographic act (Sontag, *On Photography*, 3–4; Sobchack, "Scene of the Screen," 90). See the section on Cortázar in chapter 1.
69 The last sentence of the story mentions yet another winged creature, this one decidedly ambiguous: the angel. Besides pointing to a celestial Beyond, it refers in Latin America (usually used in the diminutive) to a dead child (Linkman, *Photography and Death*, 27). Says the narrator, still in the grip of rancour and not fully grasping what has just happened, "¡Qué injusta es la vida! ¡En lugar de Adriana, que era un angelito, hubiera podido morir la desgraciada de Humberta!" (222) [How unfair life is! Instead of Adriana, who was an angel, that wretch Humberta might have died! (29)].
70 Translations of "La revelación" are from "Revelation," translated by Daniel Balderston.
71 Gunning, *Phantom Images*, 46. Commenting on the Spiritualist movement, Mulvey points out that "a technological novelty gives rise to a technological uncanny, in a collision between science and the supernatural. Thus, the intrinsic ghostliness of the black-and-white photograph elided with the sense that the machine might be able to perceive a presence invisible to the human eye" (*Death 24x a Second*, 43).
72 Golden, *Golden Images*, 119.
73 See her *nouvelle* "El impostor," included in *Autobiografía de Irene* (1948), as well as "La cara en la palma." In an interview with Noemí Ulla, Ocampo reflects on pattern recognition: "los caracoles de mar tienen la forma de las olas, tienen como un dibujito. Siempre me llamó la atención eso. Esos caracoles rosados parece que tuvieran las ondas del mar, que se van abriendo, hasta llegar al borde. Si fotografiaras las nervaduras de

las hojas solas, vas a ver un árbol" [seashells have the shape of waves, they have like a little drawing. I was always struck by that. Those pink seashells that seem to show sea waves, they seem to be opening till they reach the edge. If you photograph the nervations of the leaves, you are going to see a tree] (Ulla, *Encuentros con Silvina Ocampo*, 51–52). For a reference to photography as distorted representation, see Ocampo, "La última tarde." Ocampo exploits the fantastic and sinister potential of the photographic medium in other stories, such as "La paciente y el médico." Here, a photographic portrait is a token of an obsessive imagination, a voyeuristic desire, and a supernatural gaze. In "Los sueños de Leopoldina," a magical realist text, photographs mediate between the elusive imagery of shamanic dreams and the petty world of material artifacts. Photographs also appear in "El novio de Sibila" and "El enigma." See Klingenberg, *Fantasies of the Feminine*, 53–54.

74 Anderson, *Everything in Its Place*, 12, 121, 144; Balderston, "Lo grotesco en Piñera," 174; Santí, "Carne y papel," 83; C. L. Torres, *Cuentística de Virgilio Piñera*, 79, 103.

75 Langford points out that "showing and telling of an album" is a performance (*Suspended Conversations*, 5). Piñera, a prolific playwright and himself a theatrical person, exploited the dramatic potential of his short story and wrote a brief dramatic piece also called *El álbum*, which follows the same plot line as the short story. Though Cuban critic Rine Leal dates this piece somewhere in the 1960s ("Piñera todo teatral," xxii), it is likely that it was written closer to the date of the story's original publication, in the mid-1940s. The setting of both story and play in a boarding house reflects young Piñera's biographical circumstances (Anderson, *Everything in Its Place*, 22).

76 Critics use different terms to characterize this condition: Ladagga calls it "apatía profunda" [deep apathy] (*Literaturas indigentes*, 99); Cristofani assigns "aturdimiento" [bewilderment] ("Cuentos fríos," 29); and Valerio-Holguín proposes a "poética de la frialdad" [poetics of coldness] that underpins all of Piñera's work (*Poética de la frialdad*). Anderson refers to the protagonists of Piñera's stories as "impossibly impervious to brutal physical violence" (*Everything in Its Place*, 128).

77 Ladagga, *Literaturas indigentes*, 98.

78 In the short story "Santelices" (1961), by Chilean José Donoso—as in "El álbum"—a loner lives in a guesthouse subjected to the discipline and arbitrary wishes of an overbearing female owner. Photographs also mediate between the characters' disparate expectations. However, the role of photographs in each story is different. While "El álbum" explores the possibility of

expanding narrative time through the recourse of talking about images, in "Santelices" the author explores a fantastic realm that allows the protagonist to enter alternative spaces. In both texts photographs are means of escaping a mediocre or banal existence, but the fate of the protagonists are different. The woman in "El álbum" relishes her moment in the spotlight and remains a master of her limited domain, while Santelices finds death triggered, or at least influenced, by the totemic images he collects.

79 Patrizia di Bello points out that "Whether as a highly crafted collection, as a convenient container to store and view images, or—stretching the definition—reduced to a box of prints, the photographic album has become the main medium through which photographs are used to explore, construct, and confirm identity. Acts of self-reflection, such as looking at and collecting images of personal relevance, have become an indispensable feature of a modern sensibility. Viewing, sharing, and passing around albums has become an established ritual of familial gatherings, and a crucial aspect of the construction and maintenance of personal and cultural memories" ("Albums," n.p.). As for the future of this social practice, di Bello remarks that "digital techniques are dematerializing the album into infinite collections to be viewed on the computer or television screen and perhaps the Internet, where a growing number of family albums and personal or institutional collections can be inspected" (ibid.; see also Scott, *Spoken Image*, 228–29). On the history and social roles of the photo album, see the work of Marianne Hirsch as well as references in the works of Helmut Gernsheim, Beaumont Newhall, and Naomi Rosenblum, among other historians of photography. For a critical take on the conventions of the family album based on cultural studies and feminist theory, see Spence and Holland, eds., *Family Snaps*.

80 Sobchack, "Scene of the Screen," 91.
81 On this point Anderson reads the text allegorically, "as a highly exaggerated microcosm of Cuban society" (*Everything in Its Place*, 150).
82 Hirsch, *Family Frames*, 7.
83 See Langford, *Suspended Conversations*, 26–27, and Sontag, *On Photography*, 8–9. As critics have noted, the family is one of Piñera's main targets of criticism; see Hernández Busto, "Una tragedia en el trópico," 16; Ladagga, *Literaturas indigentes*, 13; Anderson, *Everything in Its Place*, 14, 140. In plays like *La boda* (1957) and *El No* (1965), the central motif is the refusal and impossibility of marriage. The novel *Pequeñas maniobras* (1963) is about a man who makes a point of escaping from others and refuses to engage in any social enterprise, family life included.
84 Bourdieu, "The Cult of Unity," 19. See also Hirsch, *Family Frames*, 53.

85 Hirsch, *Family Frames*, 7.
86 Barthes, *Camera Lucida*, 6.
87 Balderston, "Lo grotesco en Piñera," 177.
88 Julia Kristeva, quoted in Hirsch, *Family Frames*, 24.
89 Ibid., 2.

3: POLITICS OF THE IMAGE IN JULIO CORTÁZAR AND TOMÁS ELOY MARTÍNEZ

1 The works of Allan Sekula and John Tagg are good examples of how to read photographs politically, from Marxist and Foucauldian perspectives, respectively. My approach is different. Rather than summoning the broader socio-economic context of the production of pictures, I highlight the way photographic images are implicated in the political scenes, statements, and struggles that Cortázar and Martínez bring to the fore in their texts, and the way the photographs themselves are endowed with a power to shape political contexts.
2 Dávila devotes a chapter to analyzing these books in *Desembarcos en el papel*. I work with the pocket book editions, whose format differs from that of the original editions.
3 Benjamin, "On Some Motifs," 158–59; McLuhan, *Understanding Media*, 207. See also González, *Journalism*, 103; Zamora, "Novels and Newspapers," 61; Roffé, *Espejos de escritores*, 41.
4 Stephens, *History of News*, 2; Varnedoe and Gopnik, *High and Low*, 27.
5 Roffé, *Espejos de escritores*, 41.
6 Cortázar, *Libro de Manuel*, 11; translation from *A Manual for Manuel*, translated by Gregory Rabassa, 4.
7 Picón Garfield, *Cortázar por Cortázar*, 26–27.
8 Dávila, *Desembarcos en el papel*, 80, 109.
9 Cortázar, *Ultimo round*, vol. 1, 16–39.
10 See chapters 62, 114, 119, 130, and 146.
11 Bakhtin, "Discourse in the Novel," 275.
12 Mitchell, *Picture Theory*, 88.
13 Sugano, "Beyond What Meets the Eye," 337; Dávila, *Desembarcos en el papel*, 9; Perkowska, *Pliegues visuales*, 36.
14 Cortázar, *Ultimo round*, vol. 1, 224–47.
15 Cortázar, *La vuelta al día*, vol. 2, 114–19.
16 Goloboff, *Julio Cortázar*, 257.
17 Scott addresses the symbolic dimension at work in the photographic sign, by which it overcomes the conditions of its actual production: "this is the curious thing about the documentary photograph: like all photographic images, it is necessarily taken in the past, but its power to generalize and quintessentialize gives it the capacity continually to reconstitute itself, to adapt to a changing present" (*Spoken Image*, 88).
18 Ibid., 114.

19 Dávila, *Desembarcos en el papel*, 135.
20 See Russek, "Verbal/Visual Braids."
21 Cortázar, *Ultimo round*, vol. 1, 336. 156-57.
22 In "Las babas del diablo," the young protagonist is described as a "angel despeinado," (223) [disheveled angel (129)], alluding to his otherworldly charm. See also Ocampo's ambivalent reference to angels in chapter 2.
23 Jeffrey, *The Photo Book*, 468.
24 Sontag, *On Photography*, 20; Sontag, *Regarding the Pain*, 115; Barthes, "The Photographic Message," 21.
25 Linfield, *Cruel Radiance*, 22.
26 Cortázar, *Ultimo round*, vol. 1, 123-46.
27 Cortázar, *Cartas 1937-1983*, vol. 2, 1206.
28 Ibid., 1227.
29 Ibid., 1240.
30 Ibid.
31 Cortázar, *Ultimo round*, vol. 1, 141.
32 Malle's film documents daily life in the Indian city, but does not contain particularly harrowing images as conveyed by Cortázar's text. The photographs include a group of five men sitting under the sun (126-27), a close-up of an Indian girl (130-31), an old man facing the camera (134-35), a row of beggars sitting on the ground (138-39), a slim girl wearing a skirt (143), a body lying on the ground and covered by a shroud (145), and a negative take of the same photograph (147). See below for a commentary on these last two pictures.
33 Durand, "How to See," 147; Krauss, "Photographic Conditions of Surrealism," 109; Scott, *Spoken Image*, 17-18. For the link between photography and trauma, see notes 101 and 123 in chapter 1.
34 Cortázar, *Cartas 1937-1983*, vol. 1, 336.
35 Sontag, *On Photography*, 9; Osborne, *Travelling Light*, 82; Price and Wells, "Thinking about Photography," 36.
36 Pratt, *Imperial Eyes*, 4.
37 Ibid., 6.
38 Ibid., 209. See also Sontag, *On Photography*, 4.
39 Shloss points out that "the personal drive to expropriate the world through vision, to be drawn into what one sees, to unite vision with fulfillment, is rarely satisfied, and that longing is even more rarely accompanied by insight about the experience of being the Other, the recipient of such unusual but compelling scrutiny" (*In Visible Light*, 256). Scott, referring to the documentary photographer, writes that "to take a photograph at all is to proclaim a superiority, if only an economic and technological one, and the documentary photographer makes the inbuilt assumption that its subject does not take (has not the wherewithal to take) photographs of his/her own" (*Spoken Image*, 78).
40 See Sanjinés, *Paseos en el horizonte*, 193. In his memoirs Ernesto Cardenal refers to "Apocalipsis de Solentiname" as "un cuento muy realista, casi como una crónica periodística" [a very

realist short story, almost like a journalistic chronicle] in reference to Cortázar's visit to the village (*Insulas extrañas*, 421).

41 Dávila says that the main focus in *Ultimo round* is the present, and that Cortázar and Silva become "reporteros" [reporters] (*Desembarcos en el papel*, 164).

42 Roffé, *Espejos de escritores*, 43; Orlof, *Representation of the Political*, 111–13.

43 The slide show can be read as signaling the irruption of a "political unconscious" piercing the quiet middle-class life of a European intellectual. Cortázar exploits what Durand terms photography's "implosive character," ("How to See," 150), or, as Osborne explains, its ability of "provoking rather than organizing the workings of the viewer's unconscious. The photograph causes the viewer to, as it were, dream into it, causing it to become subjectivized by the viewer's desires, memories and associations" (*Travelling Light*, 77).

44 Cortázar, *Clases de literatura*, 109.

45 Ibid.

46 Rosenblum, *World History of Photography*, 478; Newhall, *History of Photography*, 260; Linfield, *Cruel Radiance*, 176.

47 Coleman, "Documentary," 39. Goldberg notes that "Bearing witness is what photographs do best; the fact that what is represented on paper undeniably existed, if only for a moment, is the ultimate source of the medium's extraordinary powers of persuasion" (*Power of Photography*, 19). See also Rosenblum, *World History of Photography*, 483.

48 Cortázar had explored the issue in other works. The fate of Oliveira in *Rayuela* centres around the impossible longing for unity and transcendence (Colás, *Postmodernity in Latin America*, 31). In the essay "Del sentimiento de no estar del todo," from *La vuelta al día en ochenta mundos*, Cortázar developed the idea of the artist's failure to adapt to society, coming up with a conceptual distinction that echoes the art-and-life polarity: "entre vivir y escribir nunca admití una clara diferencia" (32) [I never admitted a clear distinction between living and writing]. Writing and ethics, as Moran points out, "were inextricable" for Cortázar (*Questions of the Liminal*, 7n17). Ferré traces the romantic heritage in Cortázar's work.

49 Sugano remarks that "Although the narrator of 'Apocalypse' is certainly more in touch with a determined historical reality, the extent of his horizon of engagement seems paradoxically to be limited to the quality of his vision itself" ("Beyond What Meets the Eye," 346). Linfield points out that "photography has, more than any other twentieth-century medium, exposed violence—made violence *visible*—to millions of people all over the globe. Yet the history of photography shows just how limited and inadequate such exposure is: seeing does

not necessarily translate into believing, caring, or acting. That is the dialectic, and the failure, at the heart of the photograph of suffering" (*Cruel Radiance*, 33).

50 Franco, "Crisis of the Liberal Imagination," 267.

51 Ritchin, "Close Witnesses," 591. See also Orlof, *Representation of the Political*, 113.

52 Roffé, *Espejos de escritores*, 42–43.

53 See Ganduglia, "Representacion de la historia"; McDuffie, "La novela de Perón"; and Parodi, "Ficción y realidad."

54 Hutcheon, *Politics of Postmodernism*, 22.

55 See Colás, *Postmodernity in Latin America*; Halperín Donghi, "Presente transforma el pasado"; and Martin, *Journeys through the Labyrinth*. Menton, following Anderson Imbert, excludes *La novela de Perón* from the category of the new historical novel in Latin American, on the grounds that, despite its "significant historical dimension," the novel encompasses, "at least partially, the author's own time frame" (*Latin America's New Historical Novel*, 14).

56 Diana Taylor addresses the differences between Perón's authoritarian practices in the 1940s and the terror unleashed by the military regime in the 1970s (*Disappearing Acts*, 93).

57 The portrait of Isabel is referred to explicitly as a "foto de ocho metros" (36) [a twenty-five-foot portrait (28)]. Translations of *La novela de Perón* are from *The Perón Novel*, translated by Asa Zatz.

58 See, for example, the essay "Necrofilias argentinas." In his collection *Requiem por un país perdido* (2003), a book that expands and updates his previous volume of essays, *El sueño argentino*, Martínez exploits, almost with dark delight, the links between social and political decadence and his personal sense of melancholia. To quote the title of another of his collection of essays (*Lugar común la muerte*), death is common in his writings.

59 For the French critic, photography "embalms time" ("Ontology," 14).

60 Belting, "Toward an Anthropology," 47.

61 Photographs are mentioned throughout: in the magazine *Horizonte* featuring Evita as a young girl (325), Perón and Evita photographed in the radio station where she worked (295), Evita photographed with Franco's ministers (299), Evita on the cover of *Time* magazine (299), the photograph of Isabel's deceased father (21), the melancholic postcards young Isabelita sends from Chile and Colombia to the Crestos (23), a picture of an overweight Isabelita with Perón in Caracas (24), the supposed photograph of López Rega posing as singer in the magazine *Sintonía* (28), Cipriano Tizón, Potota's father, owner of a photography shop (172), Aurelia Tizón, Perón's first wife, weeping with a photograph of her mother in her

hand (215), the editor of *Horizonte* showing Zamora photographs of Perón's exile (31), chapter 3, entitled "Photographs of the witnesses," a swarm of photographers in Madrid shooting Perón just before his return to Argentina (317), reporters at Ezeiza (335), the prohibition against taking photographs at a press conference in the airport after the massacre (343), and the flash of photographic cameras when Perón exits the airplane in Morón (349).

62 On the link between ritual and photography, see the section on Rulfo in chapter 2.

63 Barnicoat, *Concise History of Posters*, 157.

64 Jean Franco points out that "Mass consensus was achieved in Peronist Argentina as in Fascist Germany through ritual—Benjamin would call it the aestheticization of politics—and also through the ruling elite's speedy grasp of the importance of the media in securing consent" ("Comic Stripping," 38).

65 A reference to the rituals of the image is made in Parodi, "Ficción y realidad," 40.

66 In the introduction to her seminal *La imaginación técnica*, Sarlo sketches the impact of new technologies on Argentina's collective imaginary at the beginning of the twentieth century.

67 Martínez, *Memorias del General*, 11.

68 Sarlo points toward this new historical age in her analysis of video games and televisual practices such as zapping, where she finds "esa velocidad y borramiento, que podría ser el signo de una época" [that speed and erasure that could be the sign of an era] (*Escenas de la vida posmoderna*, 55).

69 The novel was not yet finished when it began appearing in serial form. This may explain some of the changes in structure and style from its weekly publication to its final book form. There is no reference in the book to the fact that the text first appeared serialized in the newspaper.

70 Tomás Eloy Martínez, written communication with the author, 22 March 2004. I thank him and Professor Marcy Schwartz for their support during my research.

71 Garrels, "El *Facundo* como folletín," 419.

72 Martínez strives to do retroactively, or melancholically, what Doris Sommer identifies as the goal of the nineteenth-century Latin American writers: "In the epistemological gaps that the non-science of history leaves open, narrators could project an ideal future" (*Foundational Fictions*, 7). By reinterpreting history, Martínez is also guided by the belief that "literature has the capacity to intervene in history, to help construct it" (Ibid., 10).

73 Hutcheon points out that "The photo ratifies what was there, what it represents, and does so in a way that language can never do. It is not odd that the historiographic metafictionist, grappling with the same issue of representation of

the past, might want to turn, for analogies and inspiration, to this other medium, this 'certificate of presence' . . . , this paradoxically undermining yet authentifying representation of the past real" (*Politics of Postmodernism*, 91).

74. Insofar as the reader of the novel has to assemble the narrative pieces that compose each chapter, research journalism can be regarded as the organizing principle of the plot.

75. For an account of Martínez's last hours in Argentina, in 1975, see David Streitfeld, "The Body of a Novelist's Work," *Washington Post*, 24 December 1996, http://www.davidstreitfeld.com/archive/writers/eloymartinez.html.

76. Colás remarks that Martínez's basic literary operation consisted in re-writing history and de-mythologizing Perón: "Martinez's novel . . . attempts to renegotiate the course of history, of society. . . . [I]t does so by *respiración artificial*: resuscitating not the dead General but the petrified image that the General carefully left behind" (*Postmodernity in Latin America*, 157). Marble, indeed, seals a destiny in death. In the text, Perón chats with Cámpora and refers to his advisor Figuerola: "Cierta vez me advirtió Figuerola que los argentinos somos adictos a la muerte. Empleó una palabra extraña: tanatófilos" (318) [Figuerola once called to my attention that the Argentines are death-oriented. He used a strange word: 'thanatophiles' (316)]. As I have suggested before, that is an opinion the author certainly shares.

77. The word "mercurial" may also be applied here, referring to "a person having a lively, volatile, or restless nature; liable to sudden and unpredictable changes of mind or mood." Oxford English Dictionary Online, s.v. "mercurial."

78. The character of Tomás Eloy Martínez could agree with Baudrillard: simulacra have taken over the real Perón, and no original can be found to sustain the proliferation of replicas. After interviewing Perón, Martínez believes that the General is an empty form, a mere empty word: "Tantos rostros le ví que me decepcioné. De repente, dejó de ser un mito. Finalmente me dije: él es nadie. Apenas es Perón" (261) [I saw so many of his semblances that I became disillusioned. He was no longer a myth. At last, I said to myself, he's nobody. He's hardly even Perón (259)]. It is less likely that this reflects the position of the author, who traces almost with gusto the decadence of an all too real historical figure.

79. Martin writes that the novel provides not a "portrait" but a "picture" of Perón, by which he presumably means that the novel does not specifically intend to depict the man's life, but rather to contextualize it (*Journeys through the Labyrinth*, 342).

80. The phrase "un águila guerrera" is a reference to "Canción de la bandera" [Flag song], whose first stanza is this: "Alta en el cielo un

águila guerrera,/ audaz se eleva en vuelo triunfal,/ azul un ala del color del cielo,/ azul un ala del color del mar." [High in the sky a warrior eagle,/ bold rises in triumphant flight,/ Blue a wing of the colour of the sky/ Blue a wing of the colour of the sea.] The song, about the Argentine flag and a staple of national culture, was originally an aria in the 1908 opera *Aurora* by Argentine composer Héctor Panizza. The song became, by a decree issued precisely during Peron's first presidential term in the early 1950s, a mandatory song in grade and middle schools all over Argentina (Panizza, *Medio siglo de vida musical*, 73).

81 Barnicoat, *Concise History of Posters*, 22.

82 Max Gallo points out that "crowds were organized to acclaim these men [Hitler, Mussolini, and Stalin], whose pictures appeared in increasing numbers on walls.... On posters showing these leaders, words had all but disappeared. At most the posters bore a few words—"Heil Hitler"" or "Si" (the latter when inviting people to vote yes in a plebiscite). Otherwise, the image was enough. In public Hitler and Mussolini always wore the military trappings of their offices. Until early in the 1930s, Mussolini often appeared in civilian clothes, like the chiefs of foreign states he was meeting. But after the Ethiopian war and the triumph of German Nazism, he appeared only in uniform. Posters after 1935 show him helmeted, with his jaws clamped shut and his face set in what he believed to be a heroic expression" (*The Poster in History*, 246–49). Gallo includes an illustration of one of these posters, in which Mussolini dons a black helmet adorned with a silver eagle (247).

83 Frizot, "States of Things," 371.

84 The point is made by Sontag in these terms: "In an era of information overload, the photograph provides a quick way of apprehending something and a compact form for memorizing it" (*Regarding the Pain*, 22).

85 Mitchell, *Picture Theory*, 6.

CONCLUSION

1 Barthes, *Camera Lucida*, 93–94.
2 Mulvey, *Death 24x a Second*, 18.
3 See Michael J. de la Merced, "Eastman Kodak Files for Bankruptcy," *New York Times*, 12 January 2012, http://dealbook.nytimes.com/2012/01/19/eastman-kodak-files-for-bankruptcy/.
4 Brunet, *Photography and Literature*, 139.
5 Ibid., 140.
6 Paz-Soldán, "La imagen fotográfica," 768.
7 See Perkowska, *Pliegues visuales*, 25; Ríos, *Espectros de luz*, 34–43.
8 See Brunet, *Photography and Literature*, 85.
9 This translation from *Aura* is by Lysander Kemp.

INDEX

A

Alatorre, Antonio, 98
"Álbum, El" (Piñera). *See under* Piñera, Virgilio, works of
Alfonsín, Raúl, 144
Allende, Isabel, 15
Alonso, Carlos, 86
Amorím, Enrique, 15
Anderson, Thomas F., 213n83
Anderson Imbert, Enrique, 19, 187n17, 189n33
Ansón, Antonio, 4
Aparicio de Rulfo, Clara, 94–96
"Apocalipsis de Solentiname" (Cortázar). *See under* Cortázar, Julio, works of
Arlt, Roberto, 4
Arnheim, Rudolf, 7
Artigas Albarelli, Irene, 184n27
attraction (concept), 47
Aura (Fuentes), 156

B

"Babas del diablo, Las" (Cortázar). *See under* Cortázar, Julio, works of
Baer, Ulrich, 196n101
Bakhtin, Mikhail, 117
Balderston, Daniel, 3, 113
Baler, Pablo, 195n95
Barnicoat, John, 141
Barthes, Roland, 5–7, 67, 93, 112, 124, 145, 153, 182n16, 189n27, 194n80, 196n104, 201n126, 204n166, 205n172
Barzilay, Fréderic, 184n41
Bataille, Georges, 58, 67, 69, 195n95
Baudelaire, Charles, 67, 117, 193n71, 194n83, 202n139
Baudrillard, Jean, 219n78
Bazin, André, 5, 7, 72, 137, 145, 204n166, 205n172
Becquer Casaballe, Amado, 188n23
Belgrano Rawson, Eduardo, 4
Bellatín, Mario, 4, 15
Belting, Hans, 28, 139
Benjamin, Walter, 9, 27, 72, 116, 182n16
Berger, John, 8
Bioy Casares, Adolfo, 14, 99, 155, 182n17, 210n53
Blow-Up (Antonioni film), 3, 52
Blue, Gregory, 198n112
Bolaño, Roberto, 3, 4, 15
Boom, Latin American, 99, 134
Borges, Jorge Luis, 14, 61–63, 99

221

Bourdieu, Pierre, 111
Bourgon, Jérôme, 198n112
Bradu, Fabienne, 96–97, 208n29, 209n48
Brassaï, 38
Brignole, Alberto J., 205n4
British Royal Family, 36, *37*
Brook, Timothy, 198n112
Brooks, Peter, 74
Brunet, François, 155, 181–82n11, 181n7, 186n5, 197n104, 207n25
Bryant, Marsha, 181n7
Buñuel, Luis, 204n155
Burgin, Victor, 6, 8
Burrows, Larry, 132

C

Cabrera Infante, Guillermo, 3, 4, 15
Cadava, Edward, 204n166
Calcutta (Malle film), 127, *129*, 215n32
"Cámara oscura, La" (Quiroga). *See under* Quiroga, Horacio, works of
Camera Lucida (Barthes). *See* Barthes, Roland
cameras, 5, 24, *25*, 41–42, 79, 193n74. *See also* Polaroid cameras/pictures
"Canción de la bandera" (song), 219–20n80
Capa, Cornell, 133
Capa, Robert, 132, 134
Cardenal, Ernesto, 131, 215n40
Carroll, Lewis, 3
Cartier-Bresson, Henri, 38–39, 194n84
Catholicism, 28–29, 94
Chejfec, Sergio, 15
Chien andalou, Un (Dalí and Buñuel film), 204n155
Chirico, Giorgio de, 99
Christ, visual representations of, 20–22, *21*, 28–29, *30*, 189n29
Cien años de soledad (García Márquez), 35–36
Cioran, E. M., 61
Clark D'Lugo, Carol, 197–98n110, 203n154, 204n157

Colás, Santiago, 219n76
Coleman, A. D., 133
Colina, José de la, 90
colour, 51, 196n100
communication devices. *See* cameras; typewriters
convergence, 2
Cortázar, Julio, 4, 6–7, 13–14, 36–40, 50–52, 99, 115–17, 120–21, 123–27, 130–33, 154, 191n60, 192–93nn70–71, 194n82
Cortázar, Julio, works of
 "Acerca de la manera de viajar de Atenas a Cabo Sunion," 120
 "Album con fotos," 120, 123–24
 "Algunos aspectos del cuento," 55
 Alto el Perú, 184n41
 "Apocalipsis de Solentiname," 50–56, 108, 117, 123, 126, 128, 130–34, 191n60, 194n76
 Autonautas de la cosmopista, Los (with Dunlop), 7, 130, 193n70
 "Babas del diablo, Las," 3, 38–56, 75, 113, 126, 128, 131, 134–35, 197n106, 207n22
 "Blow-Up," 3
 Buenos Aires, Buenos Aires, 184n41
 "Carta del viajero," 184n41
 "Del sentimiento de no estar del todo," 216n48
 "Día de tantos en Saignon, Un," 117
 "En vista del éxito obtenido, o los piantados firmes como fierro," 36, 120
 Humanario, 184n41
 Libro de Manuel, 116
 "Luz negra," 185n41
 "Muñeca rota, La," 191n60
 Papeles inesperados, 185n41
 Paris, ritmos de una ciudad, 130, 184n41
 Prosa del observatorio, 7, 117, 129
 Rayuela, 117, 129, 185n43, 195n95, 216n48
 Territorios, 184n41
 "Turismo aconsejable," 120, 124–30, *129*

Ultimo round, 7, 36, 115–17, *118–19,* 120, 123, 131–32, 135, 191n60
"Vuelta al día en el Tercer Mundo," 120–23, 127
Vuelta al día en ochenta mundos, La, 7, 115–17, 120, 123, 129, 131, 135, 216n48
Crary, Jonathan, 32–33, 190n45
Crookes, William, 188n18
"Crucifixion with Roman soldiers" (Day photograph), *21*
Cuarterolo, Miguel Angel, 189n23
Cuban Revolution, 132
Curley, Dermot, 73, 201n131

D

daguerreotypes, 2, 158
Dalí, Salvador, 204n155
D'Amico, Alicia, 99
Darío, Rubén, 17–20, 22, 26, 34, 154
Darío, Rubén, works of
 Cantos de vida y esperanza, 20
 "Ciencia y el más allá, La," 187n18
 "Diorama de Lourdes," 22–23
 "Extraña muerte de Fray Pedro, La," 187n17, 189n33
 Mundo adelante, 22
 Mundo de los sueños, El, 187n18
 Obras Completas, 22
 "Responso," 20
 "Verónica," 17–20, 22–23, 27–29, 32–34, 188n18
 "Yo soy aquel que ayer no más decía . . . ," 20
Dávila, María de Lourdes, 120, 214n2, 216n41
da Vinci, Leonardo, 10
Day, Frederick Holland, 20–22
de Andrade, Alecio, 184n41
de Armas, Frederick A., 183n27
"Death by a Thousand Cuts" (photograph), 58, *59,* 61–62, 66, 74, 198n112
Debroise, Olivier, 189n23, 209n43

Delgado, José M., 205n4
dialogism, 117
Díaz, Francisco Fabricio, 36
Di Bella, Maria Pia, 204n165
di Bello, Patrizia, 213n79
digital age, 2, 155–56
"Dirty War" (Argentina), 4, 136
Doisneau, Robert, 38
Donoso, José, 15, 212n78
Duncan, David Douglas, 132
Dunlop, Carol, 7, 130
Durán, Manuel, 200n121
Durand, Régis, 216n43
"Dying Swan, The" (ballet solo), 103–4

E

Eastman, George, 24
Eastman Kodak, 155
ekphrasis, 8–9, 14, 45, 47, 50, 59, 69–71, 93, 100, 112, 123, 144, 183–84n27
ekphrasis, notional, 9, 96
ekphrastic fear, 47, 56, 86, 194n85
ekphrastic hope, 45–46, 194n85
ekphrastic principle, 50
Elizondo, Salvador, 4, 7, 11, 13, 57–64, 66–67, 70–71, 73–74, 99, 154
Elizondo, Salvador, works of
 Autobiografía precoz, 57, 62, 200n122
 Cuaderno de escritura, 58, 73–74, 201n130
 "Ein Heldenleben," 202n139
 Farabeuf, 57–64, 67–75
 "Gironella," 201n130
 "Invocación y evocación de la infancia," 63
 "Mnemothreptos," 204n155
 "Morfeo o la decadencia del sueño," 198n112
 "Putridero óptico, El," 63, 198n113, 201n130
Elkins, James, 198n112, 204n165
Elliot, John, 188n23

El obrador de Francisco Lezcano (Gironella painting), 58
enargeia, 59, 183n27
Englekirk, John E., 206n15

F

Facio, Sara, 99, 100, 189n23
family albums. *See* photo albums
Farabeuf (Elizondo). *See under* Elizondo, Salvador, works of
Farabeuf, Louis Herbert, 198n112
Ferré, Rosario, 216n48
Filer, Malva, 202n132
film, black-and-white, 51
fixity, violence, and memory (re: Elizondo), 61–63
flâneur, 190–91n53
Fontcuberta, Joan, 145
Foster, Hal, 192n66
"Fotografías, Las" (Ocampo). *See under* Ocampo, Silvina, works of
fotonovela (literary subgenre), 4
Foucault, Michel, 203n143
fragmentation, 196–97n110
Franco, Jean, 10, 97, 134, 208n29, 218n64
Fraser, Benjamin, 207n25
Fraser, Howard M., 187n17
Freedberg, David, 140
French symbolism, 70
Freud, Sigmund, 11, 52
Frizot, Michael, 32, 150, 189n29
Fuentes, Carlos, 15, 156

G

Gabara, Esther, 4
Gallo, Max, 220n82
Galvez, Antonio, 184n41
García Krinsky, Emma Cecilia, 189n23
García Márquez, Gabriel, 14–15, 35–36
Garro, Elena, 91
Gautier, Théophile, 182n11
Gernsheim, Helmut, 213n79

ghost photography, 24, 108
Gironella, Alberto, 58
Glantz, Margo, 206n15
God, visions of, 28, 35–36
Goldberg, Vicky, 32, 60, 216n47
González, José Luis, 4
González Aktories, Susana, 184n27
González Echevarría, Roberto, 192n67, 194n82
Gorodischer, Angelica, 15
Grant, Catherine, 4
Grossvogel, David I., 194n77
Guerrero, Fernando, 199n117
Gumbrecht, Hans Ulrich, 186–87n16
Gunning, Tom, 24, 196–97n104
Guttiérrez Mouat, Ricardo, 191n53, 193n71
Guttiérrez Nájera, Manuel, 186n16

H

Habra, Hedy, 98, 207n26, 208n29
Hagstrum, Jean, 183n23
Hahn, Oscar, 189n33
Heath, Stephen, 199n118
Heffernan, James, 10, 47, 70
Hernández Busto, Ernesto, 213n83
Hirsch, Marianne, 111–12, 208n38, 213n79
Hoffmann, Heinrich, 63
Hogar, El (magazine), 82
Holland, Patricia, 213n79
Holmberg, Eduardo, 11
Holmes, Oliver Wendell, 33
Horstkotte, Silke, 181n7
Hughes, Alex, 3, 201n126
Huidobro, Vicente, 4
Hutcheon, Linda, 136, 218n73
Huysmans, Joris-Karl, 188n18

I

India, 7, 124–27
intermediality, 183n27
Invención de Morel, La (Bioy Casares), 155

J

Jackson, Rosemary, 40, 62, 190n35, 193n71
Jara, René, 199n117
Jenkins, Henry, 2
Jesus Christ. *See* Christ
Jiménez, José Olivio, 187n17
journalism, 116–17, 143–44, 146–47
journalism, illustrated, 1, 12, 116, 123, 127, 134
Jrade, Cathy Login, 20, 187n17
Jussim, Estelle, 21

K

Kertész, André, 38
Kirstein, Lincoln, 39
Kittler, Friedrich A., 41, 194n76
Klingenberg, Patricia Nisbet, 102
Kodak camera (Brownie), 24
Kracauer, Sigfried, 197n104, 201n126
Krauss, Rosalind, 8, 192n66, 205n172
Krieger, Murray, 8–9, 47, 50

L

Ladagga, Reinaldo, 213n83
Langford, Martha, 204n166, 212n75
Leal, Rine, 212n75
Léger, Fernand, 99
"Leng Tch'é" (photograph). *See* "Death by a Thousand Cuts"
Leys, Ruth, 196n101
Lida, Raimundo, 187n17
Linfield, Susie, 70, 203n149, 204n166, 216n49
Linkman, Audrey, 206n12, 207n18
literature and photography. *See* photography: and literature
looking, act of, 39
López Rega, José, 136, 147
Lourdes (village), 188n22
Lubitsch, Ernst, 108
Lugones, Leopoldo, 3, 4, 18, 79–80

M

machines, 18, 41–43
Mackintosh, Fiona J., 211n60
Malle, Louis, 127, 215n32
Marien, Mary Warner, 32
Marks, Laura U., 195n91
Martí, José, 11
Martin, Gerald, 11, 219n79
Martínez, Isabel, 136
Martínez, Juan Luis, 4
Martínez, Patricia, 199n118
Martínez, Tomás Eloy, 7, 12, 115, 135, 137, 143–44, *145*, 147, 154
Martínez, Tomás Eloy, works of
 Lugar común la muerte, 217n58
 Memorias del General, Las, 144
 "Necrofilias argentinas," 217n58
 Novela de Perón, La, 135–51
 Requiem por un país perdido, 217n58
 Santa Evita, 137
Matamoro, Blas, 102
Matto de Turner, Clorinda, 11
McLuhan, Marshall, 5, 41
McMurray, George R., 200n121
media and anxiety, 41
Meiselas, Susan, 133
memory. *See* fixity, violence, and memory; photography: and memory/postmemory
Menton, Seymour, 217n55
Metz, Christian, 204n166, 208n31
Meyer-Minnemann, Klaus, 193n71, 194n82
Meyerowitz, Joel, 190n52
Mitchell, W. J. T., 8, 34, 41, 47, 120, 151, 194n85
modernism, 29, 197n110
modernismo, 18, 20
modern science. *See* science
Moholy-Nagy, László, 181n9
Monsiváis, Carlos, 10, 14, 92, 94
Moran, Dominic, 48, 191n62, 192n67, 216n48
Moreiras, Alberto, 199n117
Morris, Wright, 3
Mraz, John, 4, 186n16, 189n35, 190n49

Index 225

Mulvey, Laura, 11, 153, 196n101, 211n71
Munguía Cárdenas, Federico, 97
Musselwhite, David, 191n65

N

Nación, La (newspaper), 22, *25*, 26, *27*
Nancy, Jean-Luc, 195n91, 202n135
Negri, Pola, 107–8
Neruda, Pablo, 99, 185n5
Newhall, Beaumont, 186n16, 213n79
nitidez, 59
Noble, Andrea, 3, 4, 201n126
Nochlin, Linda, 197n110
notional ekphrasis, 9
nouveau roman, 199n118
Novela de Perón, La (Martínez). *See under* Martínez, Tomás Eloy, works of

O

Ocampo, Silvina, 77, 98–100, *101*, 110
Ocampo, Silvina, works of
 Amarillo celeste, 210n58
 "Cara, La," 100
 "Cara apócrifa, La," 210n58
 "Enigma, El," 212n73
 "Fotografías, Las," 77–78, 99–100, 102–5
 Furia y otros cuentos, La, 99
 Invitadas, Las, 99
 "Novio de Sibila, El," 212n73
 "Paciente y el médico, La," 212n73
 "Revelación, La," 77–78, 99, 105–8
 "Sueños de Leopoldina, Los," 212n73
 "Última tarde, La," 212n73
Offerhaus, Manja, 184n41
Onetti, Juan Carlos, 15
Ong, Walter, 92
On Photography (Sontag). *See* Sontag, Susan
Ortega, Julio, 97
Osborne, Peter, 216n43

P

Panizza, Héctor, 220n80
Panorama (magazine), 144, 194n82
paragone, 10
Pasveer, Bernicke, 32
Pavlova, Anna, 104, 211n67
Paz, Octavio, 18, 99, 185n5, 210n48, 210n51
Paz-Soldán, Edmundo, 4, 155
Pedri, Nancy, 181n7
Pedro Páramo (Rulfo, Juan). *See under* Rulfo, Juan, works of
Pepper, William, 121
Pérez y Effinger, Daniela, 193n71, 194n82
Periodista de Buenos Aires, El (newspaper), 144
Perkowska, Magdalena, 4, 120, 183n20, 184n39, 185nn44–45, 198n110, 220n7
Perón, Juan Domingo, 136–38, 144–45, *145*
photo albums, 5, 110–11, 123, 213n79
photographic technologies. *See* cameras; daguerreotypes; film, black-and-white; Polaroid cameras/pictures; slide projection; slides, colour photography
 conventional definition of, 1
 and death, 71, 78, 83, 137
 fixity of, 142, 204n166
 future of, 155–56
 historical development of, 2–3, 24, 188n23
 as hobby of writers, 6
 and journalism (*See* journalism, illustrated)
 and literature, 3–10, 14–15, 72–73, 89, 154–55
 magical properties of, 85, 141, 196n104
 materiality of, 6, 72–73, 96
 and memory/postmemory, 60–61, 77, 137, 201n126, 208n38
 paradox of, 135
 politics of, 115
 power of, 8, 74, 120, 135–36, 150, 154, 201n126
 as prophecy, 91

testimonial use of, 116–17, 120, 122, 124, 131, 135, 151
theories and theorists of, 7–8, 72, 145–46, 194n80, 196–97n104, 204n166
and traditional visual arts, 5, 9
and trauma/violence, 61, 67, 68, 75, 124, 196n101, 200n123
and truthfulness, 5, 75, 146
uncanny dimension of, 10–11, 24, 51, 108, 115, 154, 162n66, 196n104
photography, digital, 2, 153
photojournalism. *See* journalism, illustrated
Picón Garfield, Evelyn, 7, 77–78
Pictorialism (photographic movement), 20–21
Piñera, Virgilio, 77–78, 109, 154
Piñera, Virgilio, works of
 Álbum, El, 212n75
 "Álbum, El," 77–78, 109–14
 Boda, La, 213n83
 Carne de René, La, 109
 Cuentos fríos, 109
 No, El, 213n83
 Pequeñas maniobras, 213n83
 Poesía y prosa, 109
Pius X, Pope, 29
Poe, Edgar Allan, 70, 80, 82
Poe Lang, Karen, 185n1
Polaroid cameras/pictures, 53–55, 196n103
Poniatowska, Elena, 3, 4, 14, 98, 185n44
Porrúa, Francisco, 125
Pratt, Mary Louise, 130
Praz, Mario, 202n139
psychological realism, 60
punctum, 67

Q

Quiroga, Horacio, 4, 6, 12, 77–80, 82, 88, 99, 108, 126
Quiroga, Horacio, works of
 Arrecifes de coral, Los, 80

"Cámara oscura, La," 77–78, 80, *81,* 82–88
Desterrados, Los, 78
"Retrato, El," 80
"Tacuara Mansión," 88

R

Rabb, Jane M., 3, 154
radiography, 19, 28, 32
Rama, Angel, 187n17
Ramírez, Sergio, 4, 15, 182n13
Ramparts (magazine), 121, 123–24
religion, critics of, 28
religious imagery, 92. *See also* Christ, visual representations of
reportage. *See* journalism
"Revelación, La" (Ocampo). *See under* Ocampo, Silvina, works of
Ríos, Valeria de los, 4, 185n1, 185n45, 200n124, 220n7
Rivera Garza, Cristina, 15
Rodríguez Monegal, Emir, 206n16, 208n29
Roentgen, Bertha, 32
Roentgen, Wilhelm, 26, 32
Romero, Rolando J., 198n112
Rosenblum, Naomi, 186n16, 195n99, 213n79
Rulfo, David Pérez, 97
Rulfo, Juan, 6, 12, 77, 88, 93–99, 108, 154
Rulfo, Juan, works of
 Aire de las colinas, 94
 Pedro Páramo, 77, 88–94, 96–98
Russek, Dan, 185n45, 186n15, 202n134, 207n25, 214n20

S

Sade, Marquis de, 67
Sarduy, Severo, 195n95
Sarlo, Beatriz, 10, 78, 218n66, 218n68
Sarmiento, Domingo, 144
Scarry, Elaine, 205n168
Schwartz, Hillel, 42

Schwartz, Marcy, 10, 185n41, 190n53, 218n70
science, 20, 23–24, 29, 34
Scott, Clive, 123, 182n16, 192n66, 214n17, 215n39
Sebald, W. G., 155
Sekula, Allan, 8, 197n104, 214n1
Shaw, Donald, 202n131
Sherman, Cindy, 146
Shloss, Carol, 5, 215n39
shroud of Turin, 29, *31*, 189n29
Shua, Ana María, 15
sight, sense of, 34, 48–49, 71–75
Silva, Julio, 117
slide projection, 51, 134, 194n76
slides, colour, 51, 55, 195n99
Smith, W. Eugene, 132
snapshots, 5
Snyder, Joel, 197n104
Sobchack, Vivian, 47, 110, 201n125, 204n166
Sommer, Doris, 218n72
Sontag, Susan, 7–8, 67, 124, 182n16, 189n35, 191n53, 192n66, 194n76, 194n80, 198n110, 198n112, 201n126, 204n166, 220n84
Soubirous, Bernadette (Saint Bernadette), 188n22
sound, sense of, 92
Spence, Jo, 213n79
spiritual crisis (19th century), 20
Spitzer, Leo, 8, 183n27
stereoscope (device), 33–34
Struwwelpeter, Der (Hoffmann), 63–64, *65*, 66
Sueños digitales (Paz-Soldán), 155–56
Sugano, Marian Zwerling, 38, 120, 184n38, 191n60, 216n49
Surrealism, 7, 36, 40, 182n19, 192n66

T

Tagg, John, 8, 214n1
Talbot, Henry Fox, 32
Taylor, Diana, 217n56
technology (in 19th c), 24
Tejada, Roberto, 4
Torres, Alejandra, 185n1
touch, sense of, 34, 47–49, 71–73, 75, 96
Trachtenberg, Alan, 3
typewriters, 41–42, 193n70

U

Ulla, Noemí, 211n73
Ultimo round (Cortázar). *See under* Cortázar, Julio, works of
uncanny (Freudian concept), 11, 194n79, 206n16
Ut, Nick, 124

V

Vázquez, María Esther, 182n17, 210n53
Velarde, Ramón López, 201n125
Venezuela, 121
Veronica (legend), 28–29
"Verónica" (Darío). *See under* Darío, Rubén, works of
Vietnam, war in, 121–22, *122*, 124
Villoro, Juan, 94, 97
violence. *See* fixity, violence, and memory; photography: and trauma/violence
Volek, Emil, 40
Vuelta al día en ochenta mundos, La (Cortázar). *See under* Cortázar, Julio, works of

W

Wagner, Peter, 9, 10, 183n27
Walsh, Rodolfo, 15
Watriss, Wendy, 189n23
Webb, Ruth, 183n27
Westerbeck, Colin, 190n52
Weston, Edward, 205n179
Williams, Linda, 47, 73

X

X-rays, 18–19, 26–27, *27*, 29, 32, 34

Z

zahir (concept), 62–63, 202n138
Zamora, Lois Parkinson, 10, 189n23, 192n65
Ziolkowski, Theodor, 20, 186n7
Zola, Emile, 3, 5, 22

www.ingramcontent.com/pod-product-compliance
Lightning Source LLC
Chambersburg PA
CBHW070801230426
43665CB00017B/2448